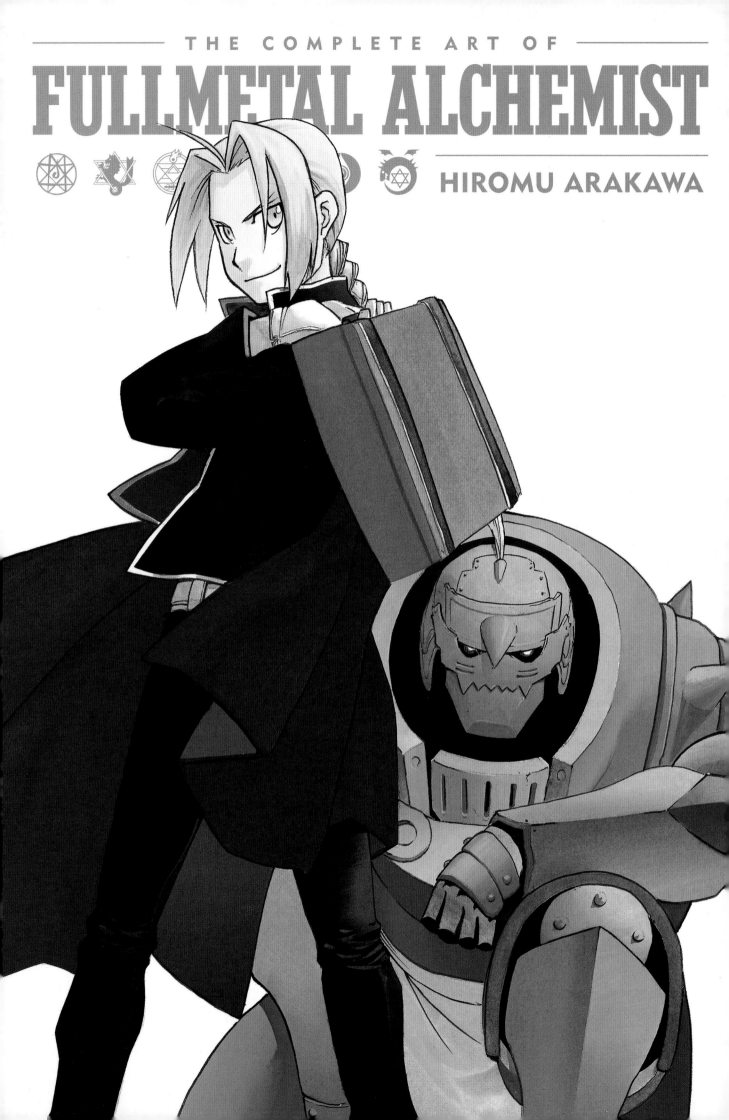

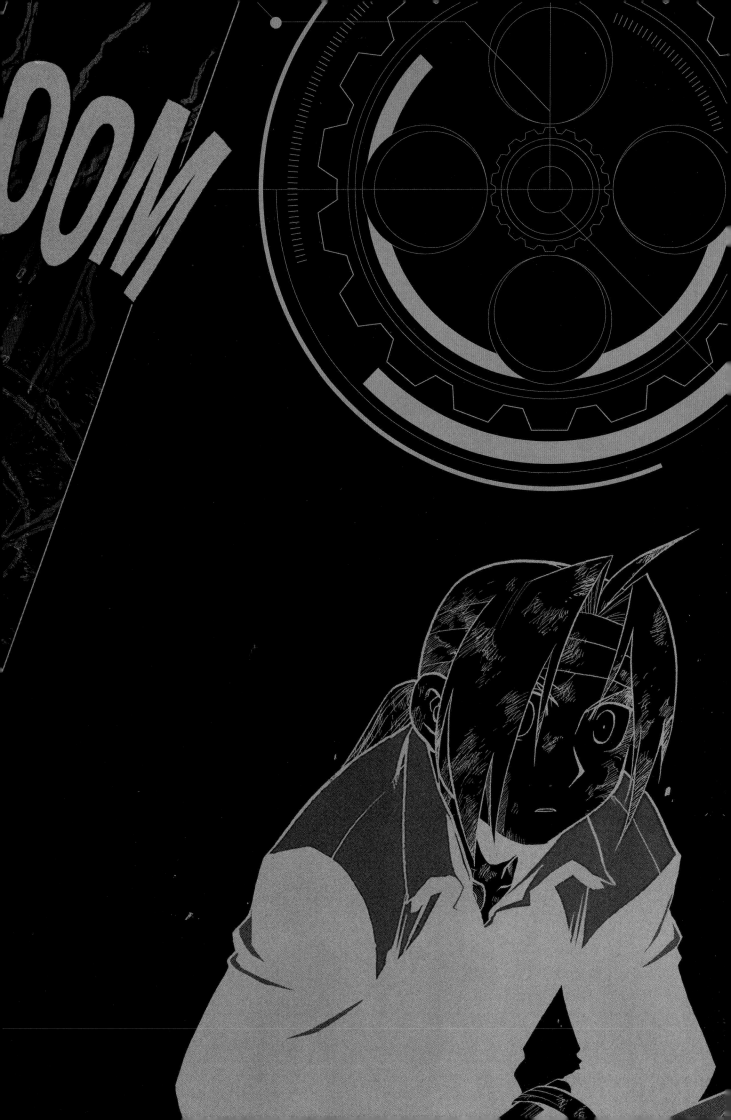

CONTENTS

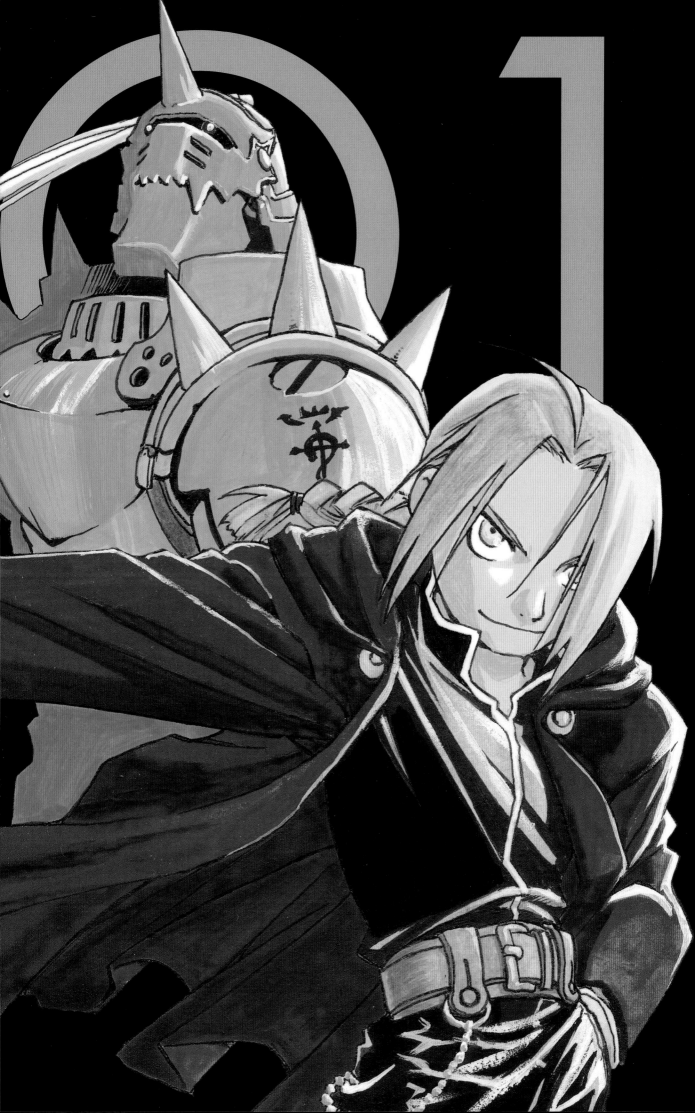

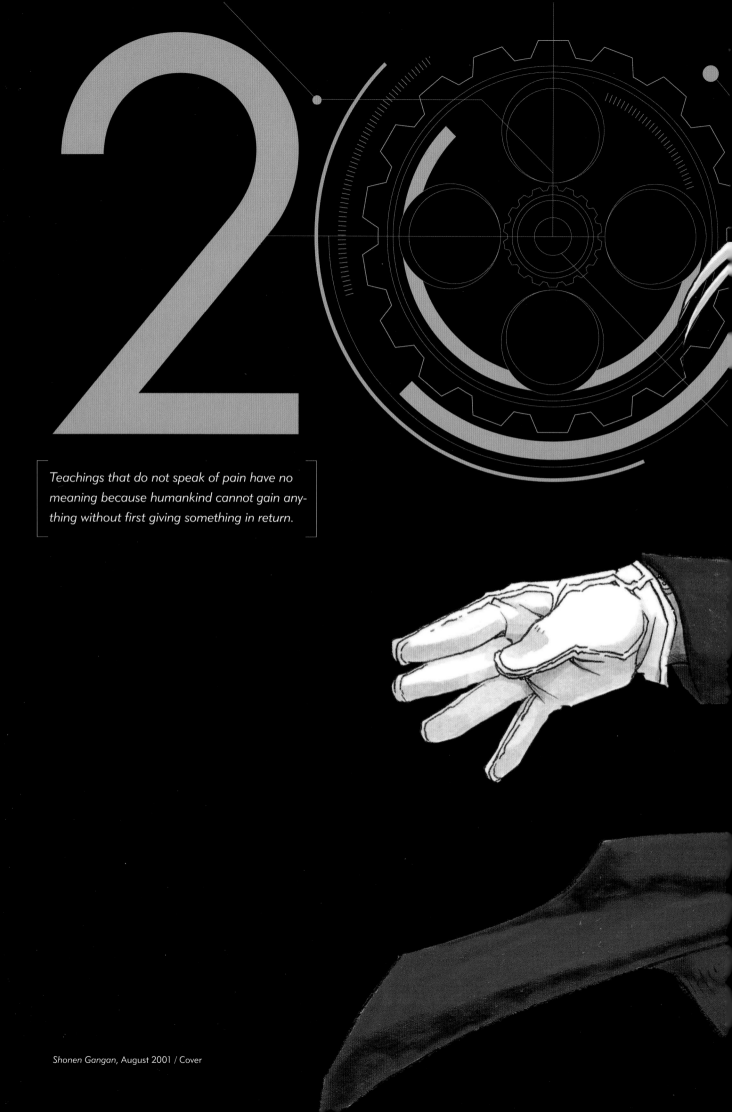

Teachings that do not speak of pain have no meaning because humankind cannot gain anything without first giving something in return.

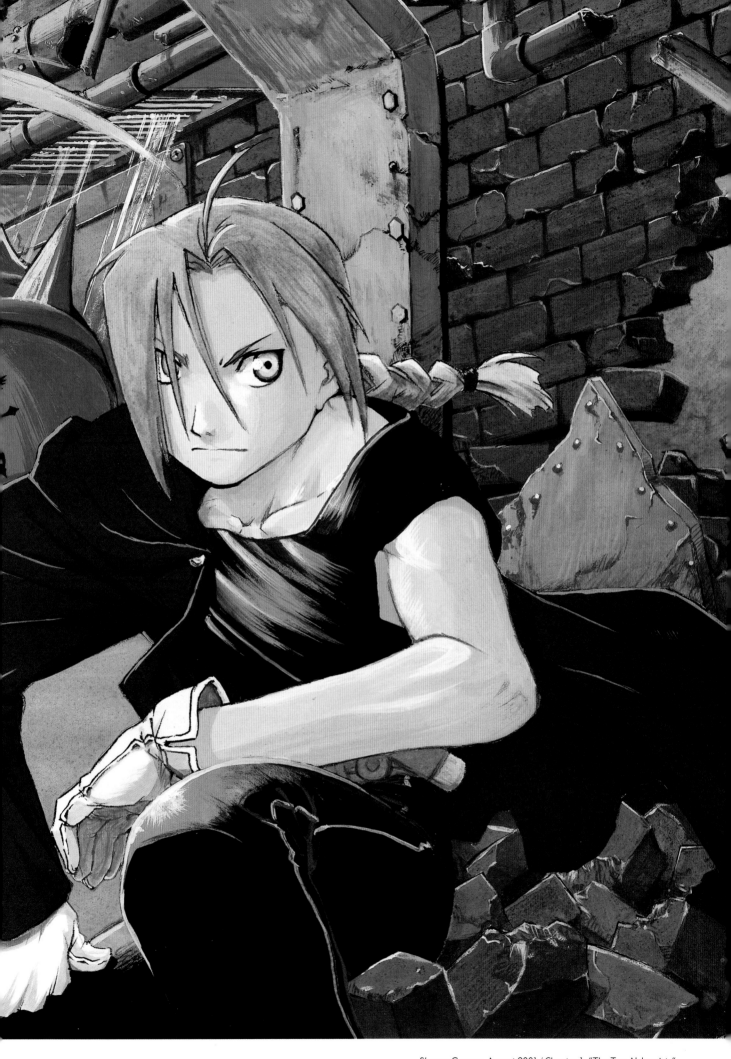

Shonen Gangan, August 2001 / Chapter 1, "The Two Alchemists"

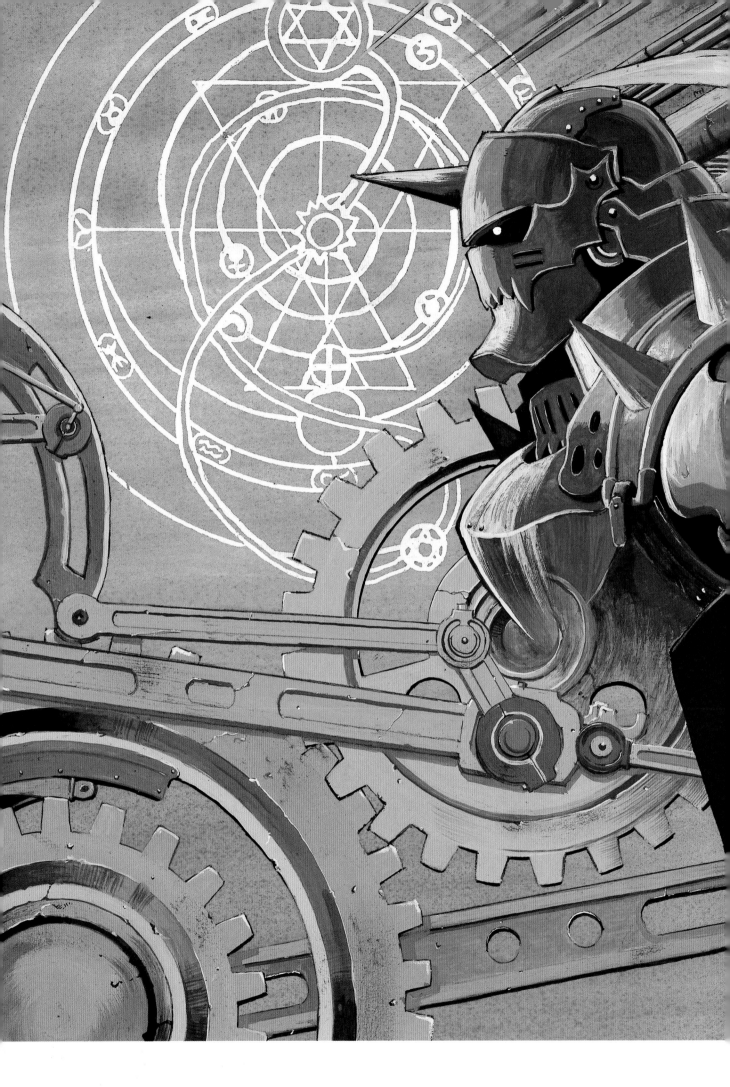

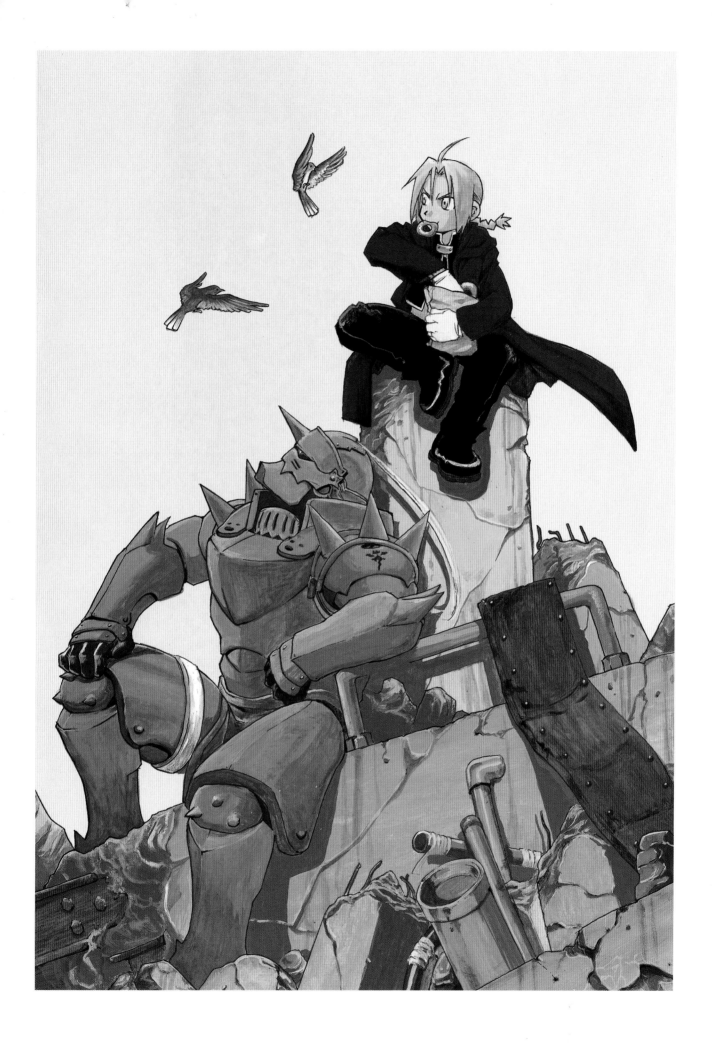

Shonen Gangan, January 2002 / Chapter 6, "The Right Hand of Destruction"

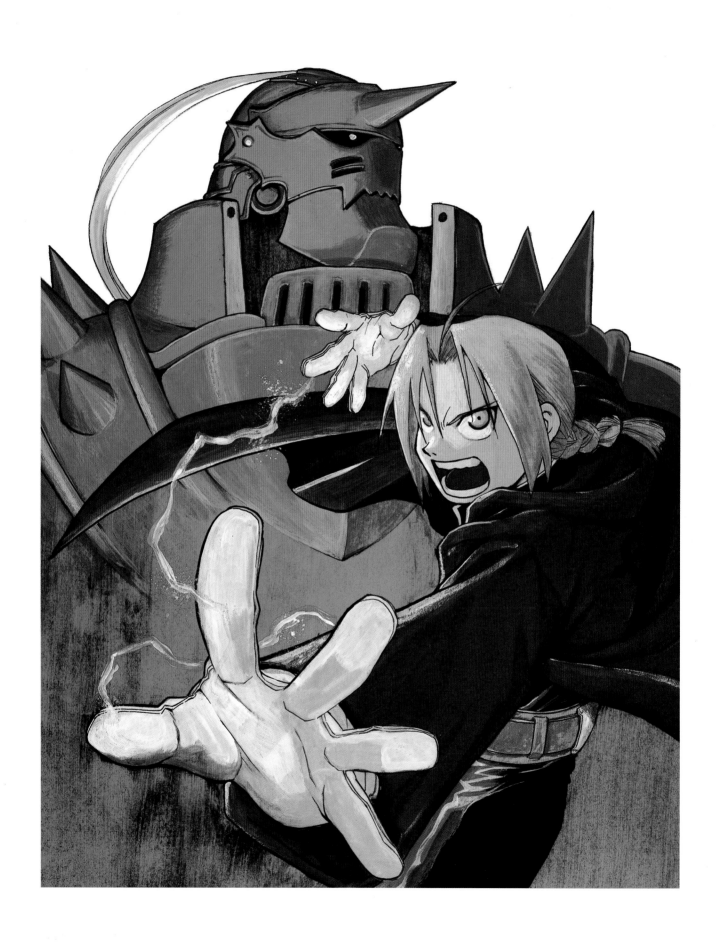

Shonen Gangan, January 2002 / Cover

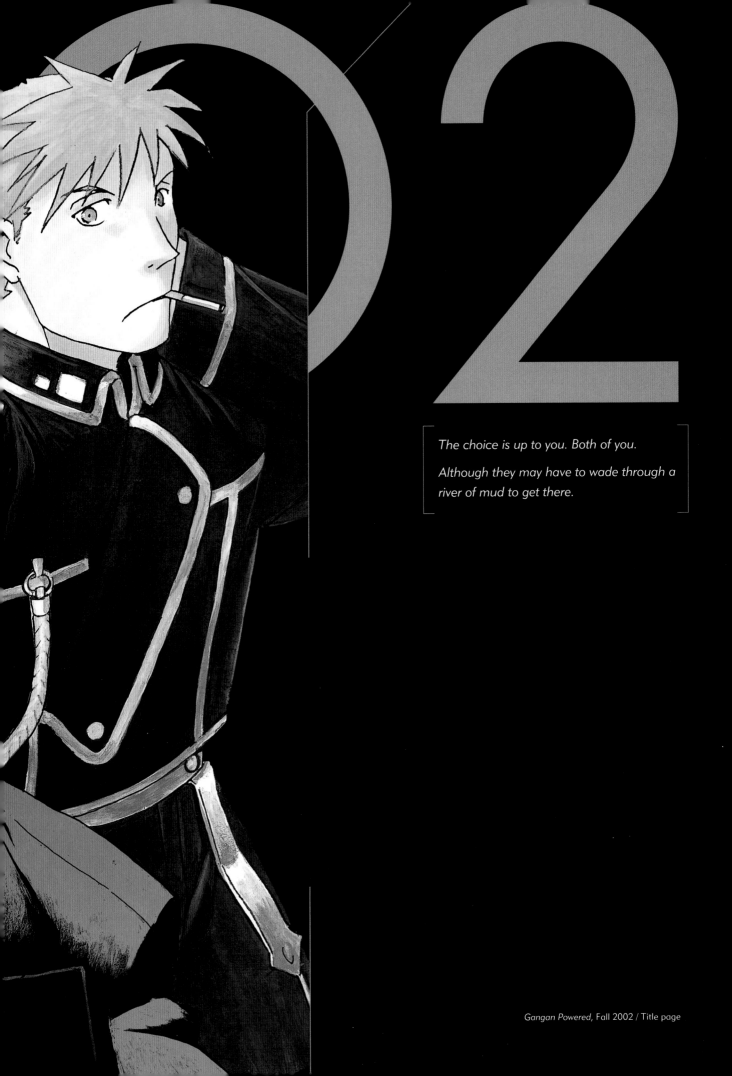

The choice is up to you. Both of you.

Although they may have to wade through a river of mud to get there.

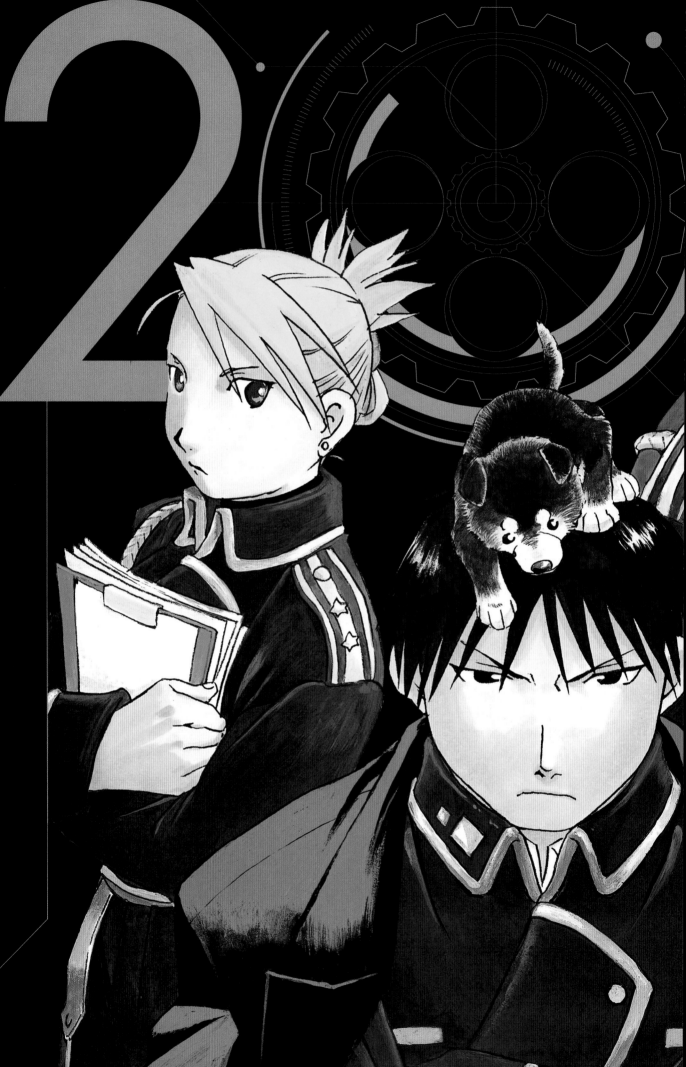

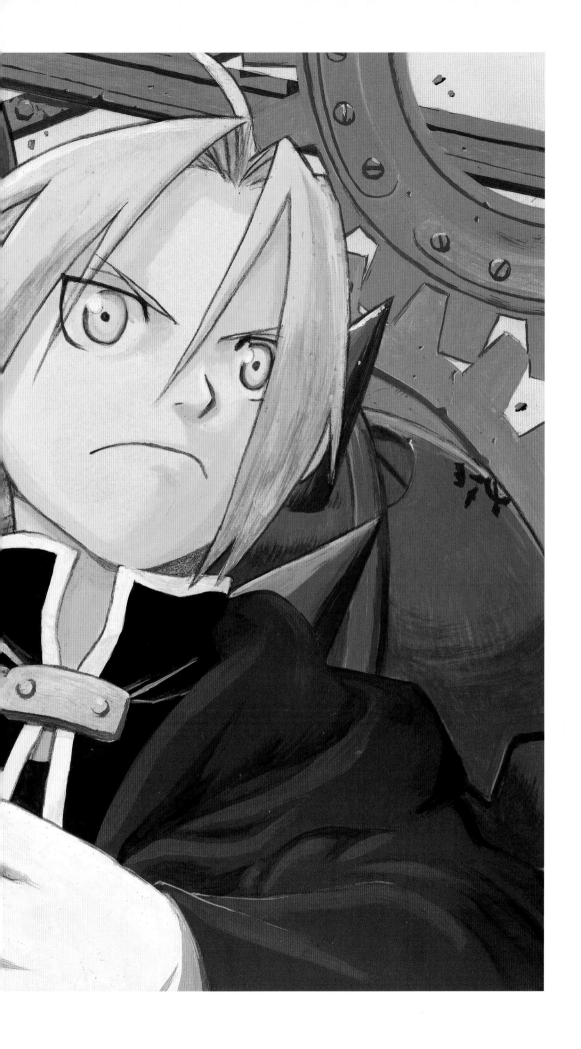

Graphic novel, volume 1 / Cover

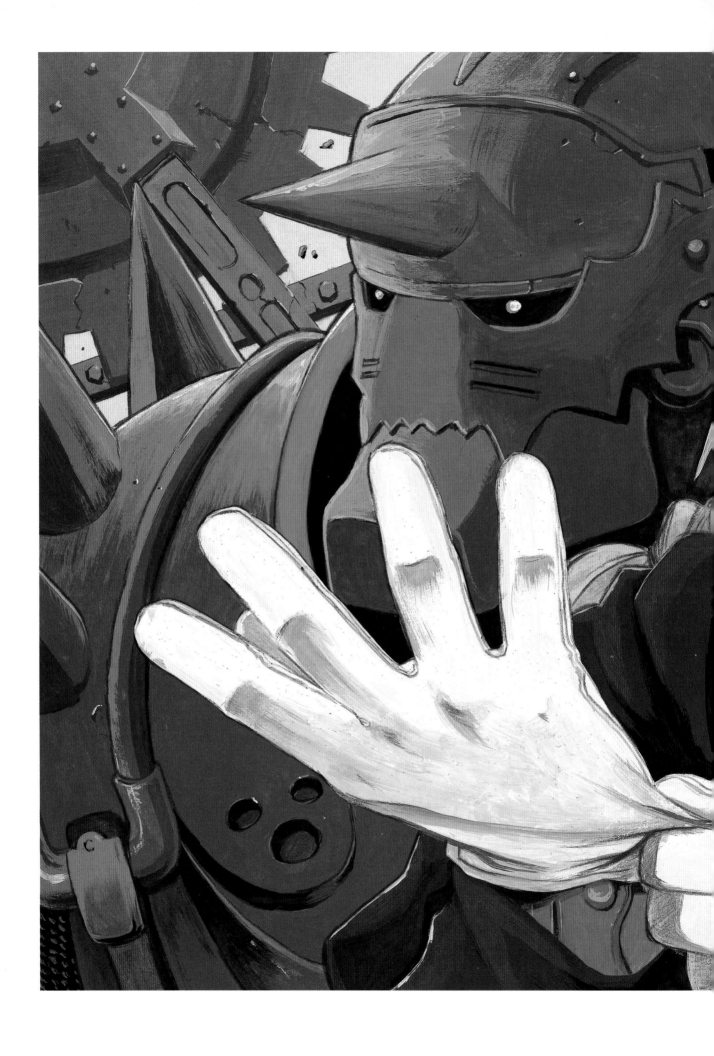

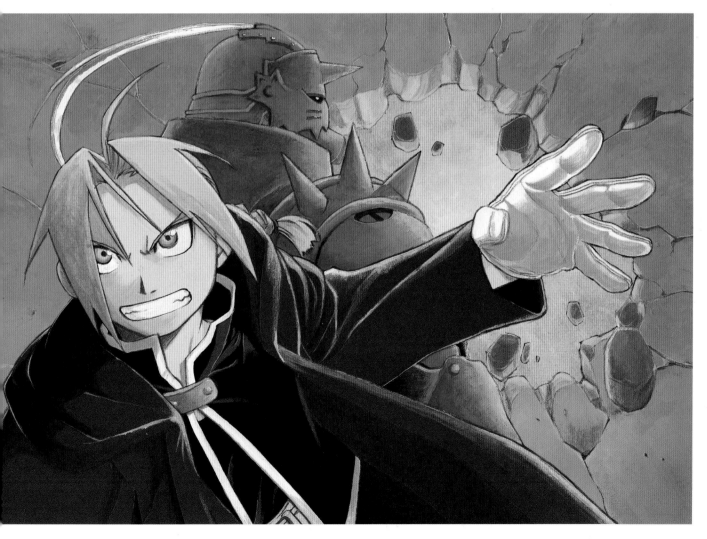

Graphic novel, volume 2 / Cover

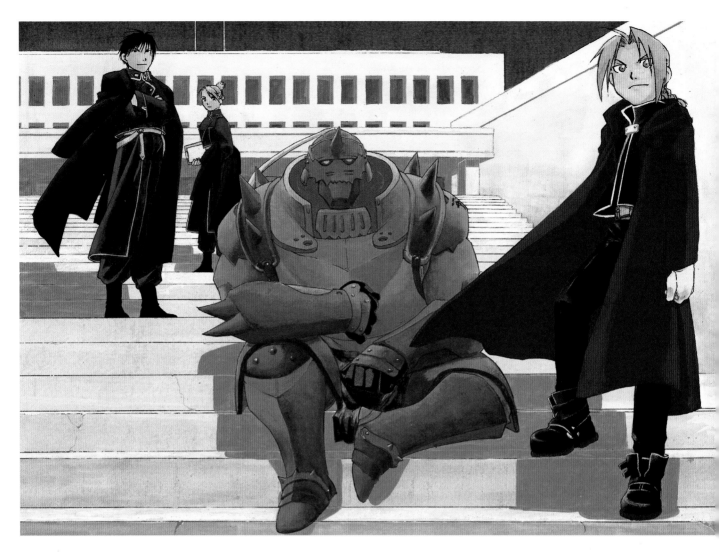

G-Collection Shop comic poster, volume 1

Gangan Powered, Spring 2002 / Bonus postcard

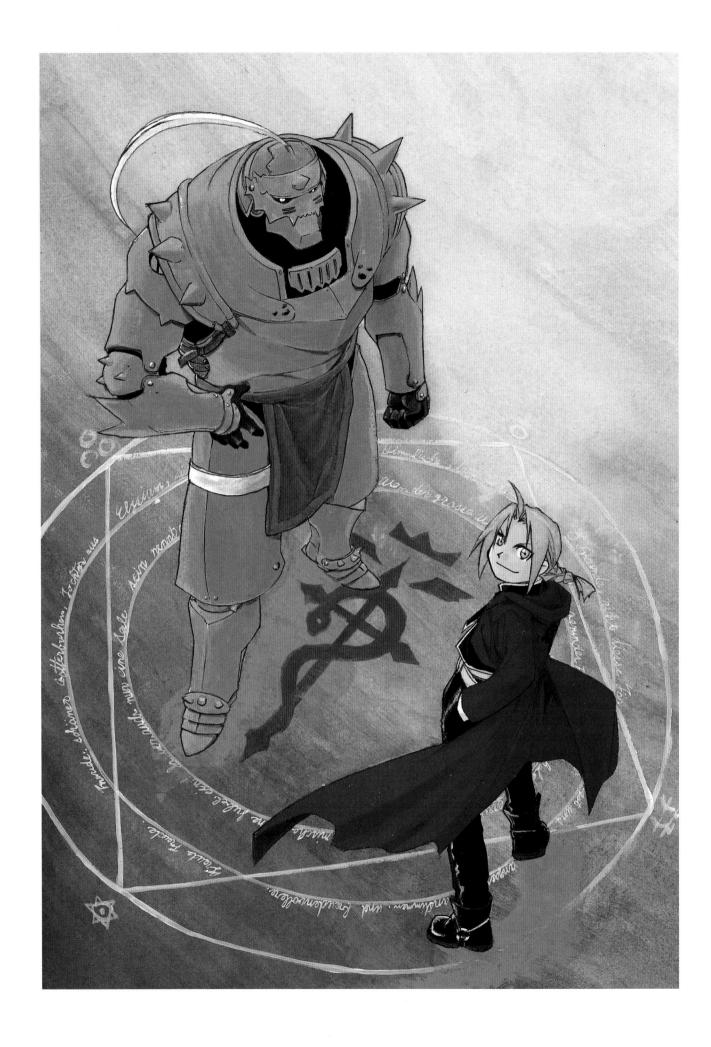

Complimentary phone card

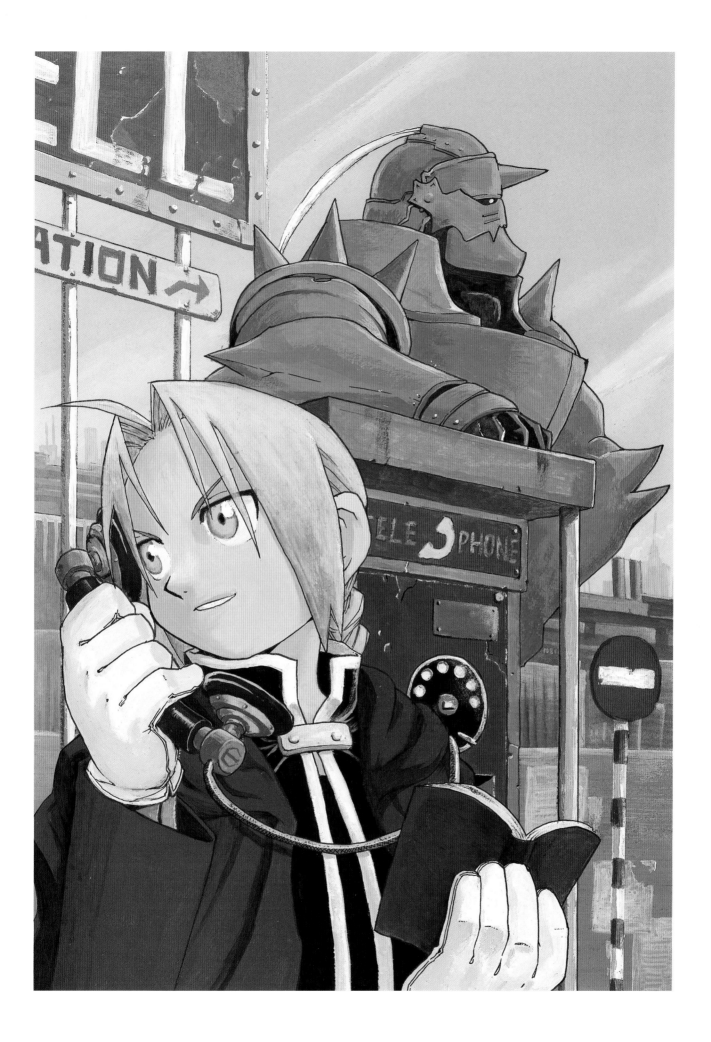

G-Collection Shop comic phone card, volume 1

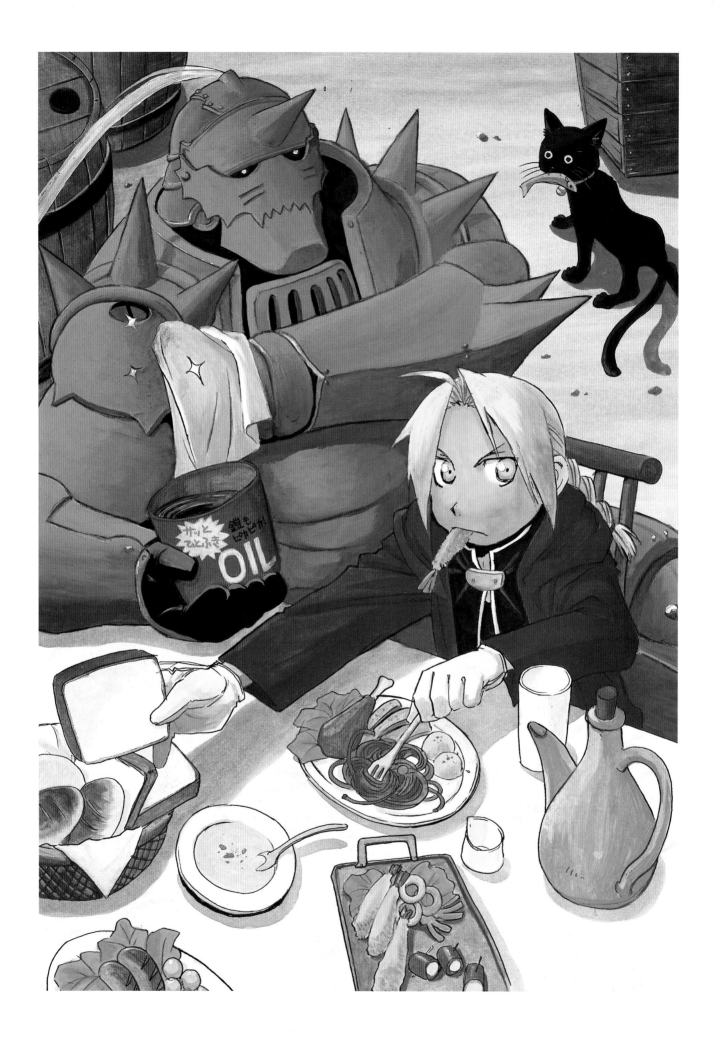

Gangan Powered, Spring 2002 / Title page

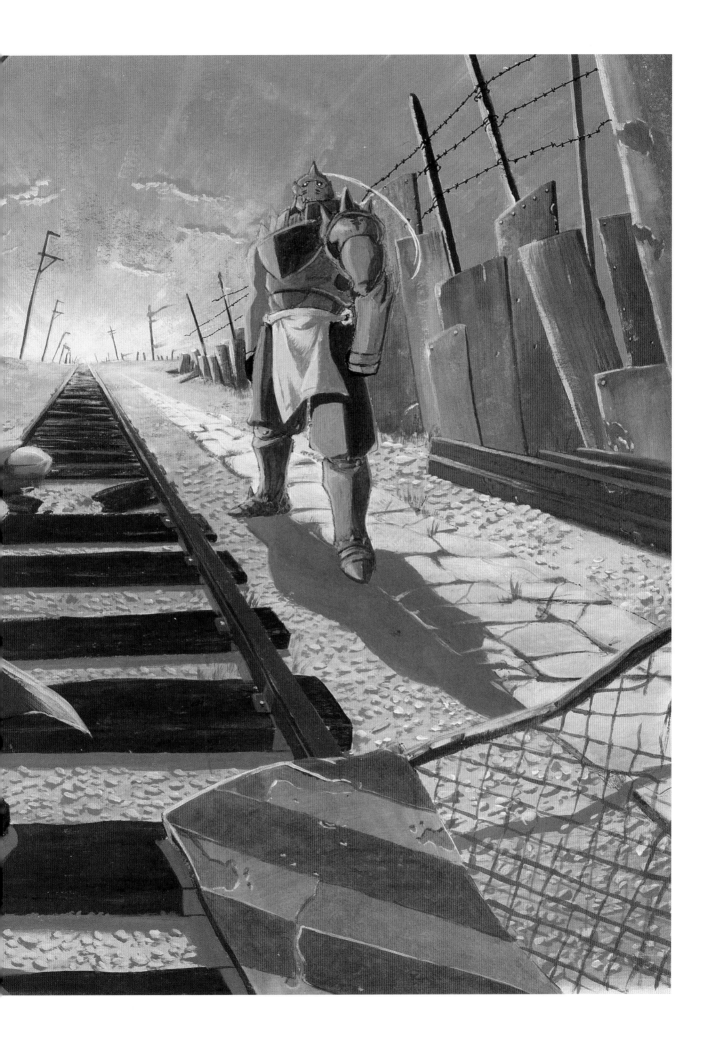

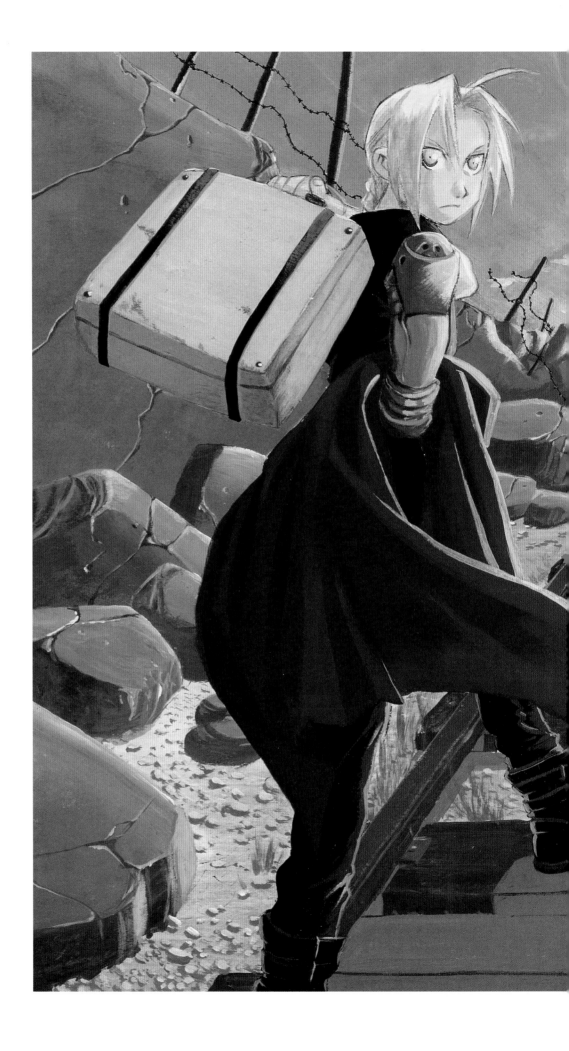

Shonen Gangan, June 2002 / Chapter 11, "The Two Guardians"

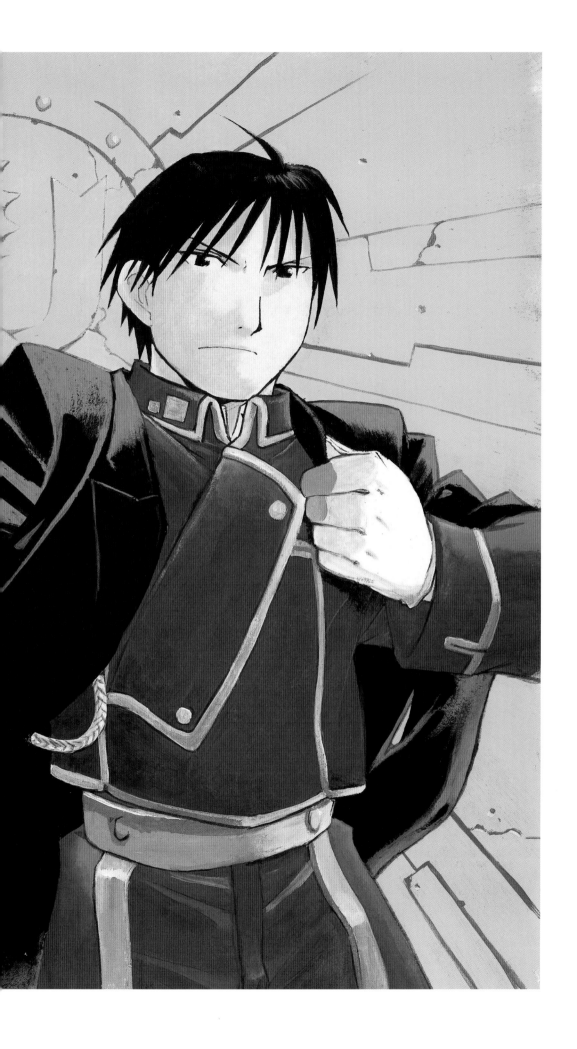

Graphic novel, volume 3 / Cover

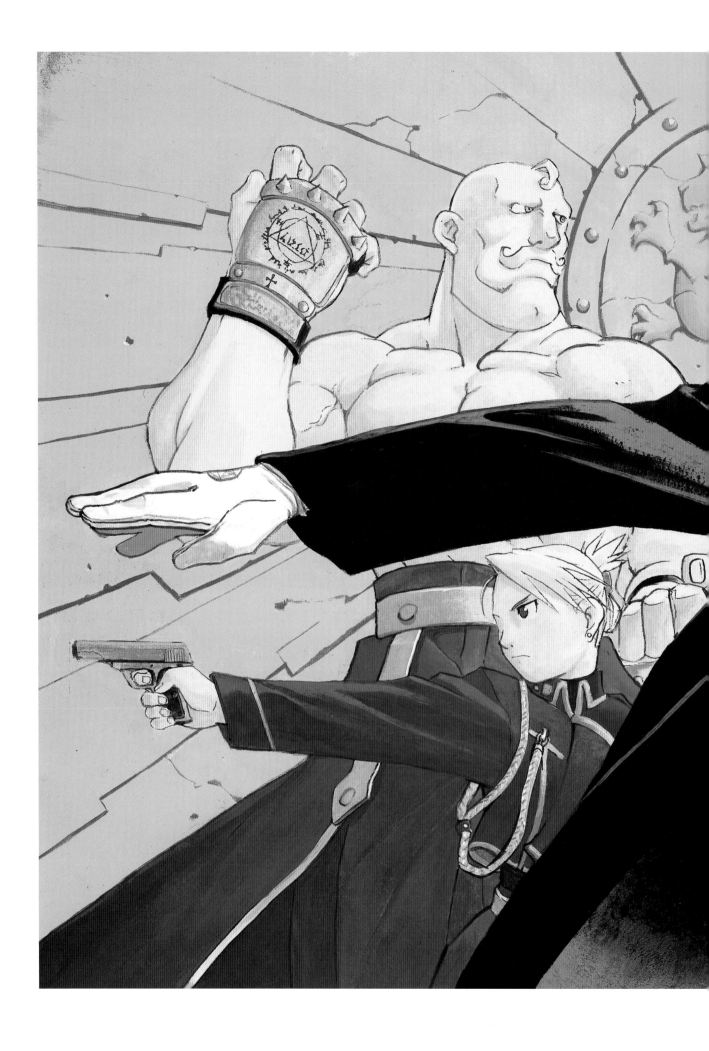

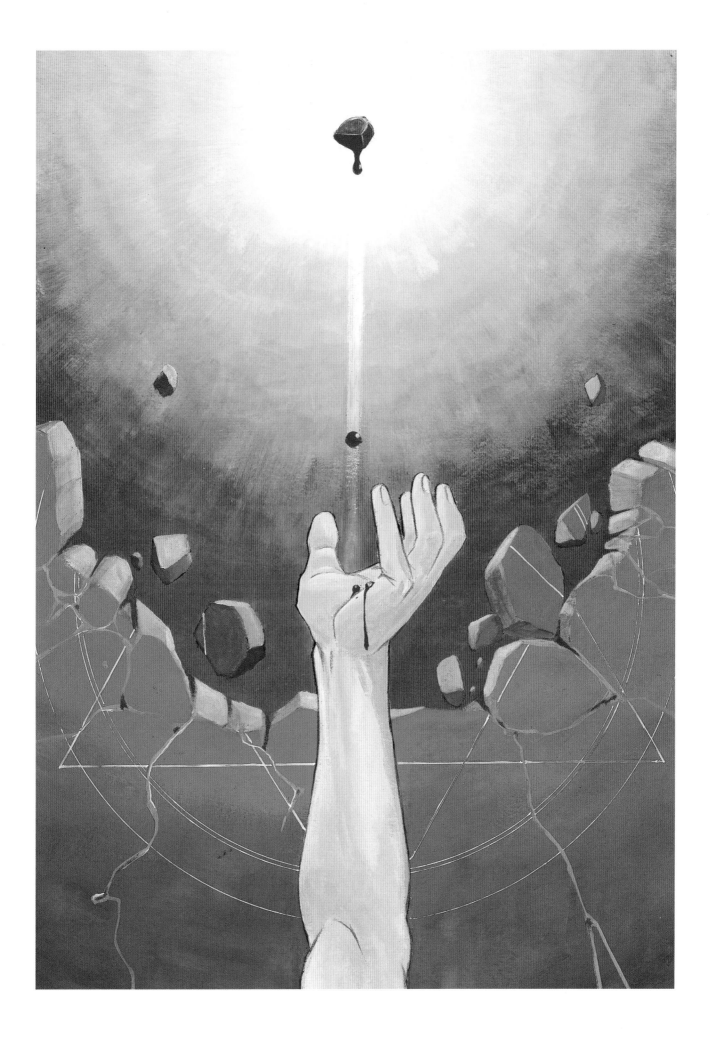

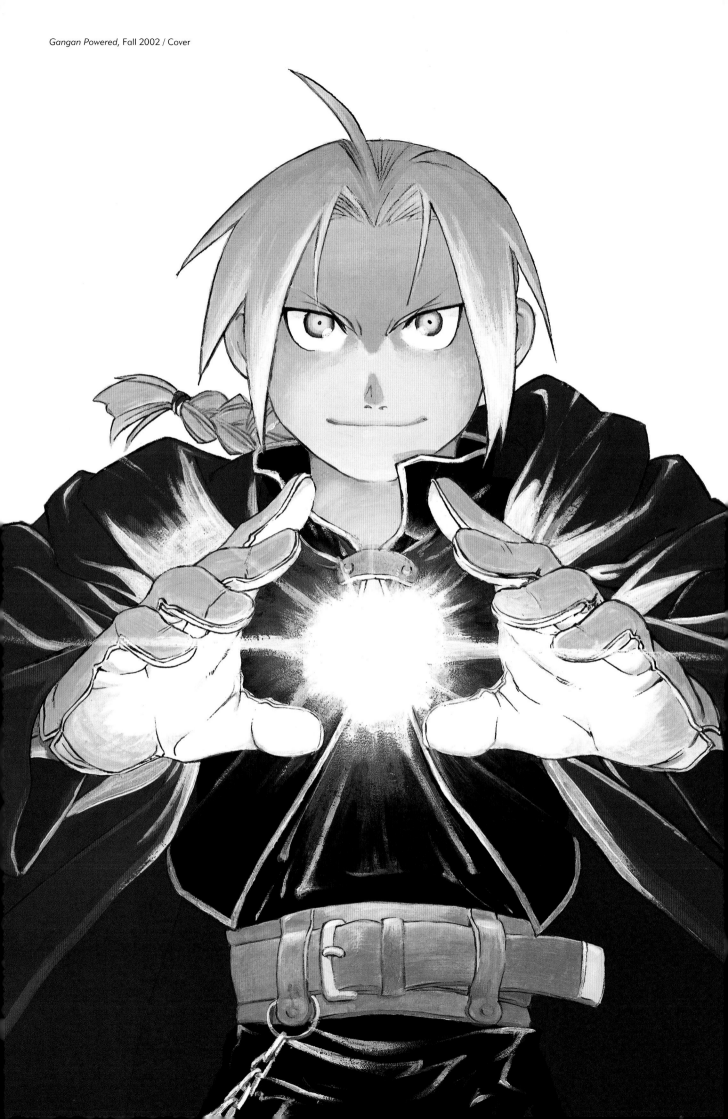

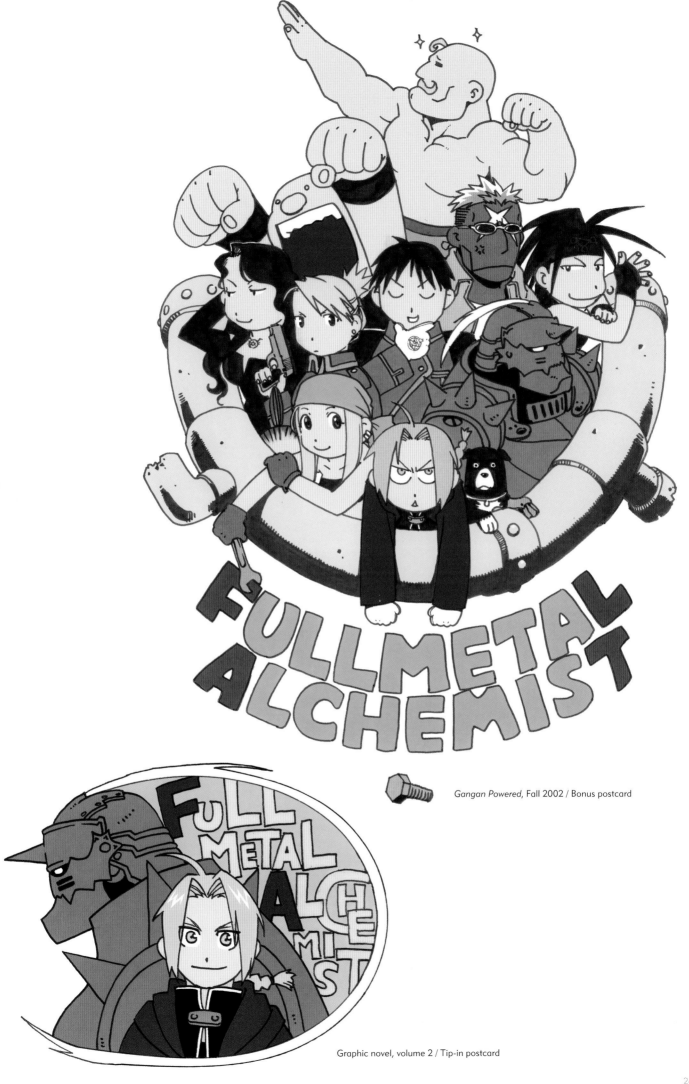

FULLMETAL ALCHEMIST

Gangan Powered, Fall 2002 / Bonus postcard

Graphic novel, volume 2 / Tip-in postcard

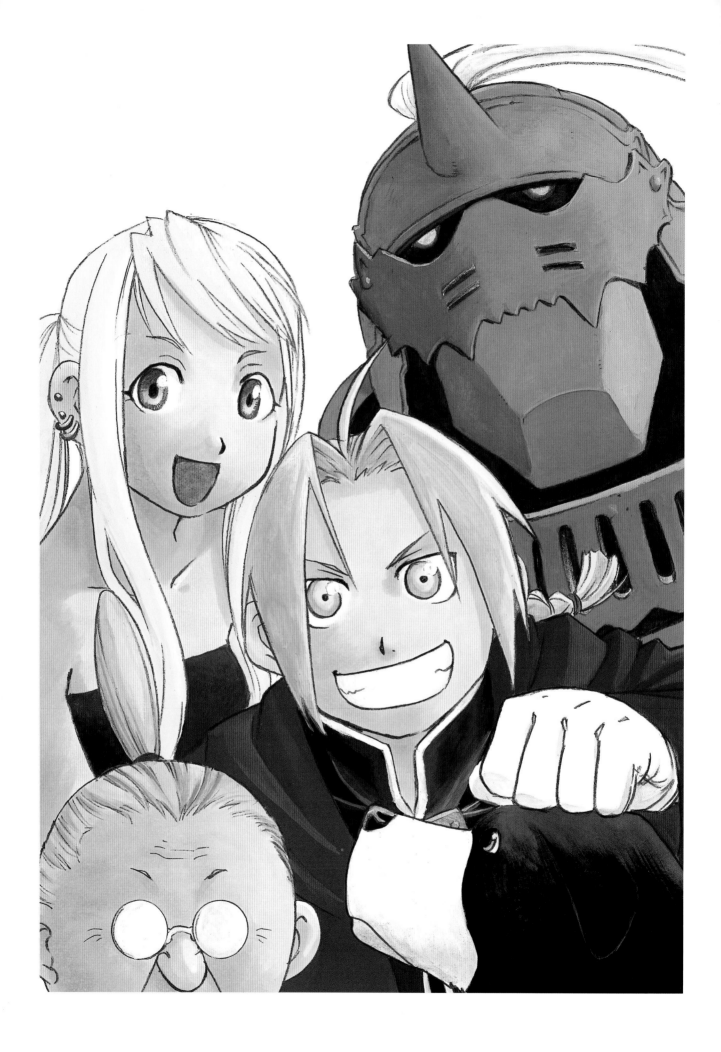

Gangan Versu

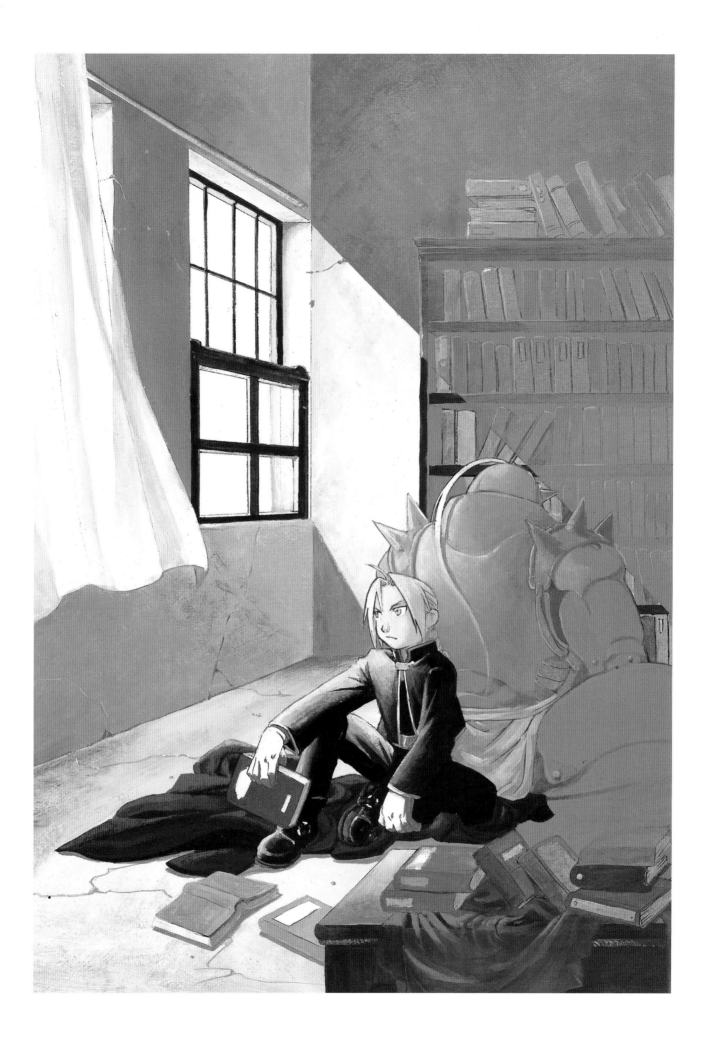

Shonen Gangan, October 2002 / Chapter 15, "Fullmetal Heart"

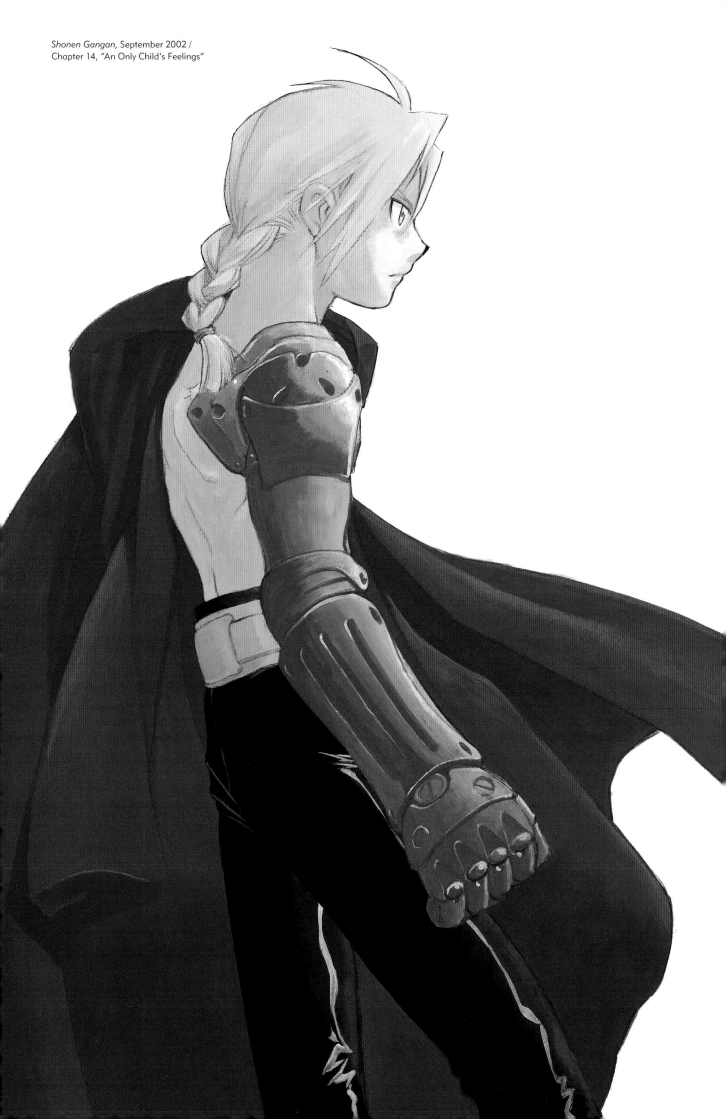

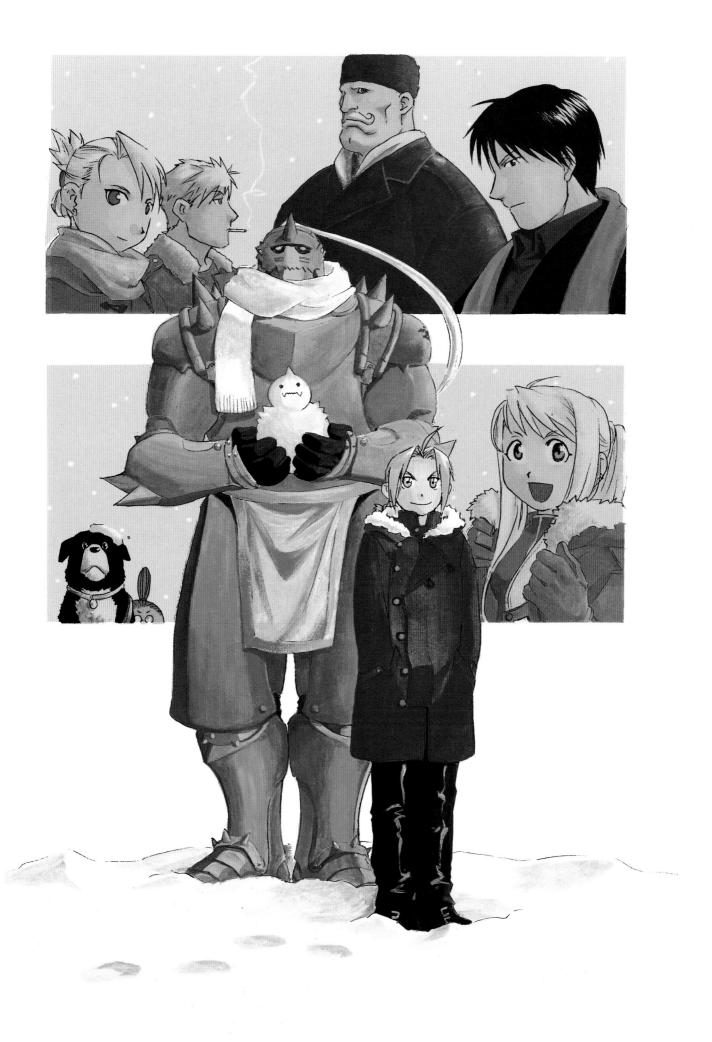

Fullmetal Alchemist Comic Special Calendar 2003 / December

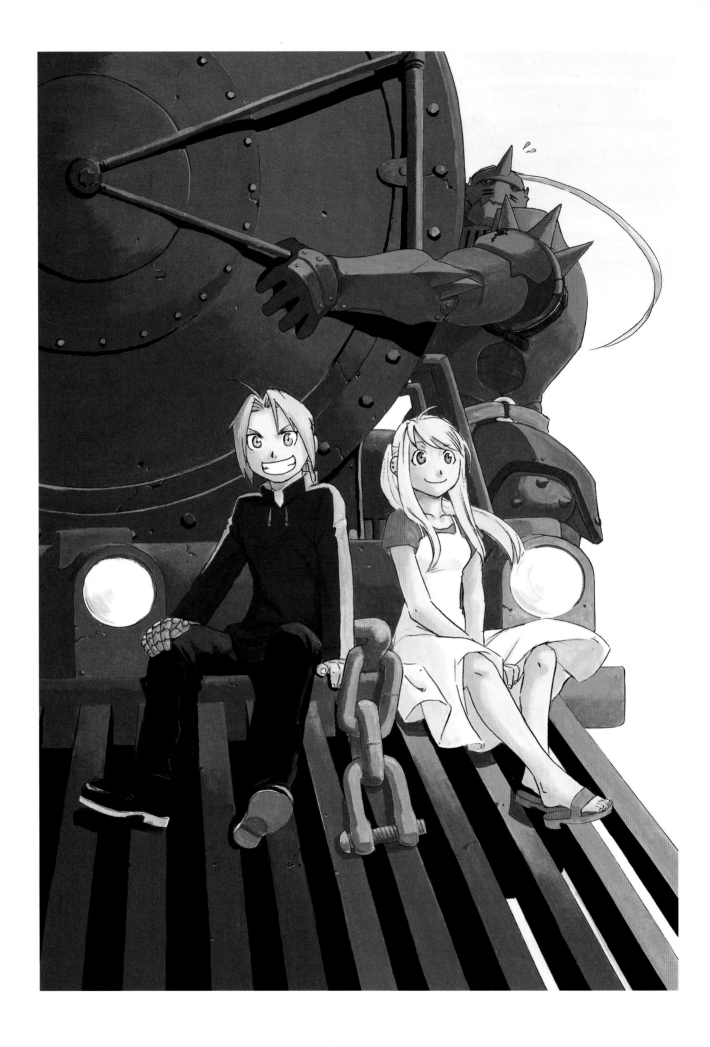

Shonen Gangan, January 2003 / Chapter 18, "The Value of Sincerity"

3

We decided that the two of us would get our bodies back to normal no matter what it took. We can't start doubting ourselves because of something this trivial.

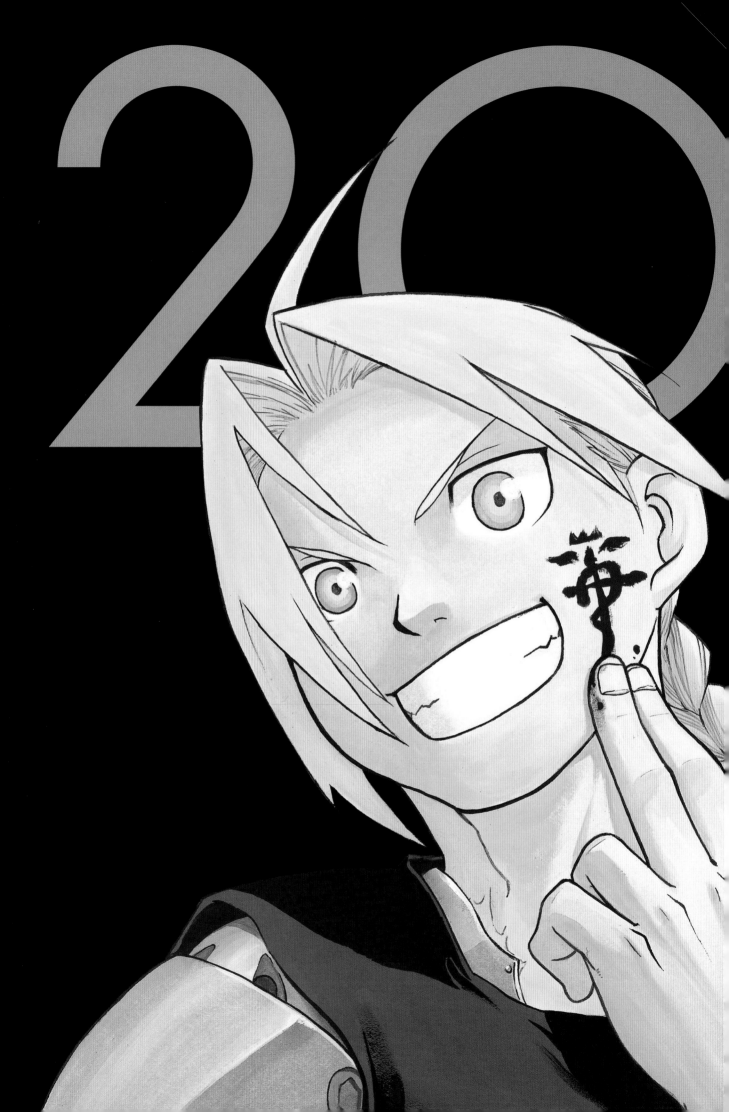

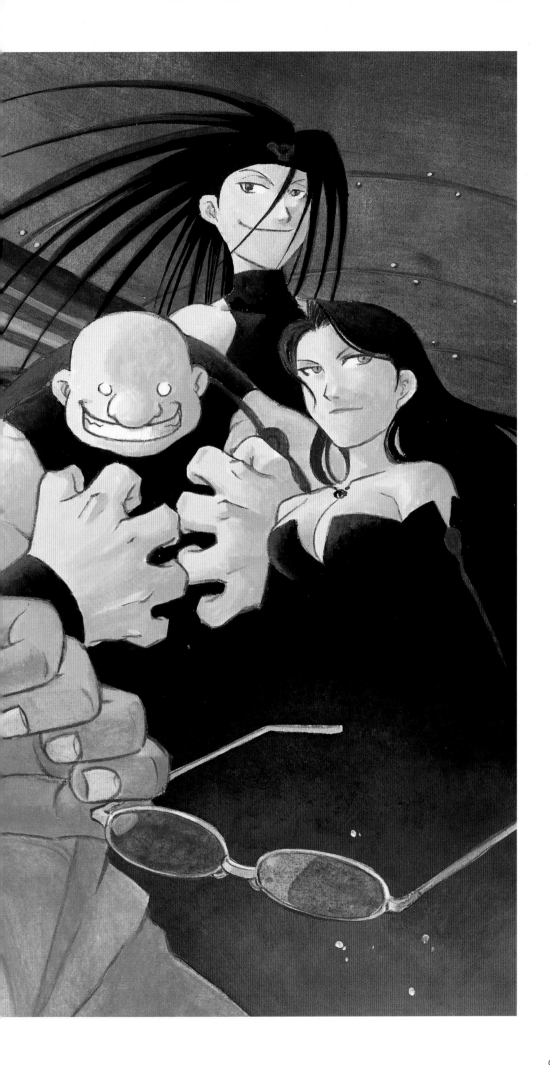

Graphic novel, volume 4 / Cover

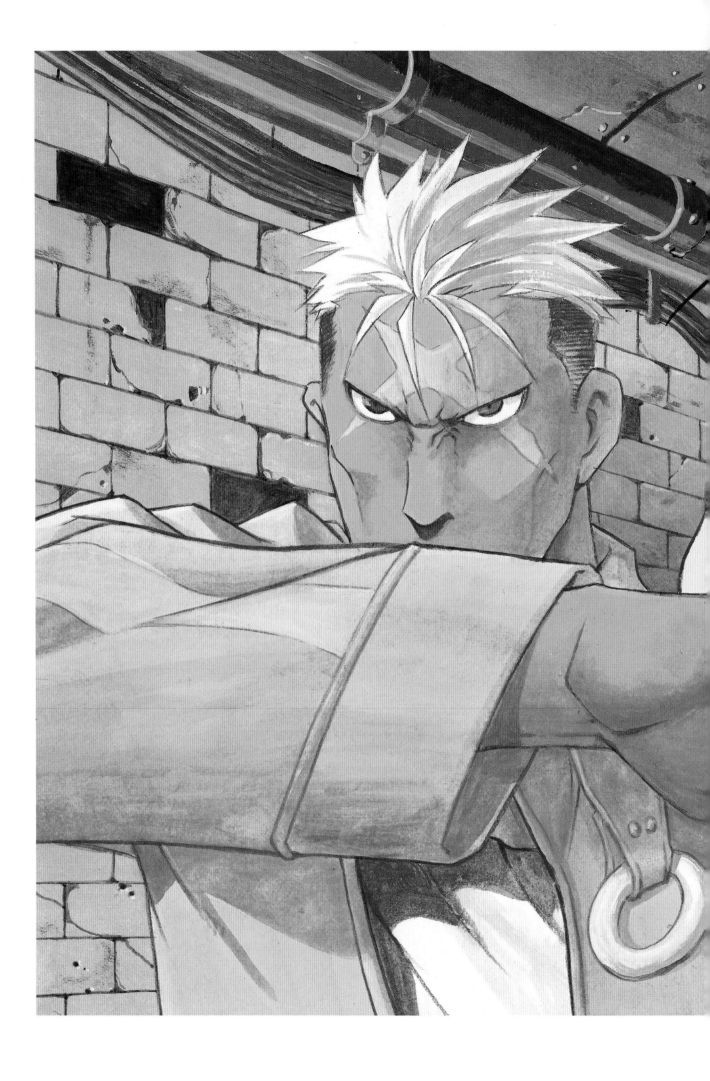

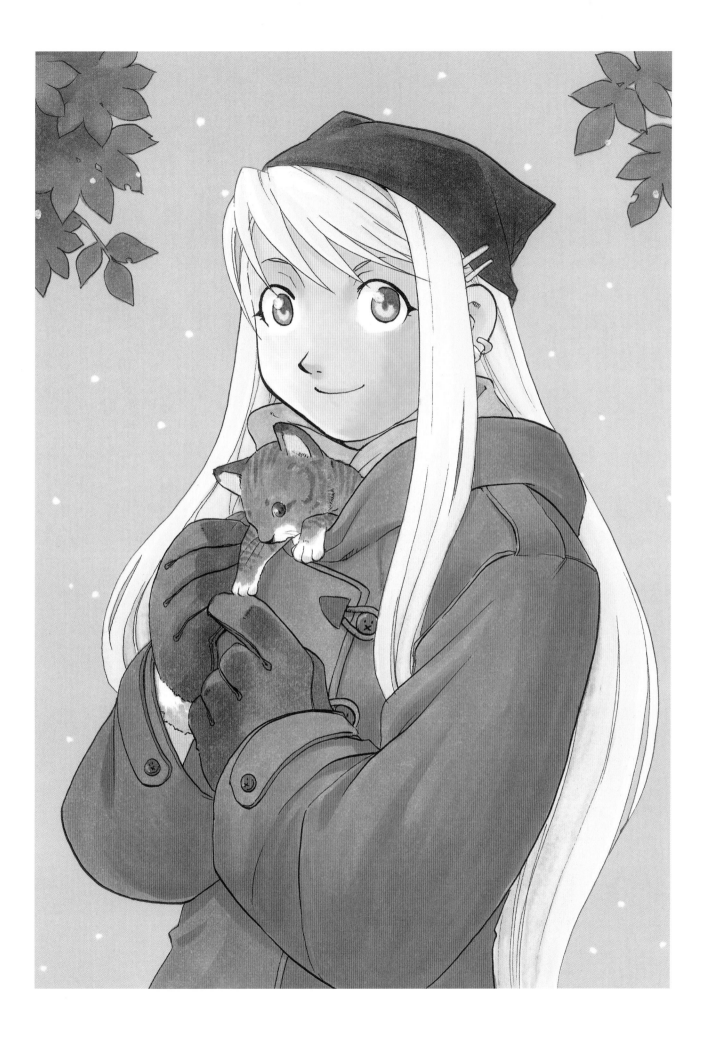

Shonen Gangan, February 2003 / Bonus postcard

Shonen Gangan, March 2003 / Cover

Shonen Gangan, December 2003 / Cover

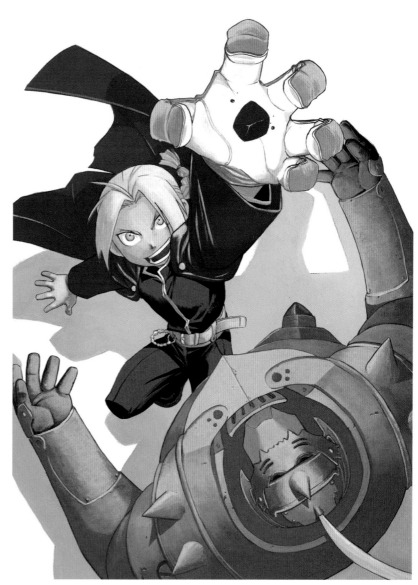

Fullmetal Alchemist: The Land of Sand, novel, volume 1 / Cover

BIG TEXT: *Writing a letter*
SMALL TEXT: *Write, write*

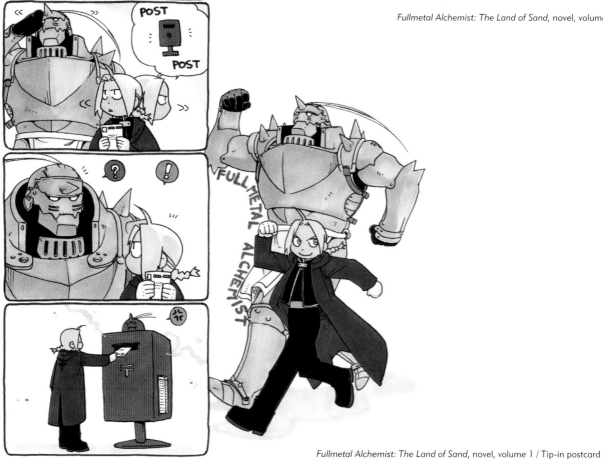

Fullmetal Alchemist: The Land of Sand, novel, volume 1 / Tip-in postcard

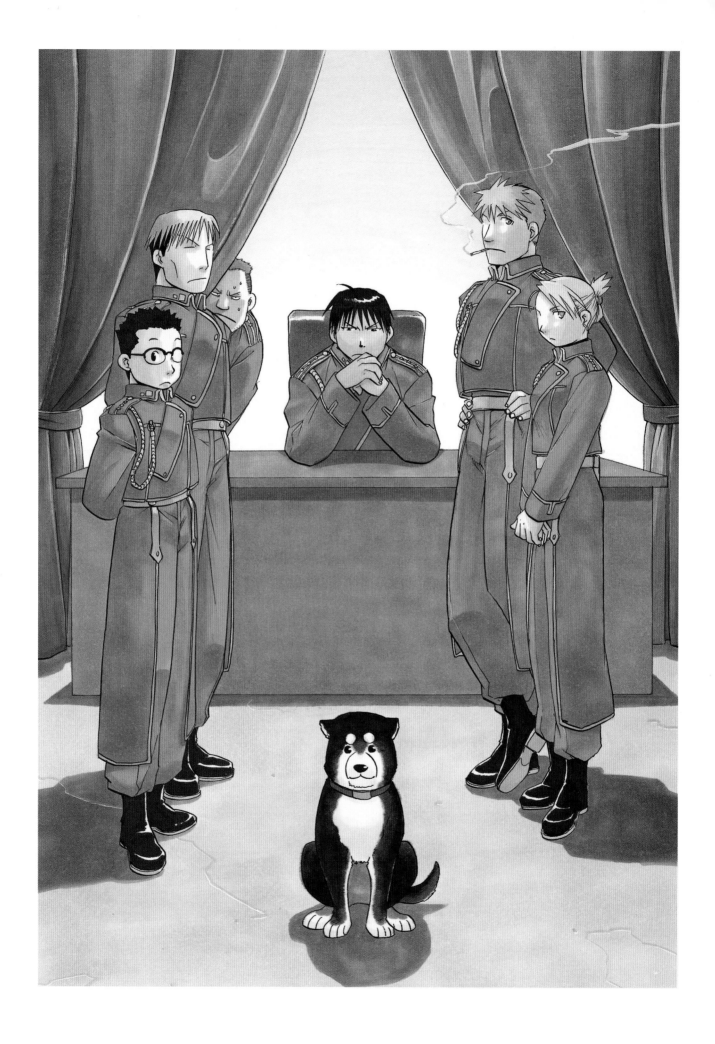

Fullmetal Alchemist: The Land of Sand, novel, volume 1 / Frontispiece

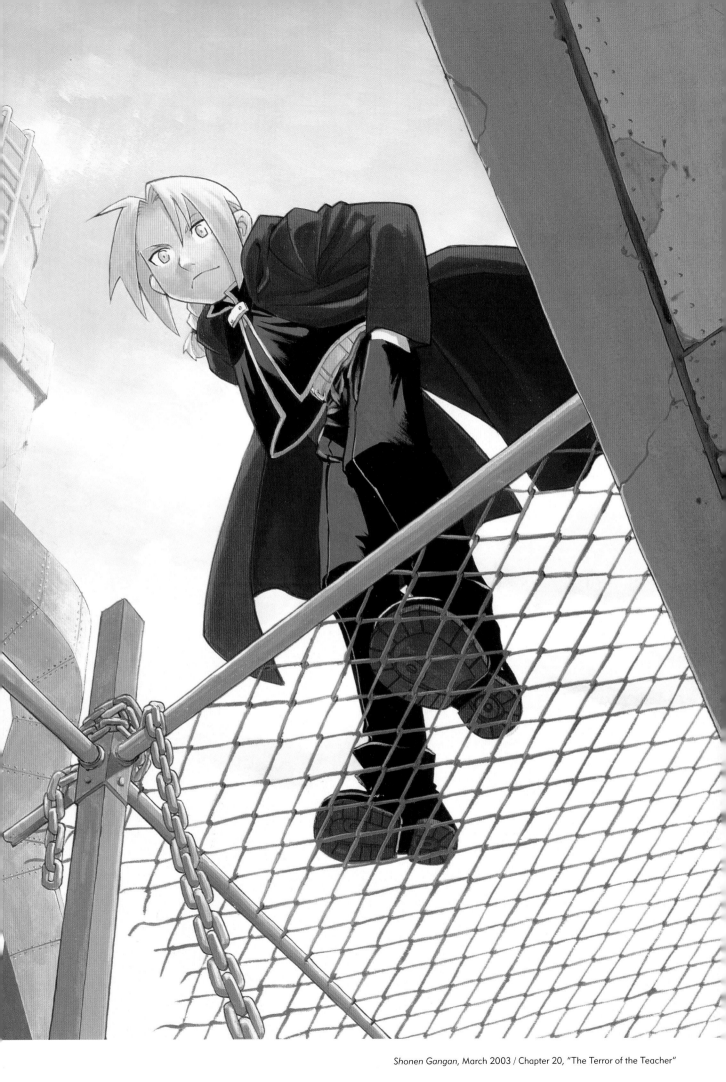

Shonen Gangan, March 2003 / Chapter 20, "The Terror of the Teacher"

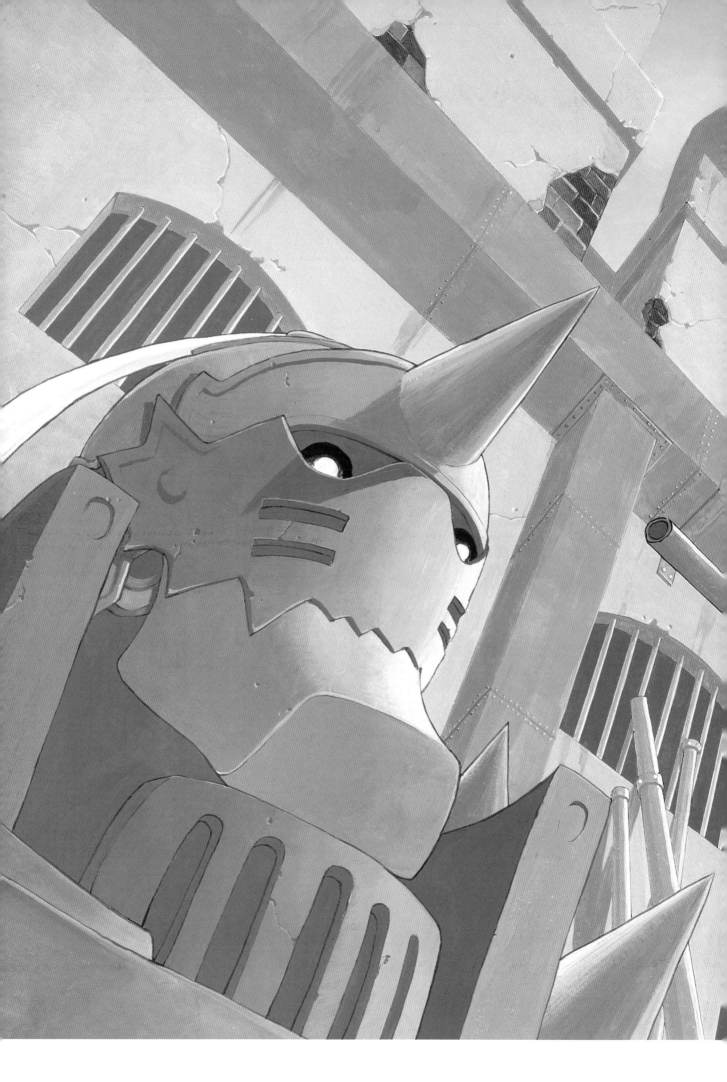

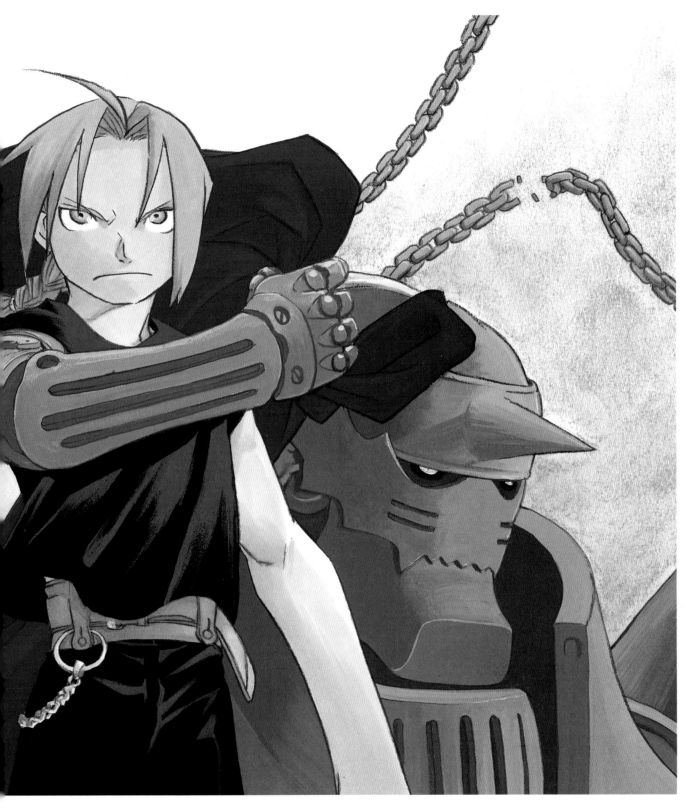

Fullmetal Alchemist: The Land of Sand, drama CD / Booklet

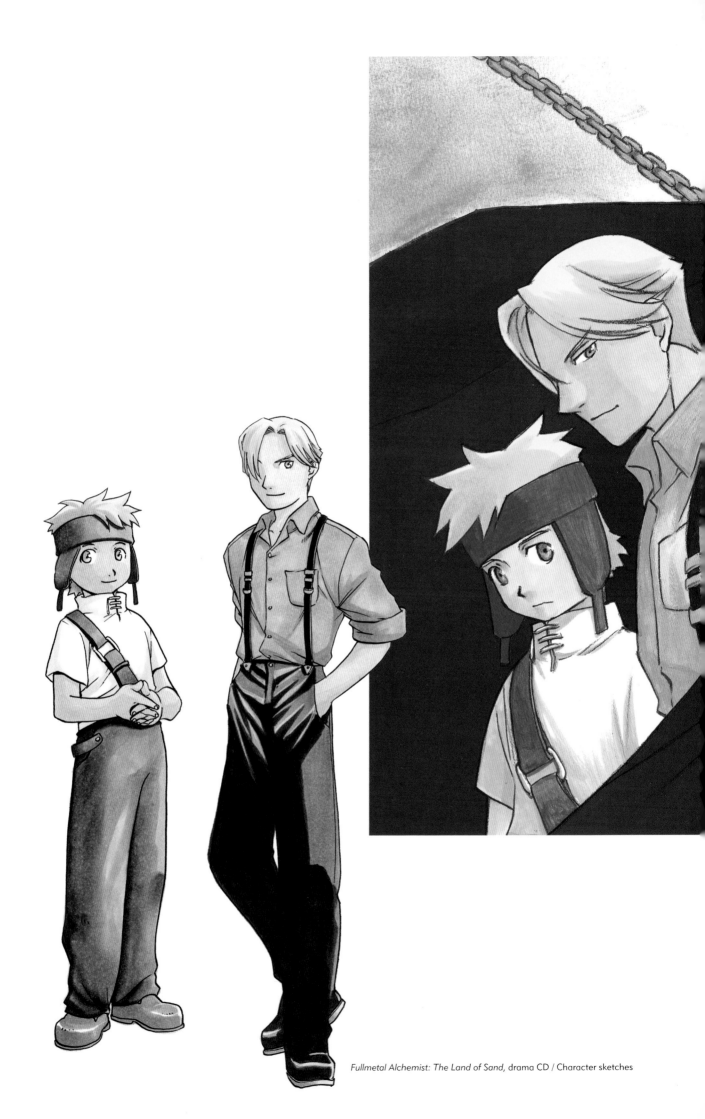

Fullmetal Alchemist: The Land of Sand, drama CD / Character sketches

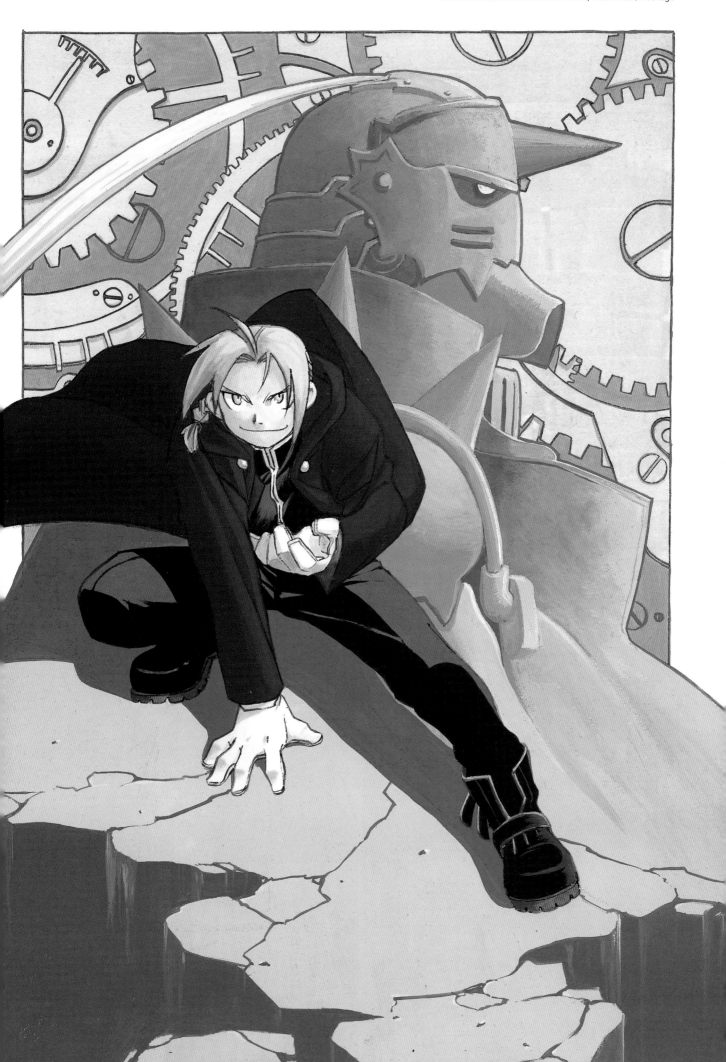

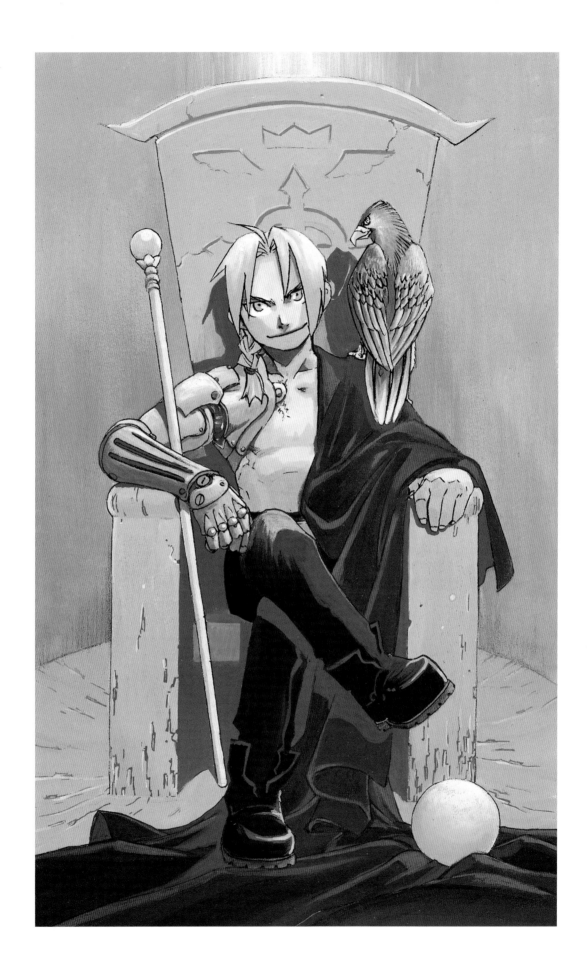

G Fantasy, May 2003 / Bonus tarot card, "Emperor"

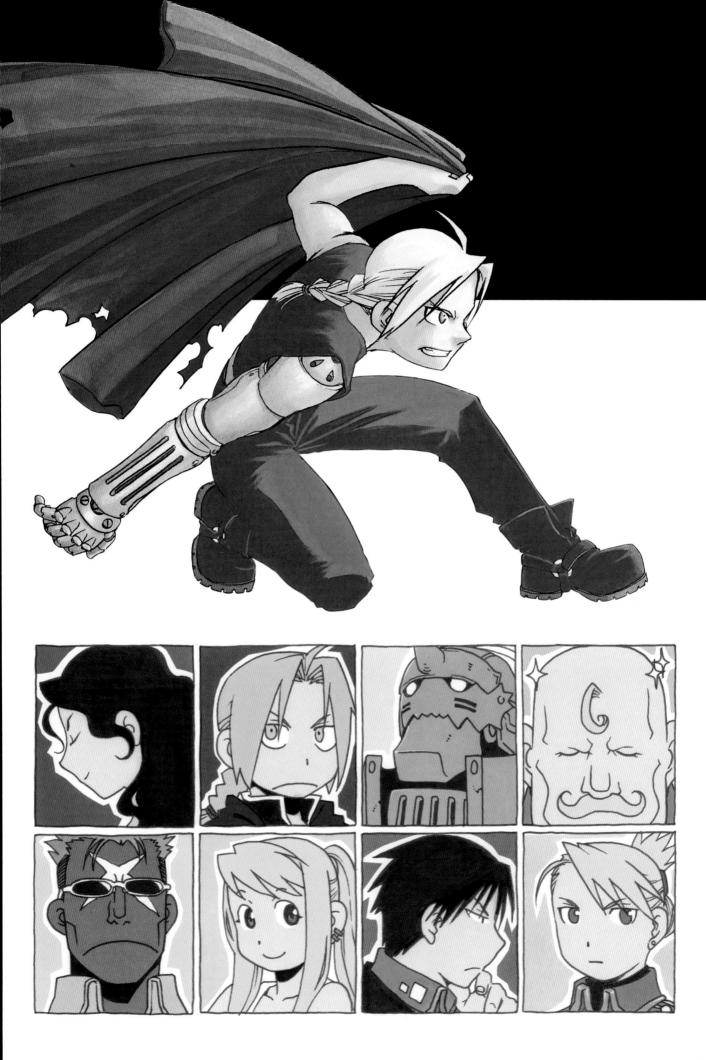

G-Collection Shop comic phone card, volume 4

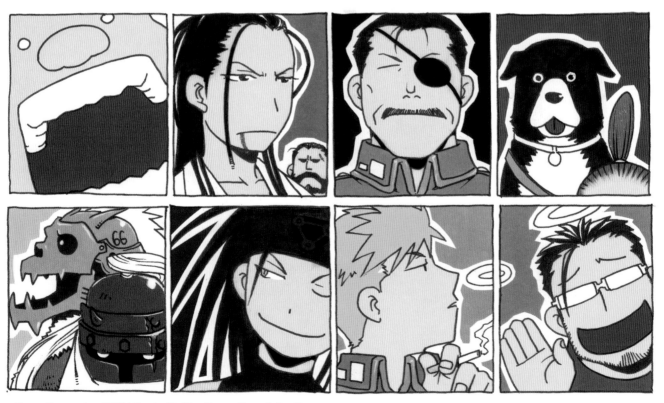

Shonen Gangan, June 2003 / Chapter 23, "Knocking on Heaven's Door"

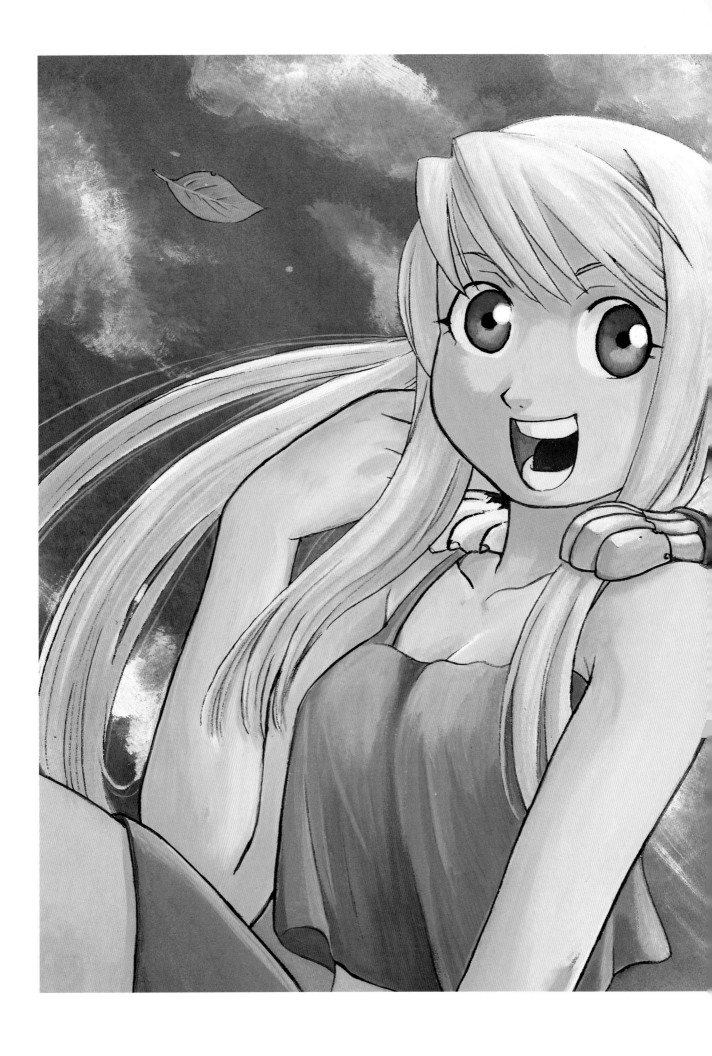

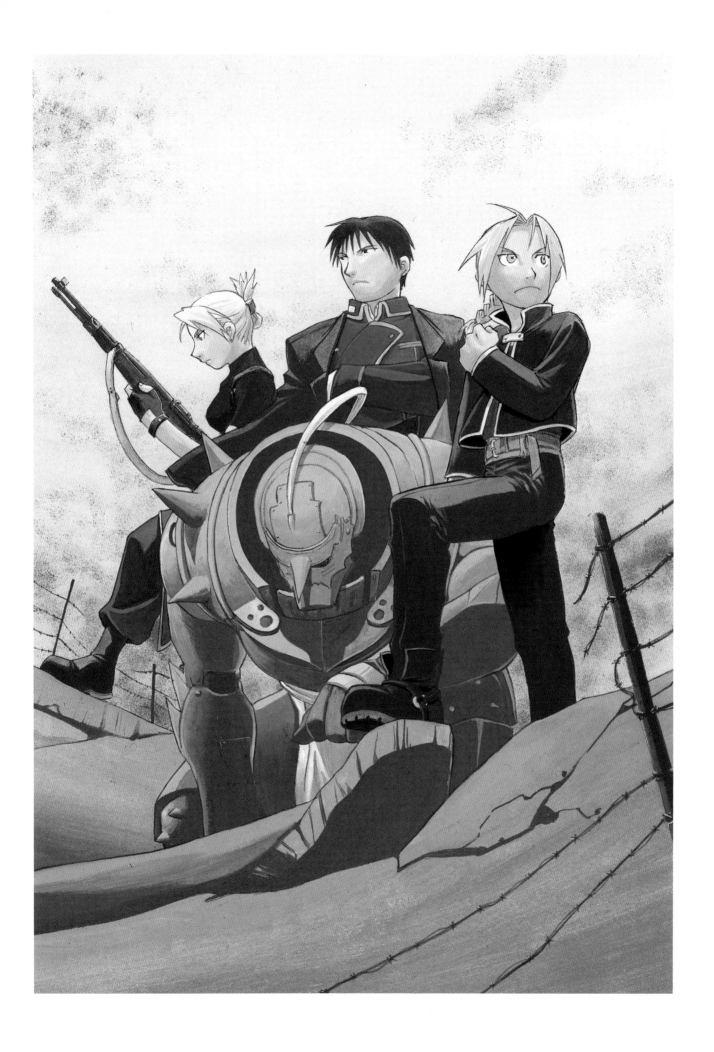

Graphic novel, volume 5 / Gift with purchase photo stand

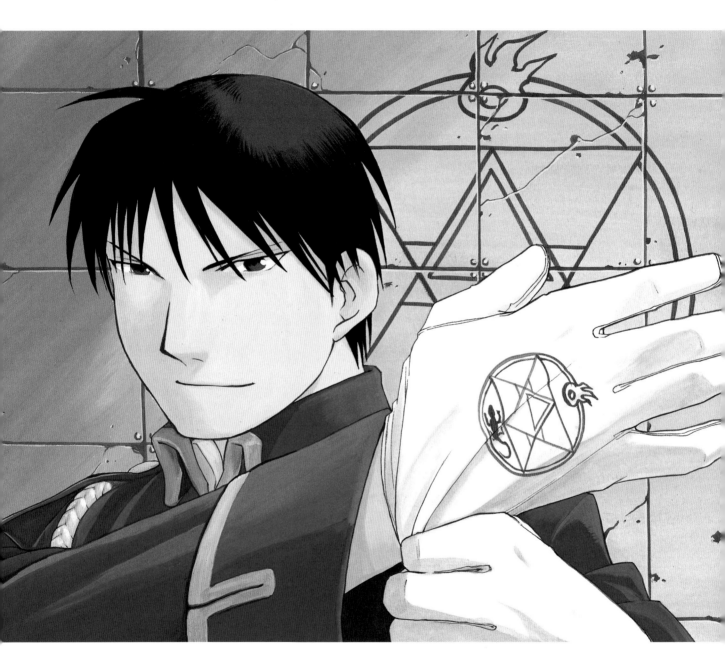

Limited edition graphic novel, volume 6 / "Flame Alchemist" cover

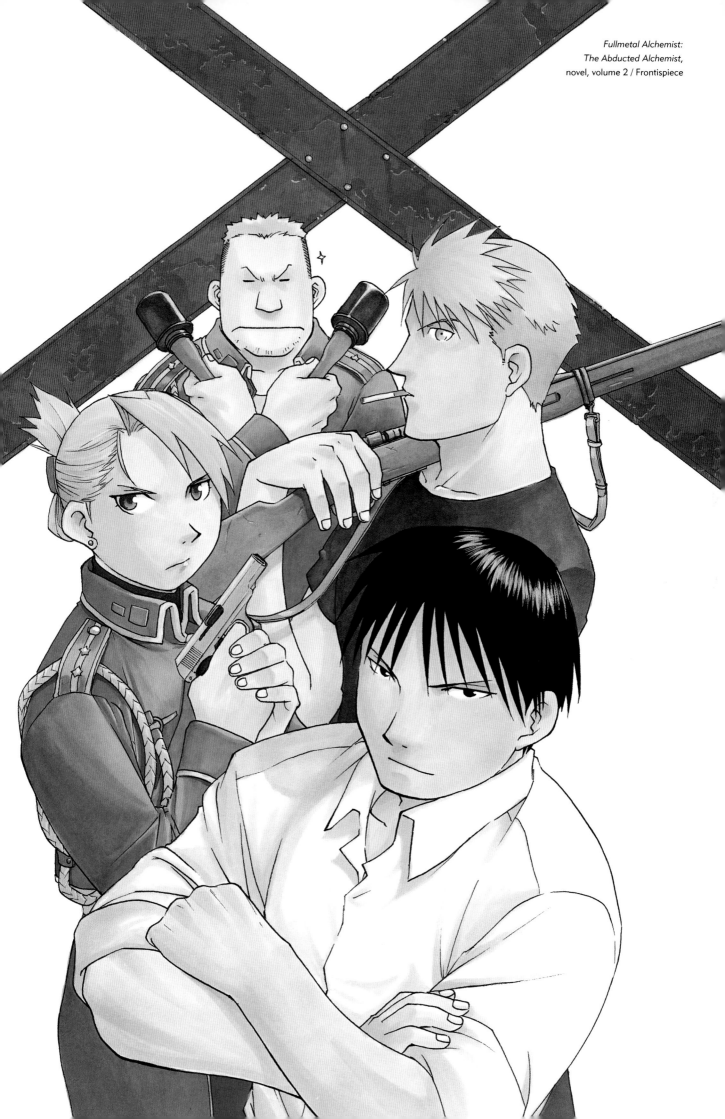

Fullmetal Alchemist:
The Abducted Alchemist,
novel, volume 2 / Frontispiece

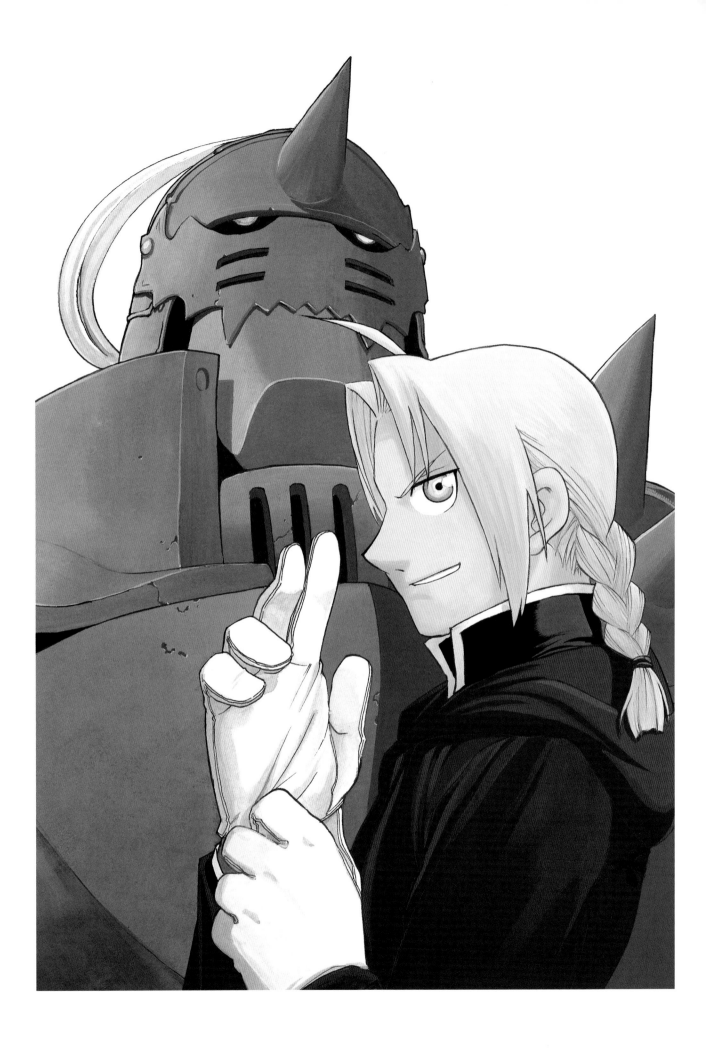

Fullmetal Alchemist: The Abducted Alchemist, novel, volume 2 / Cover

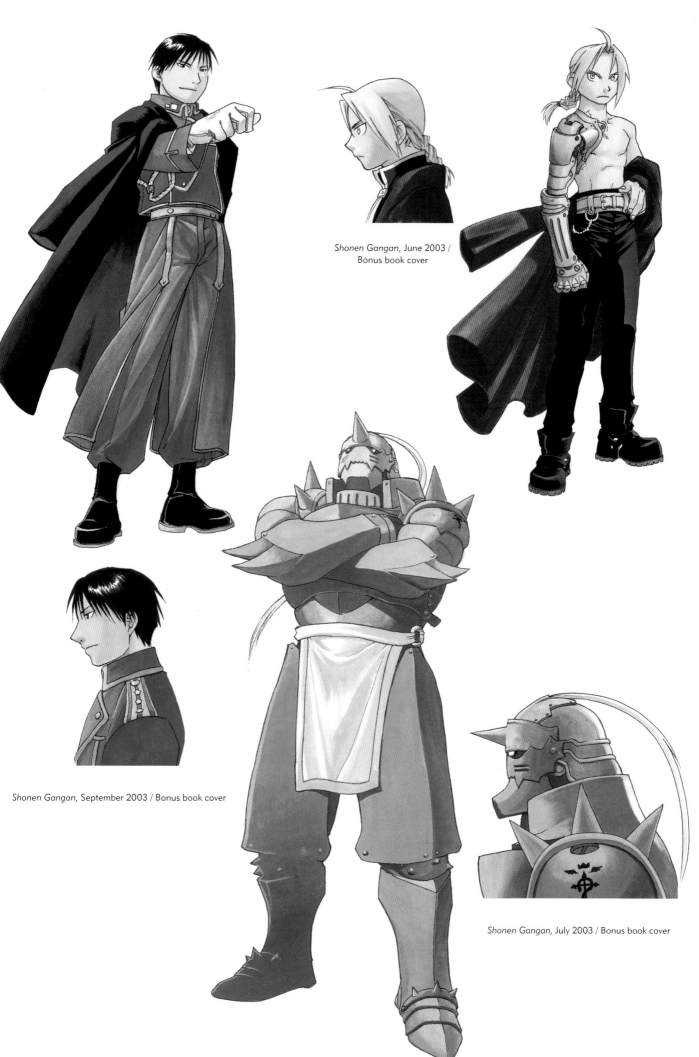

Shonen Gangan, June 2003 / Bonus book cover

Shonen Gangan, September 2003 / Bonus book cover

Shonen Gangan, July 2003 / Bonus book cover

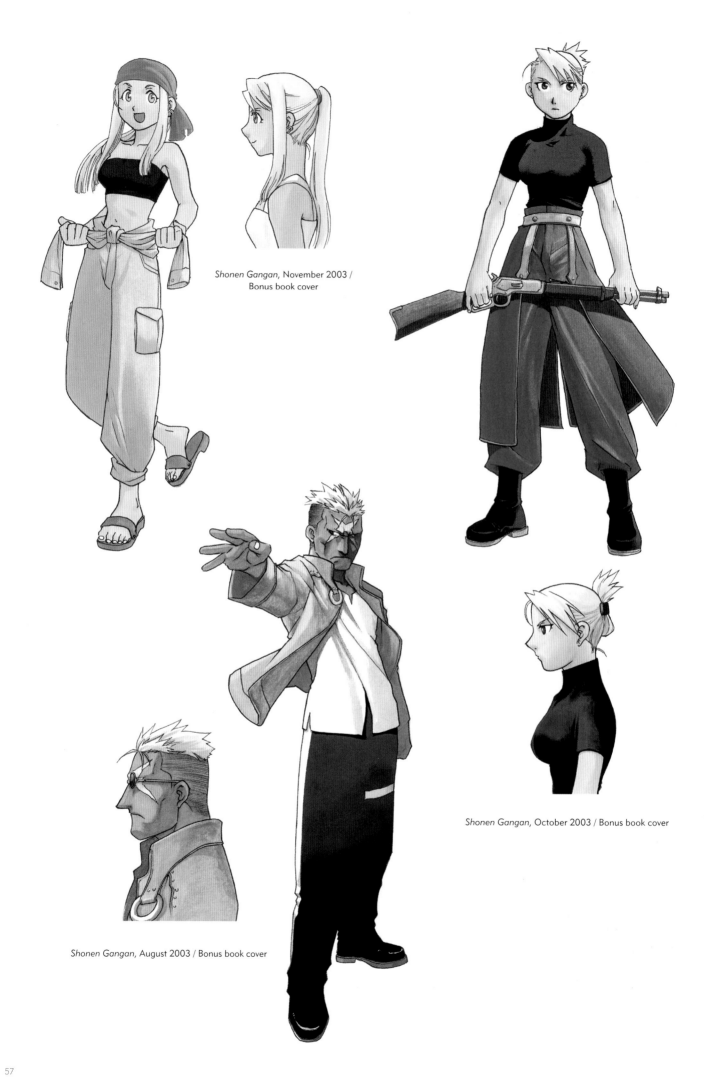

Shonen Gangan, November 2003 /
Bonus book cover

Shonen Gangan, October 2003 / Bonus book cover

Shonen Gangan, August 2003 / Bonus book cover

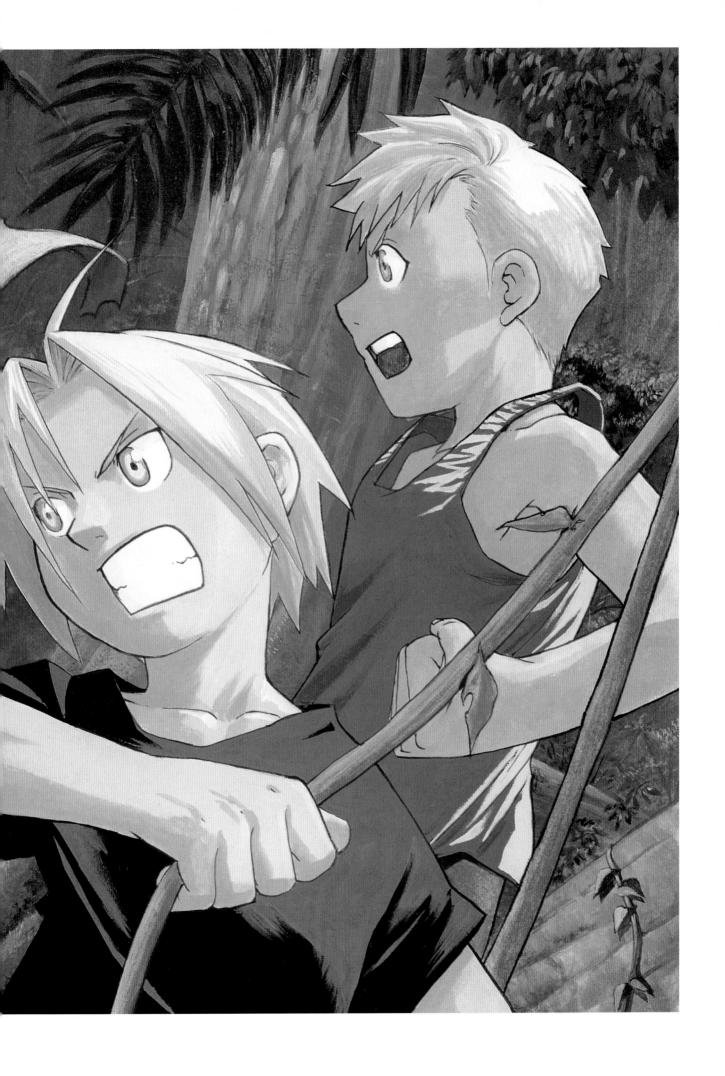

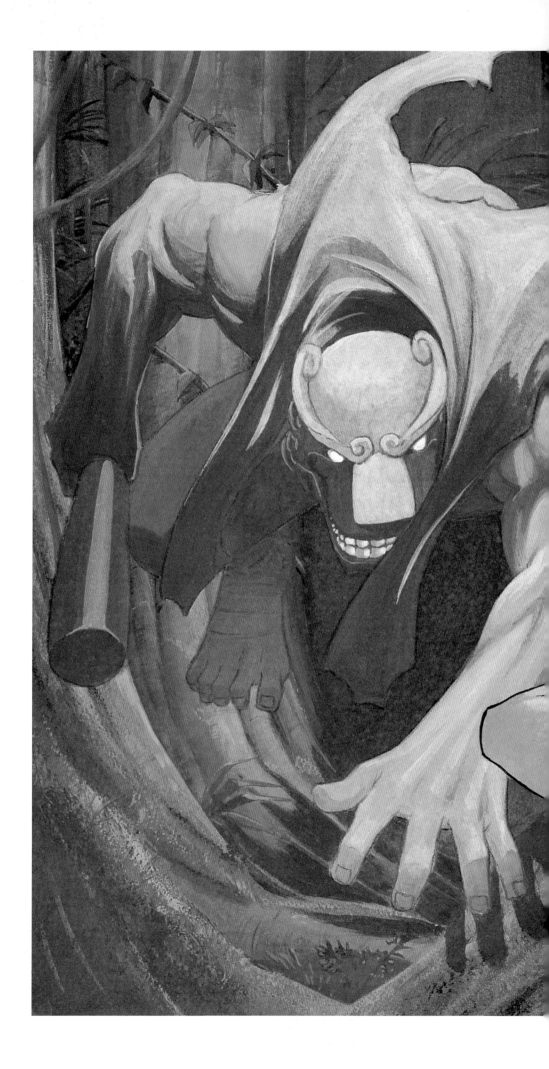

Graphic novel, volume 6 / Cover

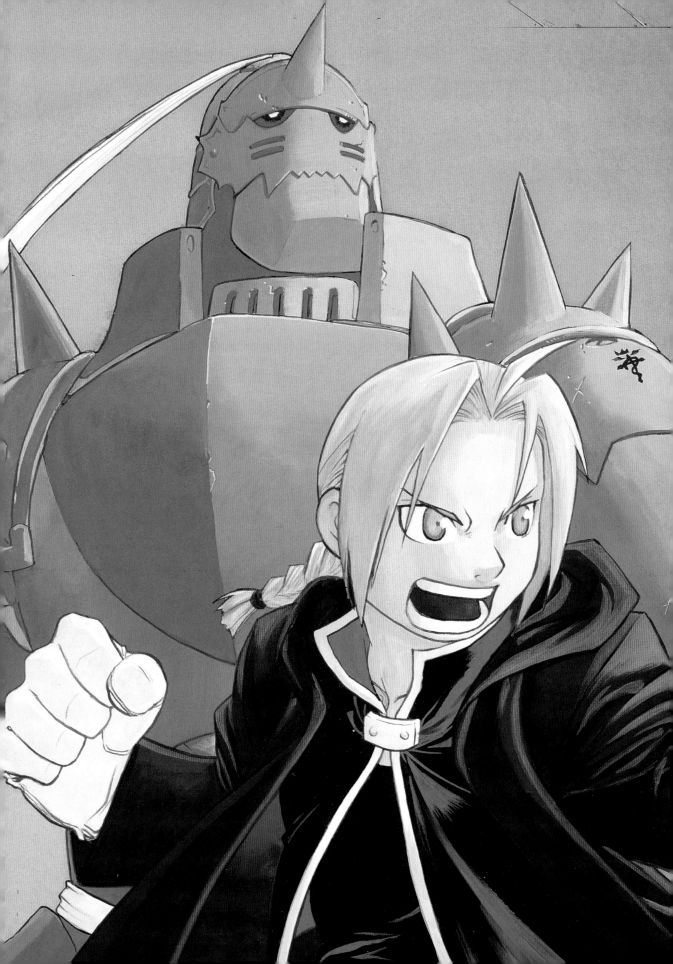

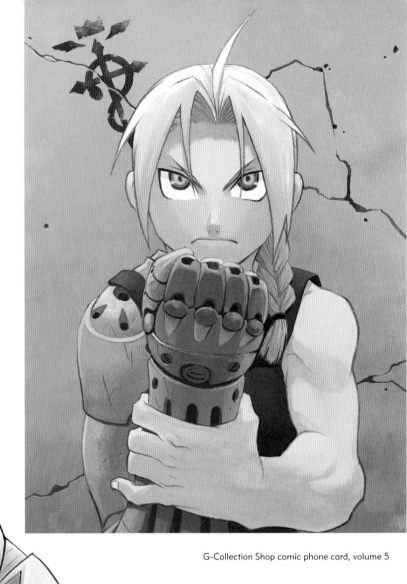

G-Collection Shop comic phone card, volume 5

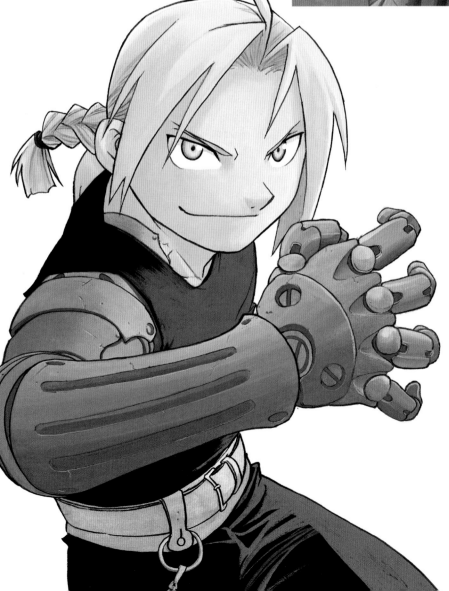

Shonen Gangan, November 2003 / Cover

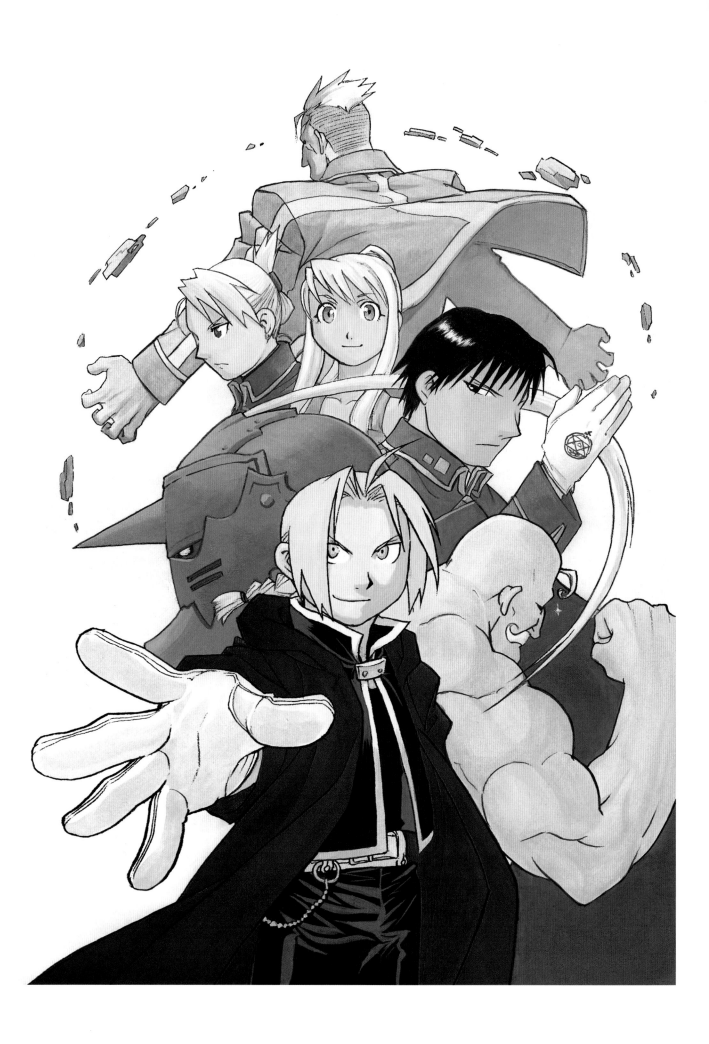

Shonen Gangan, November 2003 / Bonus pencil board

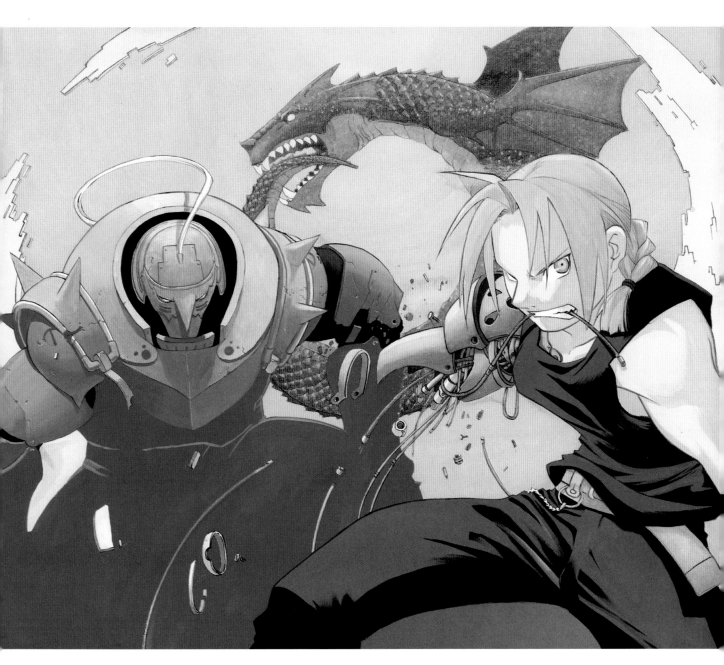

Shonen Gangan, January 2004 / Chapter 30, "The Truth Inside the Armor"

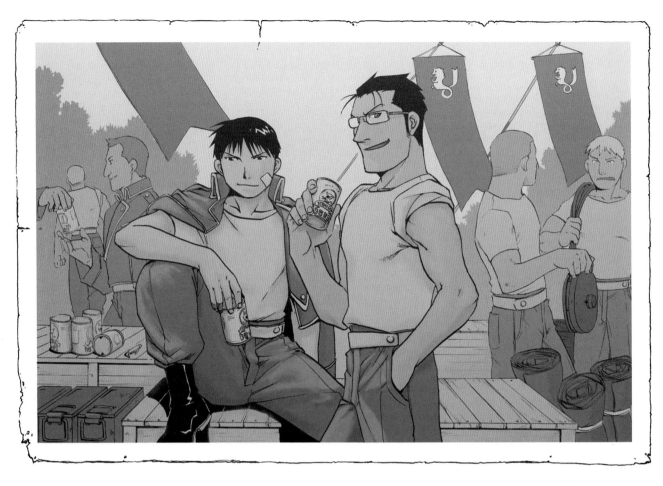

Gangan Powered, Spring 2003 / Bonus postcard

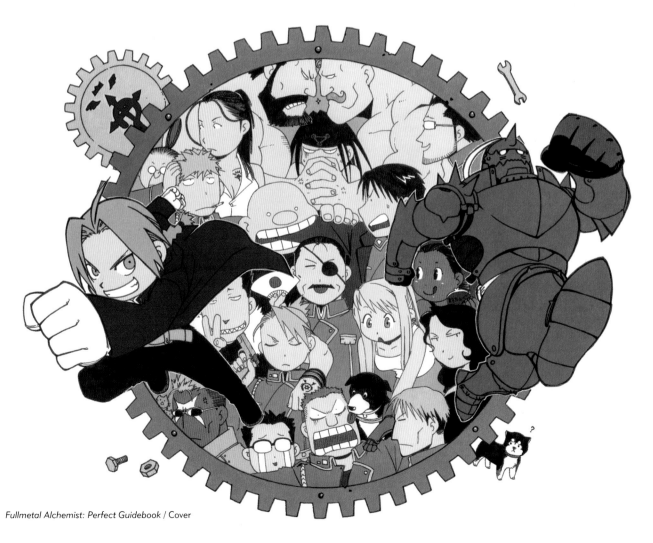

Fullmetal Alchemist: Perfect Guidebook / Cover

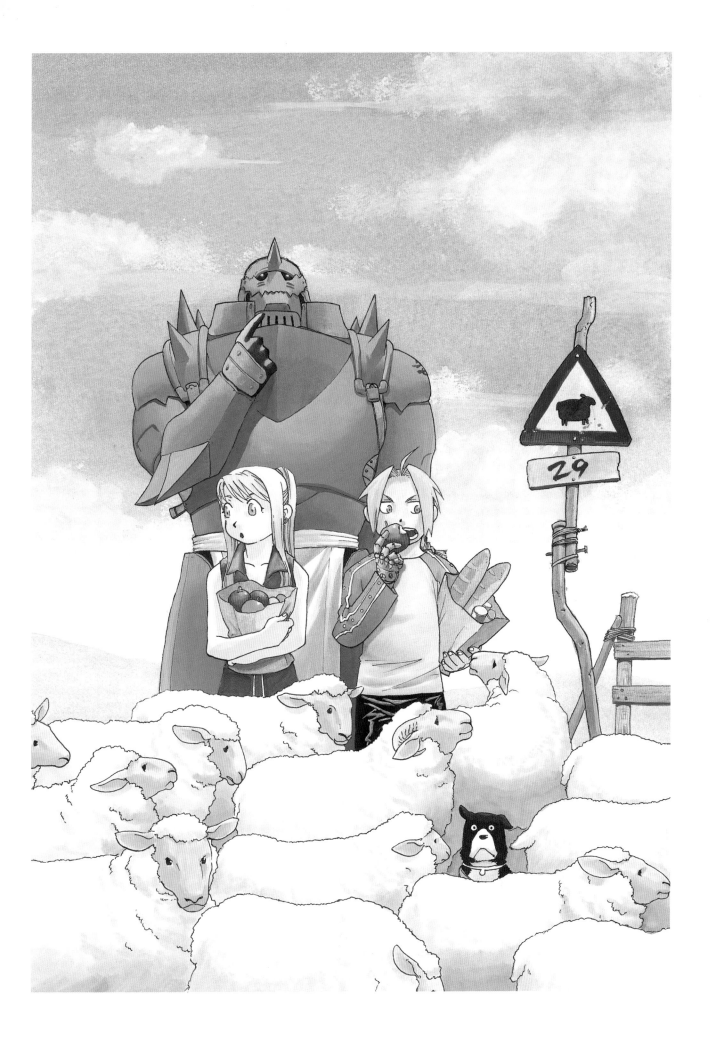

Shonen Gangan, December 2003 / Chapter 29, "The Eye of the King"

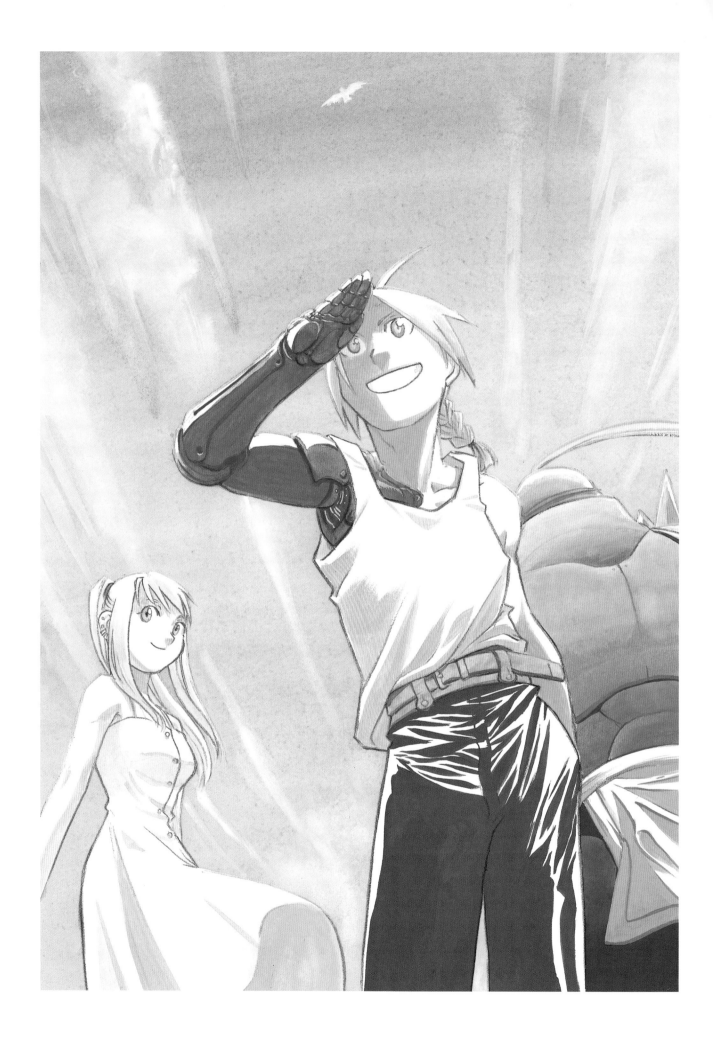

Fullmetal Alchemist Comic Special Calendar 2004 / August

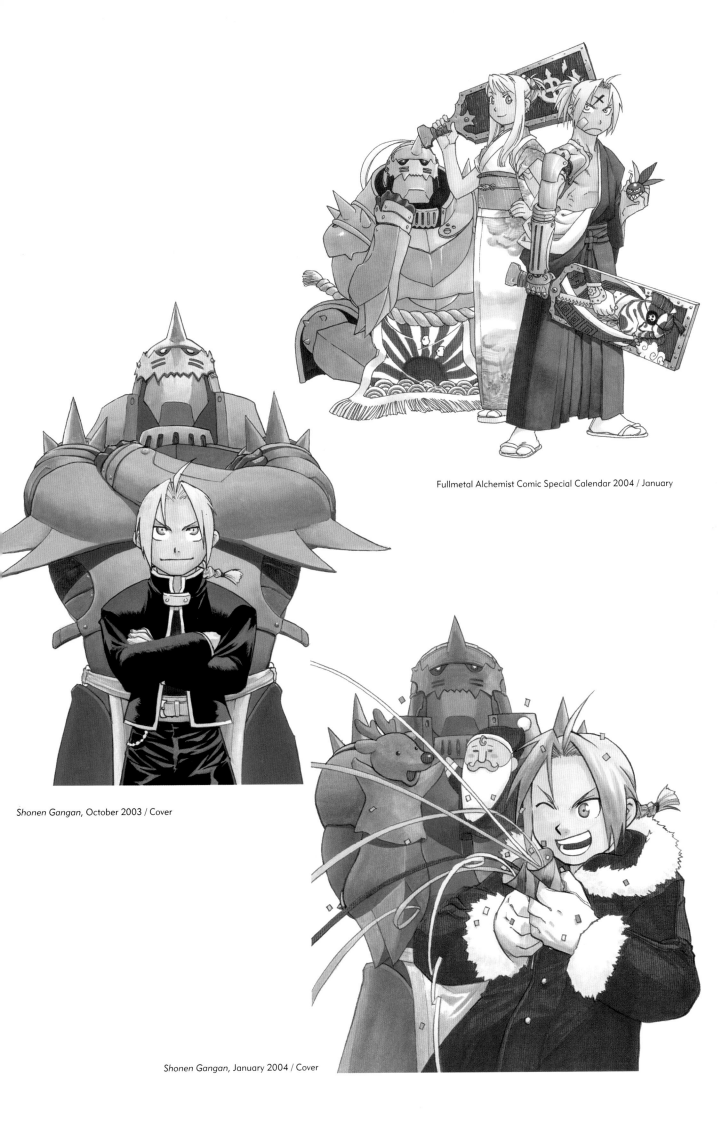

Fullmetal Alchemist Comic Special Calendar 2004 / January

Shonen Gangan, October 2003 / Cover

Shonen Gangan, January 2004 / Cover

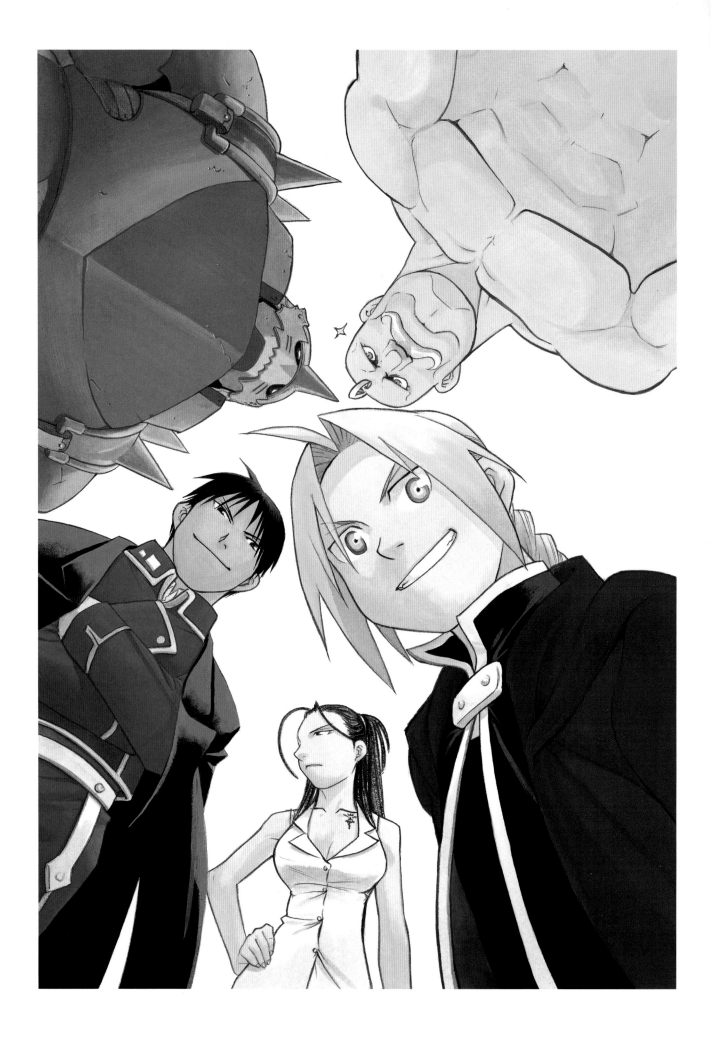

Fullmetal Alchemist magazine / Cover

But I want my own strength to be used to protect the citizens of this country who are weak and powerless.

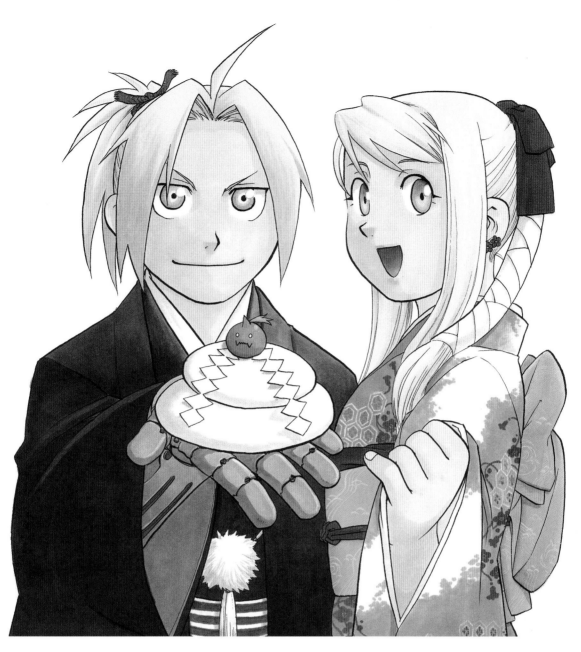

Shonen Gangan, February 2004 / Cover

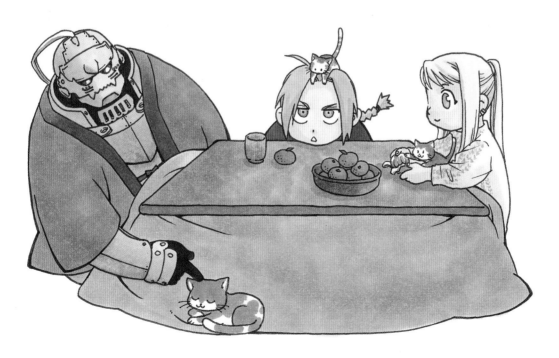

Shonen Gangan, March 2004 / Cover

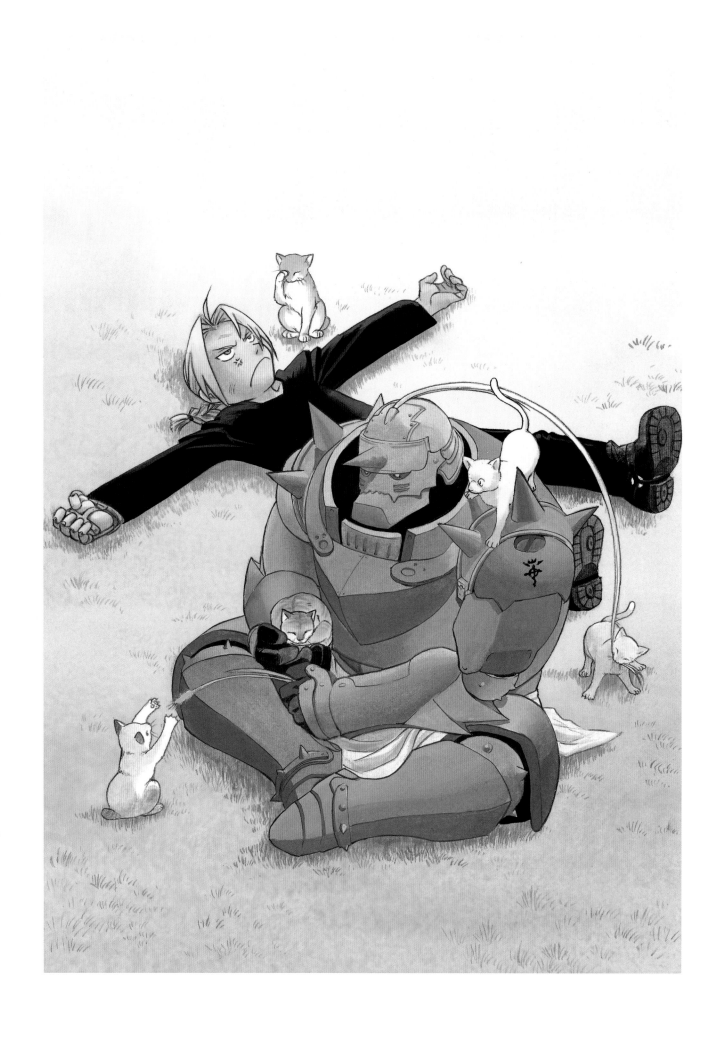

Shonen Gangan, April 2004 / Chapter 33, "Showdown in Rush Valley"

Shonen Gangan, February 2004 / Chapter 31, "The Snake That Eats Its Own Tail"

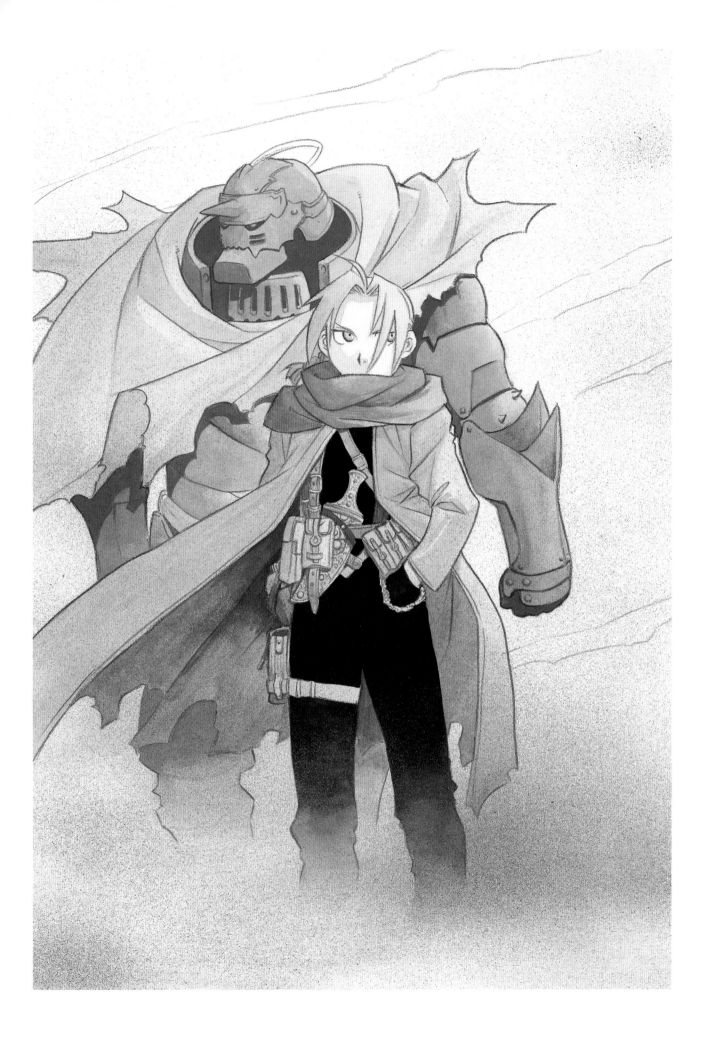

Shonen Gangan, March 2004 / Chapter 32, "Emissary from the East"

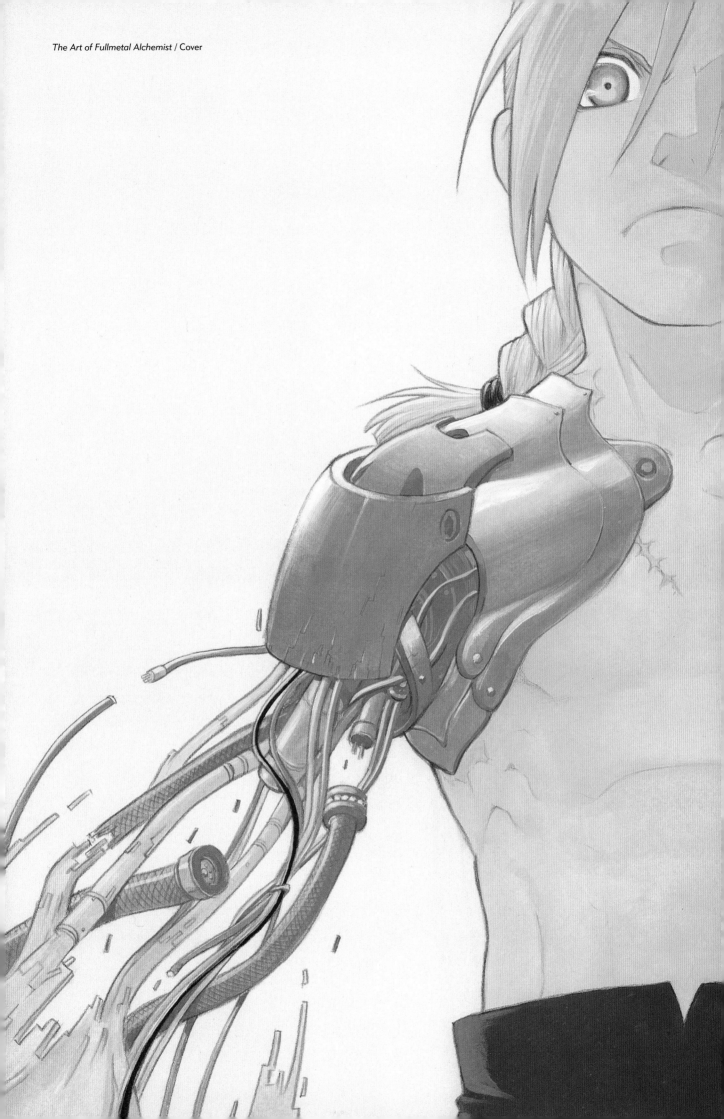

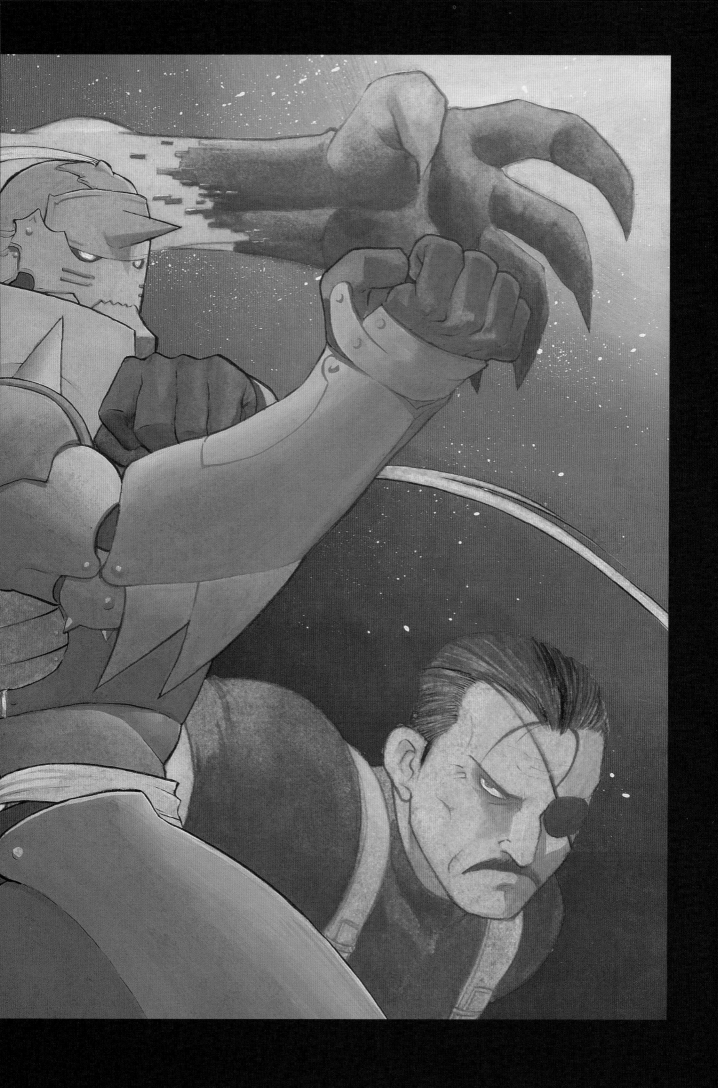

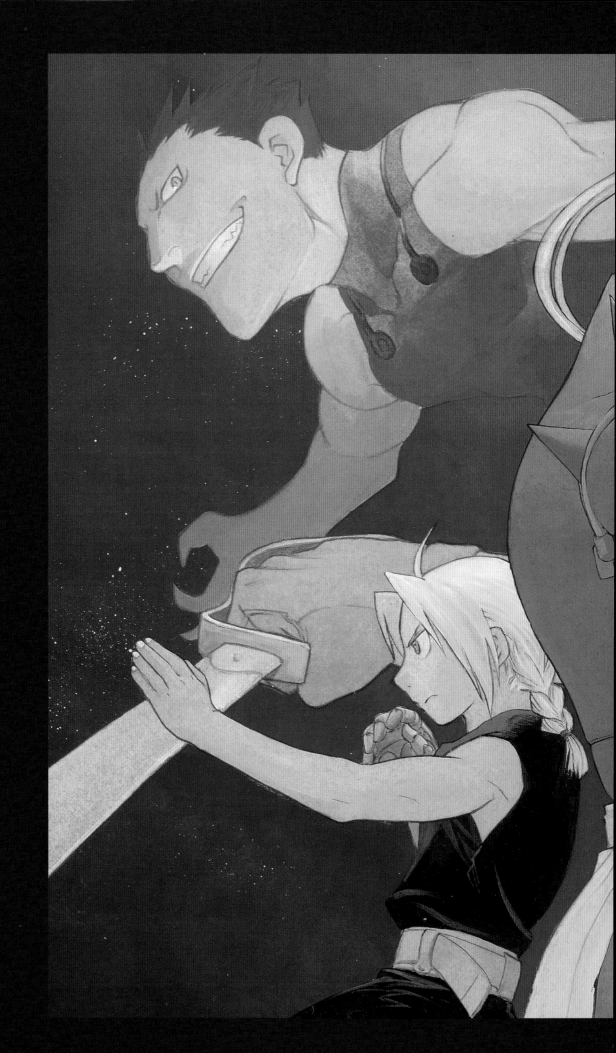

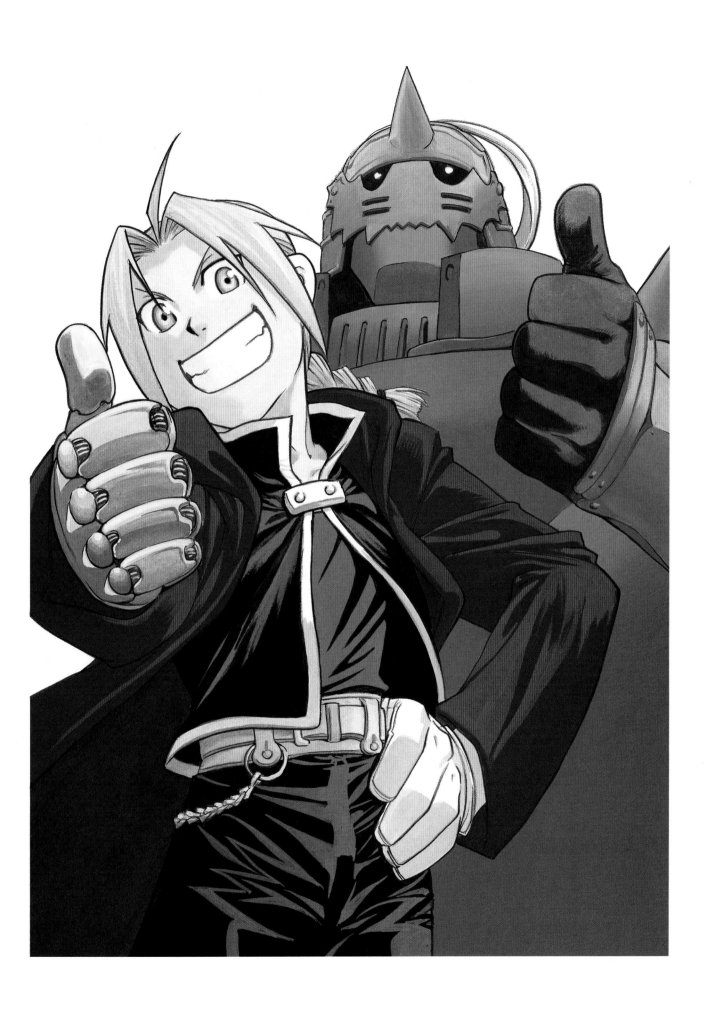

Shonen Gangan, May 2004 / Cover

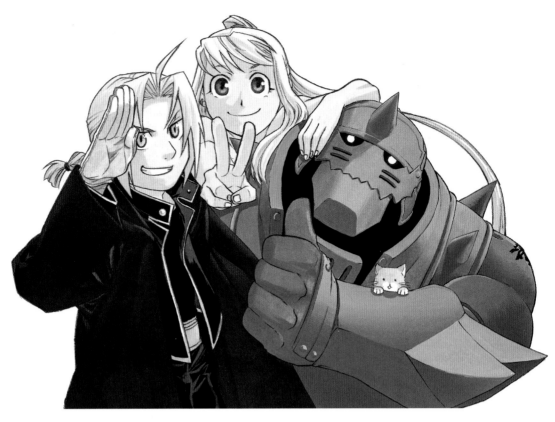

Shonen Gangan, October 2004 / Cover

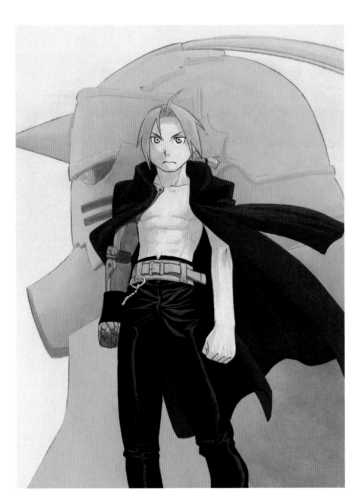

Limited edition graphic novel, volume 7 / Sketchbook

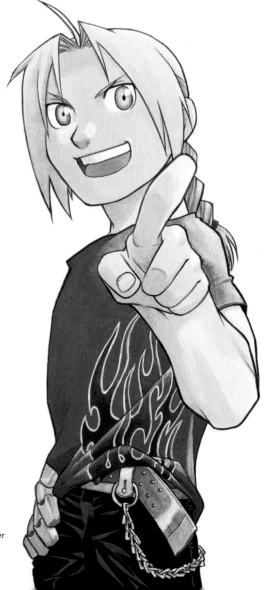

Shonen Gangan, April 2004 / Cover

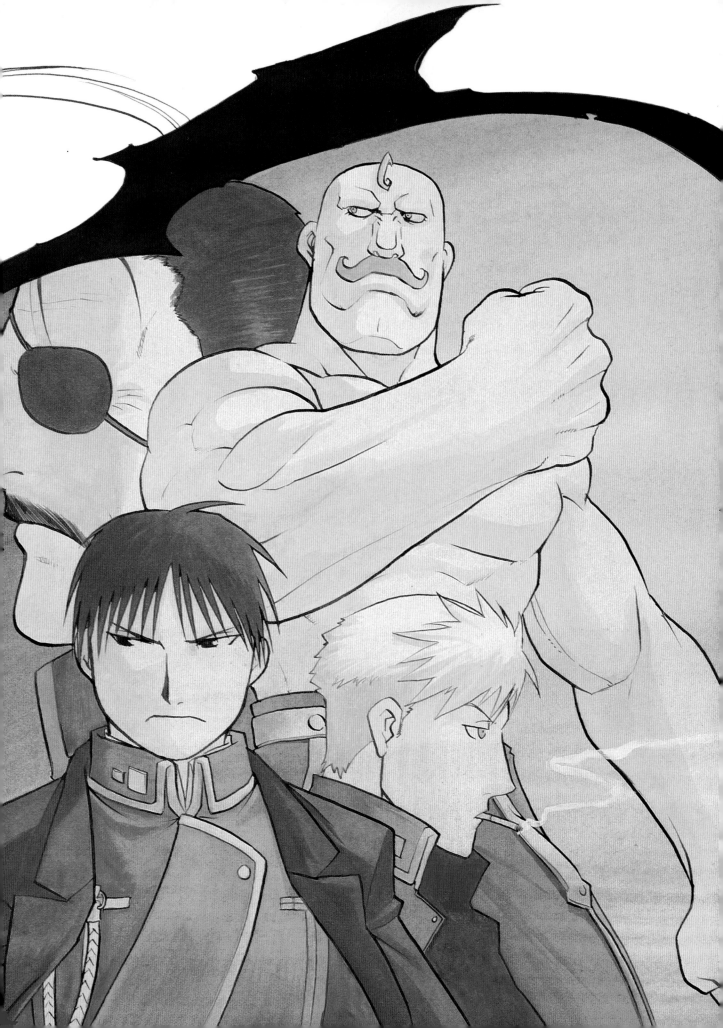

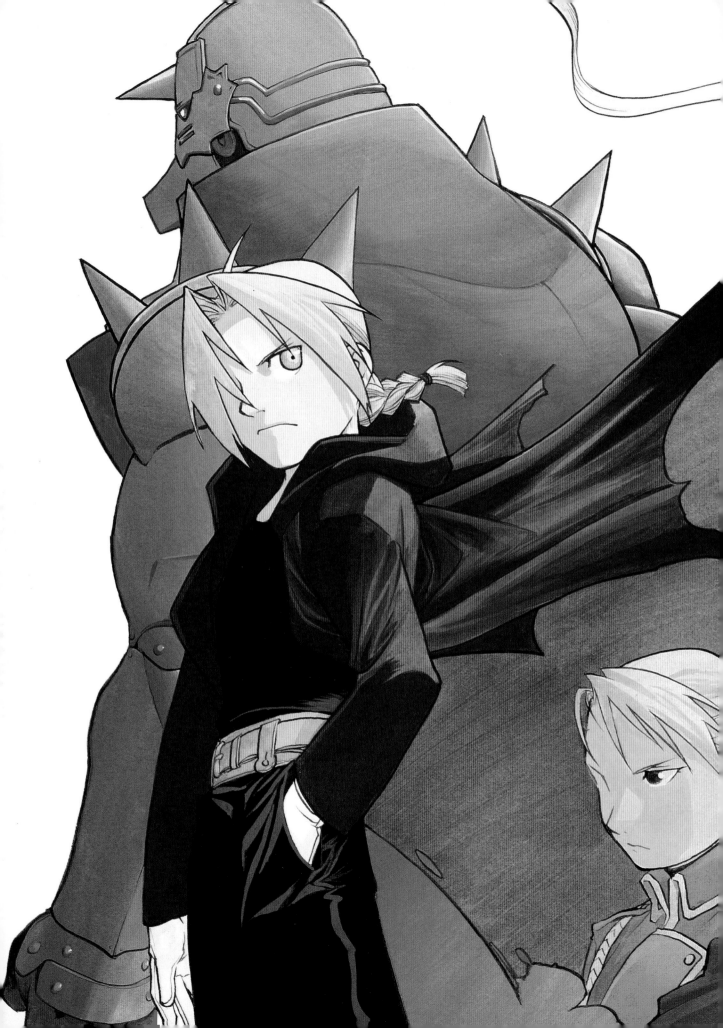

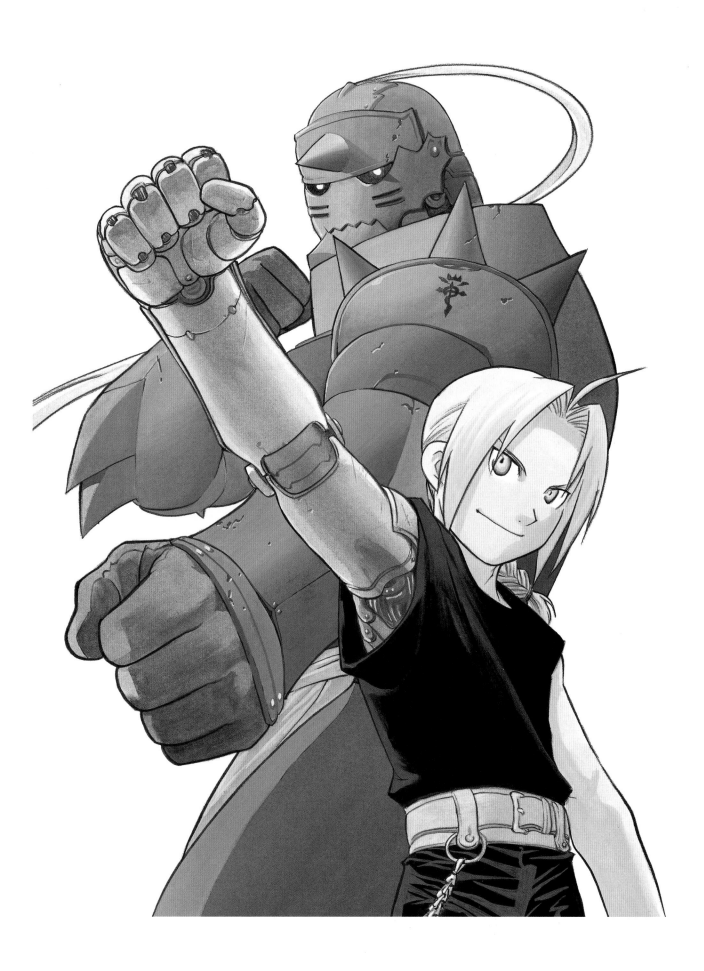

Fullmetal Alchemist: The Valley of White Petals, novel, volume 3 / Cover

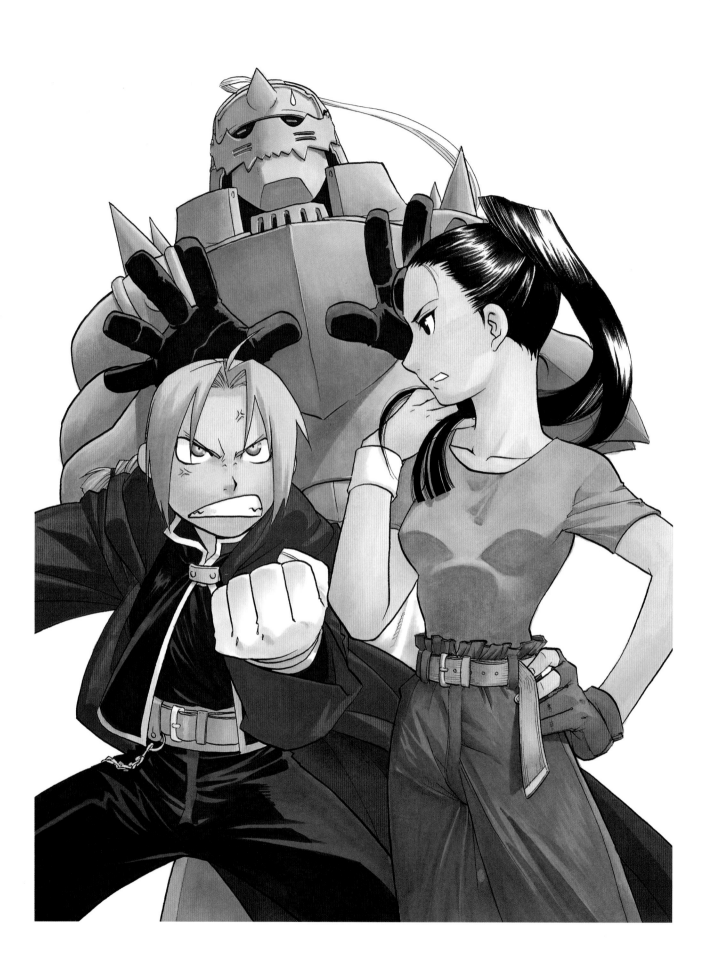

Fullmetal Alchemist: The Valley of White Petals, novel, volume 3 / Frontispiece

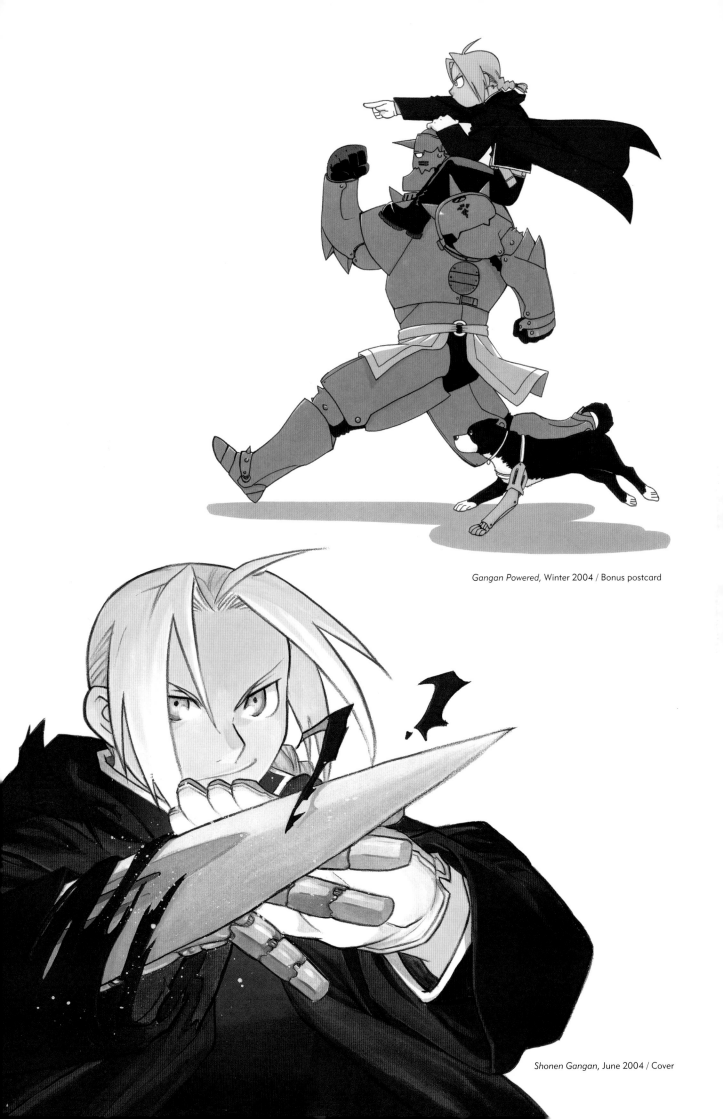

Gangan Powered, Winter 2004 / Bonus postcard

Shonen Gangan, June 2004 / Cover

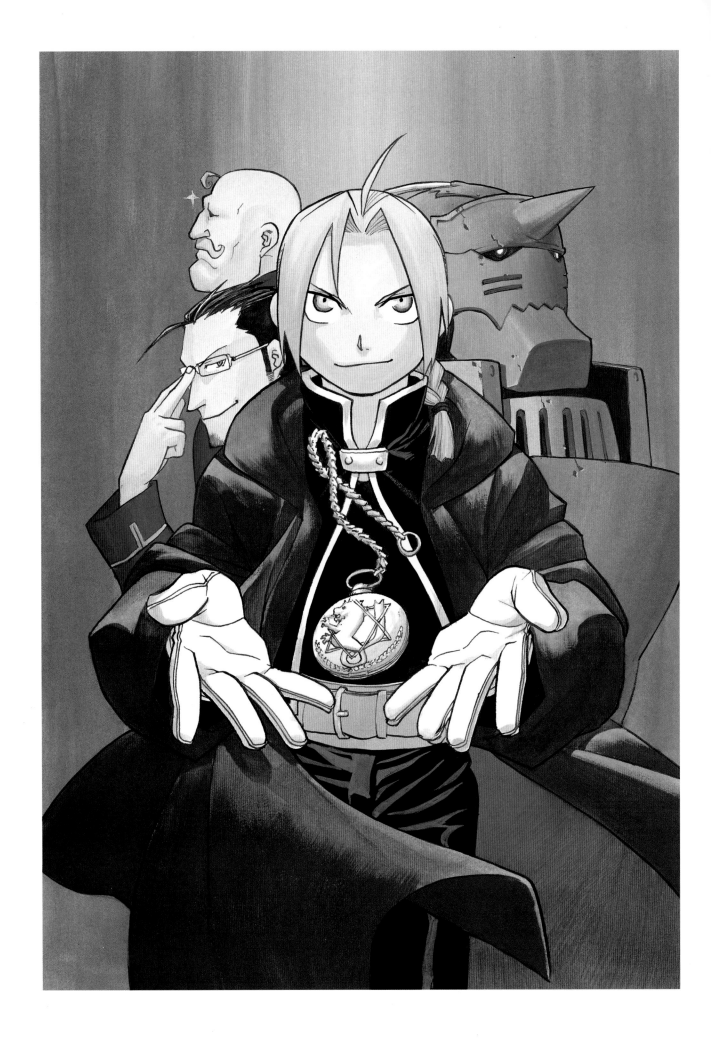

Fullmetal Alchemist: The False Light, the Shadow of Truth, drama CD, volume 2 / Package

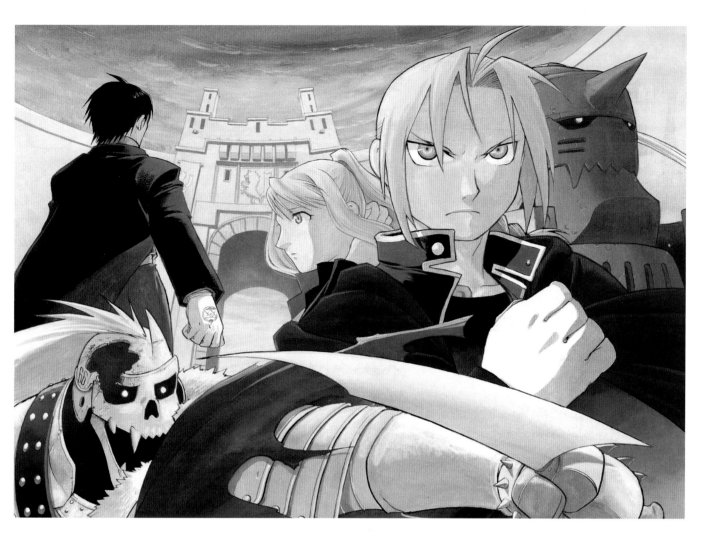

Shonen Gangan, July 2004 / Chapter 36, "Alchemist in Distress"

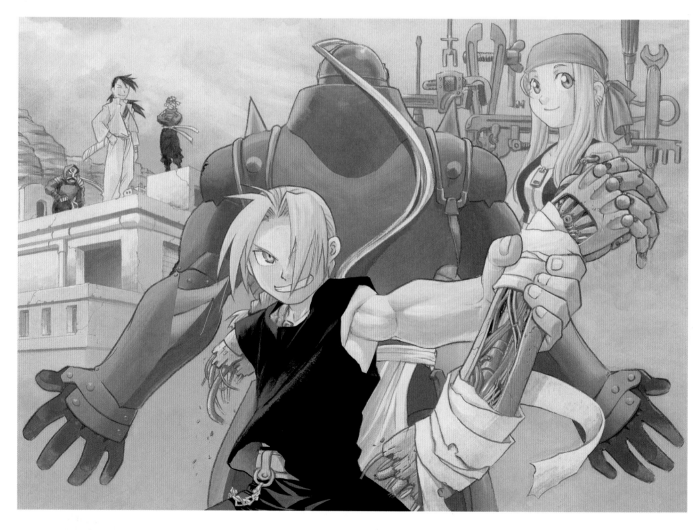

Graphic novel, volume 8 / Cover

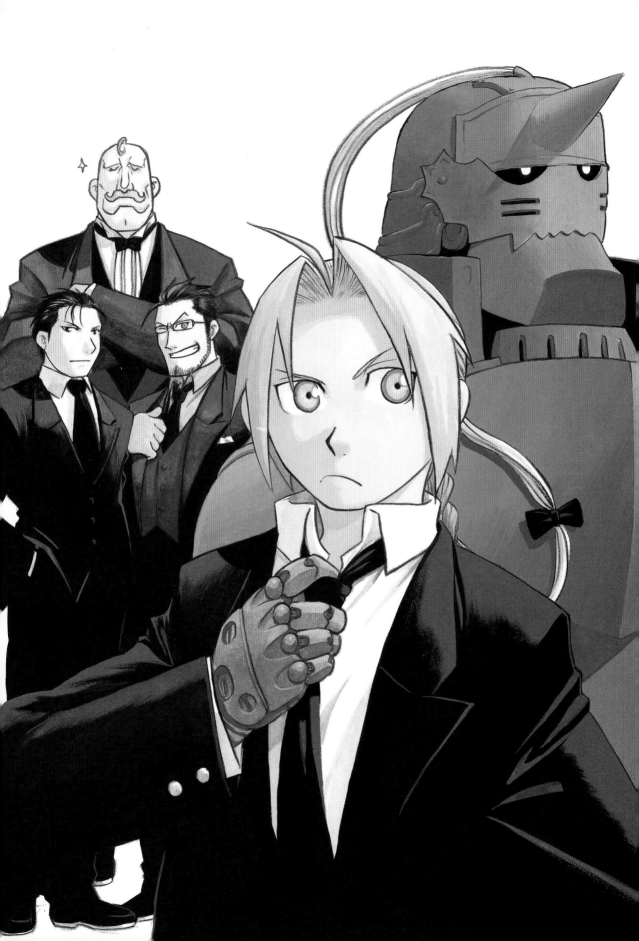

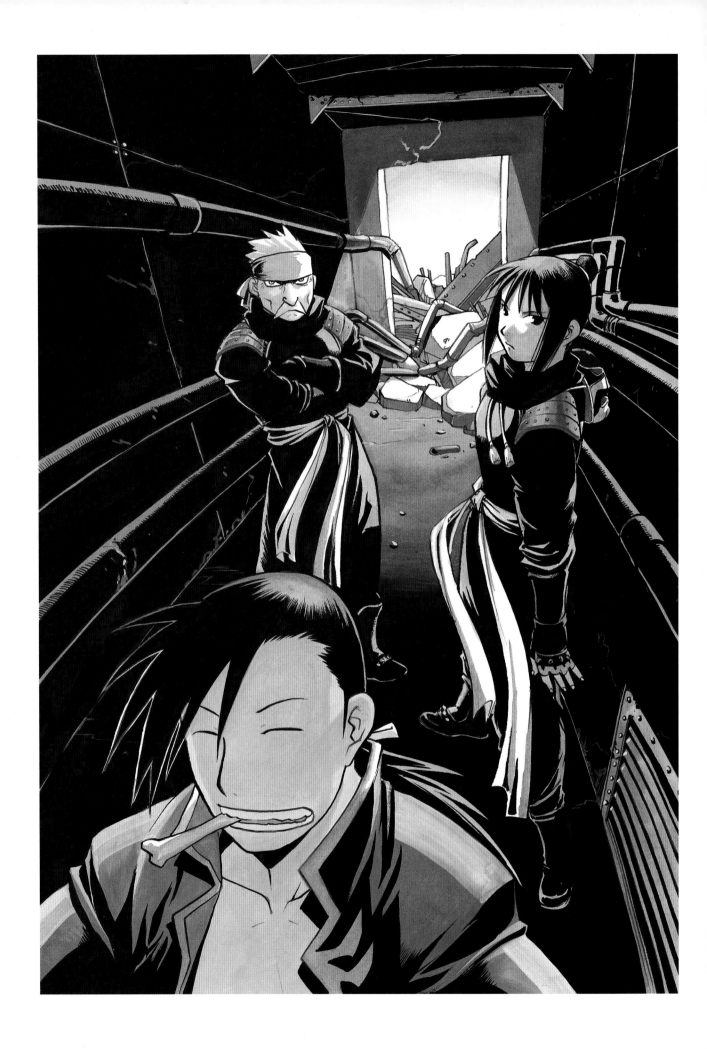

Shonen Gangan, June 2004 / Chapter 35, "The Sacrificial Lamb"

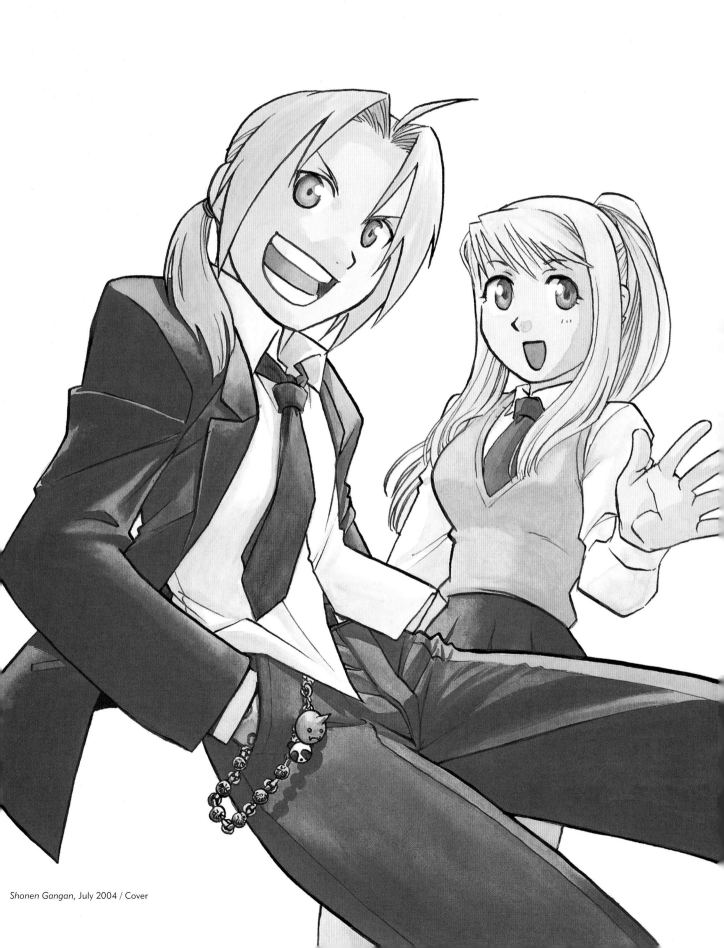

G-Collection Shop comic phone card, volume 6

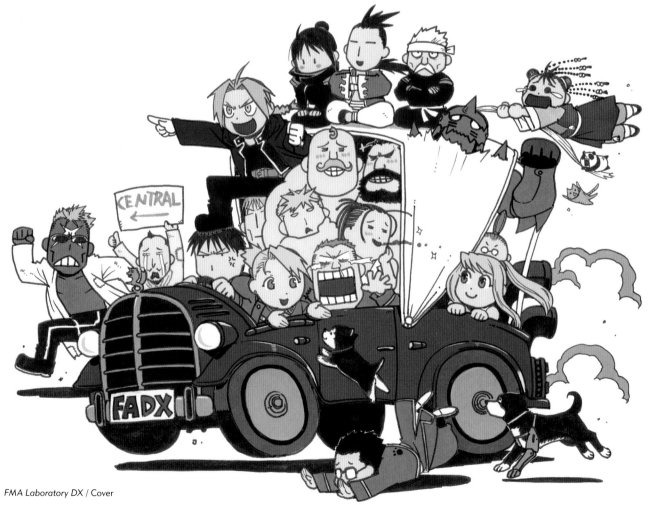

FMA Laboratory DX / Cover

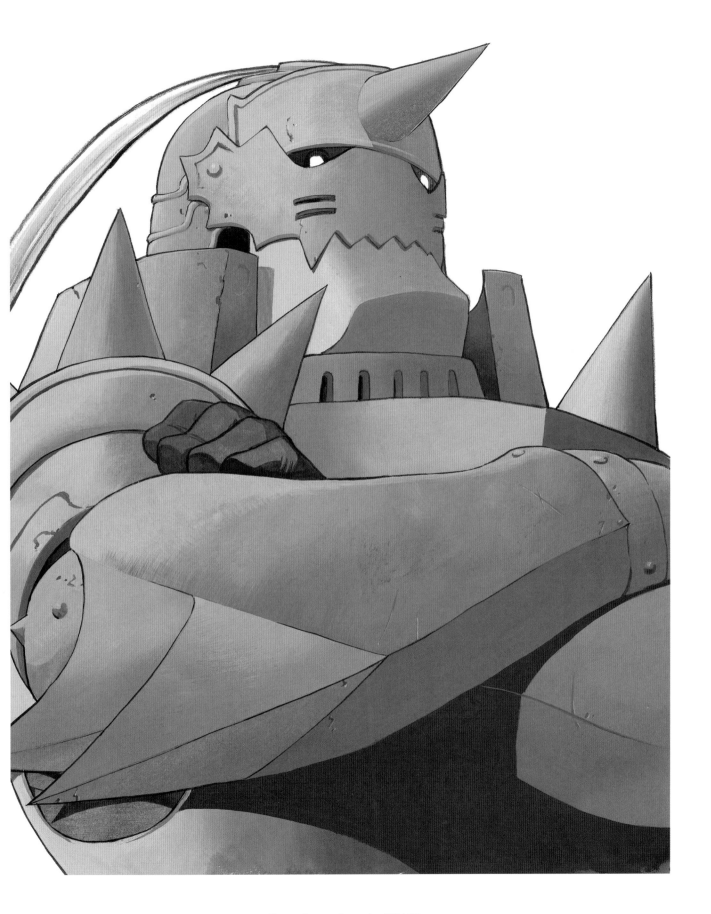

Shonen Gangan, September 2004 / Cover

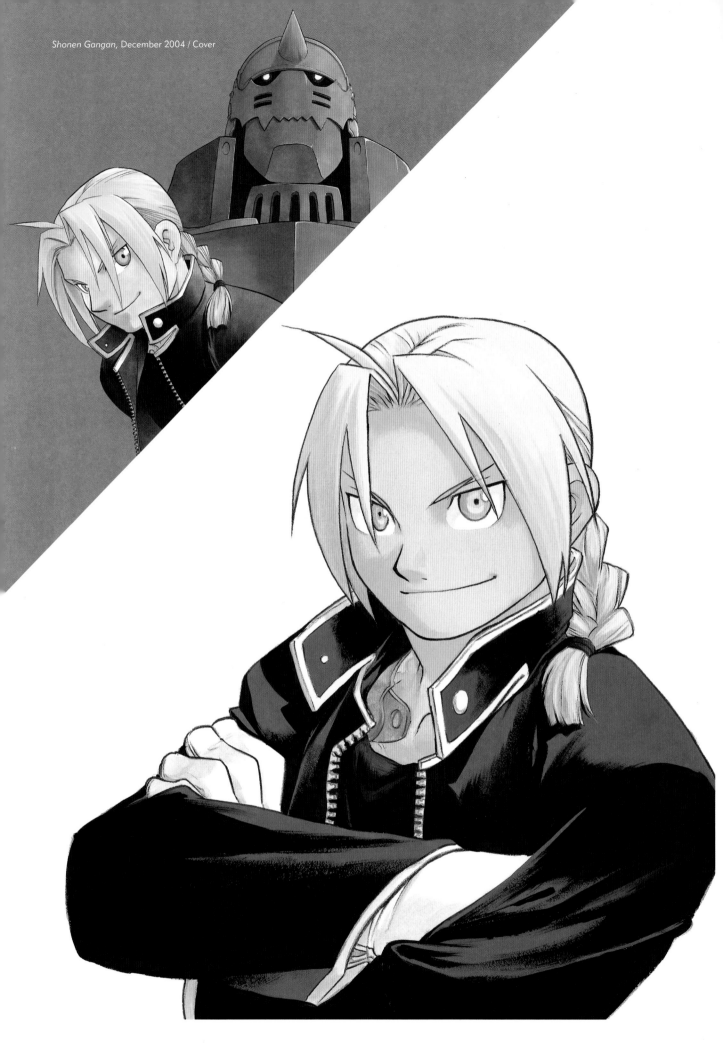

Shonen Gangan, August 2004 / Cover

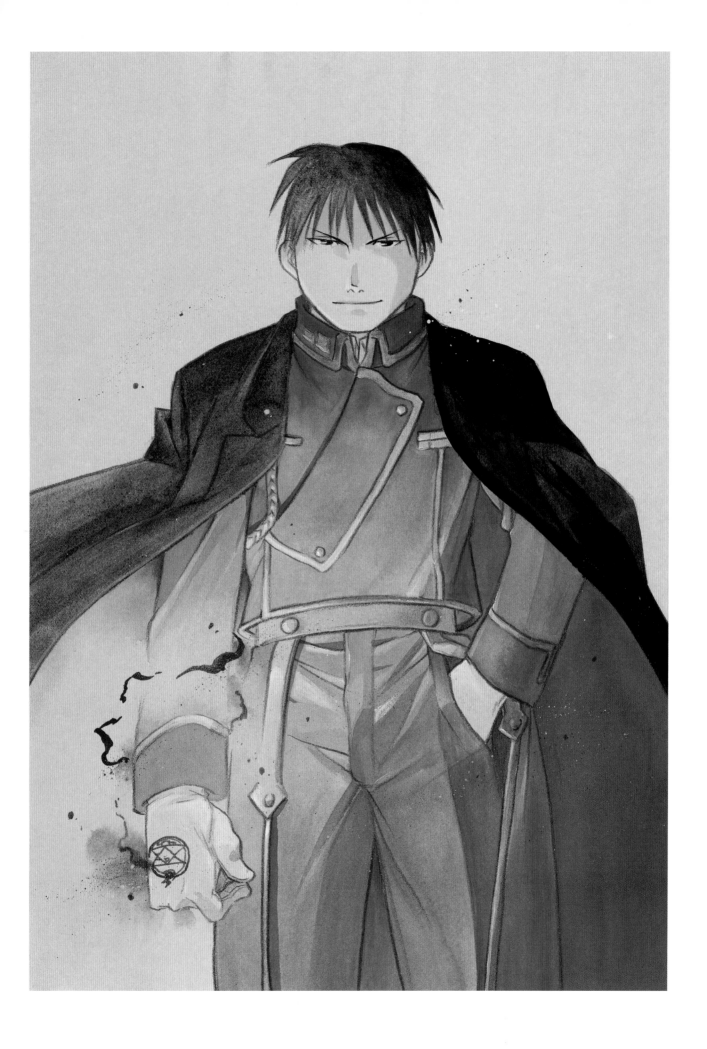

Graphic novel, volume 8 / Phone card giveaway

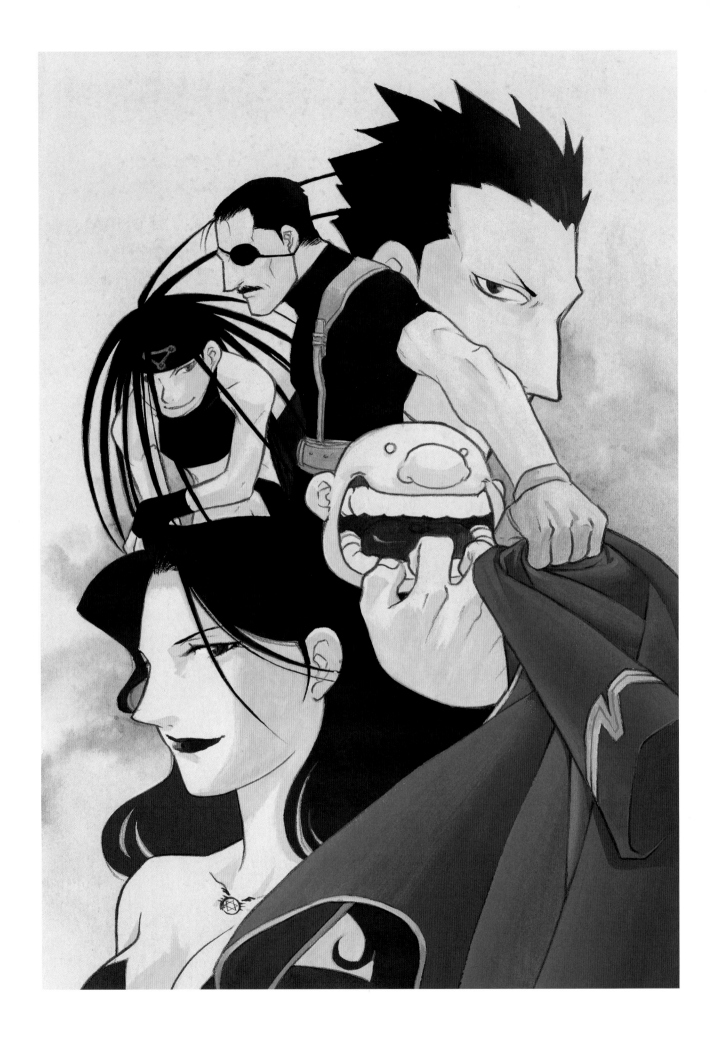

Shonen Gangan, October 2004 / Chapter 39, "Complications at Central"

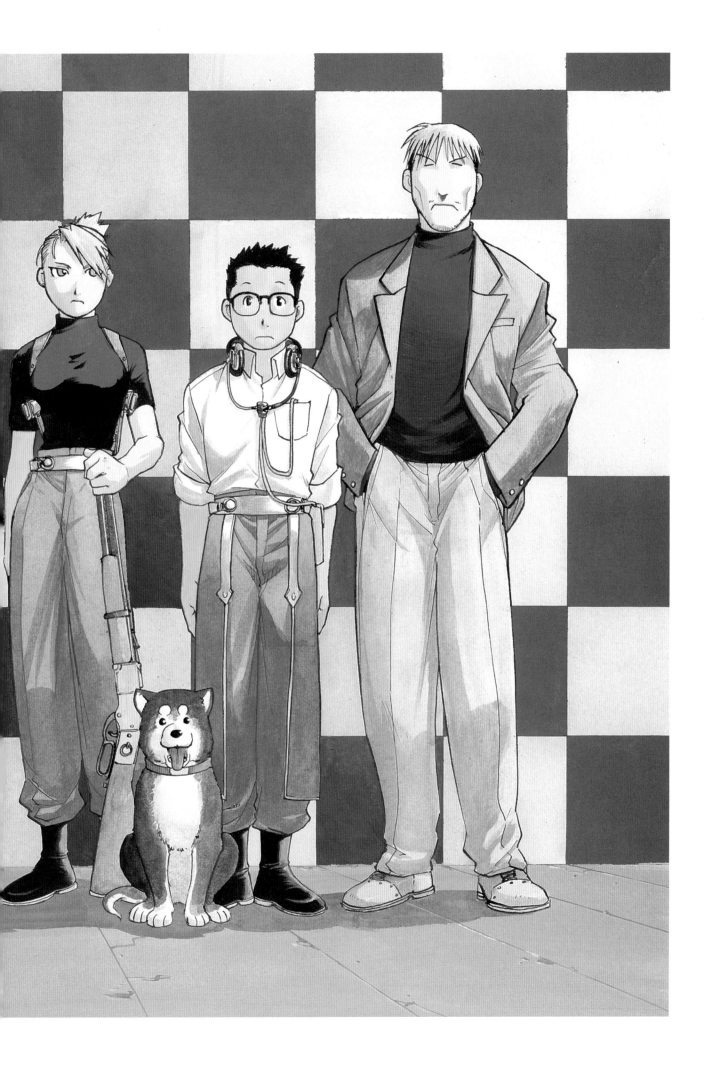

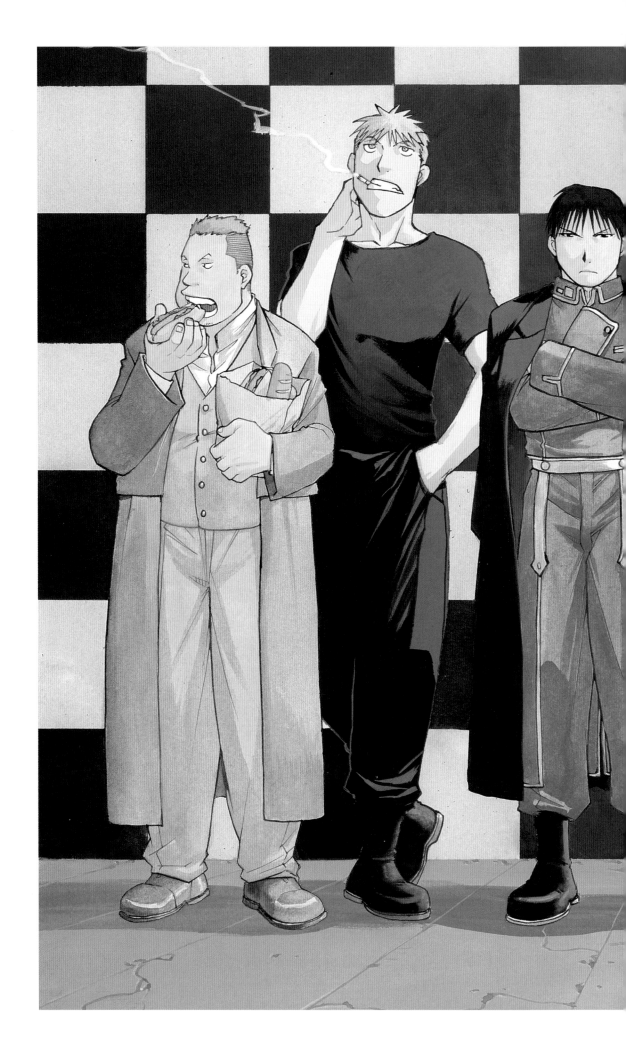

Shonen Gangan, September 2004 / Chapter 38, "Signal to Strike"

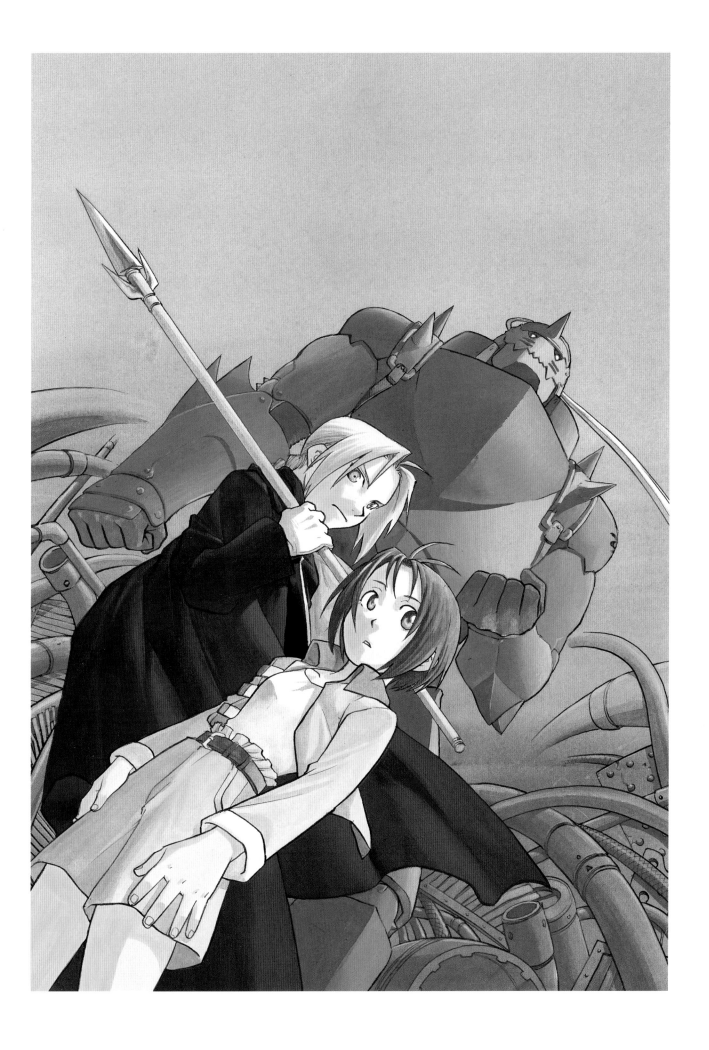

Fullmetal Alchemist and the Broken Angel game novelization / Cover

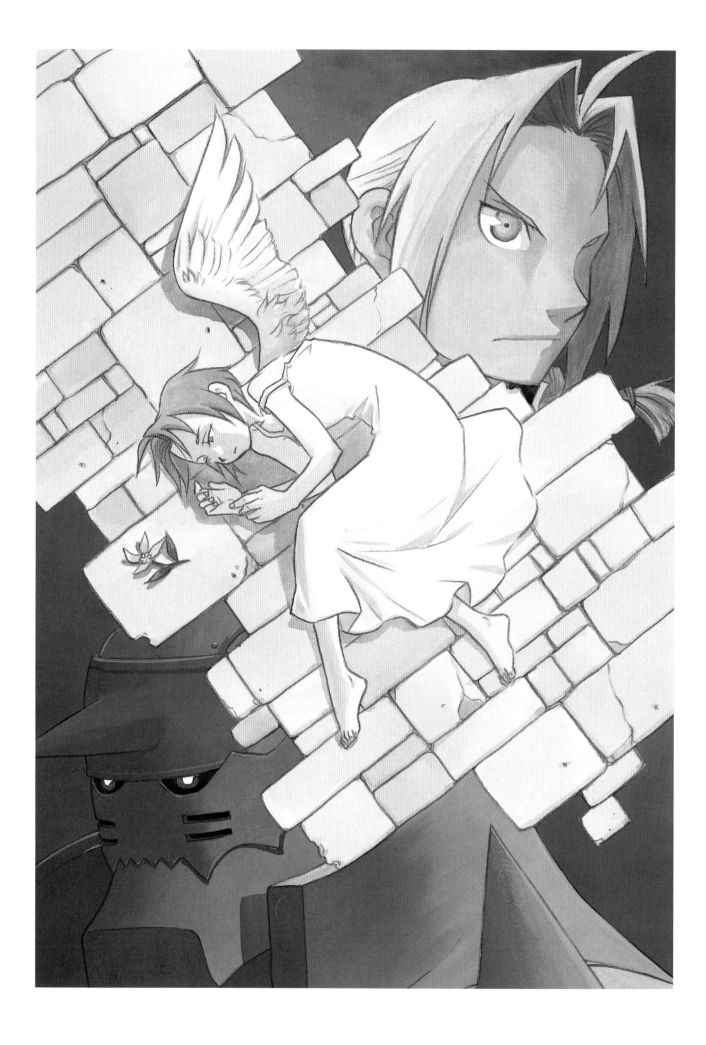

Fullmetal Alchemist and the Broken Angel game novelization / Bonus phone card

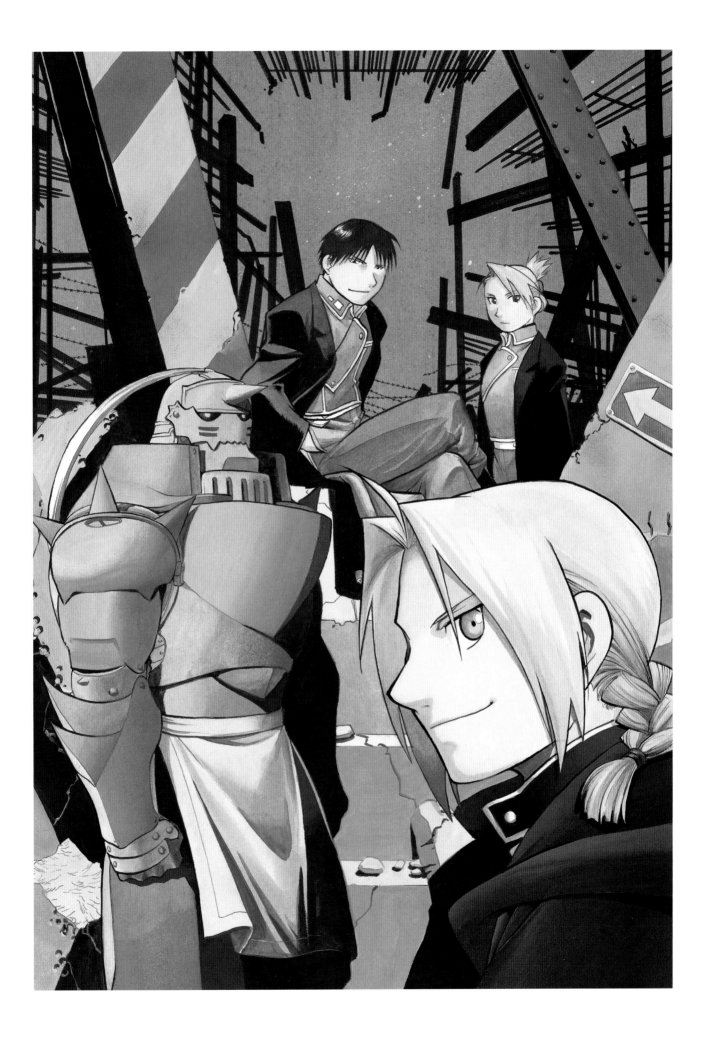

Shonen Gangan, November 2004 / Cover

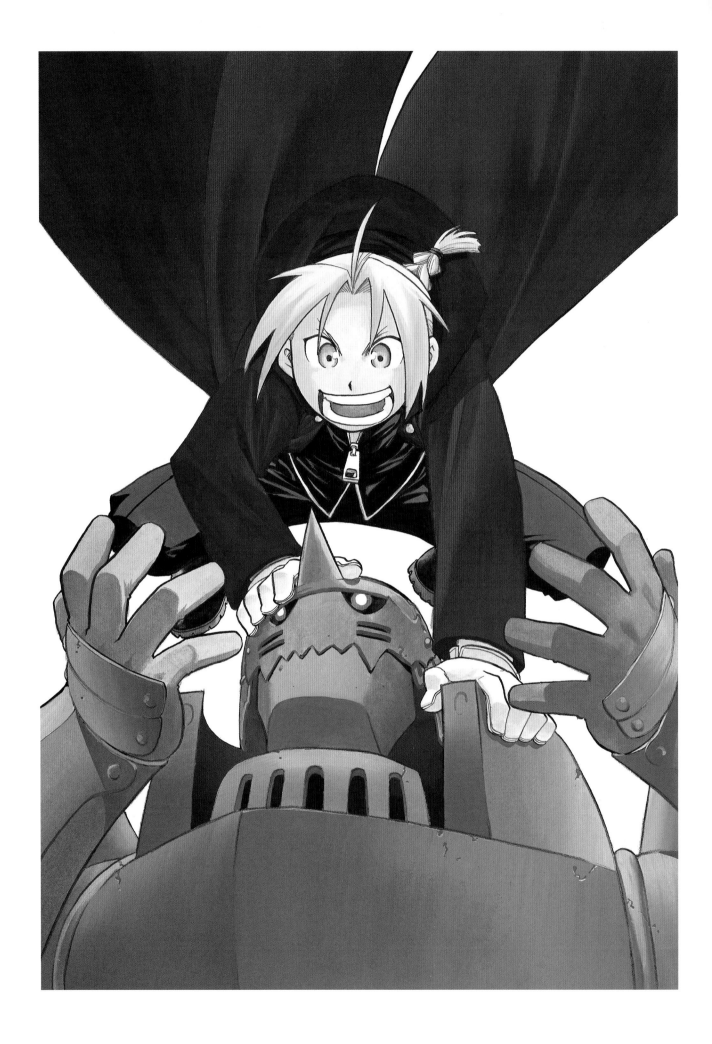

Fullmetal Alchemist: Under the Faraway Sky, novel, volume 4 / Cover

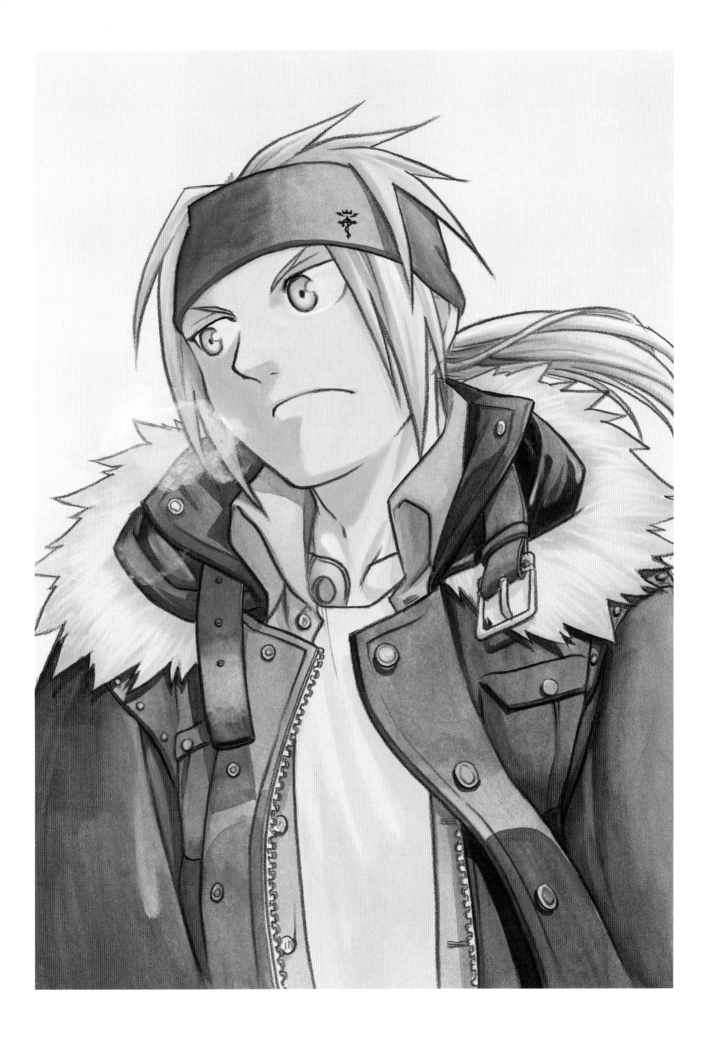

Fullmetal Alchemist Comic Special Calendar 2005 / January

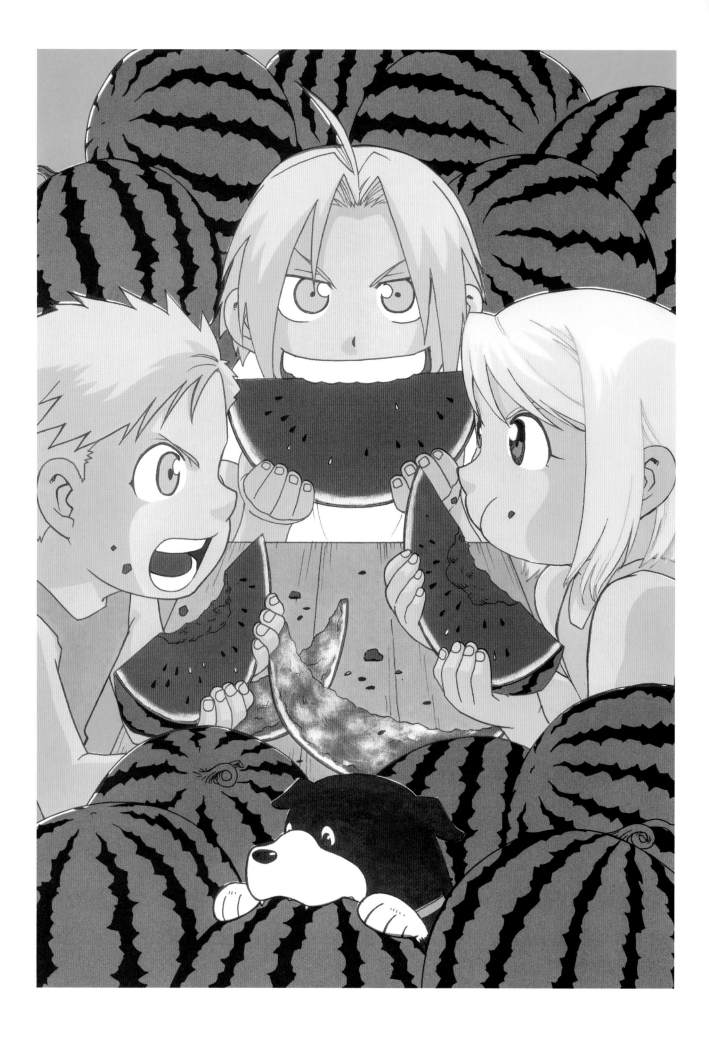

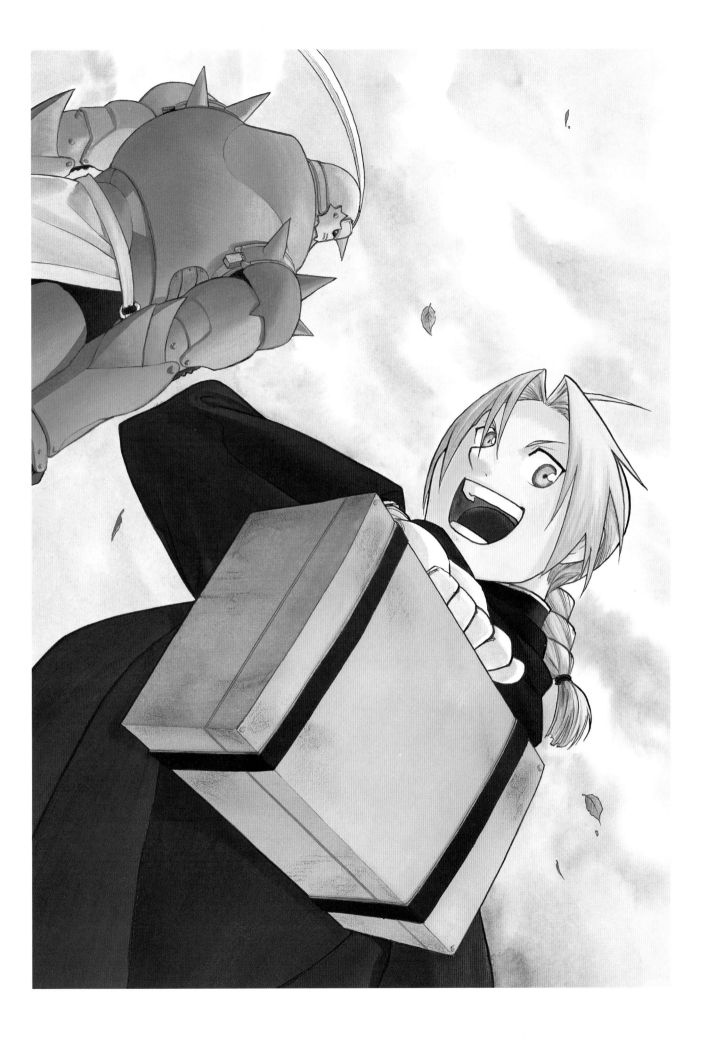

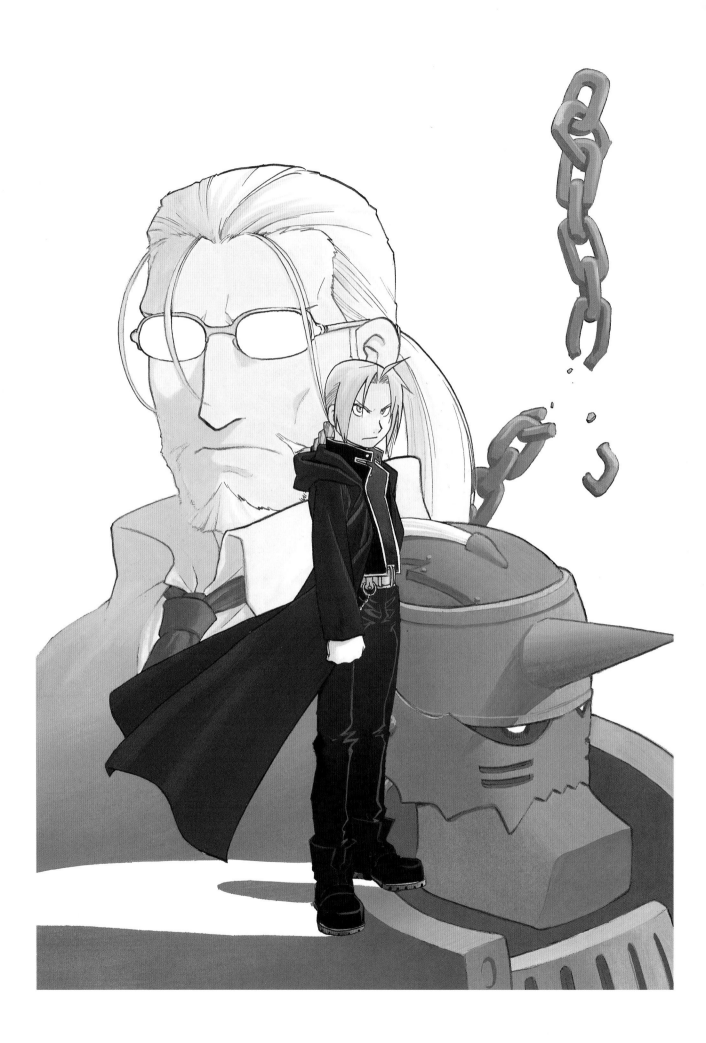

Shonen Gangan, December 2004 / Chapter 41, "On the Palm of an Arrogant Human Being"

Graphic novel, volume 9 / Cover

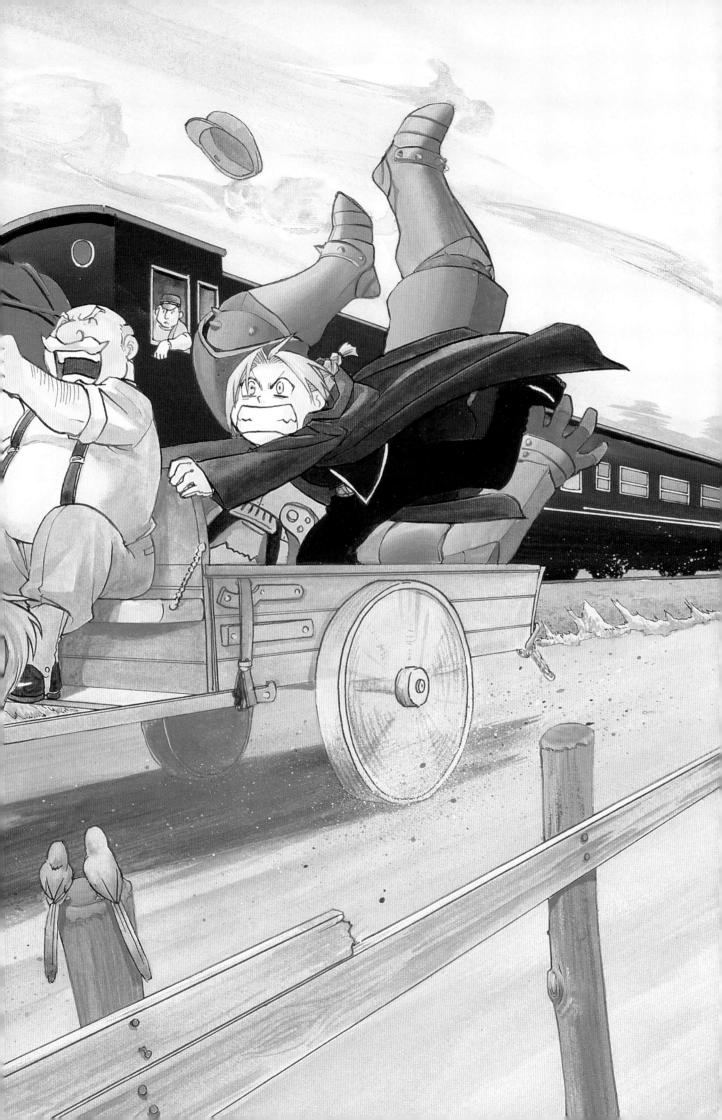

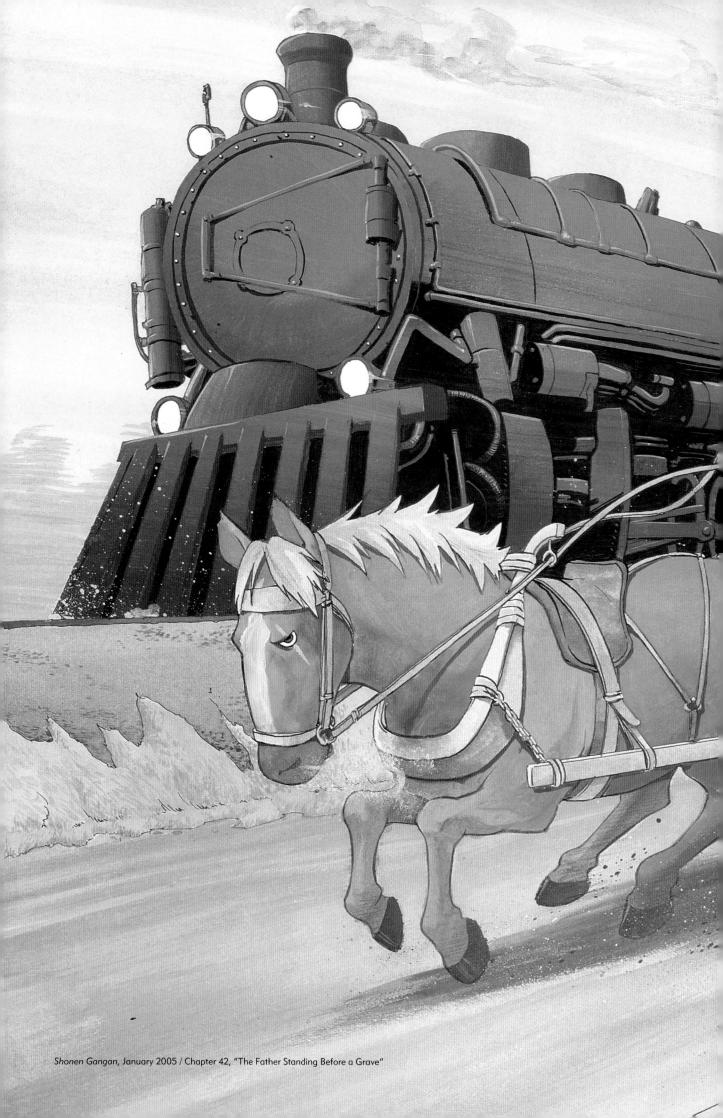

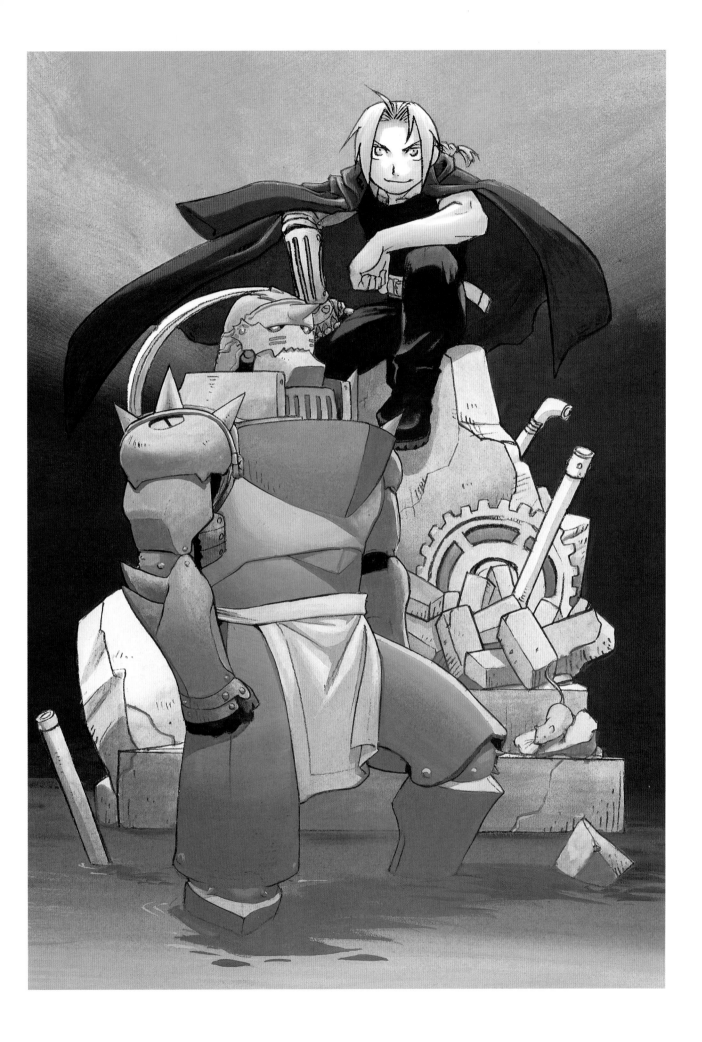

Fullmetal Alchemist: Book in Figure—RED / Package

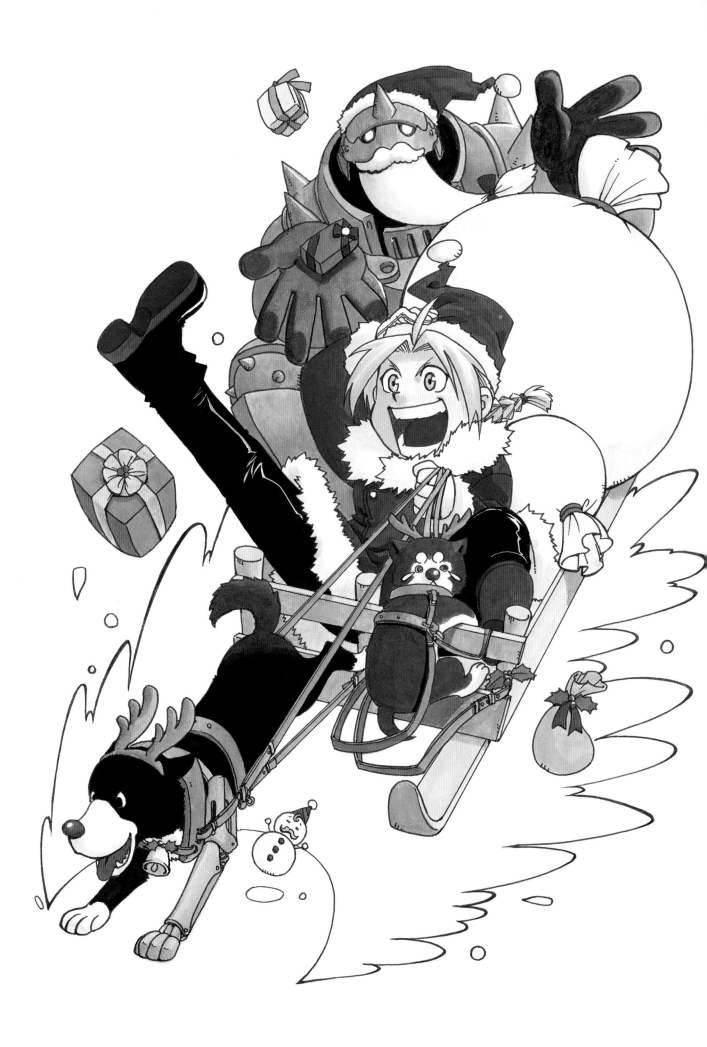

Shonen Gangan, January 2005 / Cover

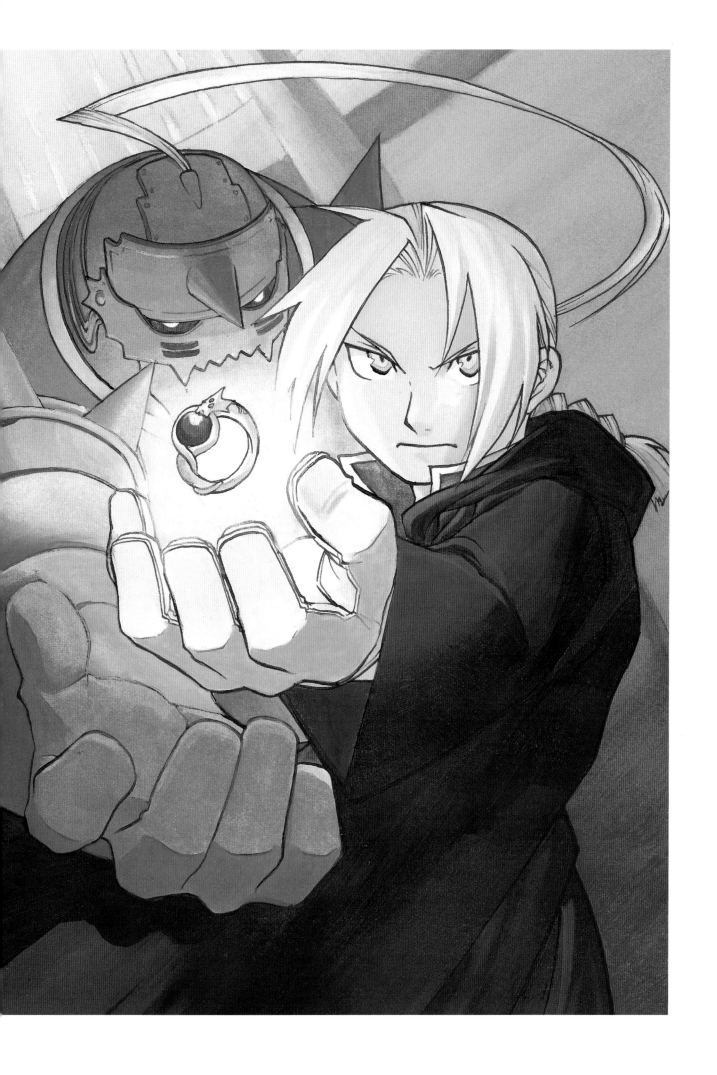

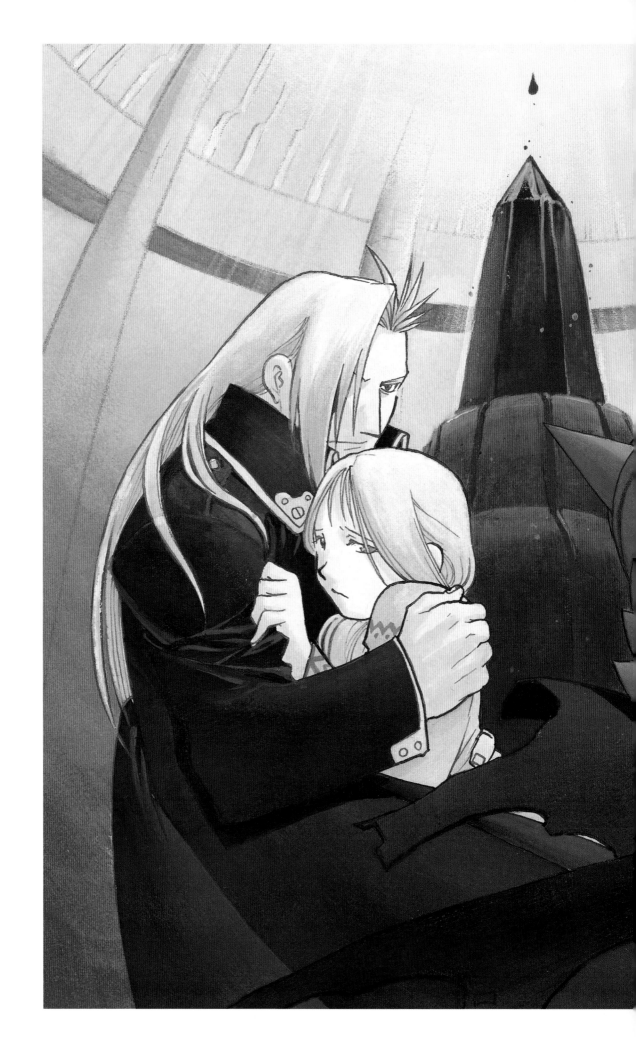

Fullmetal Alchemist 2: Curse of the Crimson Elixir game novelization / Cover

05

He didn't forsake me when I'd given up on life. And then he asked me to keep protecting his back. He's not capable of giving up on anyone. There's a place for at least one fool like that in this world.

FULLMETAL ALCHEMIST
47

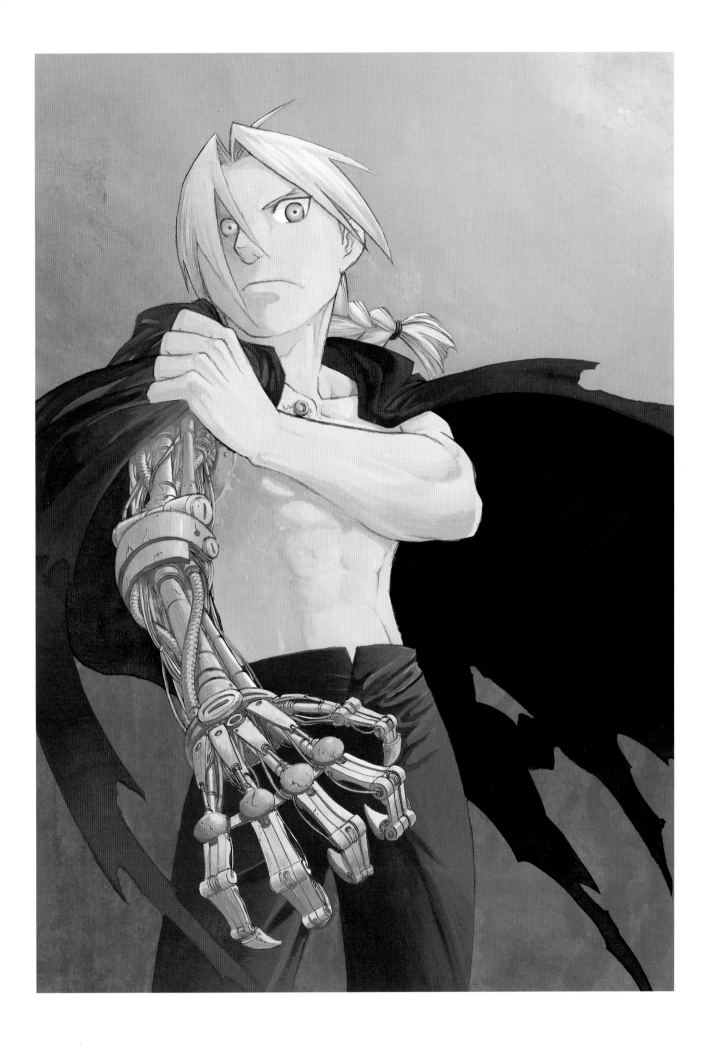

Fullmetal Alchemist DVD, volume 13 / Special illustration

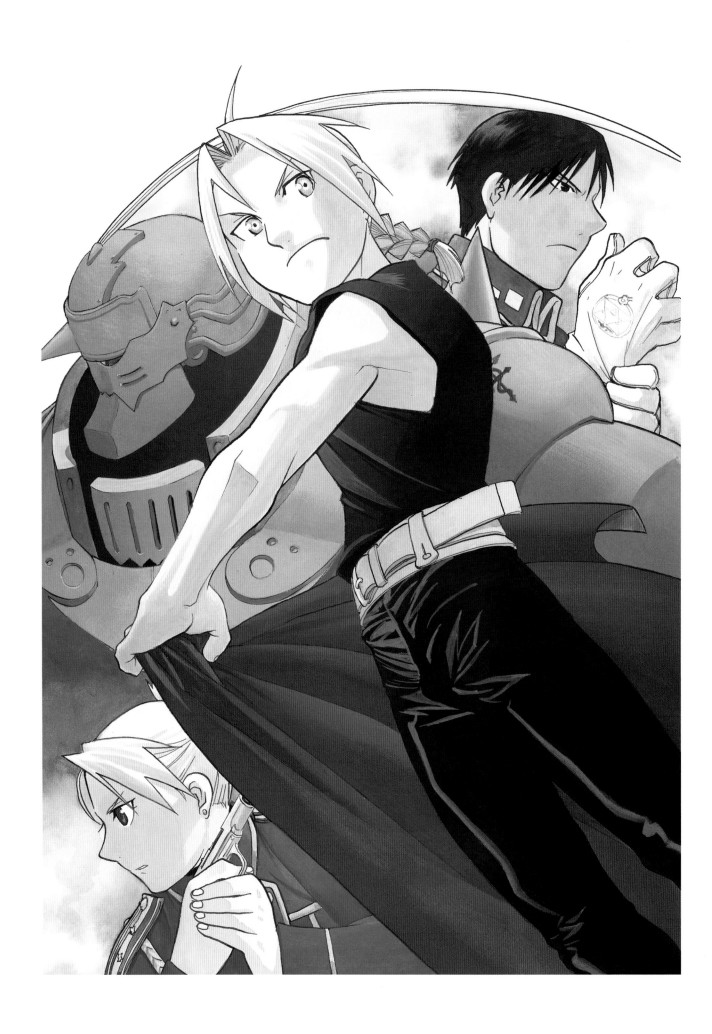

Fullmetal Alchemist: The Scars of the Criminals, drama CD, volume 3 / Package

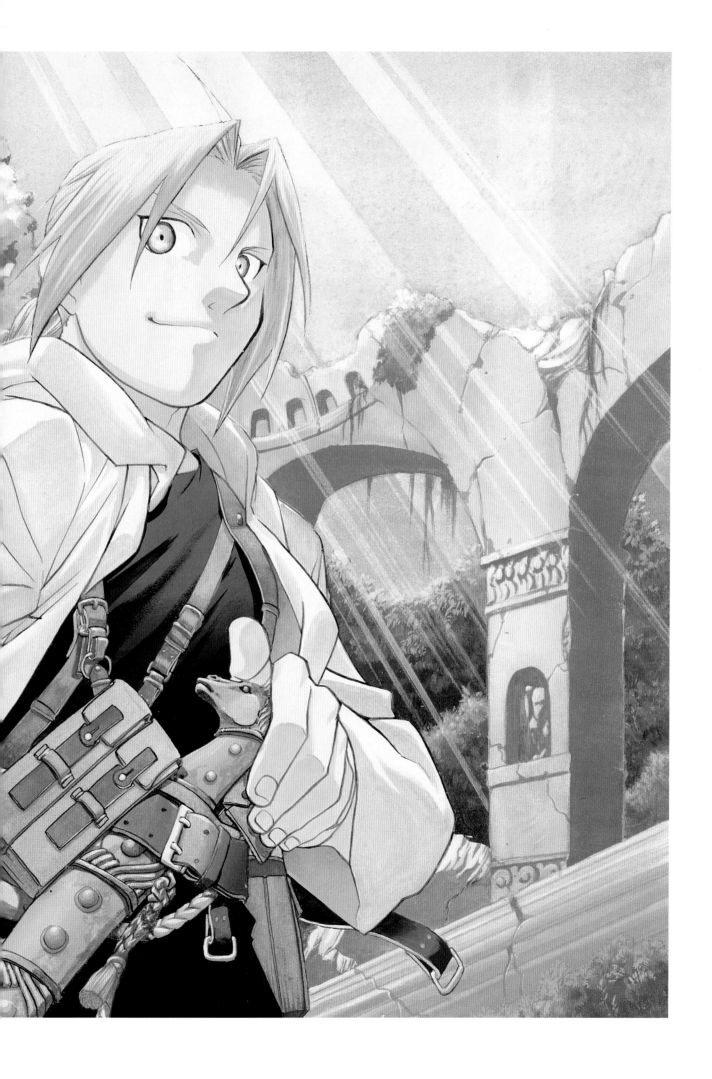

Graphic novel, volume 10 / Cover

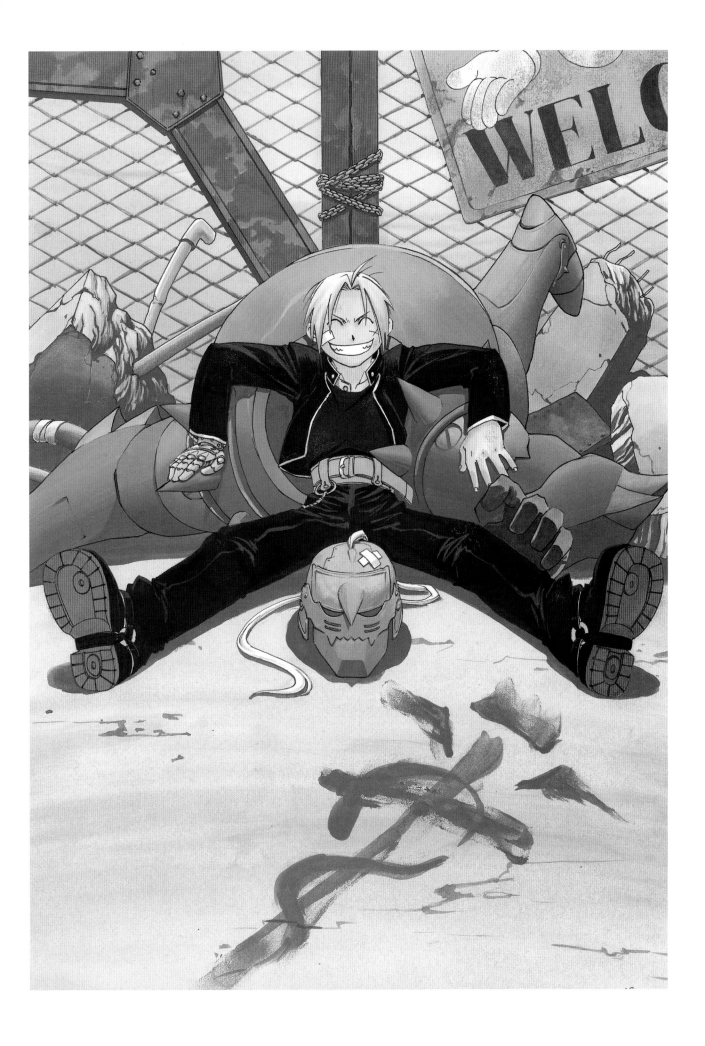

Shonen Gangan, March 2005 / Chapter 44, "The Unnamed Grave"

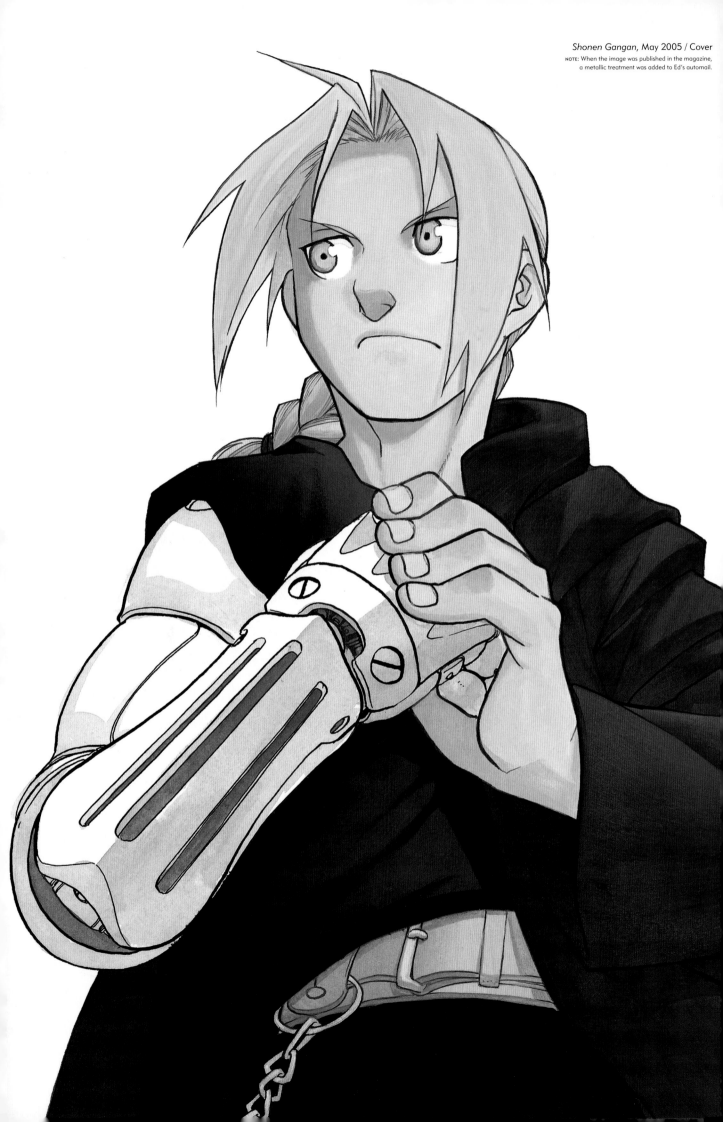

Shonen Gangan, May 2005 / Cover

NOTE: When the image was published in the magazine, a metallic treatment was added to Ed's automail.

Shonen Gangan, April 2005 / Cover

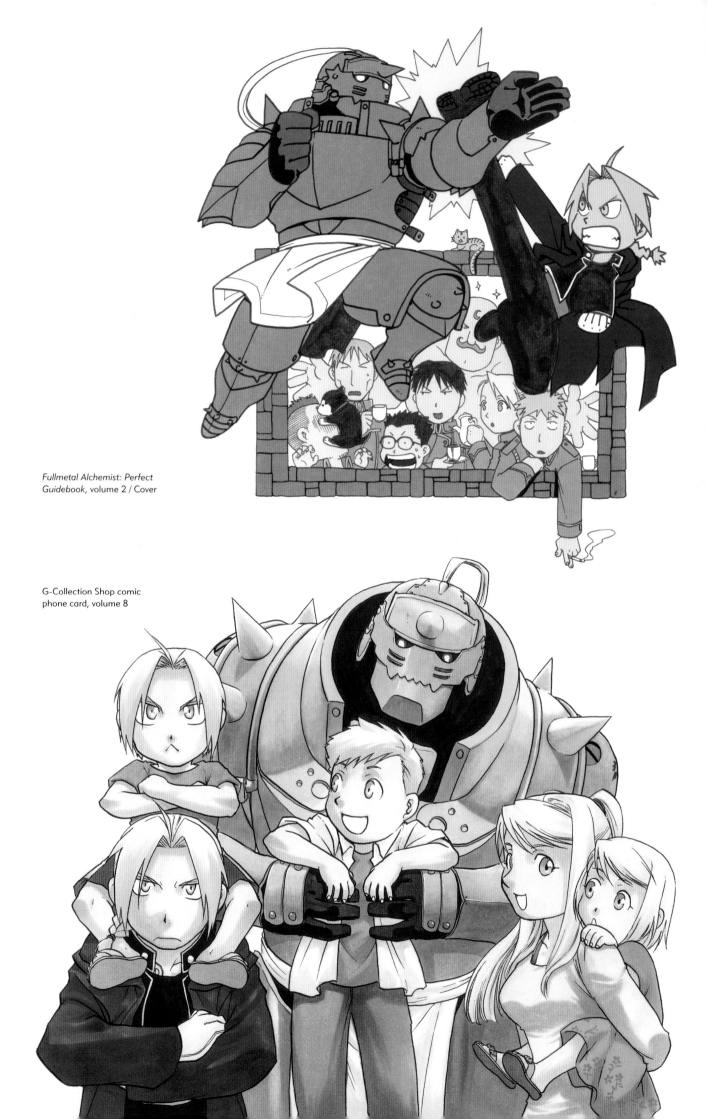

Fullmetal Alchemist: Perfect Guidebook, volume 2 / Cover

G-Collection Shop comic phone card, volume 8

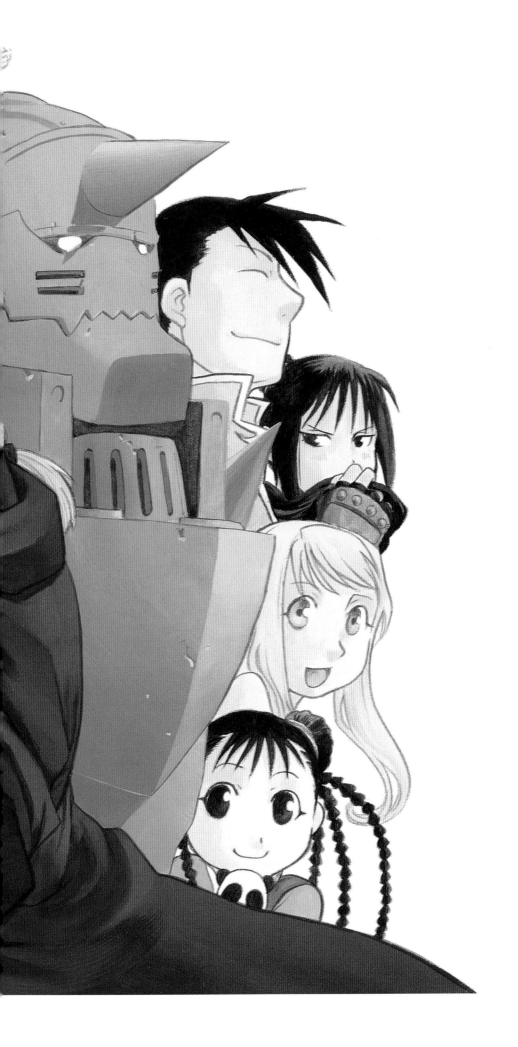

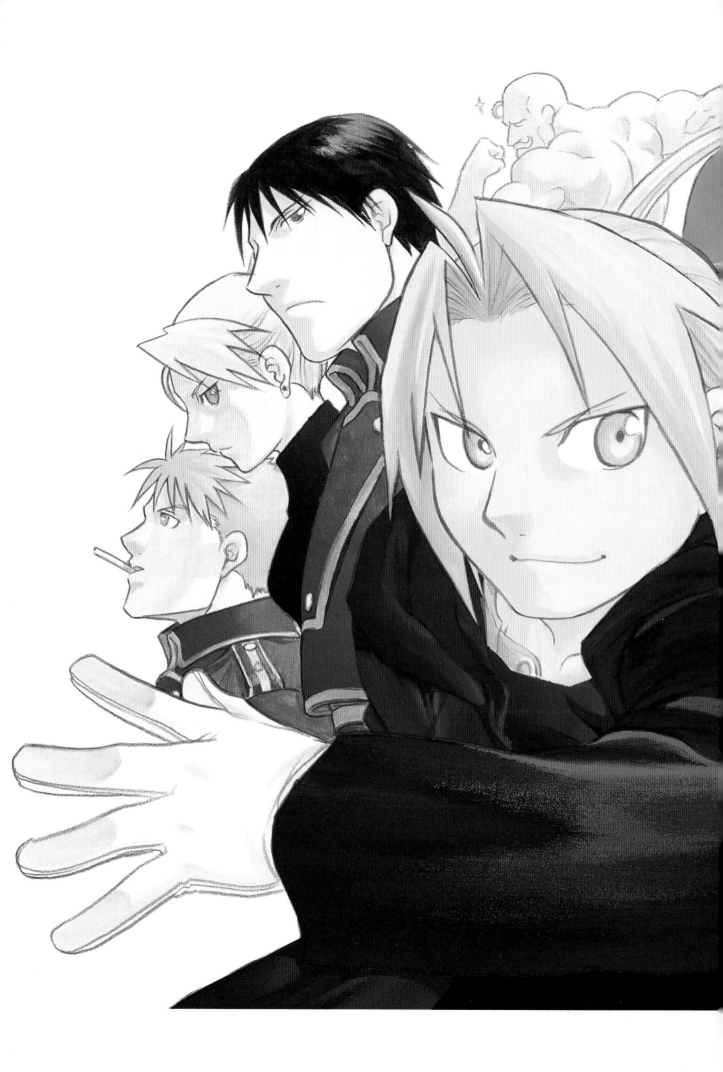

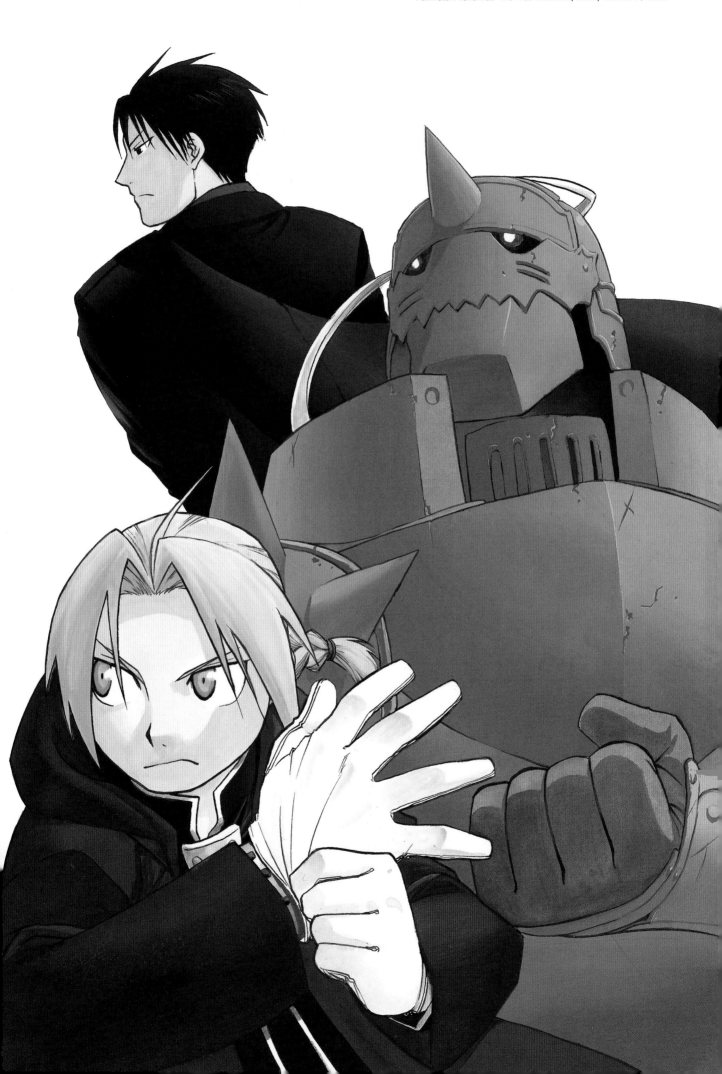

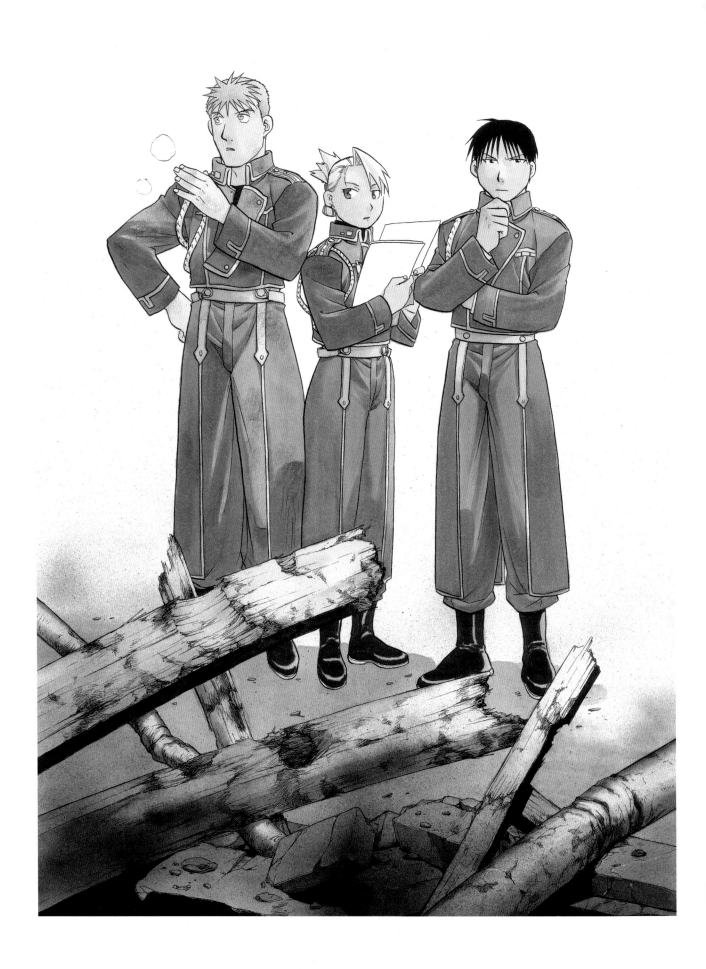

Fullmetal Alchemist: The Ties That Bind, novel, volume 5 / Frontispiece

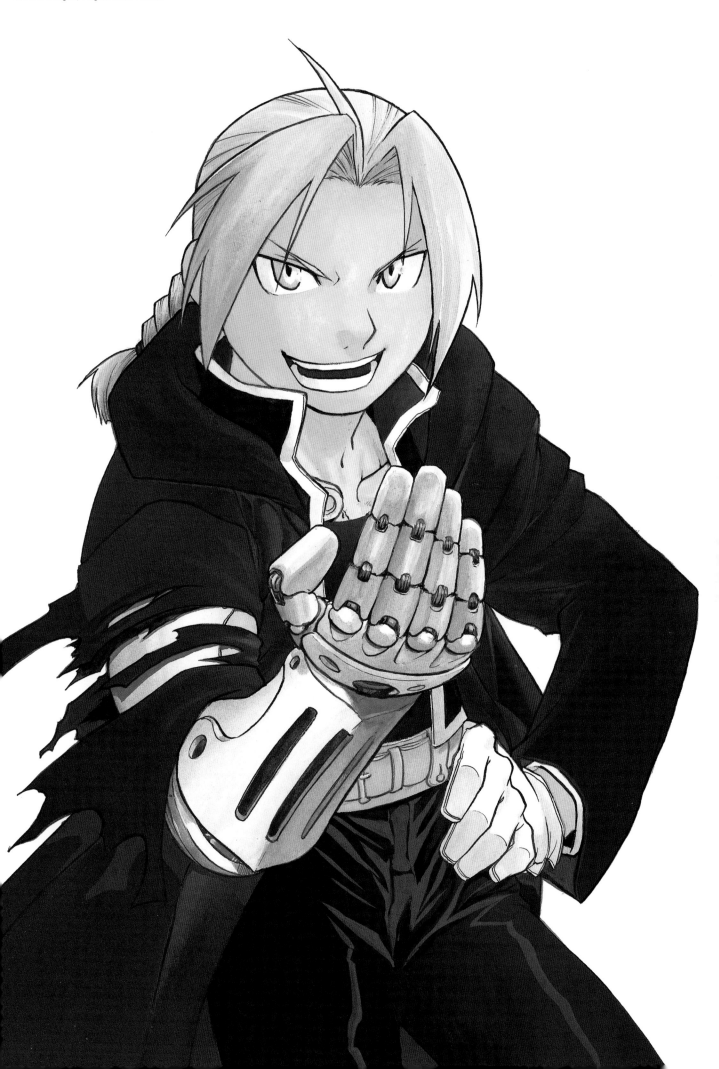

Fullmetal Alchemist: The Conqueror of Shamballa theatrical film / Postcard

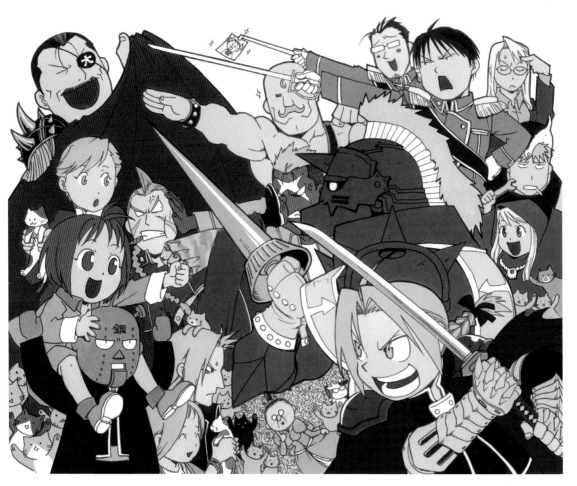

Fullmetal Alchemist 3: The Girl Who Succeeds God for PS2 / Preorder bonus

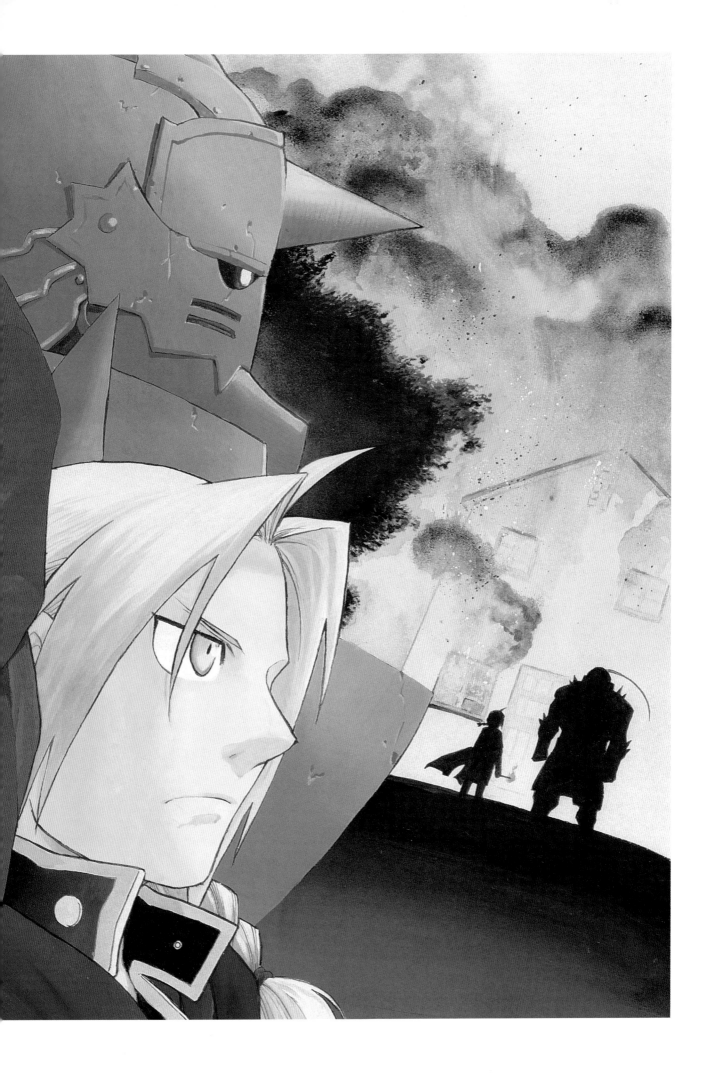

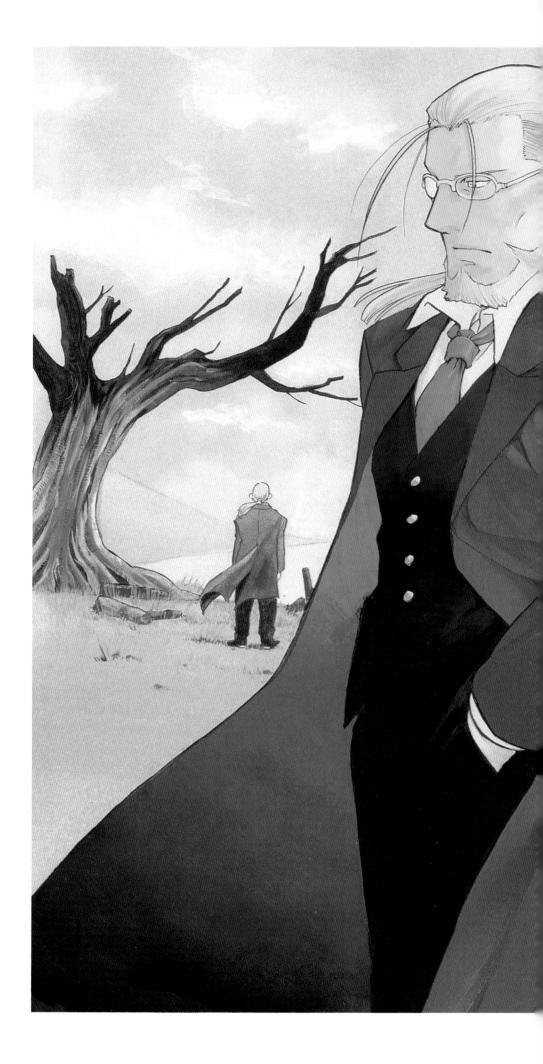

Graphic novel, volume 11 / Cover

Shonen Gangan, December 2005 / Chapter 53, "Signpost of the Soul"

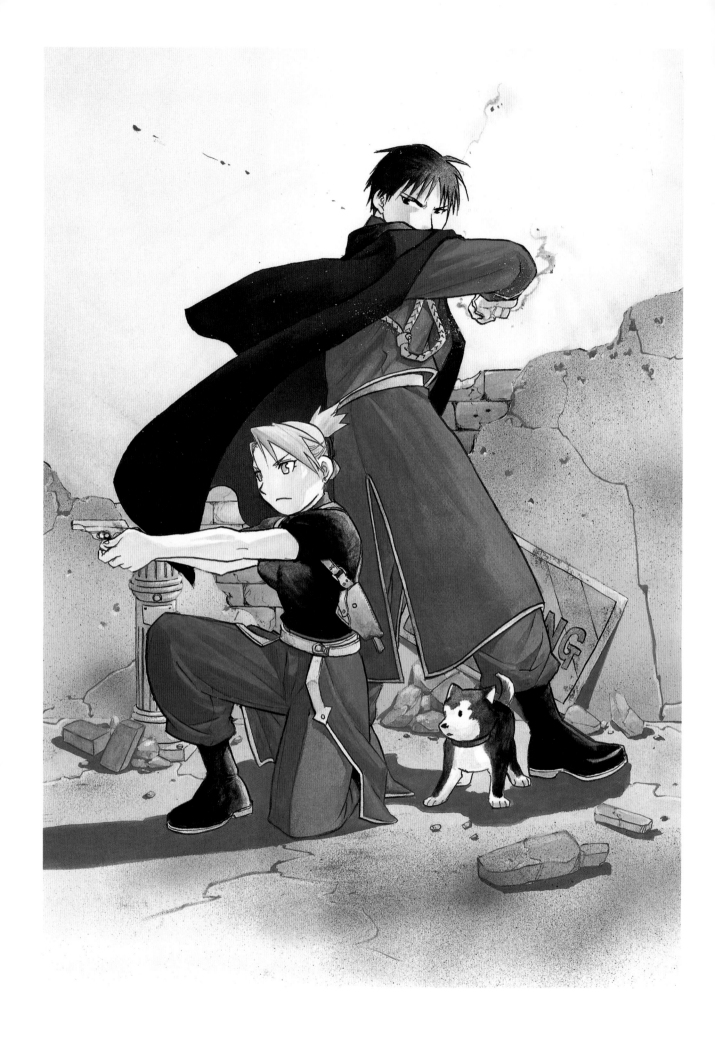

Fullmetal Alchemist: Book in Figure—BLUE / Package

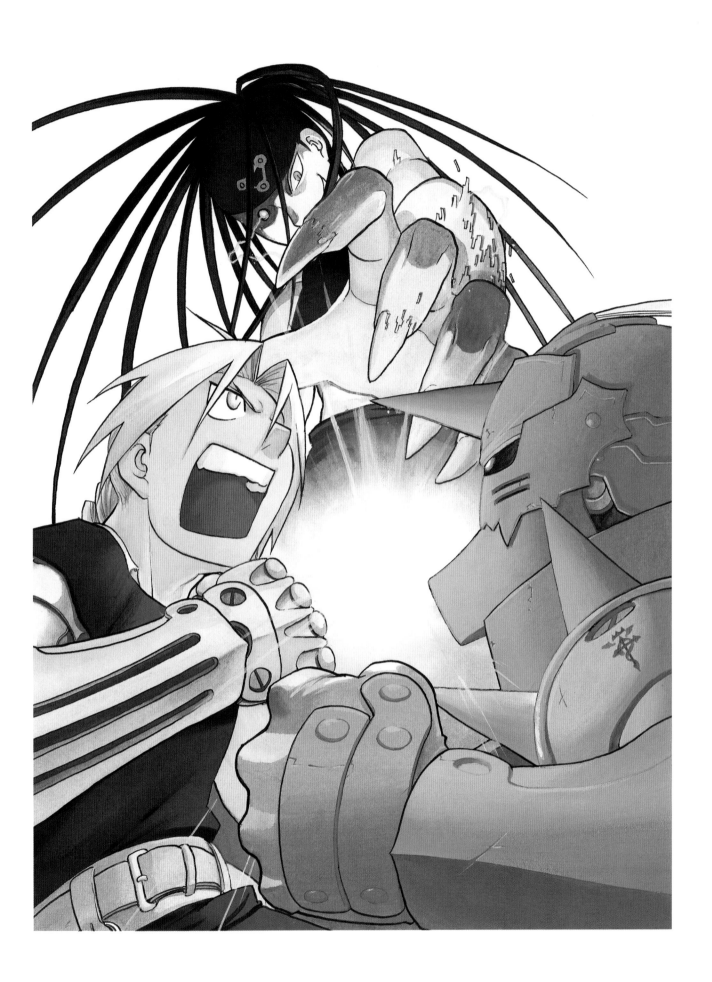

Shonen Gangan, September 2005 / Cover

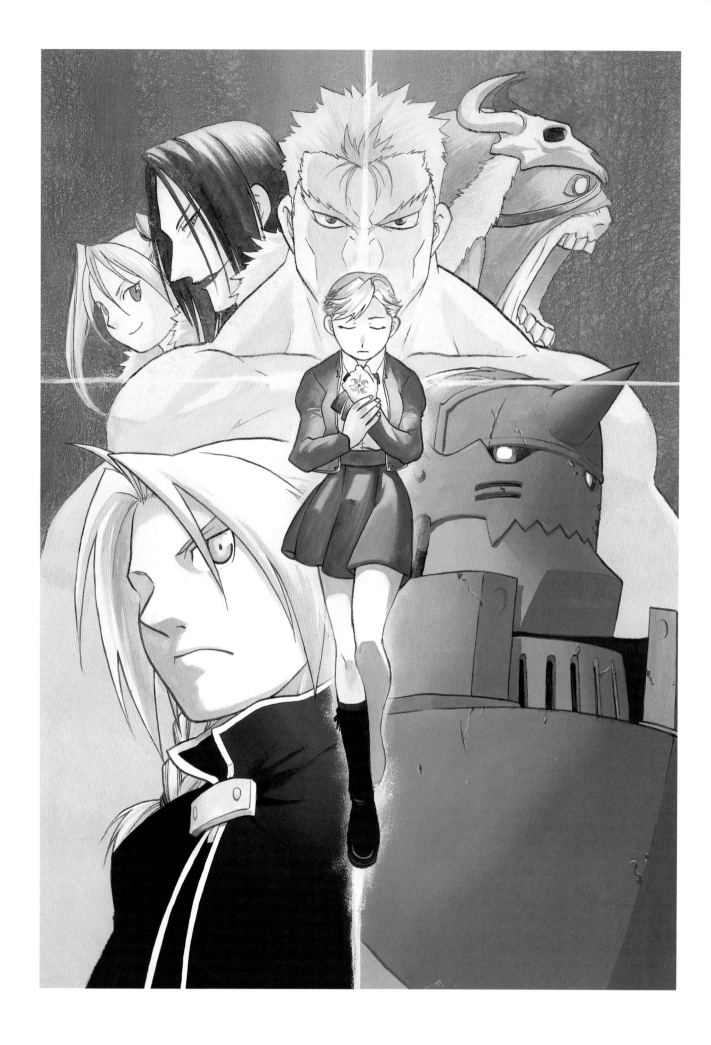

Fullmetal Alchemist 3: The Girl Who Succeeds God game novelization / Cover

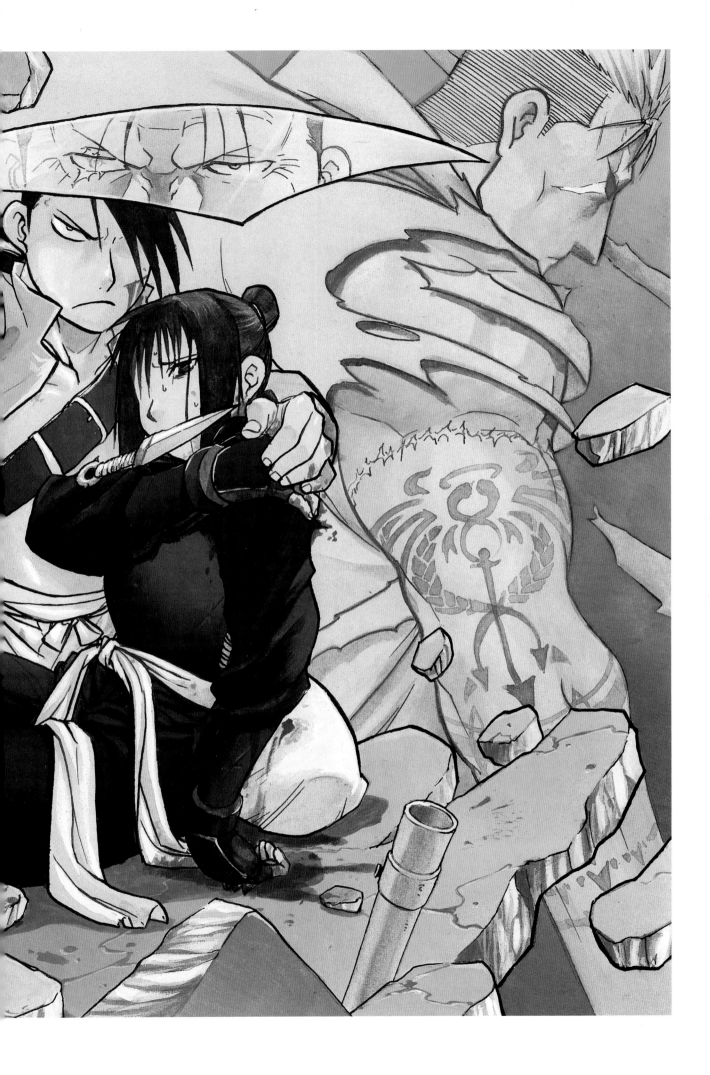

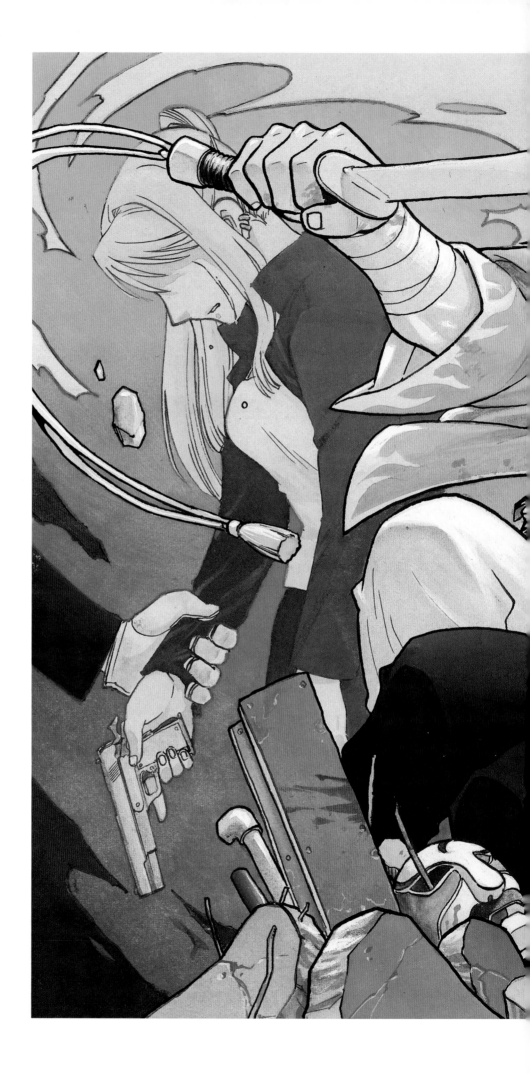

Graphic novel, volume 12 / Cover

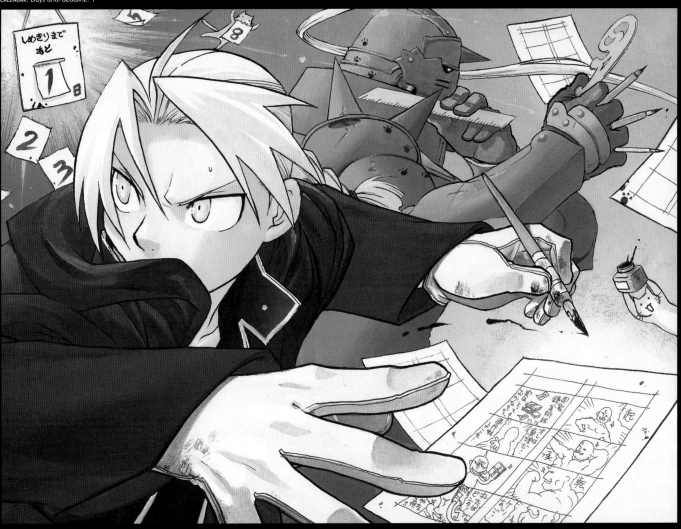

Limited edition graphic novel, volume 12, "4-Panel Training Edition" bonus booklet / Cover

COMIC 1: *Flex! Pose! Turn! Butt-chin!*

COMIC 2: *State Alchemists are actually quite wealthy.*
I'm Truth! Time to pay the toll!
ED: *I'm gonna smack you with this wad of cash!*
TRUTH: *Brat!*

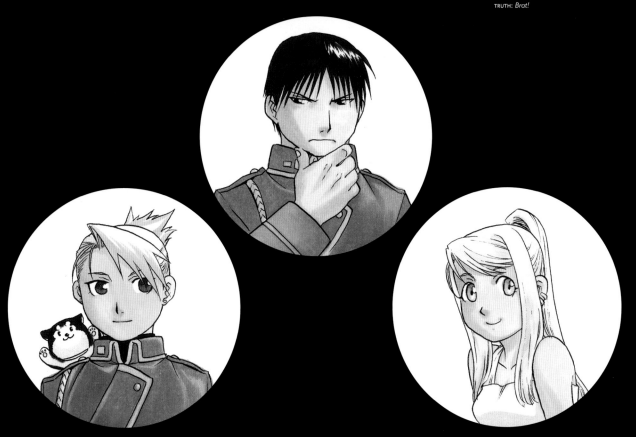

G-Collection Shop postcard and magnet set

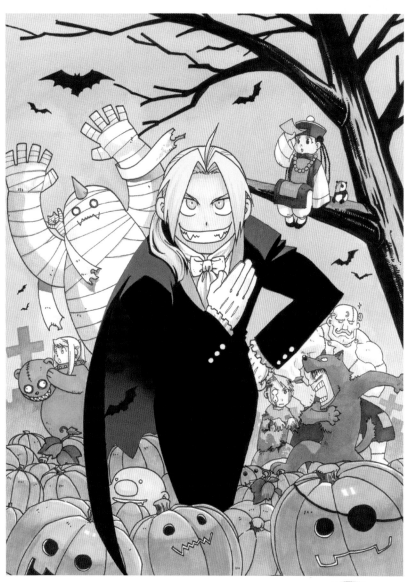

Gangan Powered, Fall 2005 / Bonus postcard

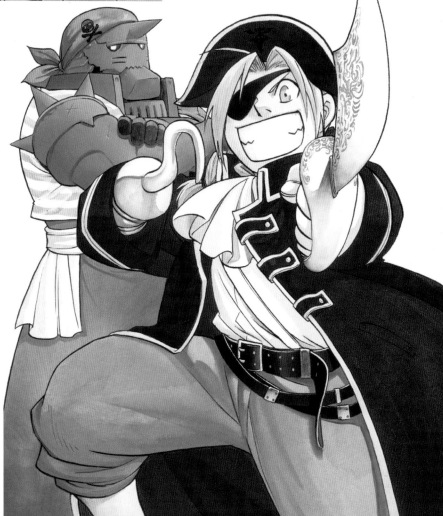

Shonen Gangan, December 2005 / Cover

Get it together! We promised each other that
we'd get our original bodies back together!

I can't give up on him now!

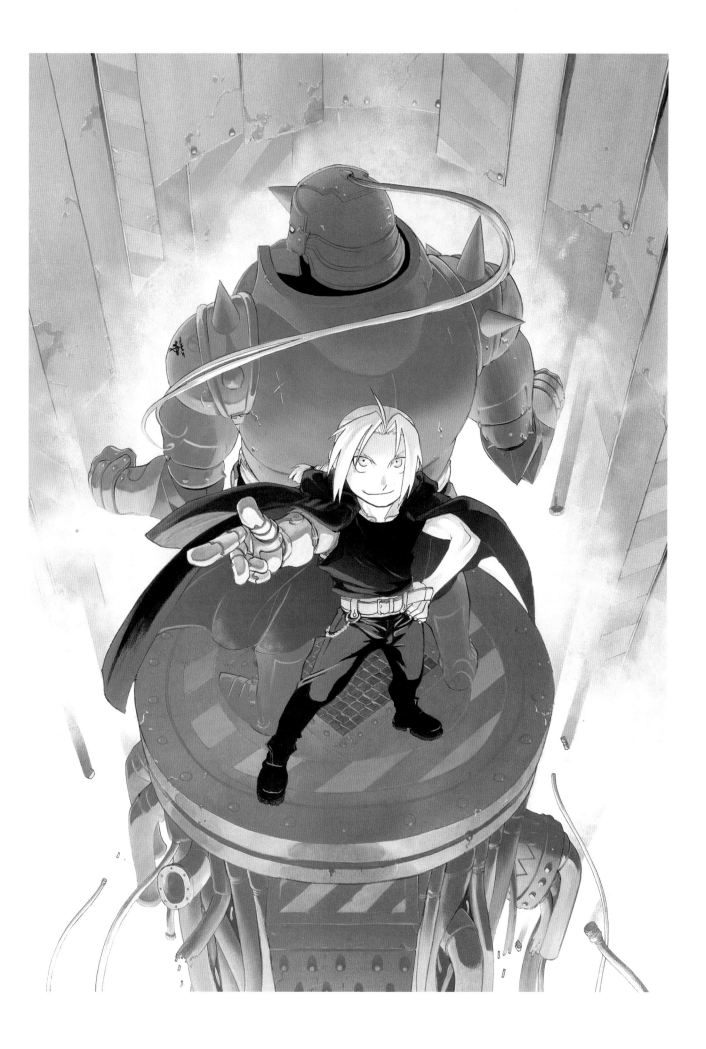

The Art of Fullmetal Alchemist 2 / Cover

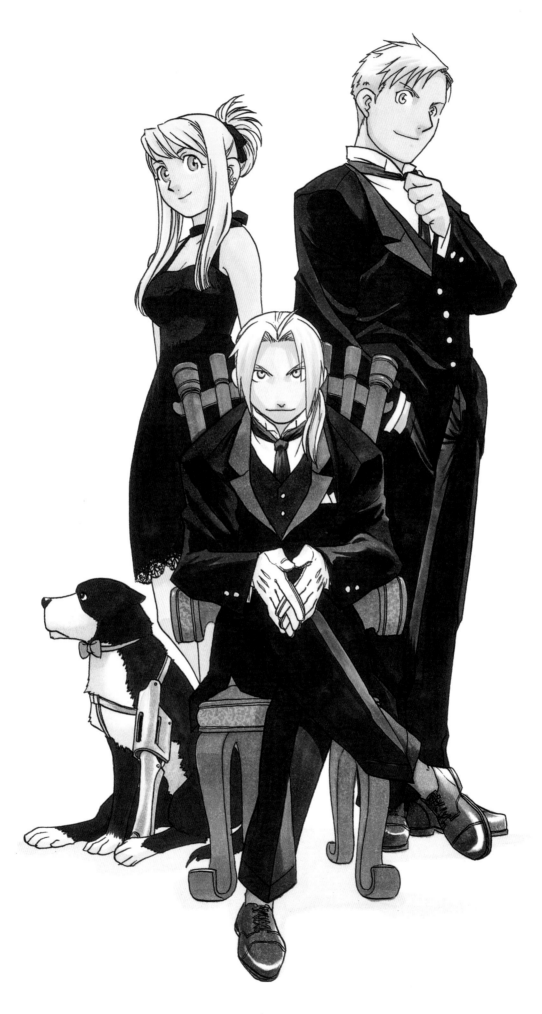

The Art of Fullmetal Alchemist 2 / Frontispiece

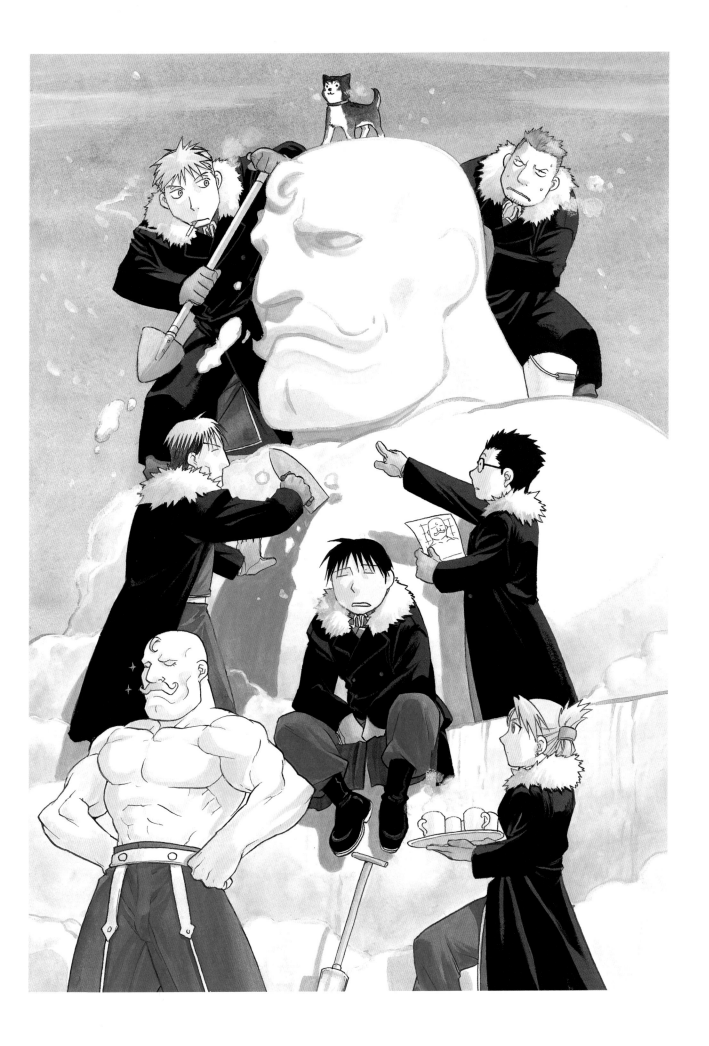

Fullmetal Alchemist Comic Special Calendar 2006 / January

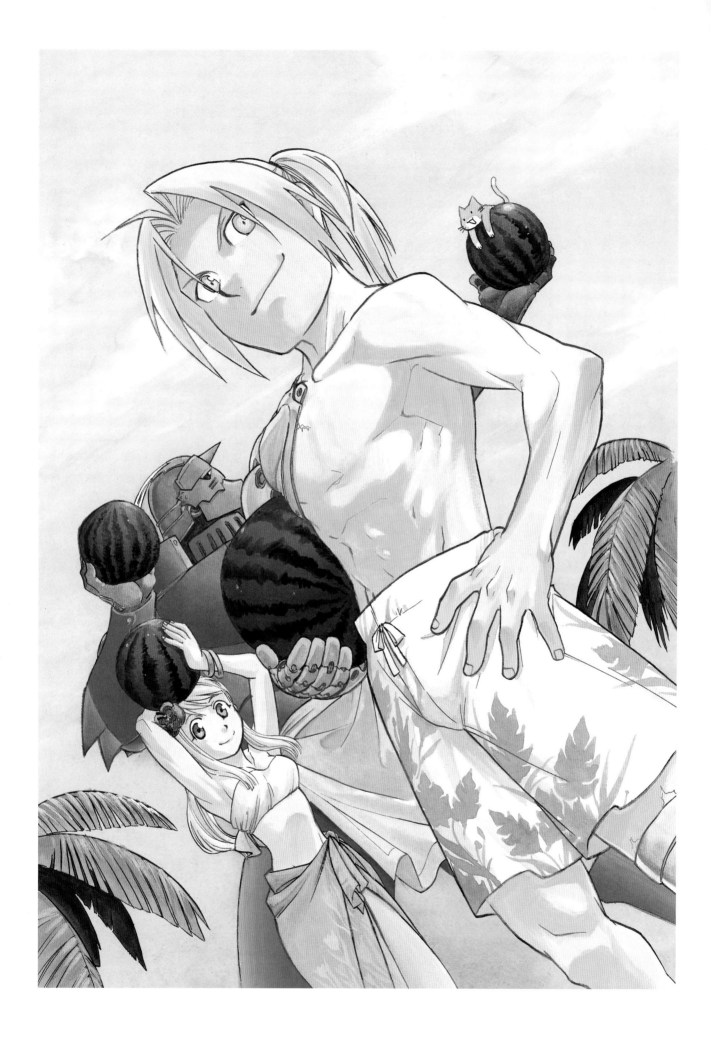

Fullmetal Alchemist Comic Special Calendar 2006 / August

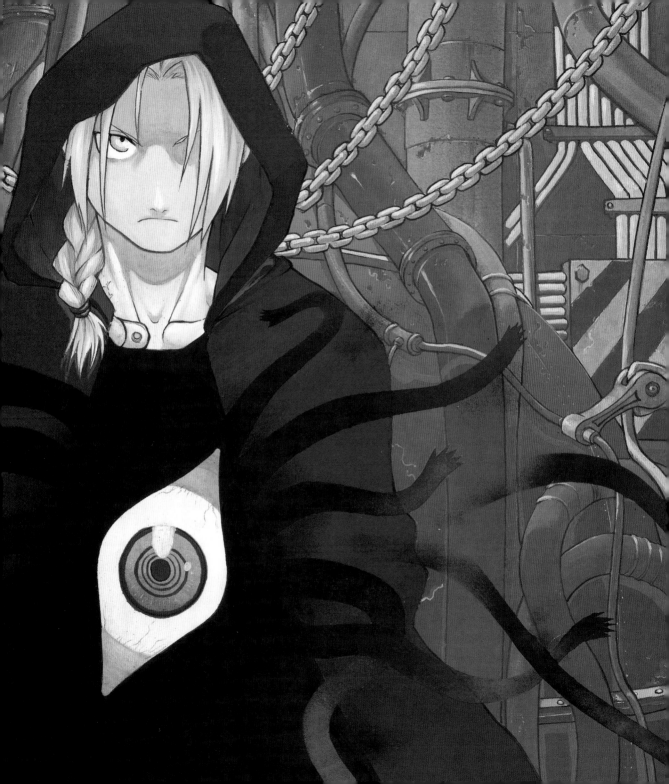

SIGN: *No graffiti!*

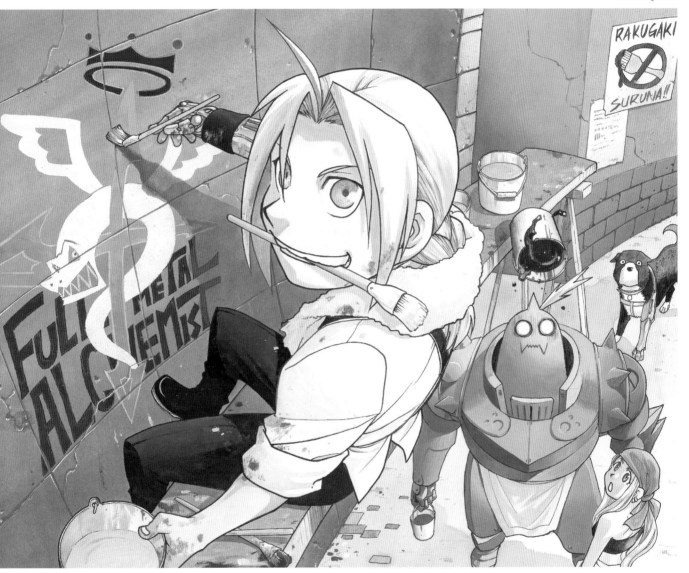

Limited edition graphic novel, volume 14, "Rough Sketch Collection" bonus booklet / Cover

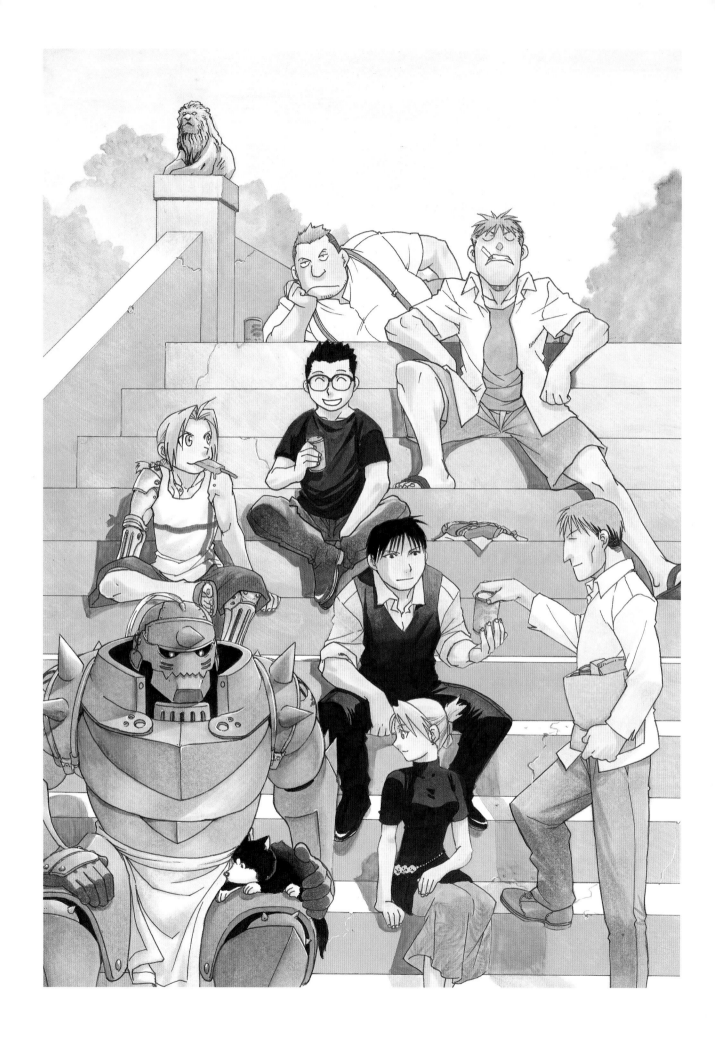

G-Collection Shop comic phone card, volume 9

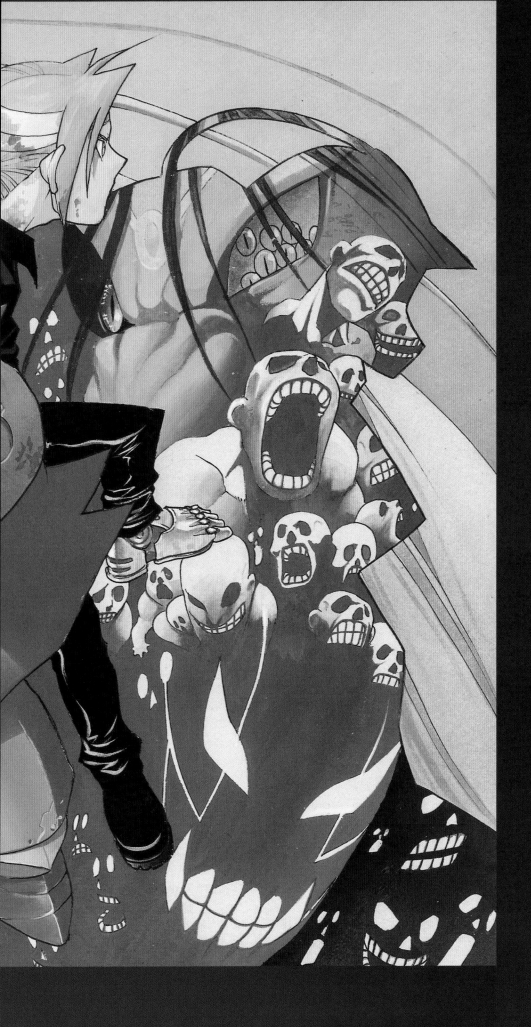

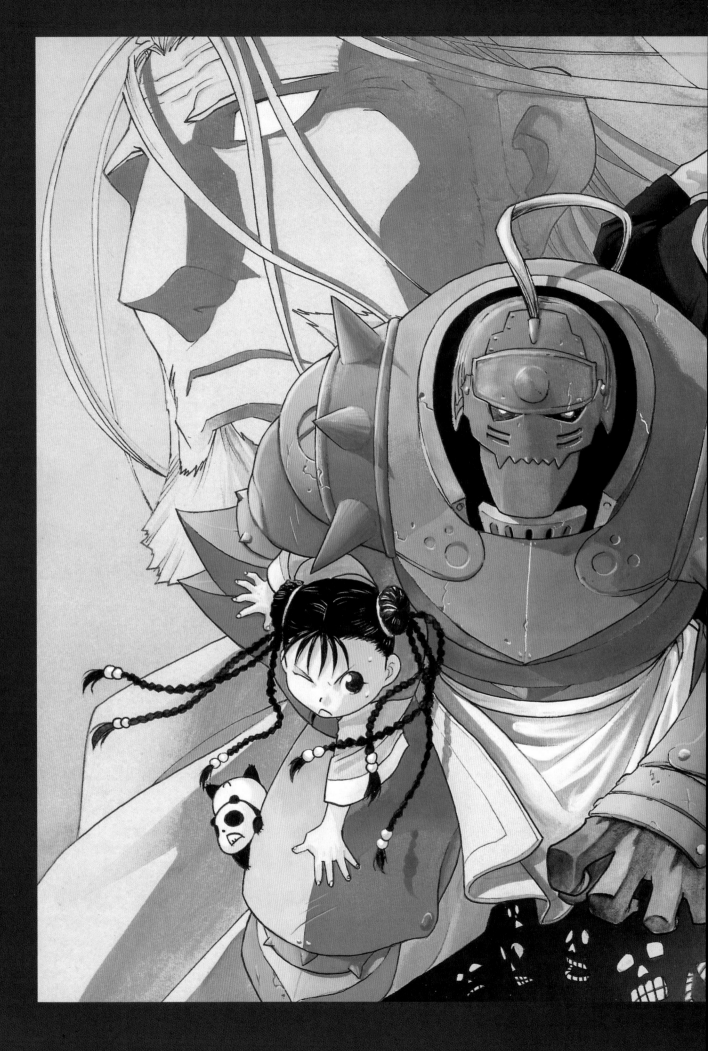

156

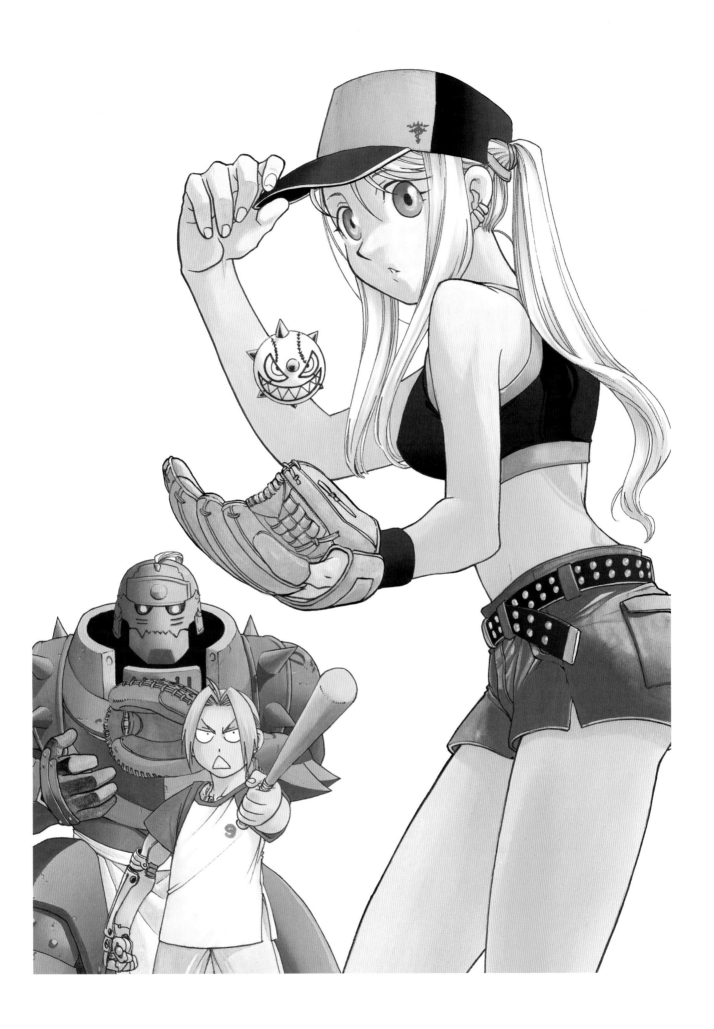

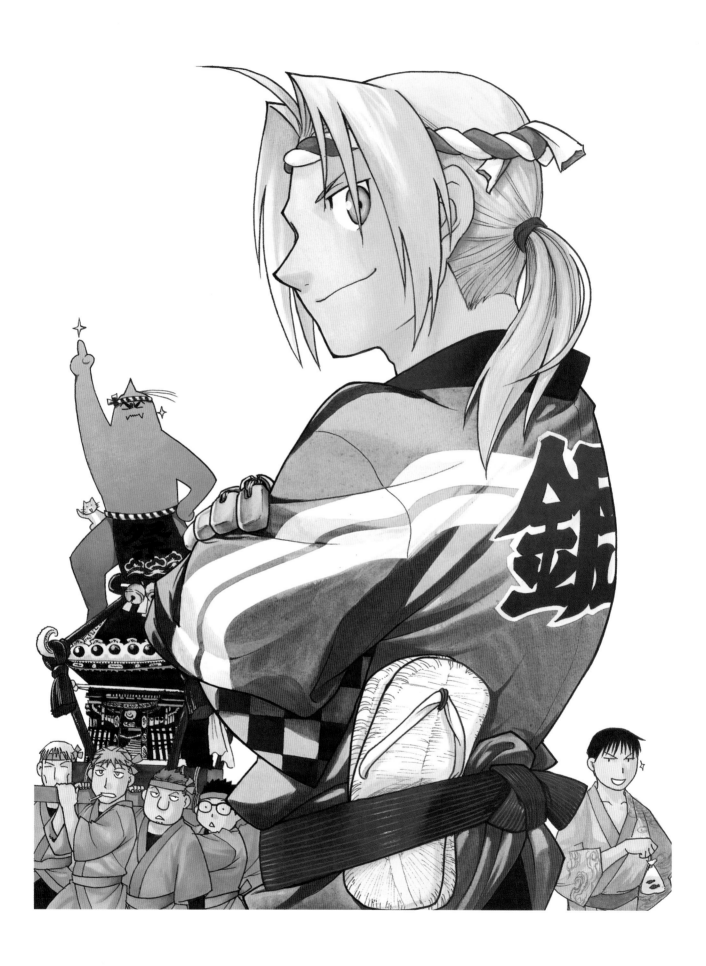

Shonen Gangan, August 2006 / Cover

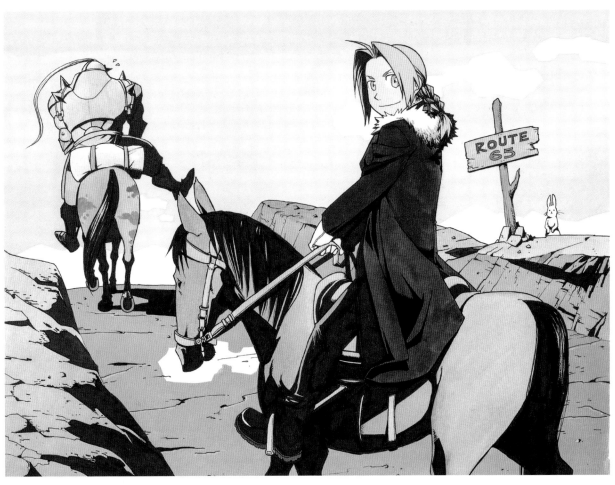

Shonen Gangan, December 2006 / Chapter 65, "The Ironclad Rule"

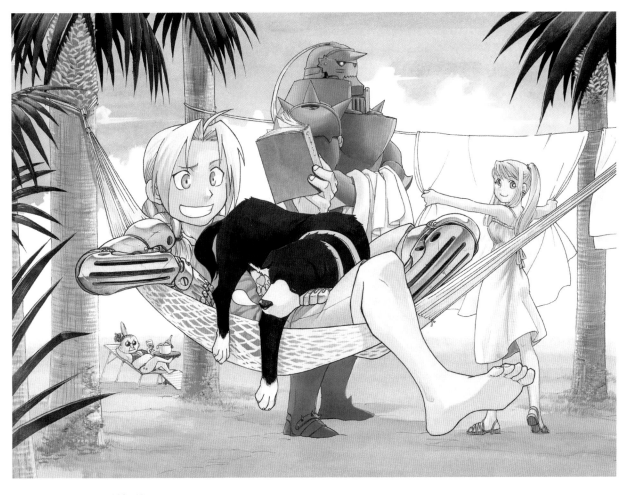

Shonen Gangan, August 2006 / Bonus poster

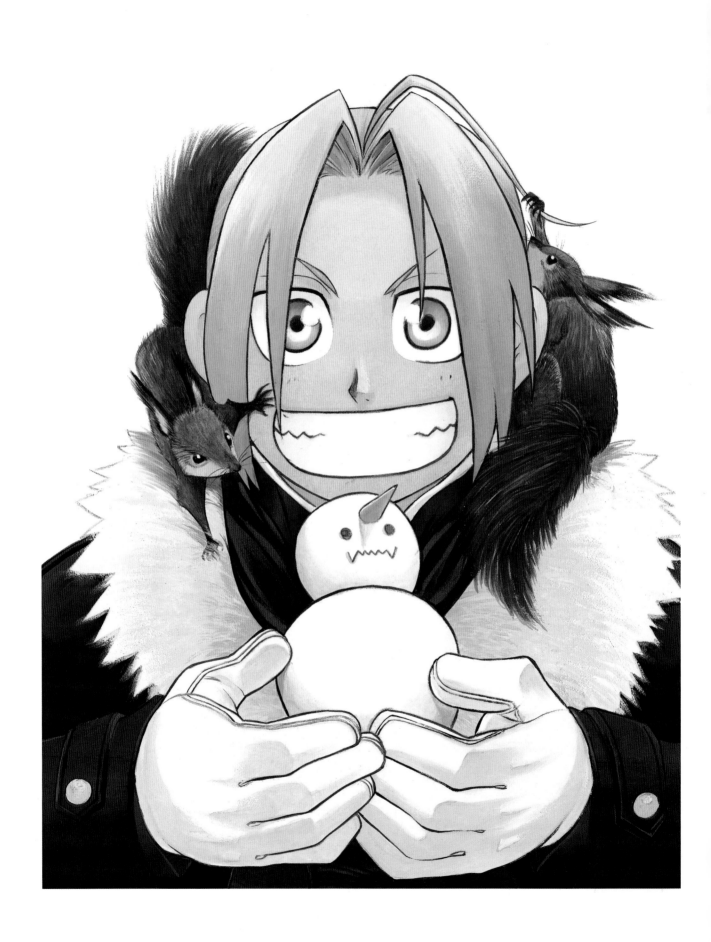

Shonen Gangan, December 2006 / Cover

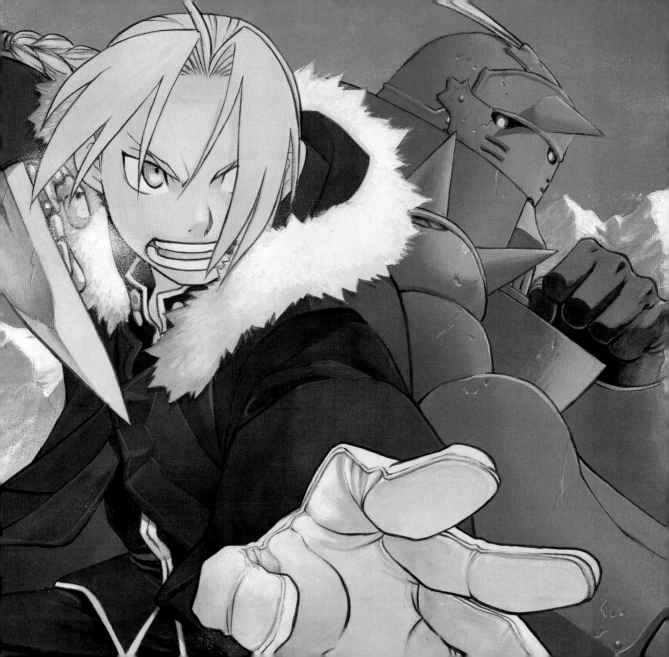

I told you before that I can't wait to see your smiling face again... But I want to see everyone smiling.

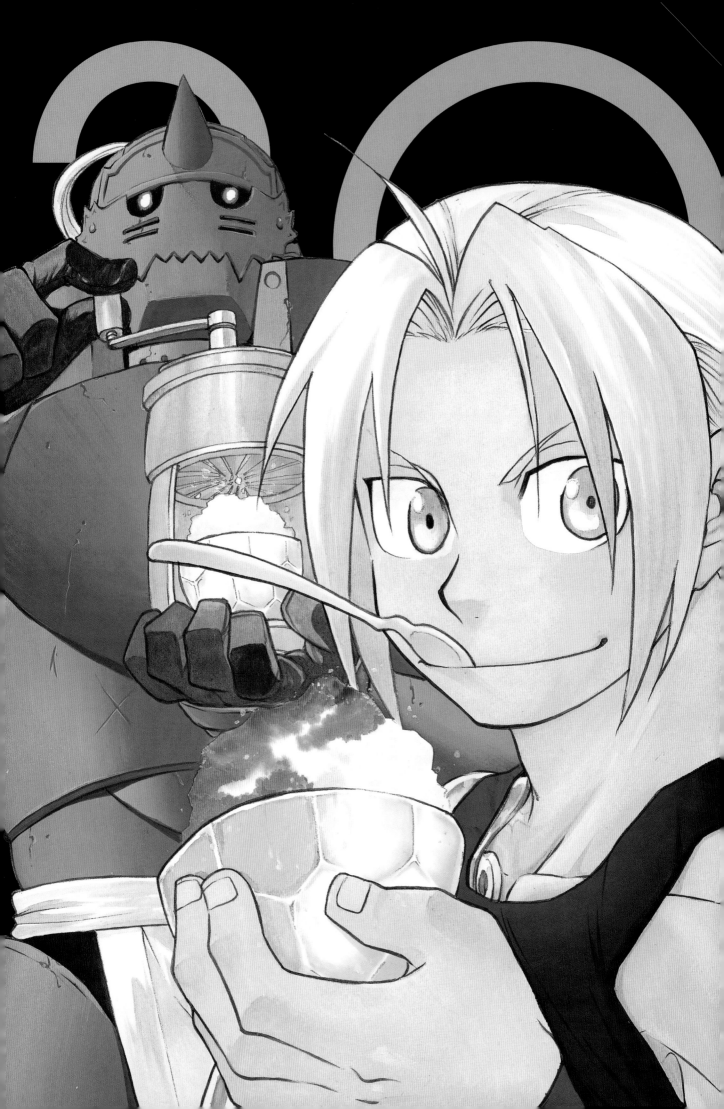

Shonen Gangan, April 2007 / Chapter 69, "The Foundation of Briggs"

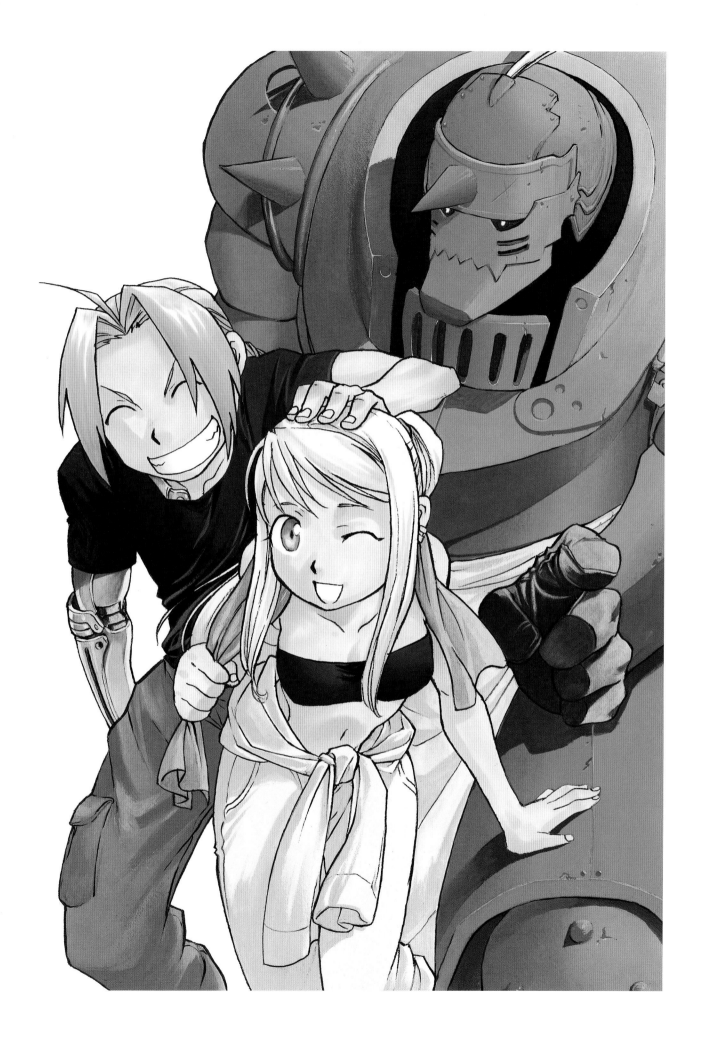

Fullmetal Alchemist: A New Beginning, novel, volume 6 / Cover

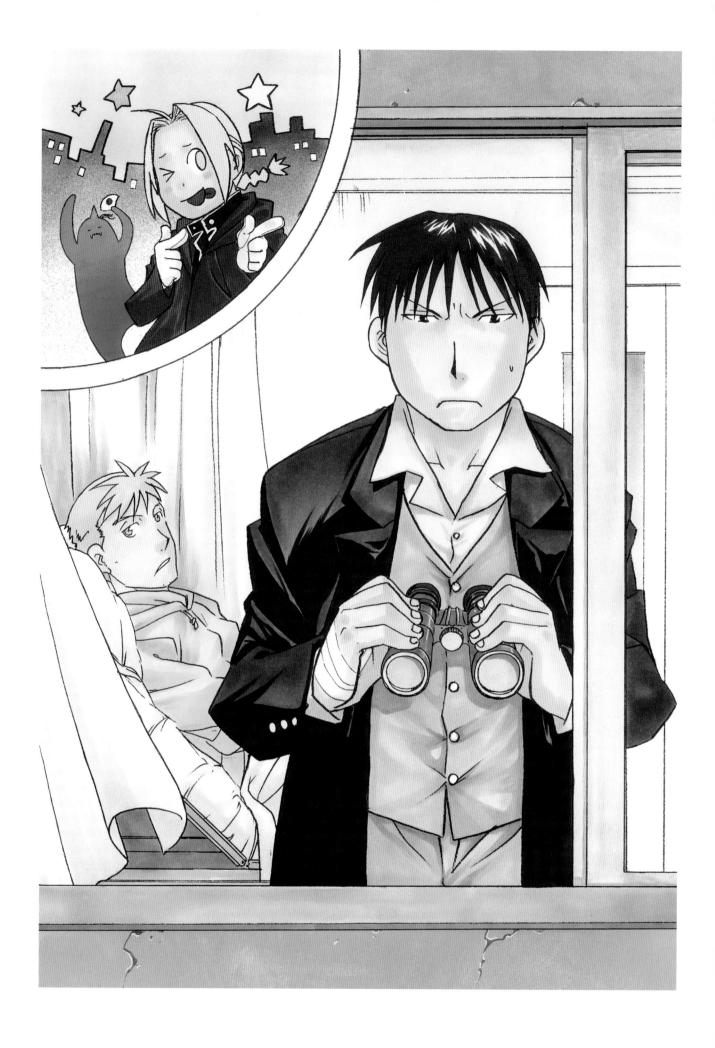

Fullmetal Alchemist: A New Beginning, novel, volume 6 / Frontispiece

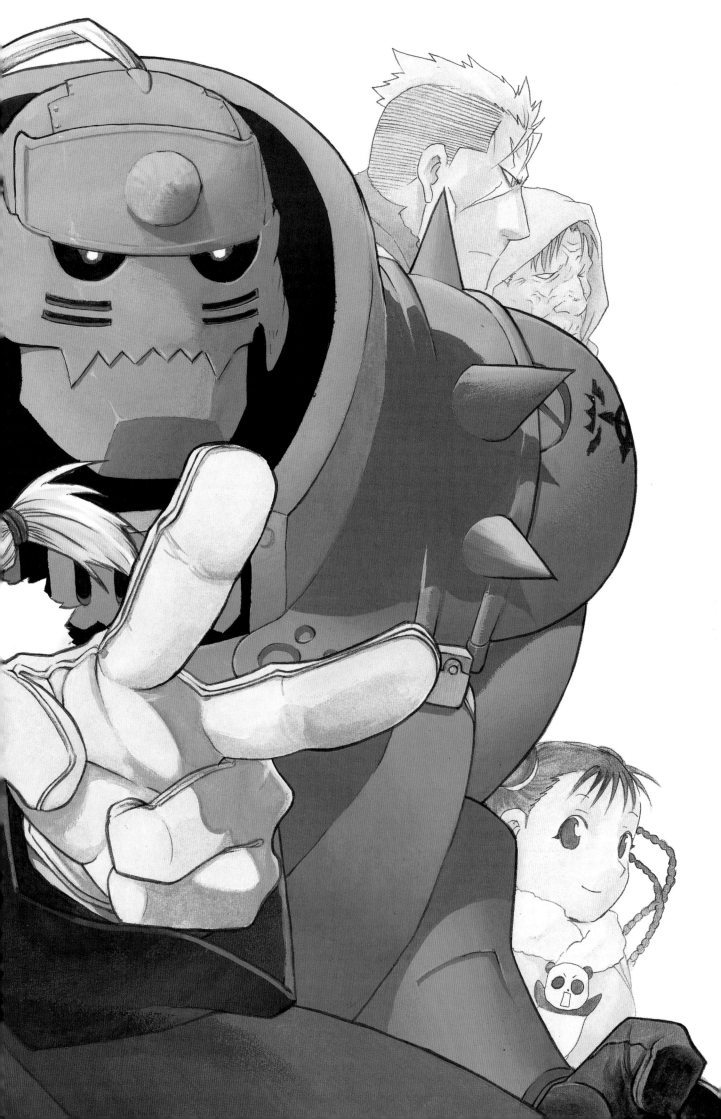

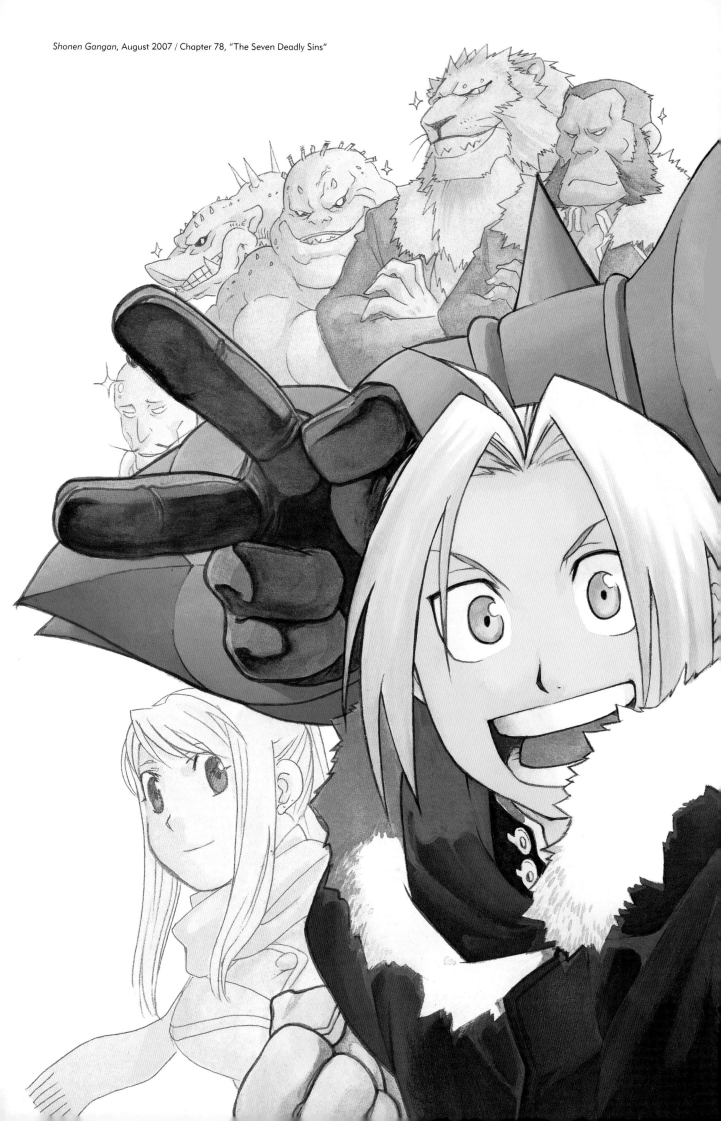

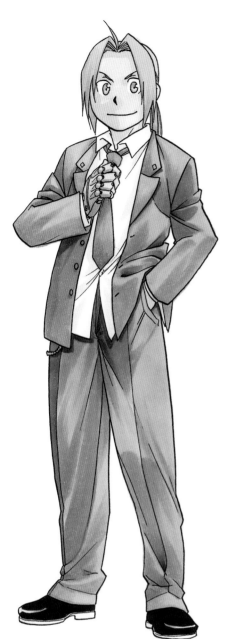

Fresh Gangan, Spring 2007 / Cover

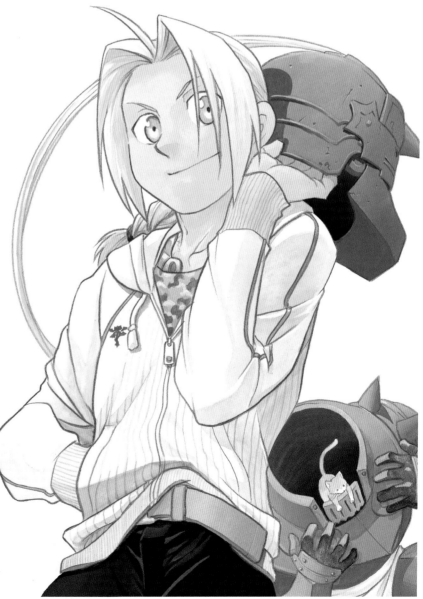

Shonen Gangan, April 2007 / Cover

G-Collection Shop library card, volume 1

Fullmetal Alchemist Comic Special Calendar 2008 / January

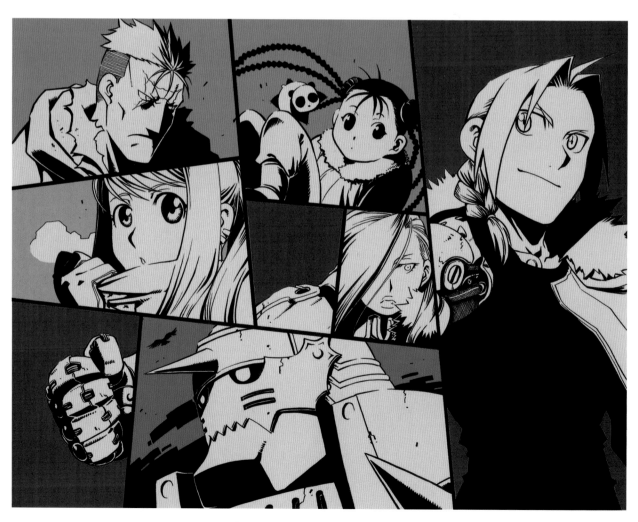

Shonen Gangan, September 2007 / Chapter 74, "The Dwarf in the Flask"

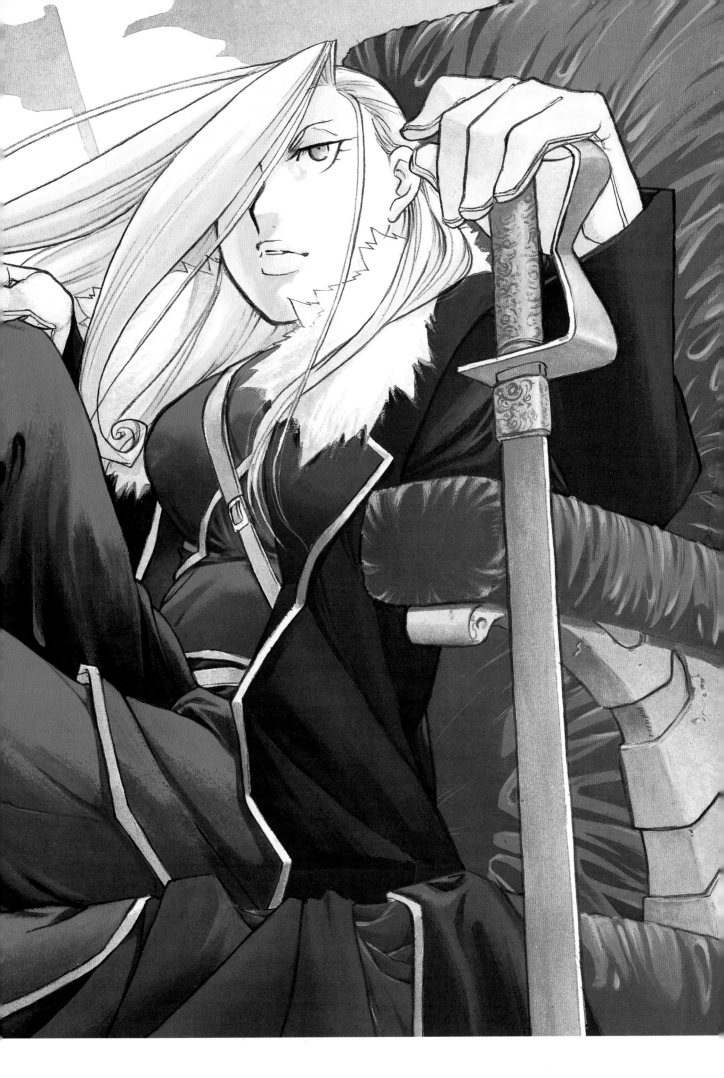

Graphic novel, volume 17 / Cover

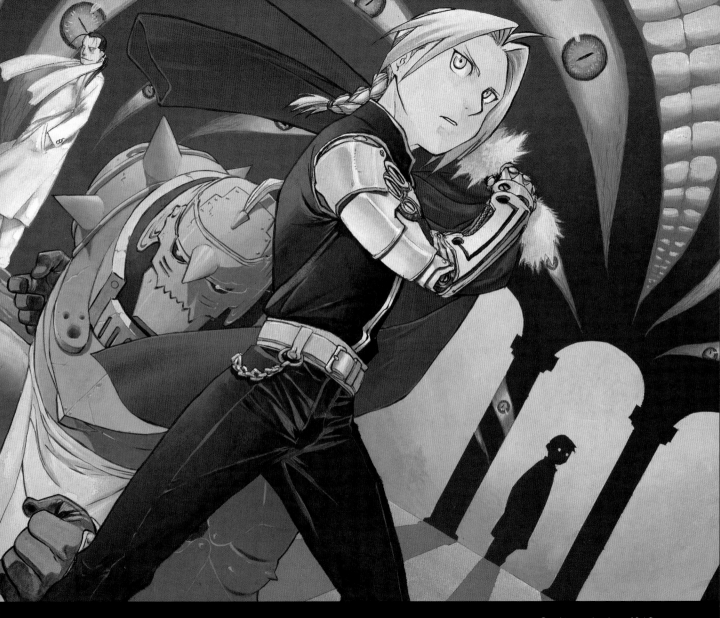

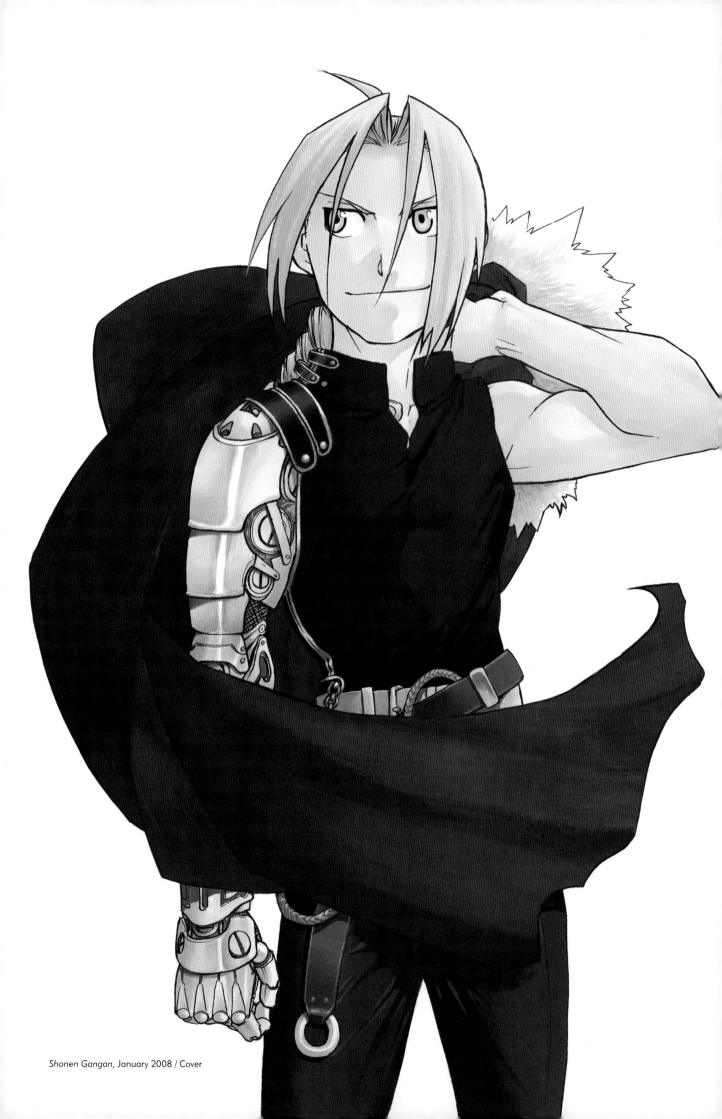

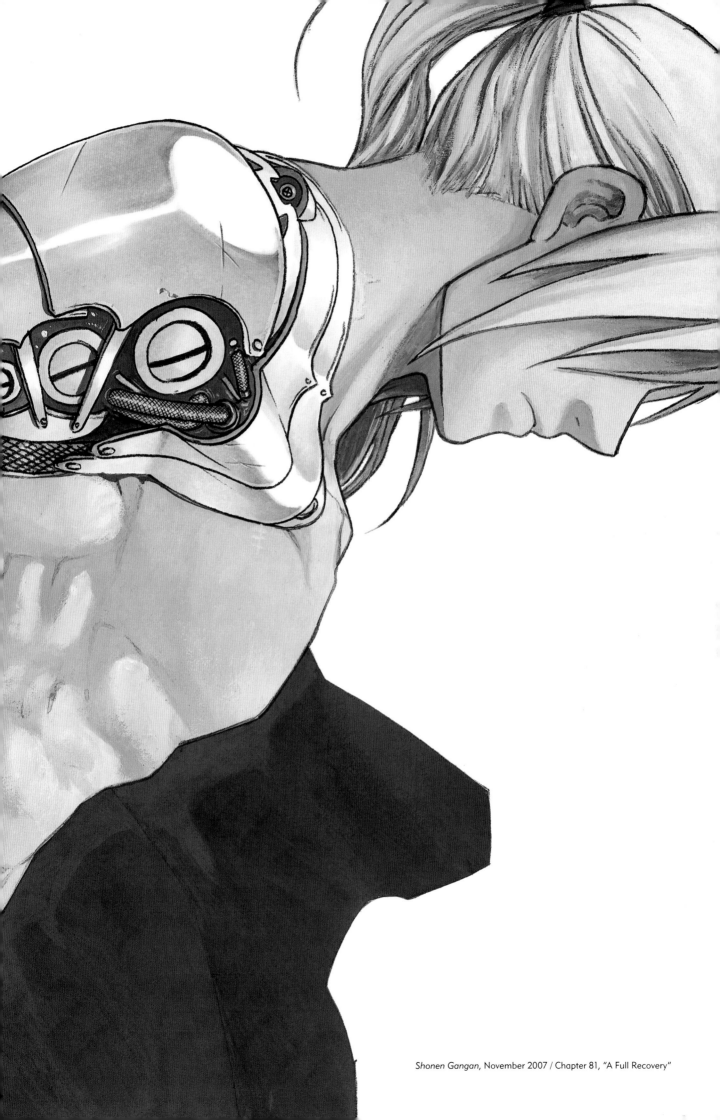

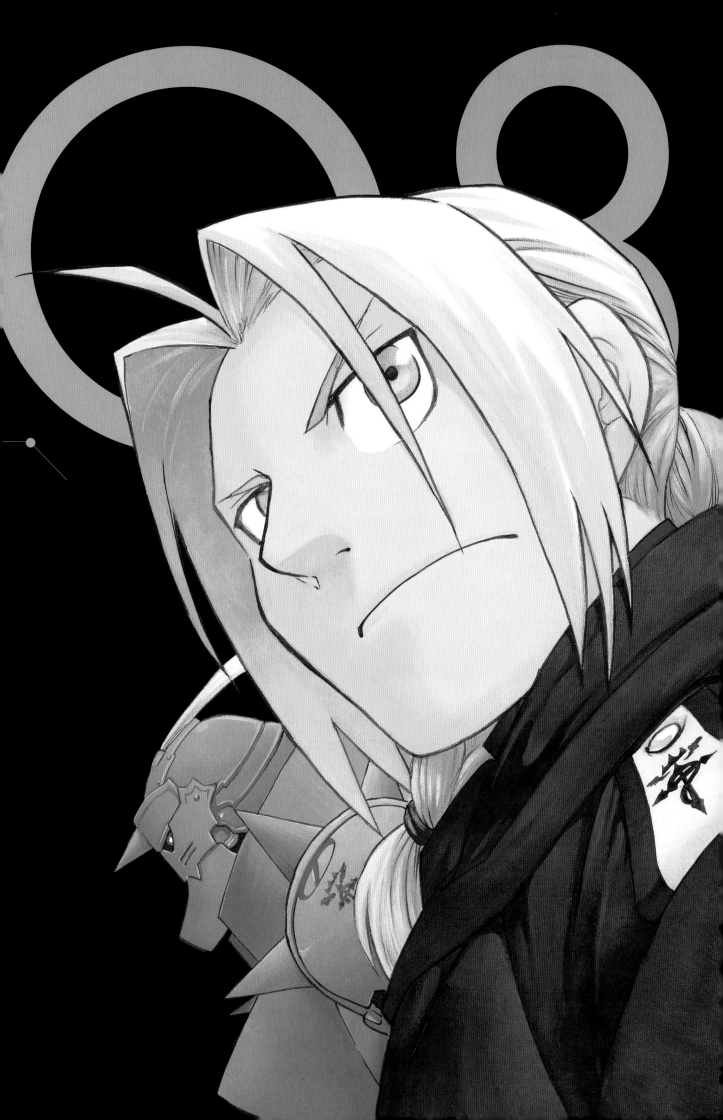

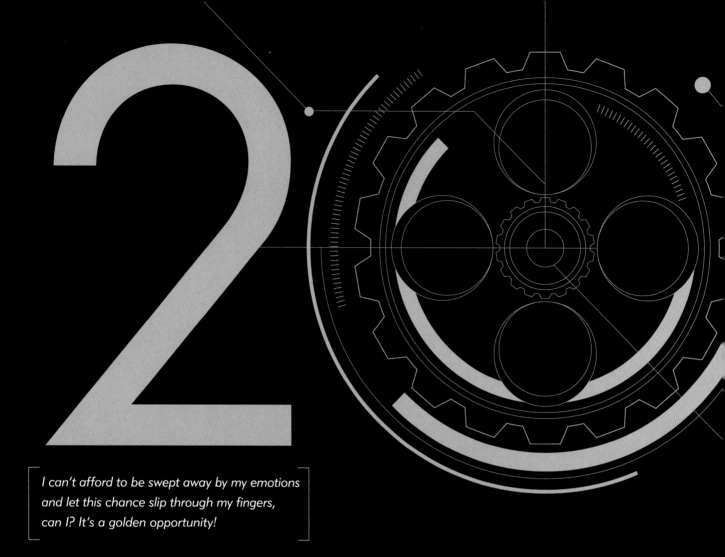

I can't afford to be swept away by my emotions and let this chance slip through my fingers, can I? It's a golden opportunity!

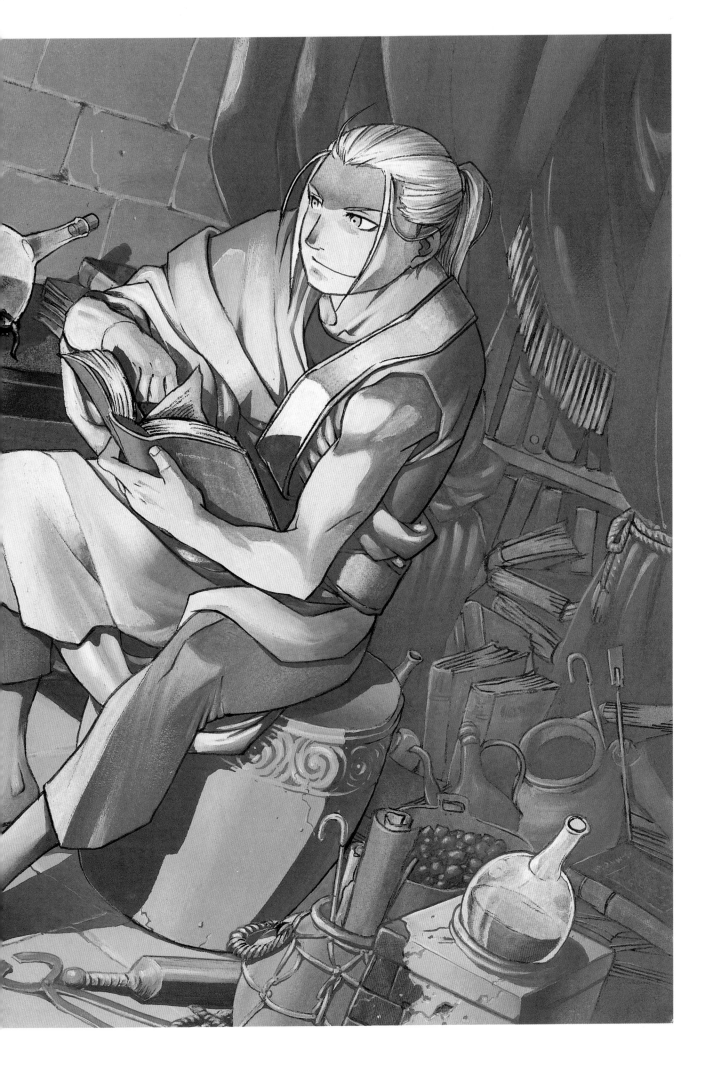

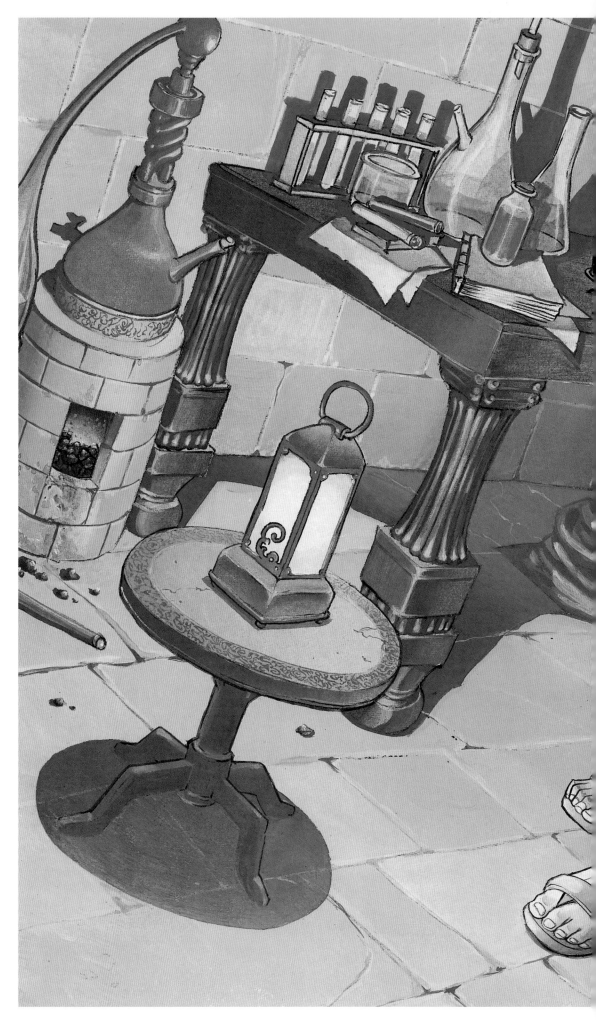

Graphic novel, volume 19 / Cover

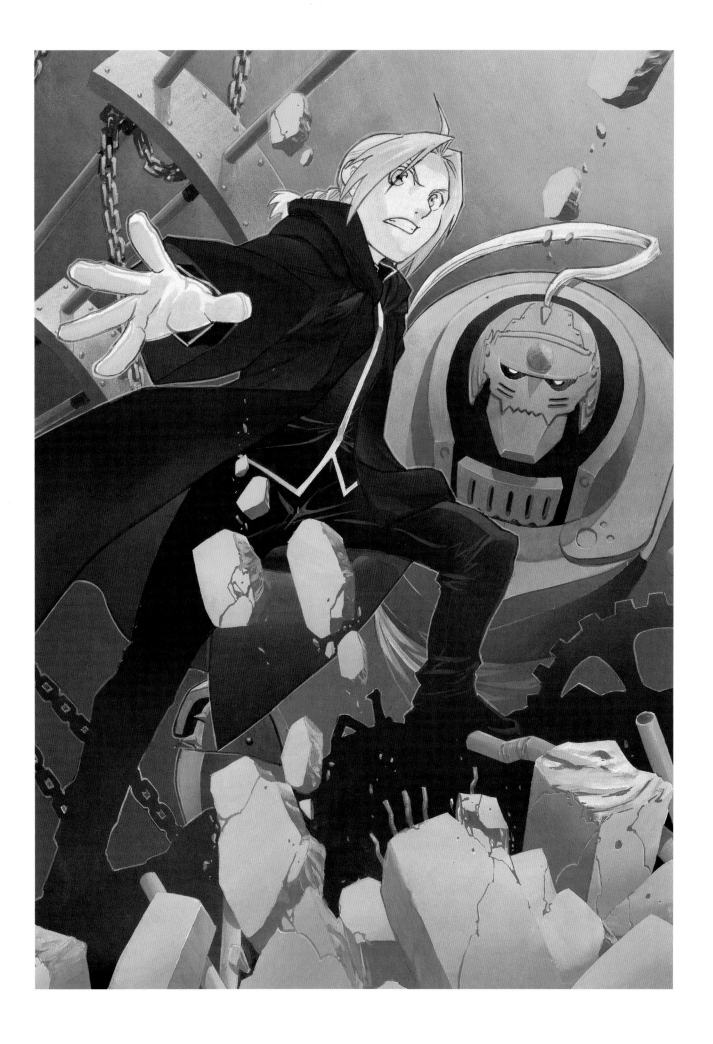

Fullmetal Alchemist DVD Box Set –Archives– Special Edition

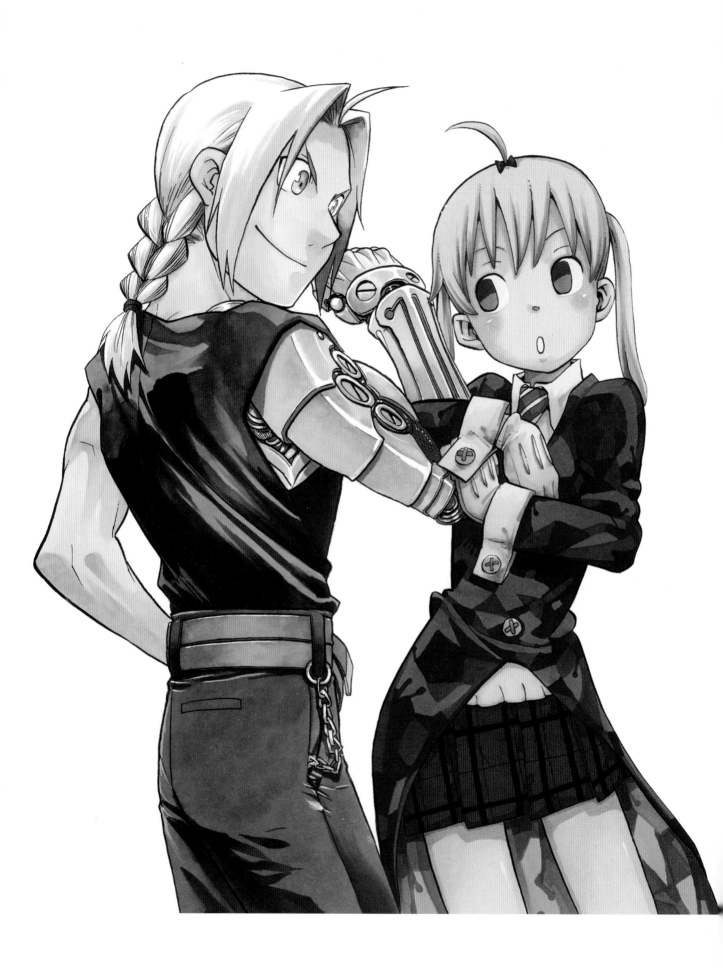

Shonen Gangan, September 2008 / Cover, "Fullmetal Alchemist x Soul Eater"

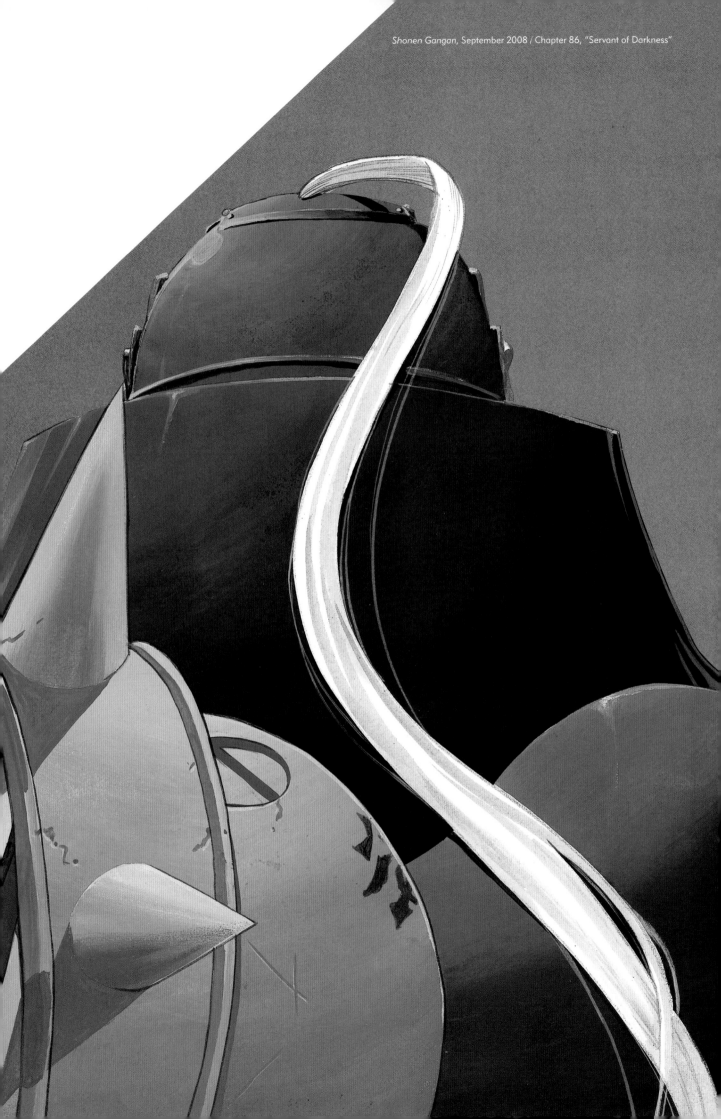

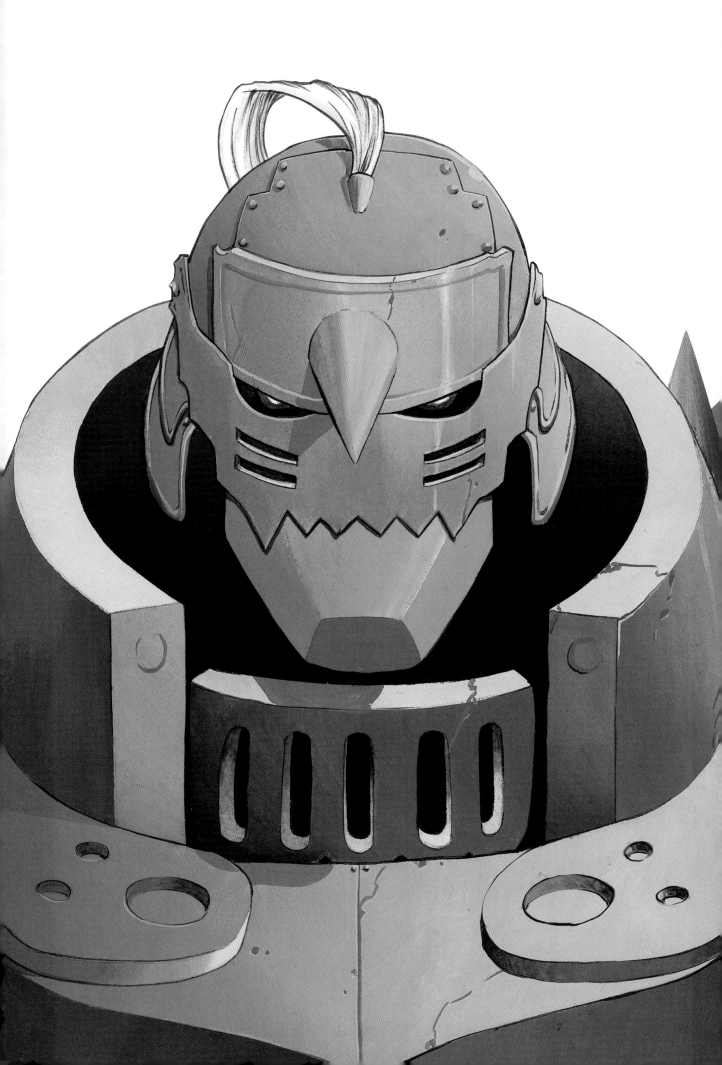

Shonen Gangan, January 2009 / Chapter 90, "Army of Immortals"

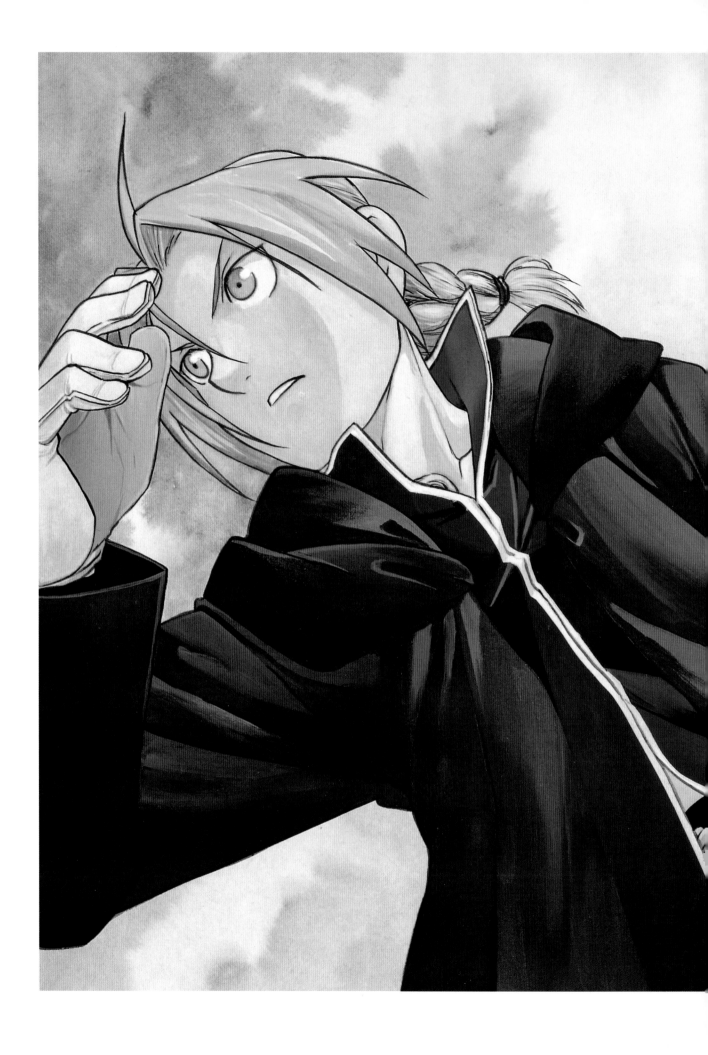

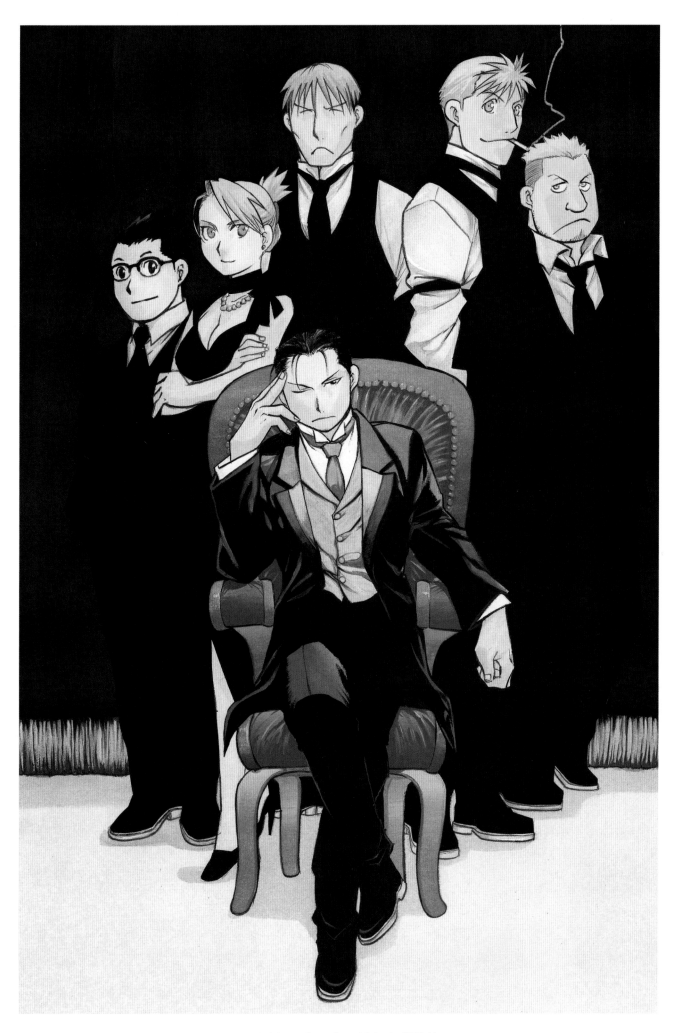

Fullmetal Alchemist Comic Special Calendar 2009 / August

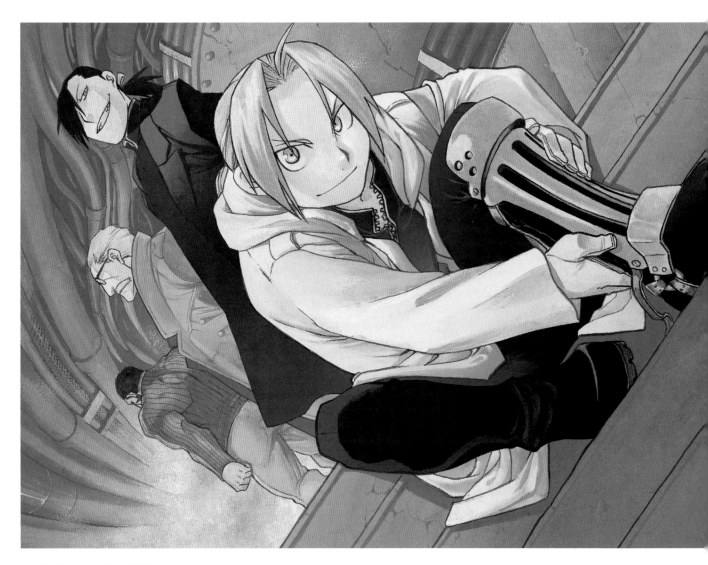

Graphic novel, volume 20 / Cover

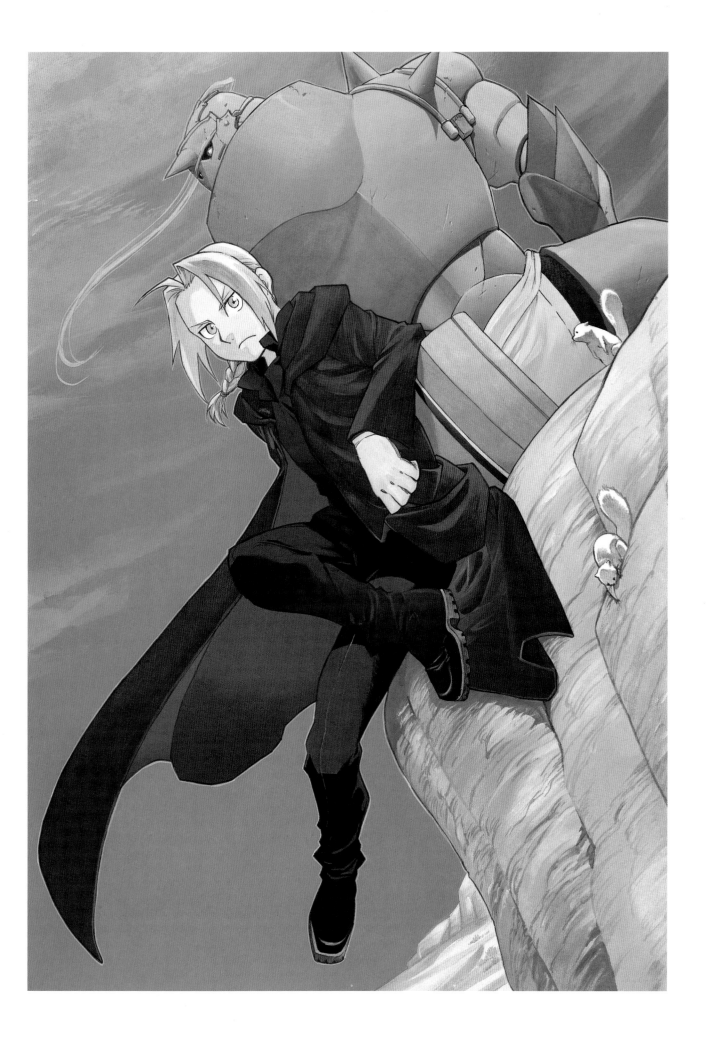

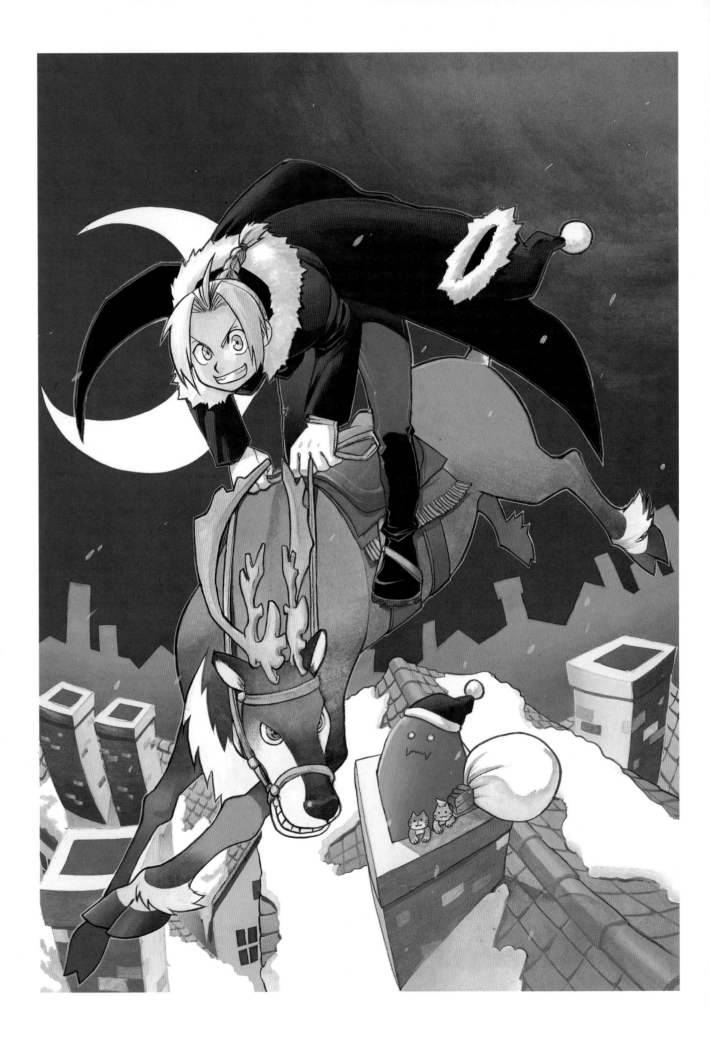

Shonen Gangan, January 2009 / Cover

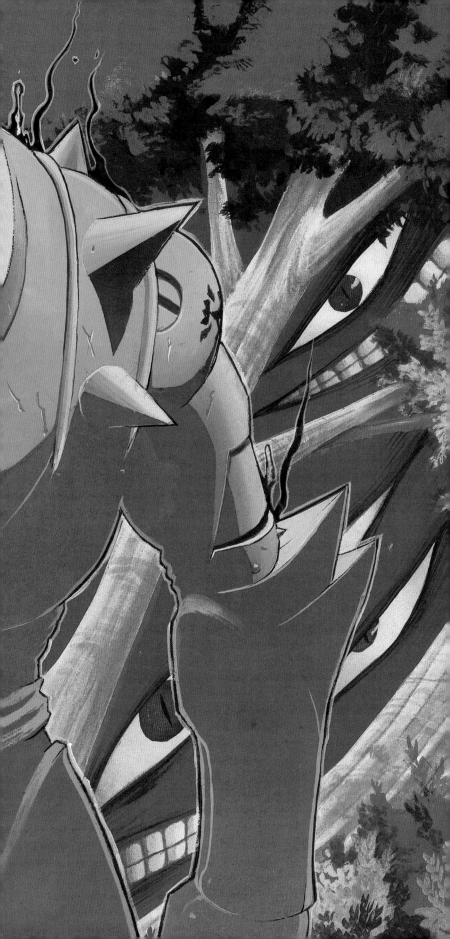

But first, take a good look in the mirror! With a face like that, how do you expect to lead this country?! Isn't that what you've been fighting for, Colonel?!

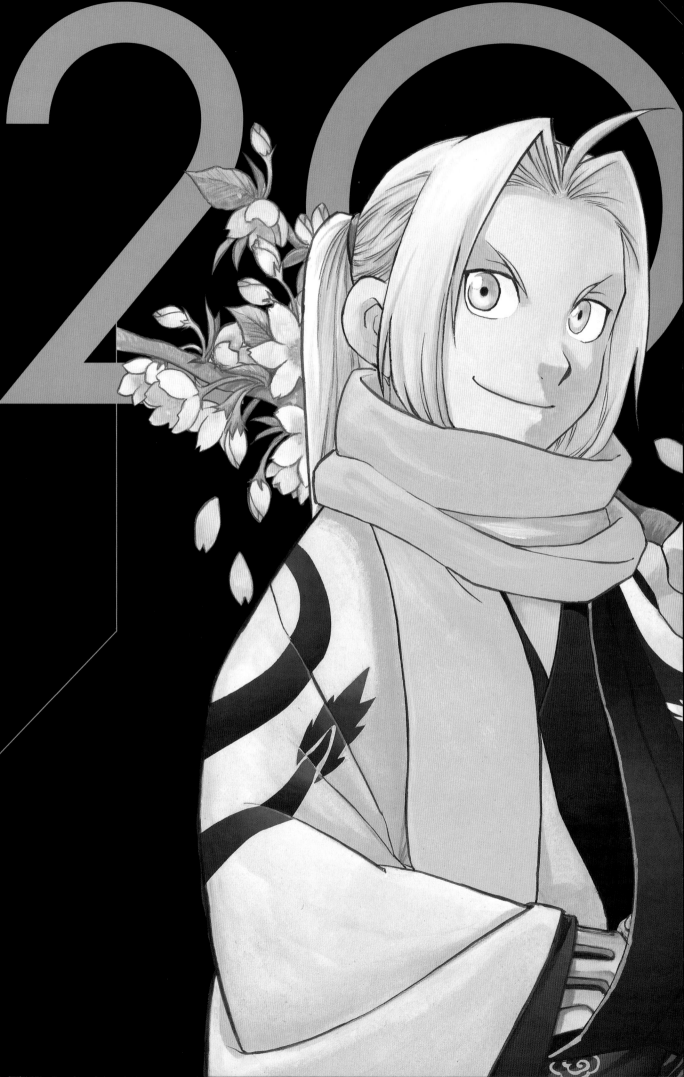

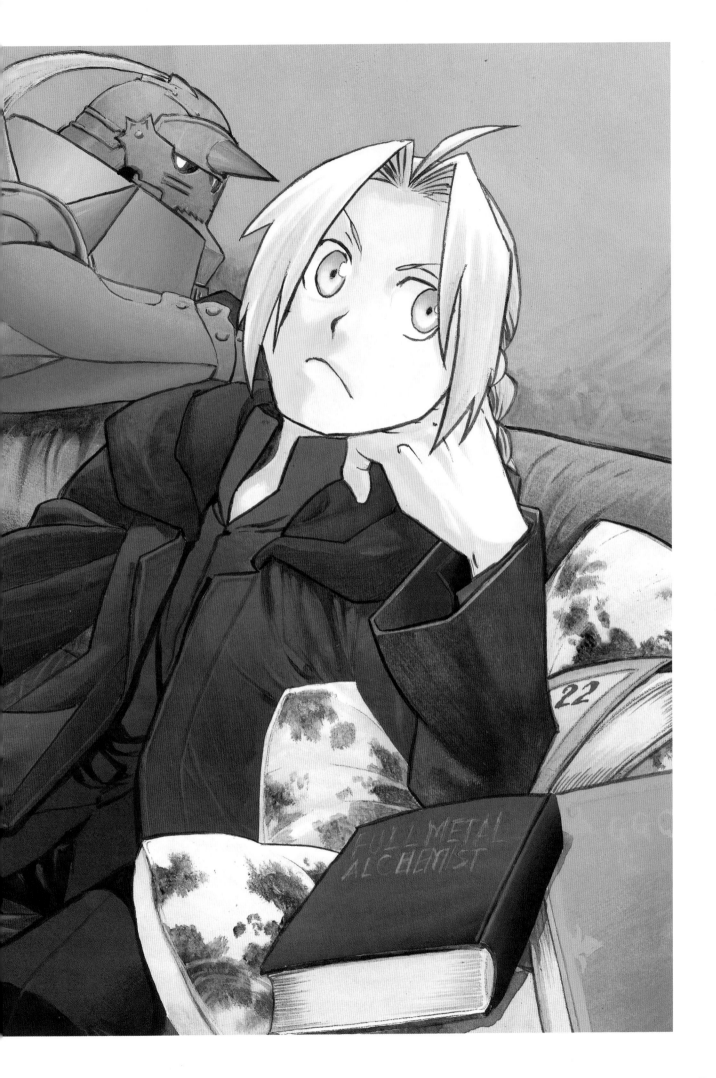

Graphic novel, volume 22 / Cover

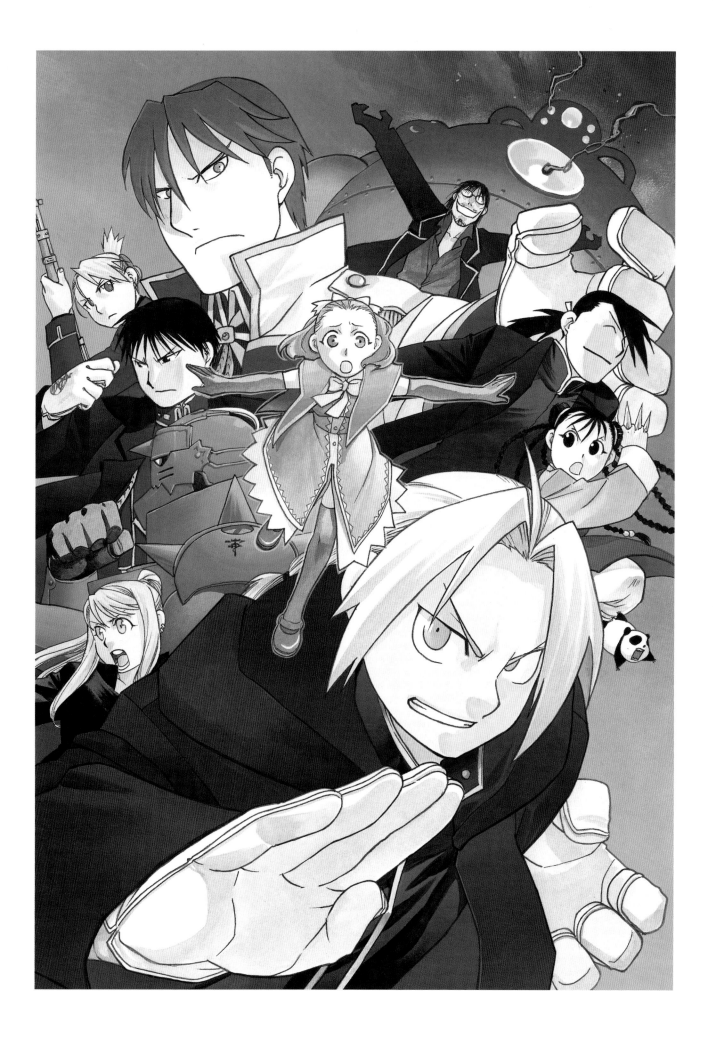

Fullmetal Alchemist: The Prince of Dawn for Wii / Announcement

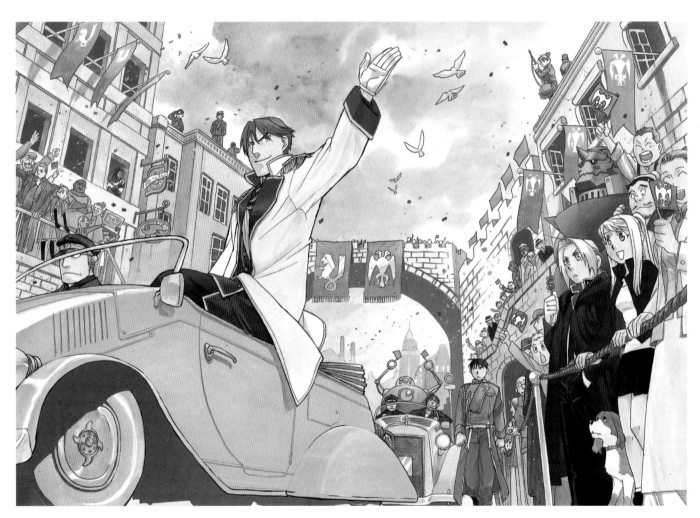

Fullmetal Alchemist: The Prince of Dawn for Wii / Announcement

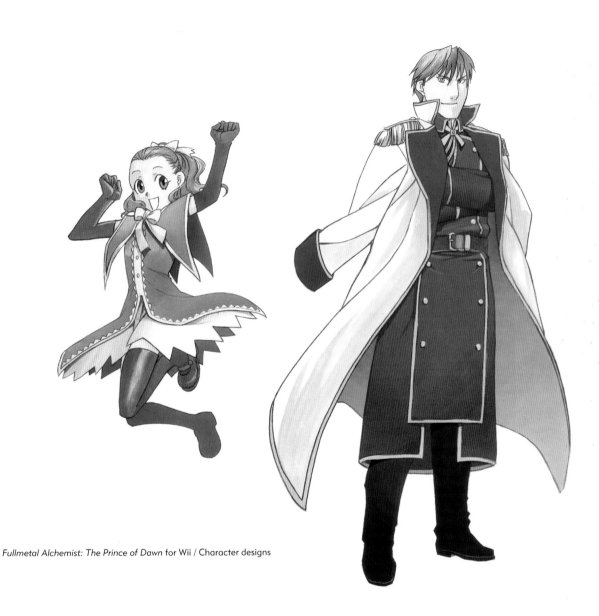

Fullmetal Alchemist: The Prince of Dawn for Wii / Character designs

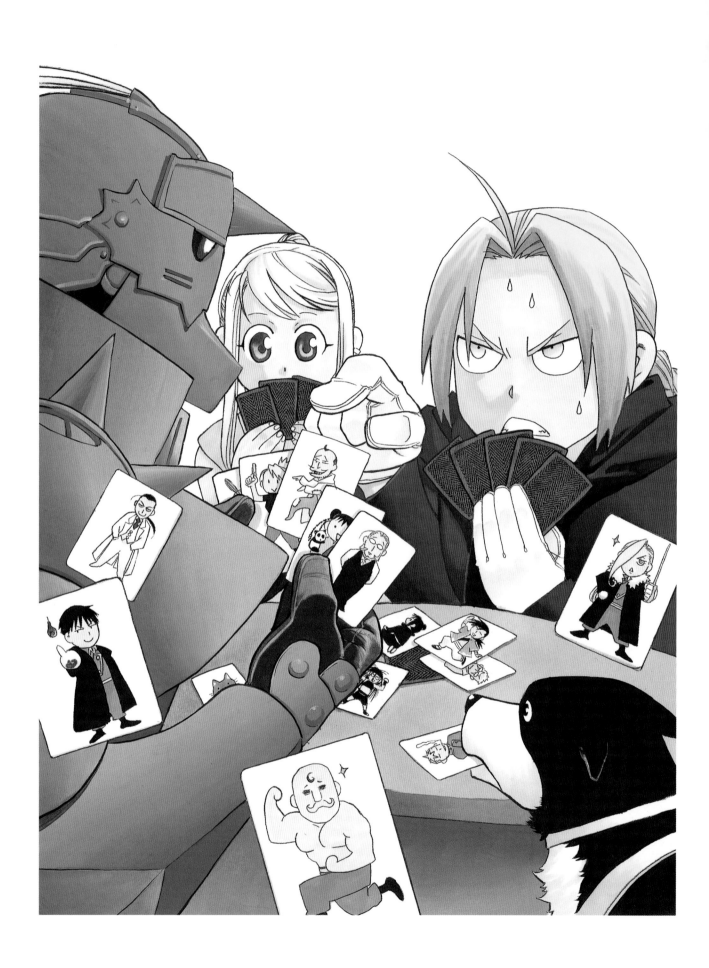

Fullmetal Alchemist: Character Guide / Cover

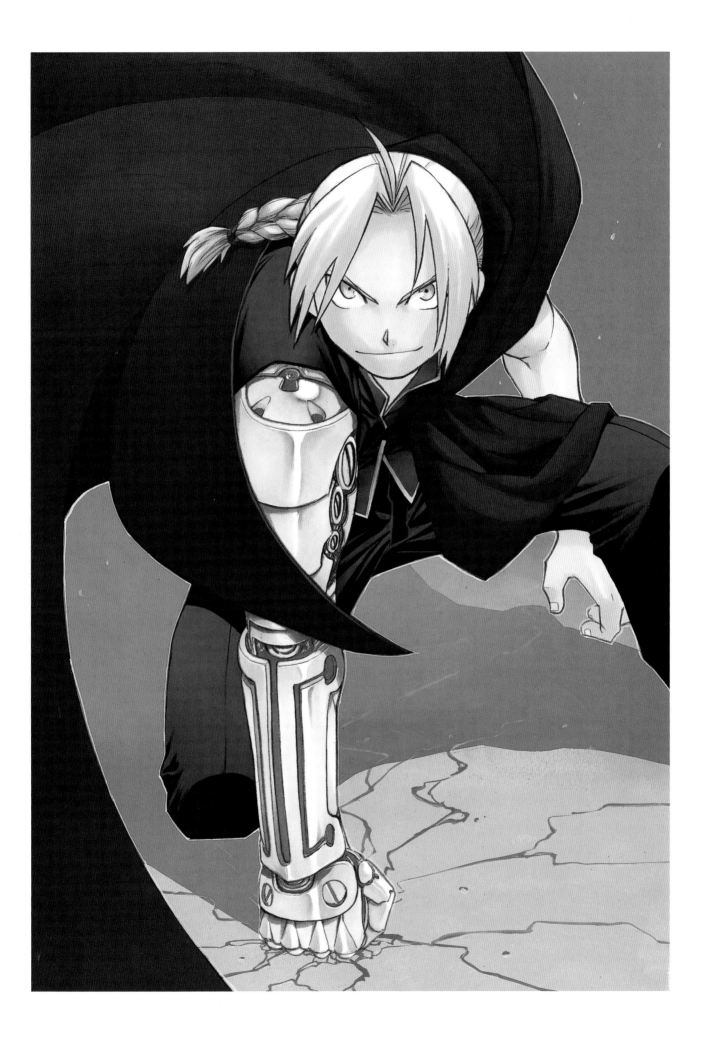

Shonen Gangan, July 2009 / Chapter 96, "Two Strong Women"

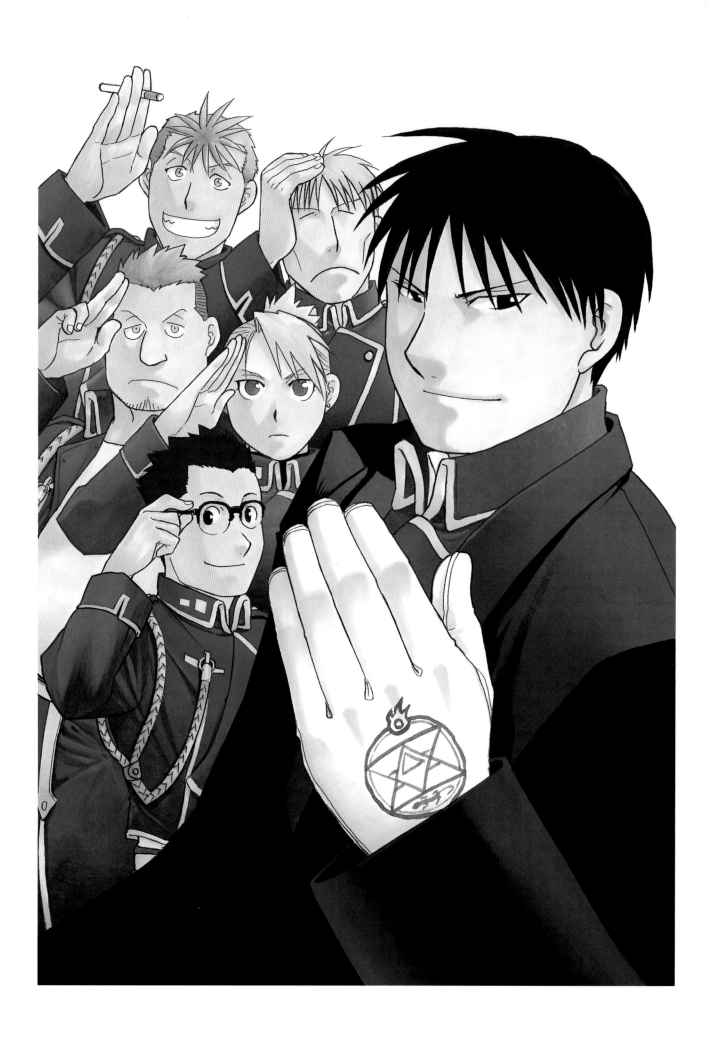

Shonen Gangan, July 2009 / Cover

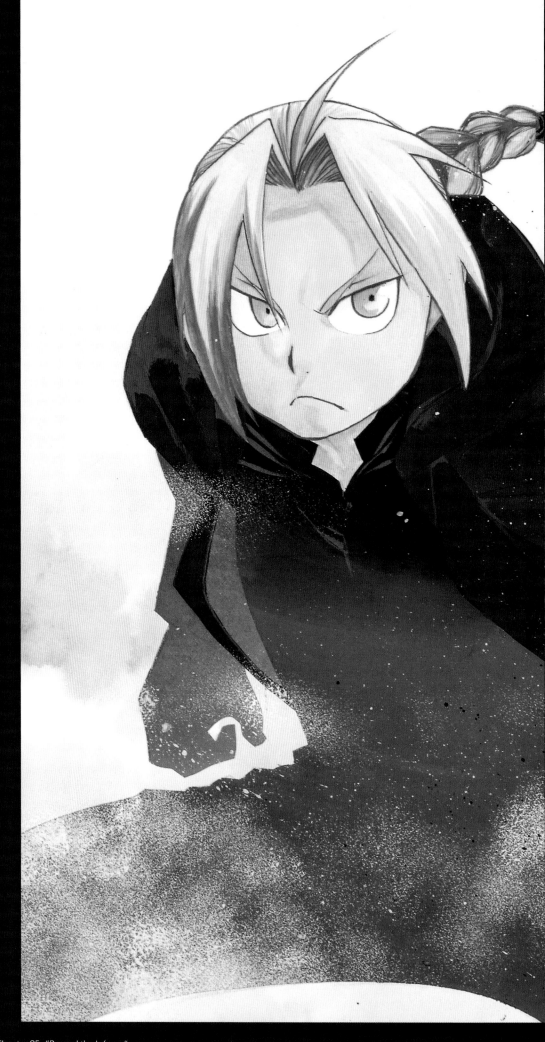

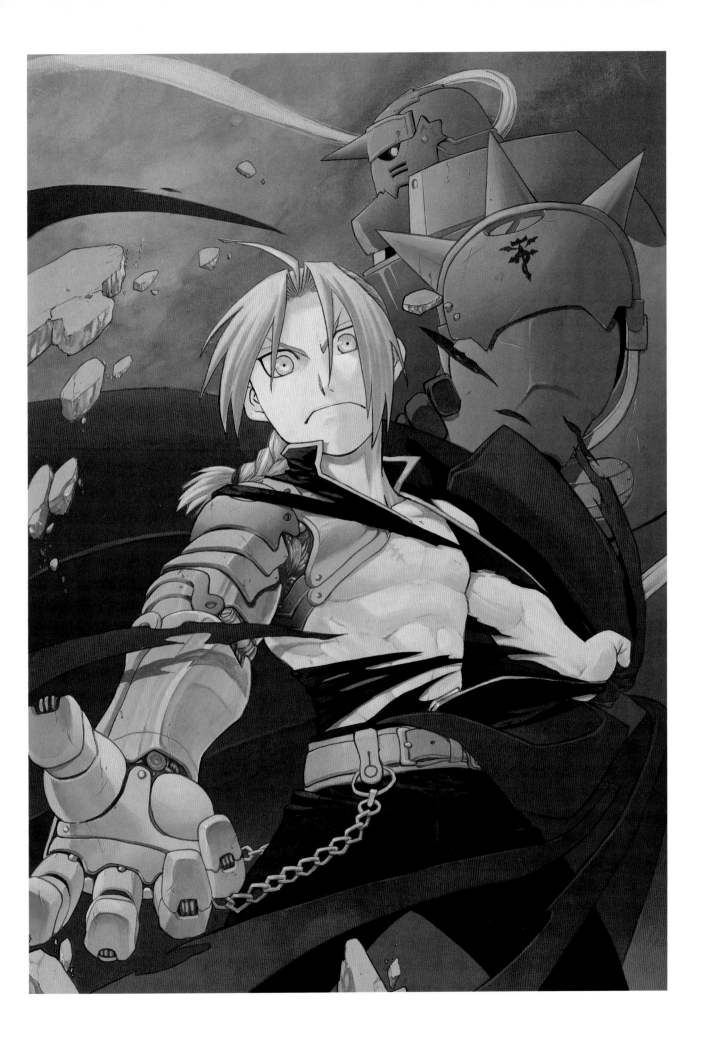

Fullmetal Alchemist DVD & BD, volume 1 / Special edition box

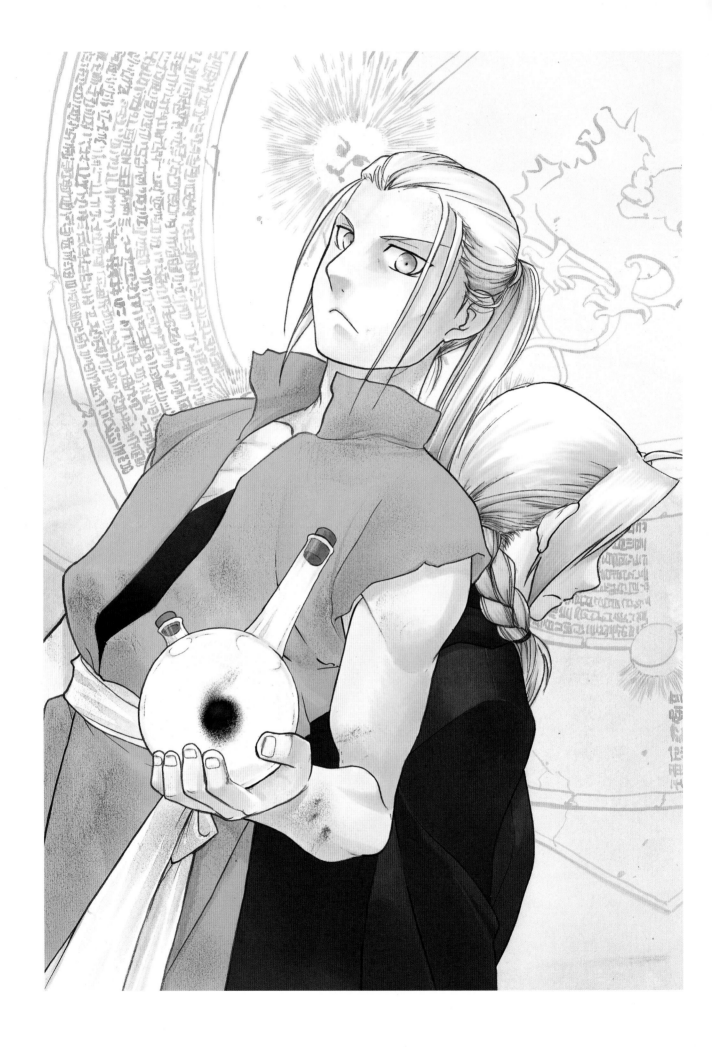

Shonen Gangan, August 2009 / Chapter 97, "The Two Philosophers"

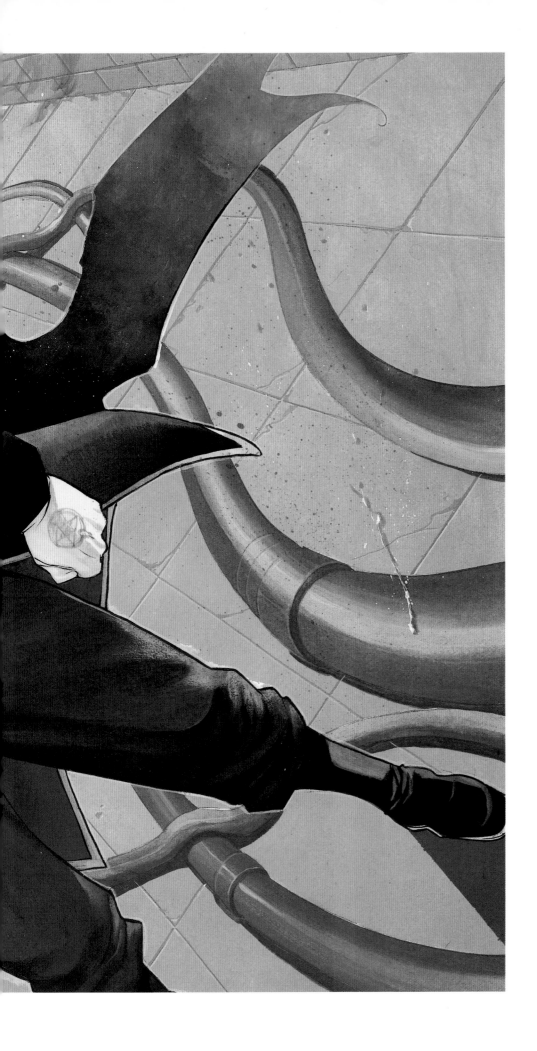

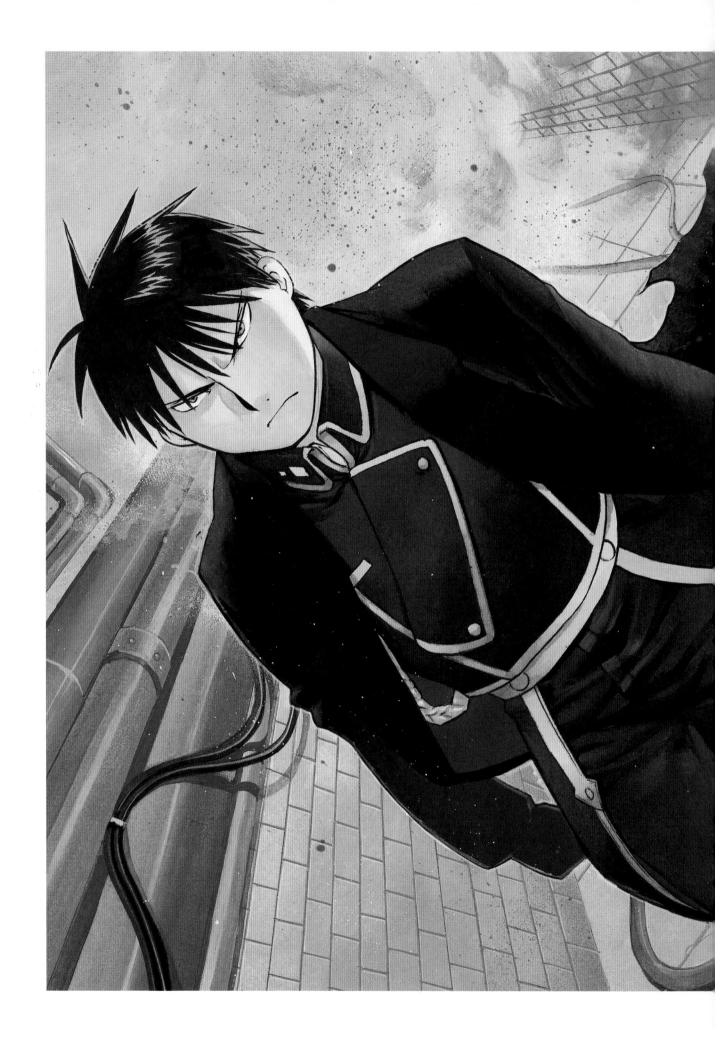

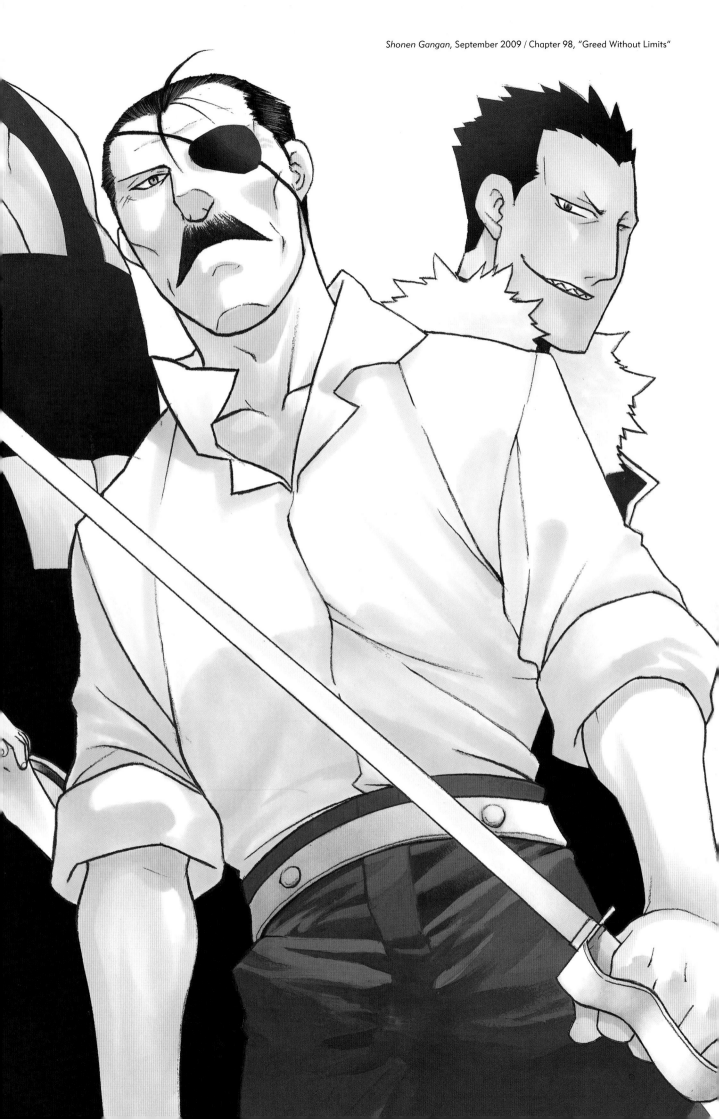

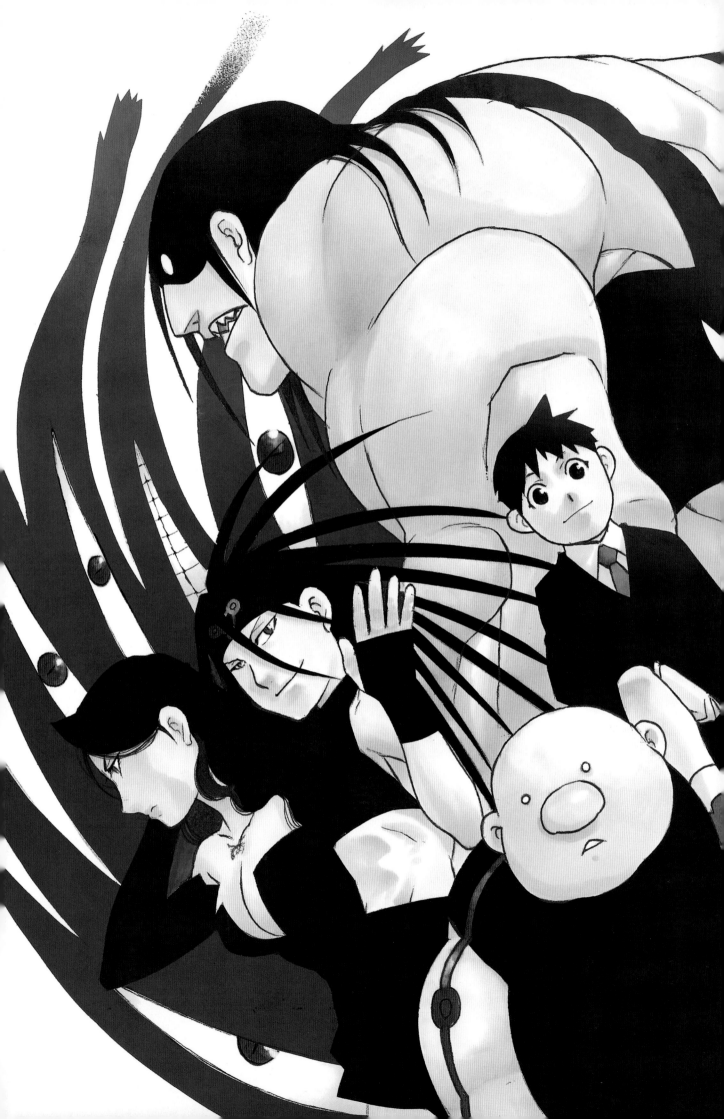

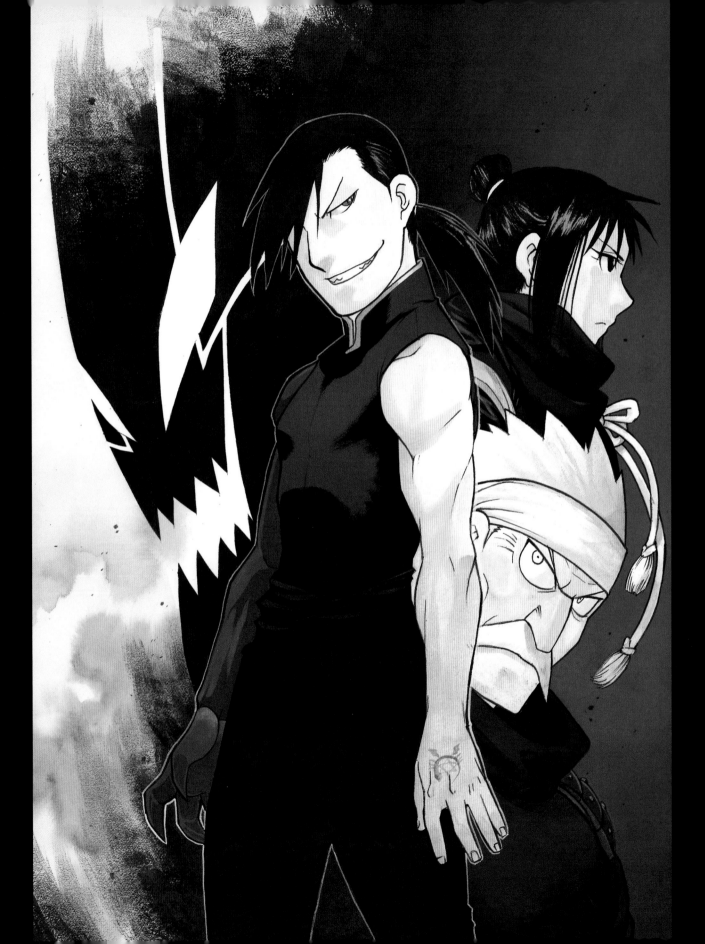

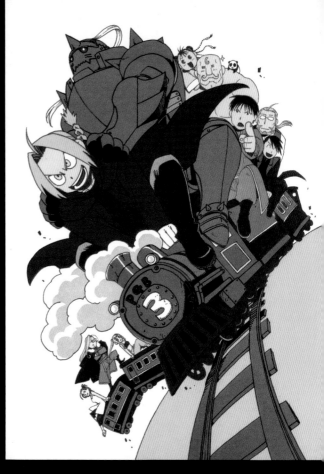

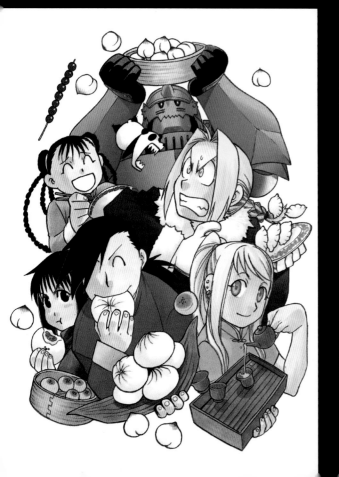

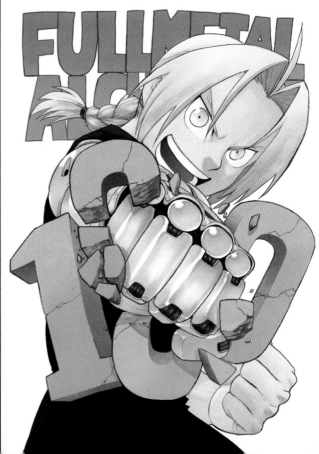

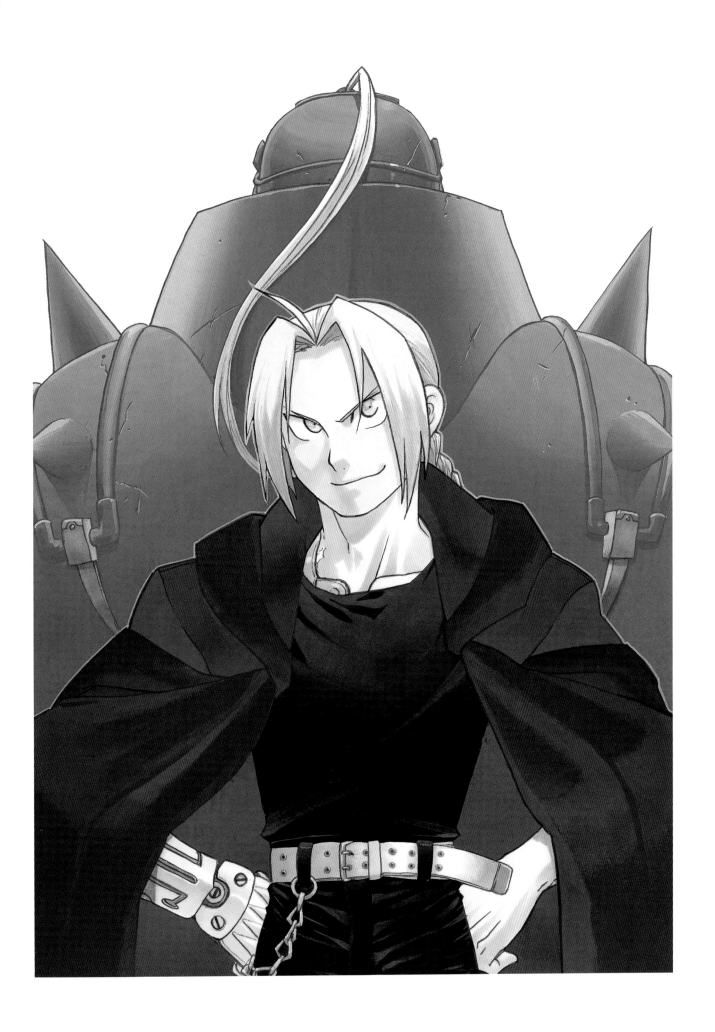

Shonen Gangan, October 2009 / Cover

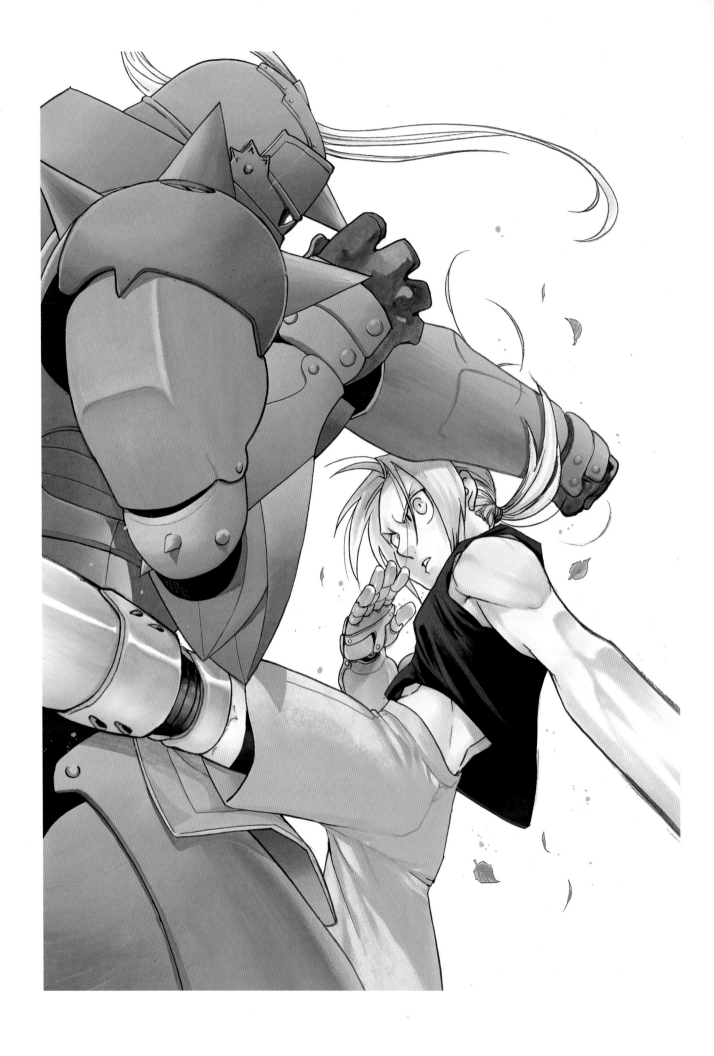

Fullmetal Alchemist Comic Special Calendar 2010 / May

Fresh Gangan, Fall 2009 / Cover

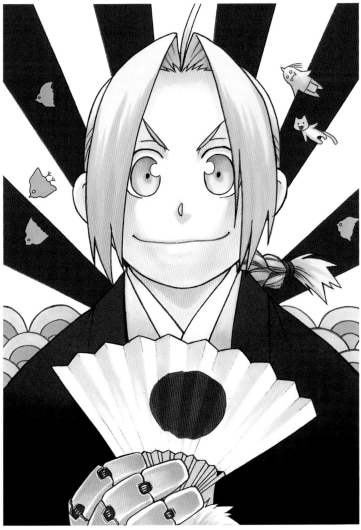

100th chapter celebratory New Year's postcard

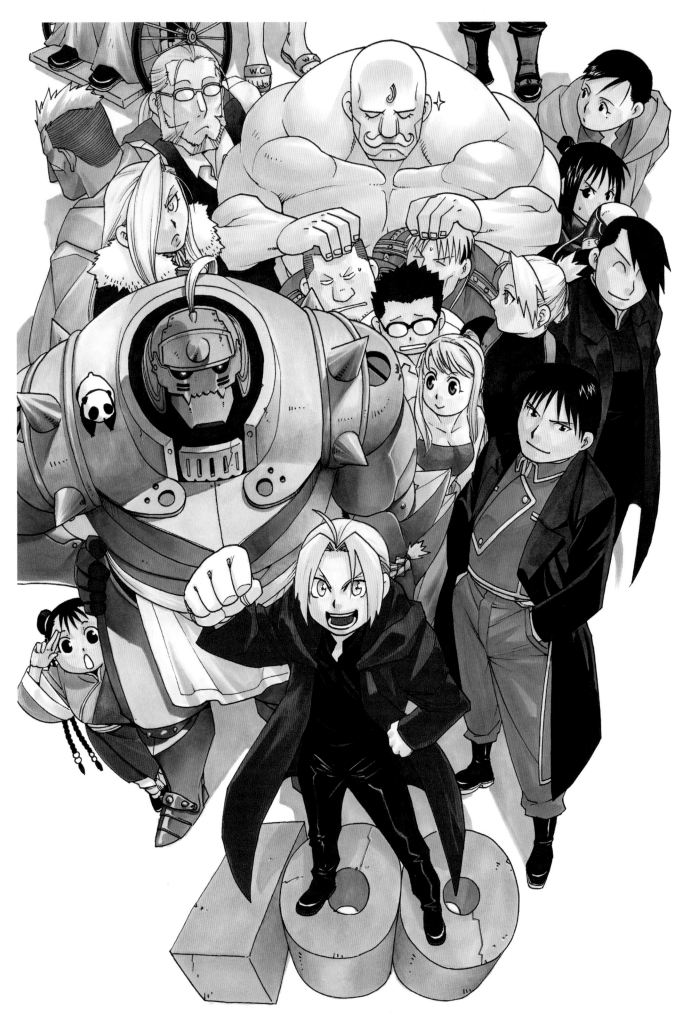

Shonen Gangan, November 2009 / Chapter 100, "The Forbidden Door"

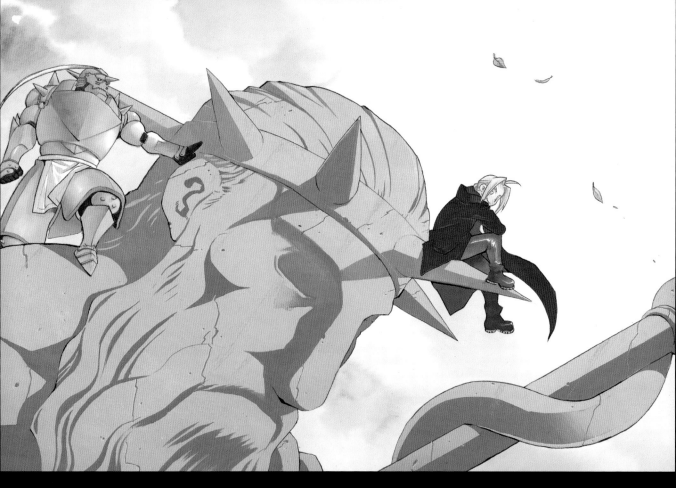

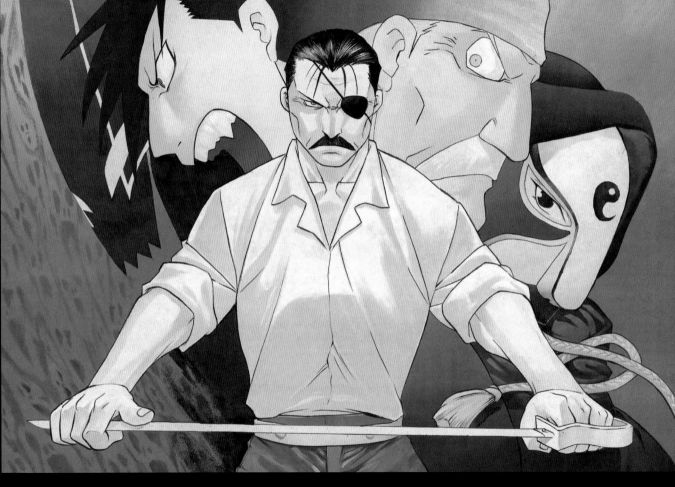

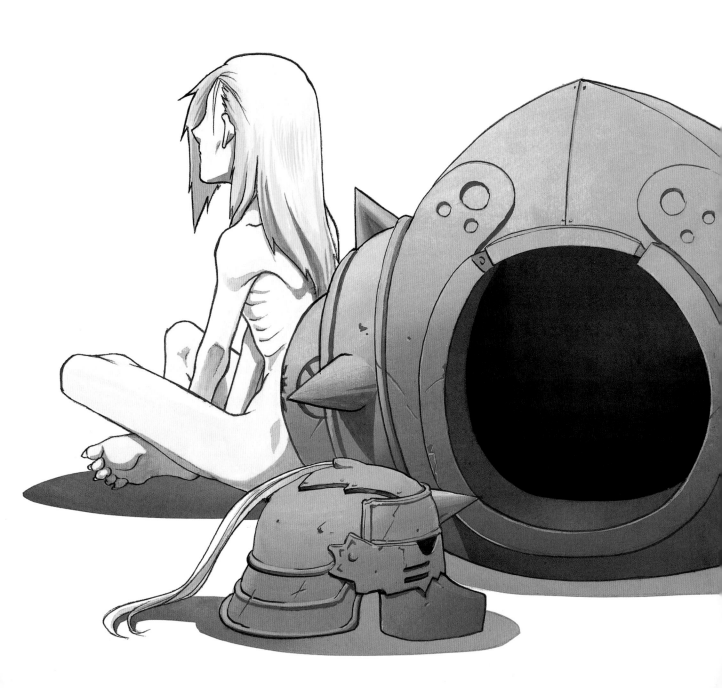

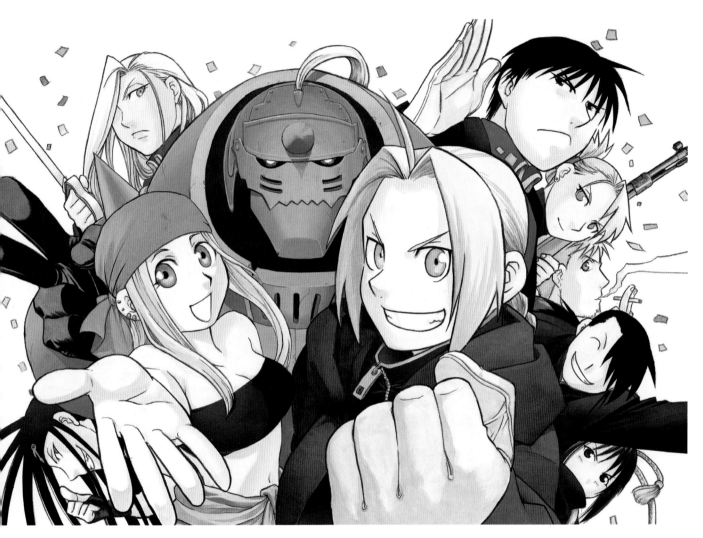

Shonen Gangan, May 2009 / Chapter 94, "The Flames of Vengeance"

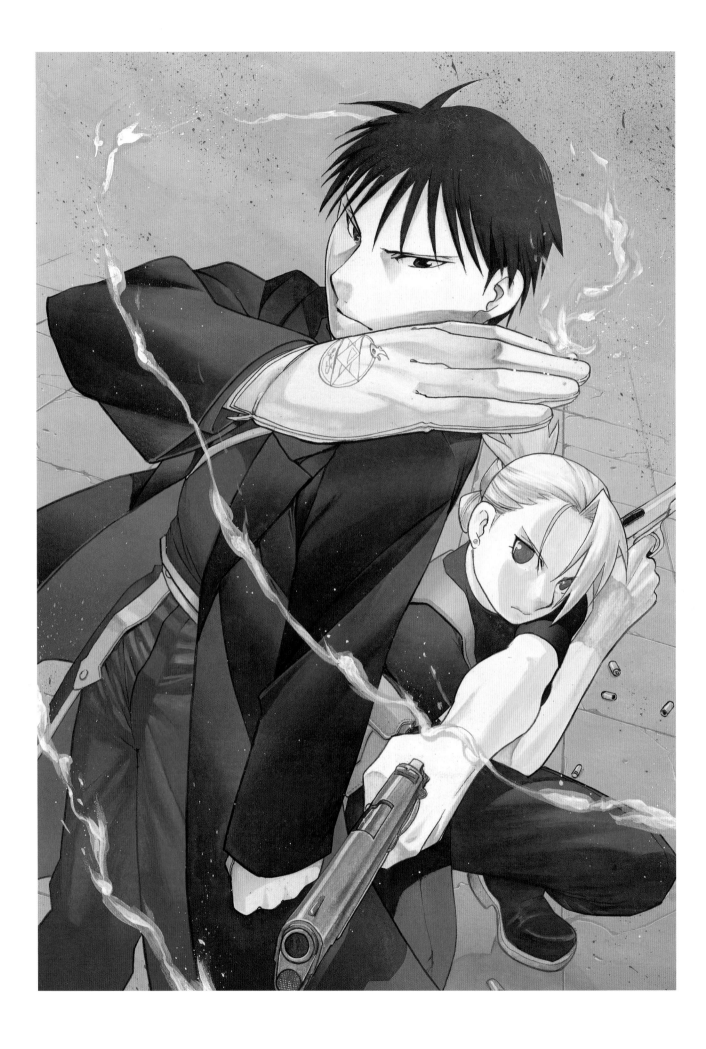

Fullmetal Alchemist DVD & BD, volume 5 / Limited edition box

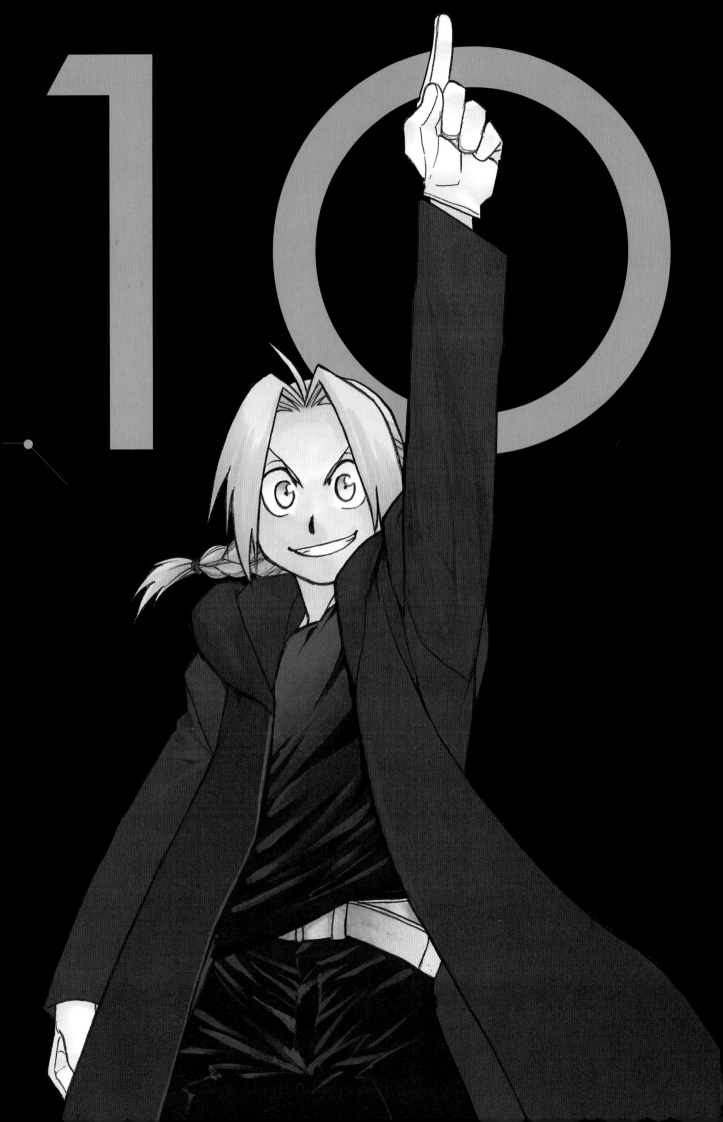

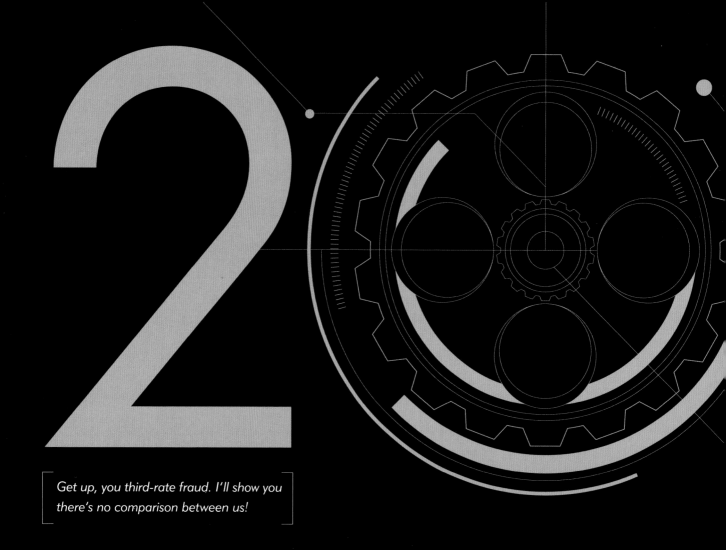

Get up, you third-rate fraud. I'll show you
there's no comparison between us!

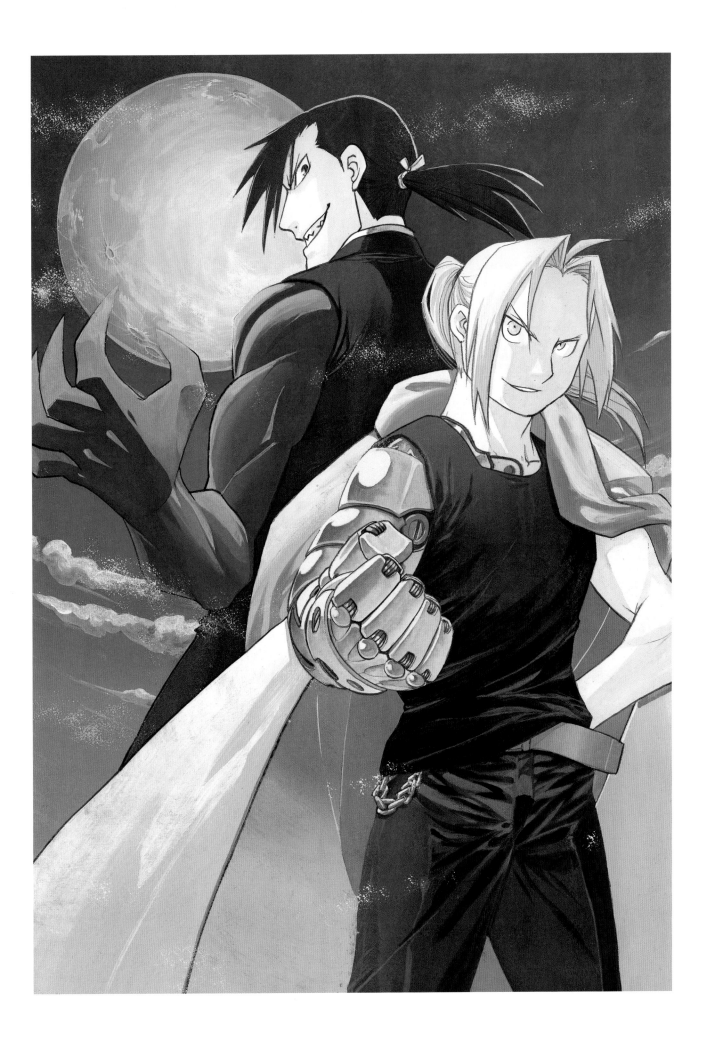

Fullmetal Alchemist DVD & BD, volume 9 / Limited edition box

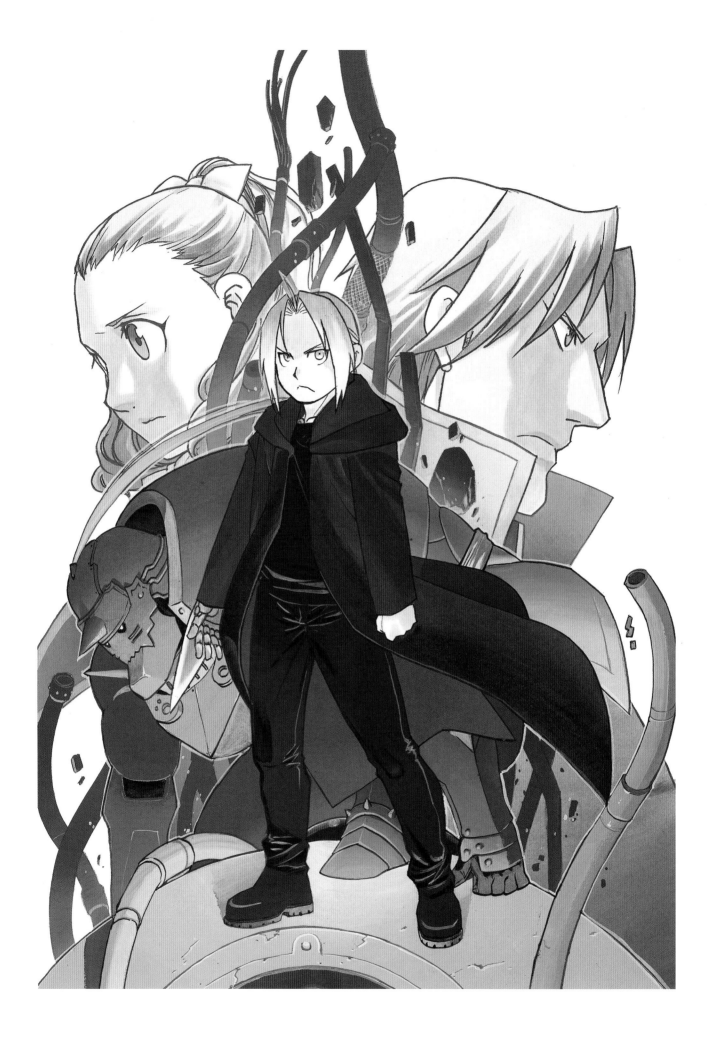

Fullmetal Alchemist: The Prince of Dawn and the Daughter of the Dusk game novelization / Cover

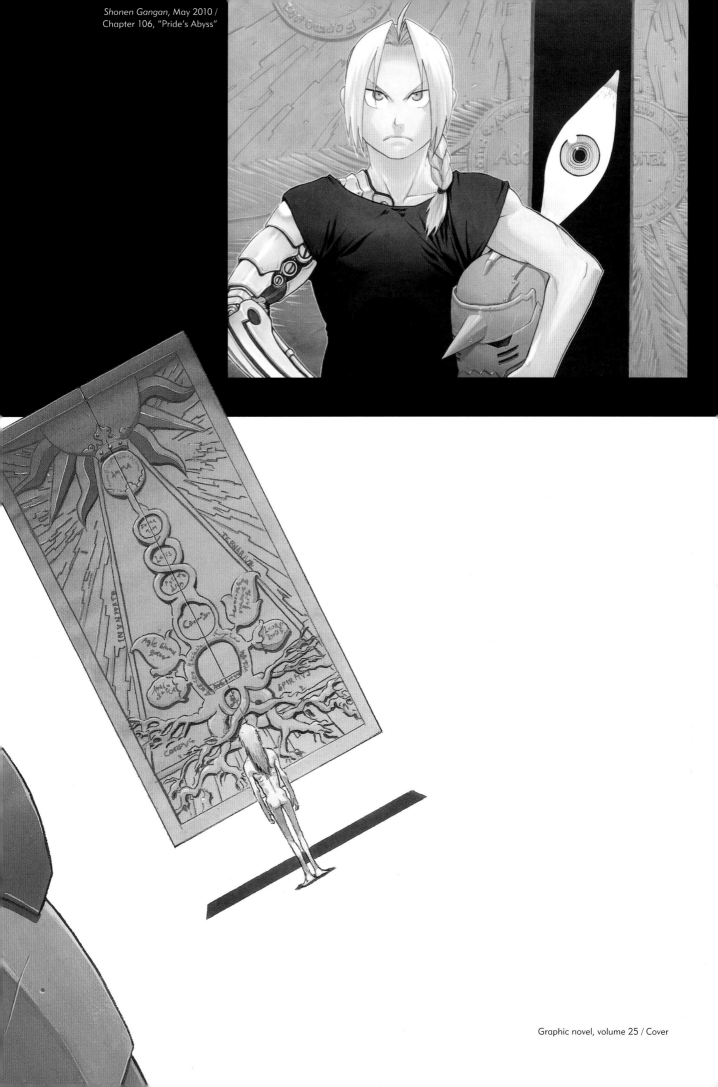

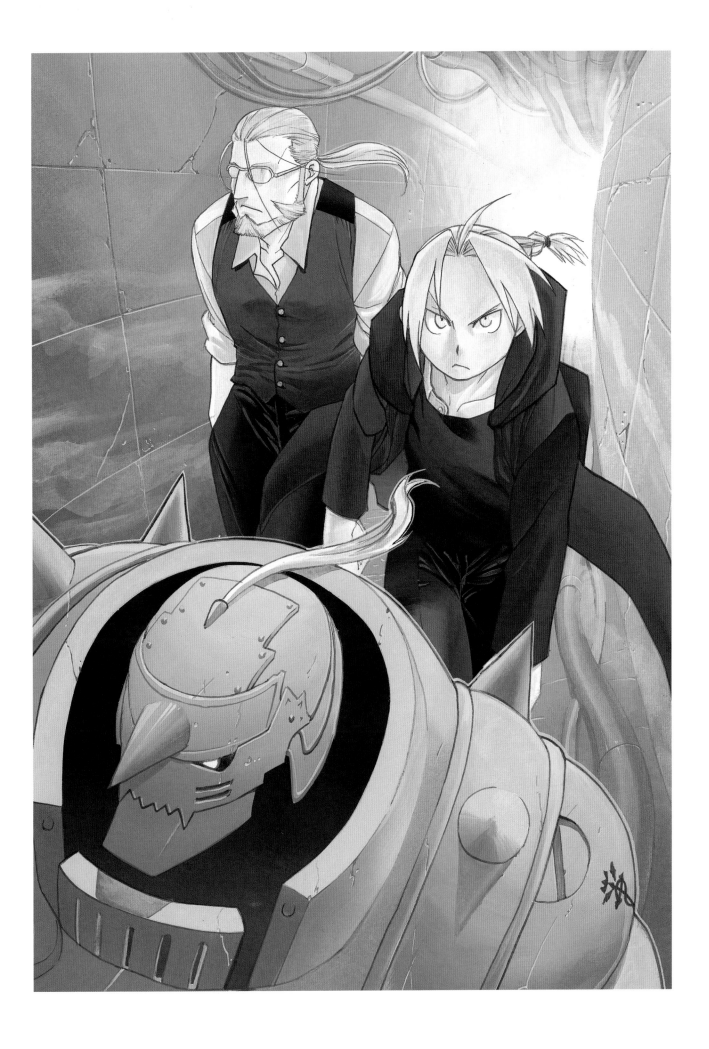

Fullmetal Alchemist DVD & BD, volume 13 / Limited edition box

Fullmetal Alchemist: Final Best CD

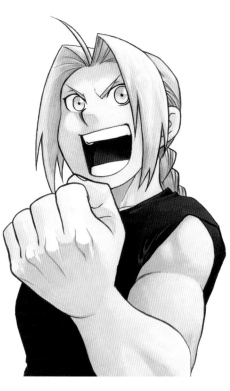

Shonen Gangan, April 2010 / Cover

Shonen Gangan, June 2010 / Cover

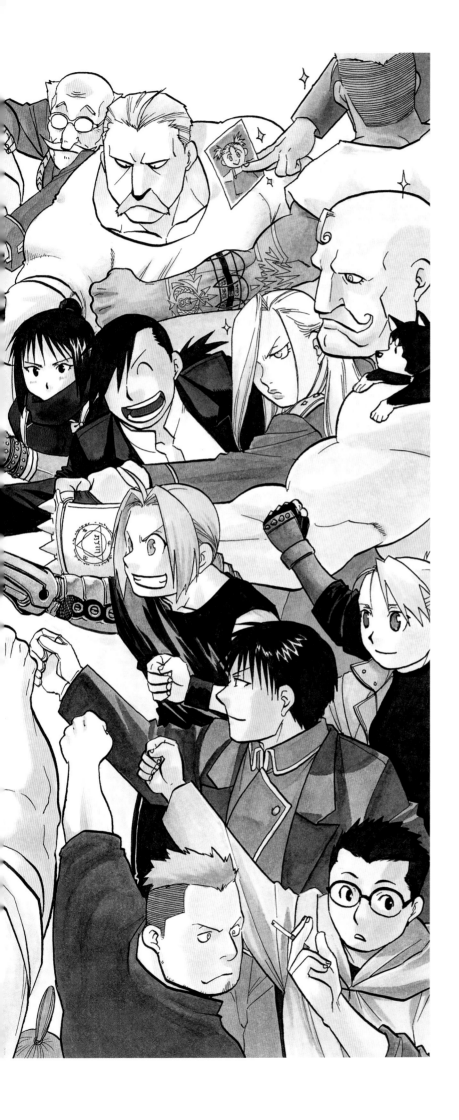

Shonen Gangan, June 2010 /
Chapter 107, "The Last Battle"

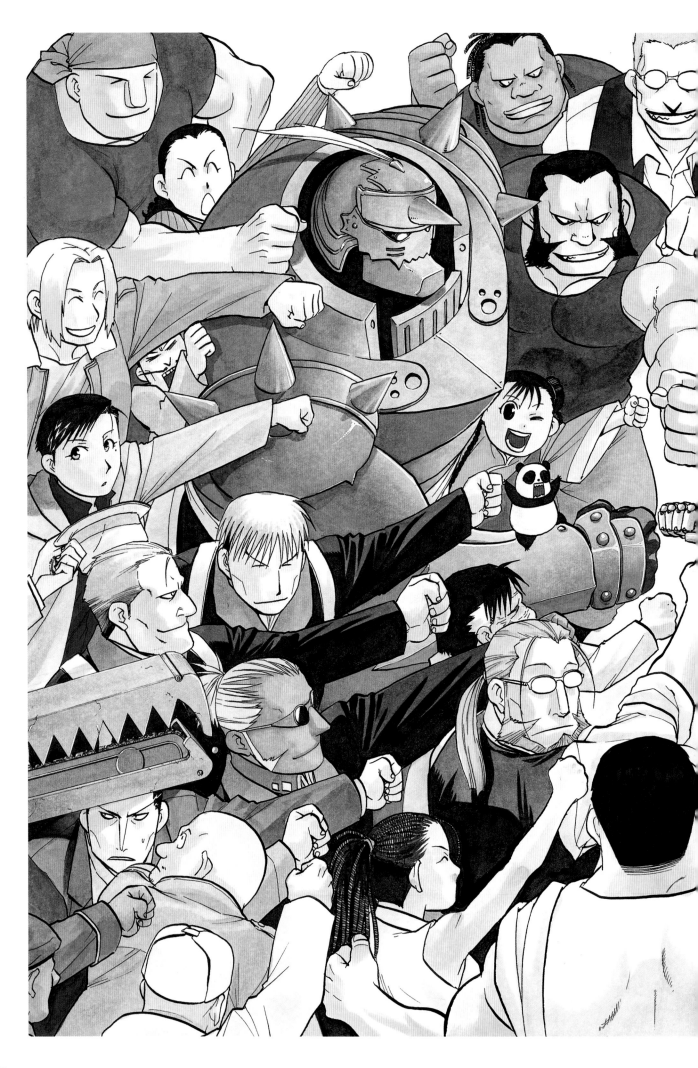

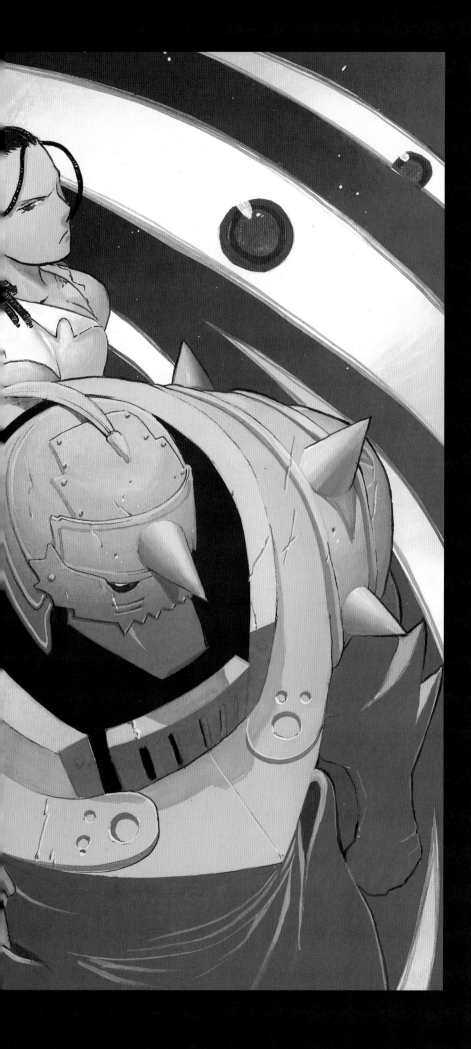

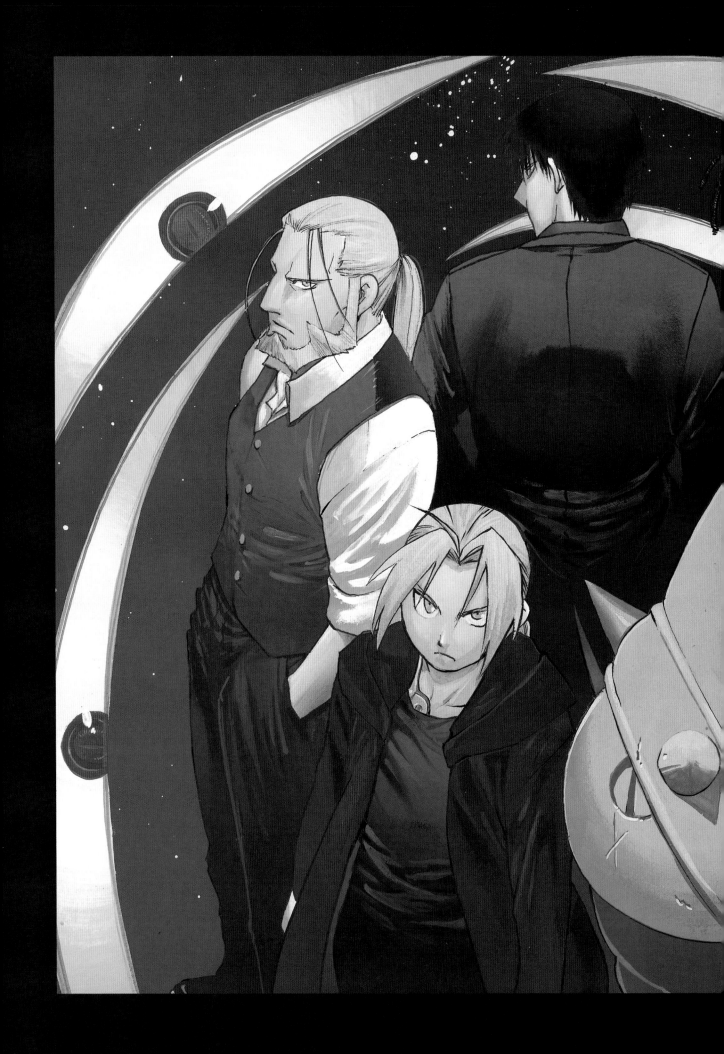

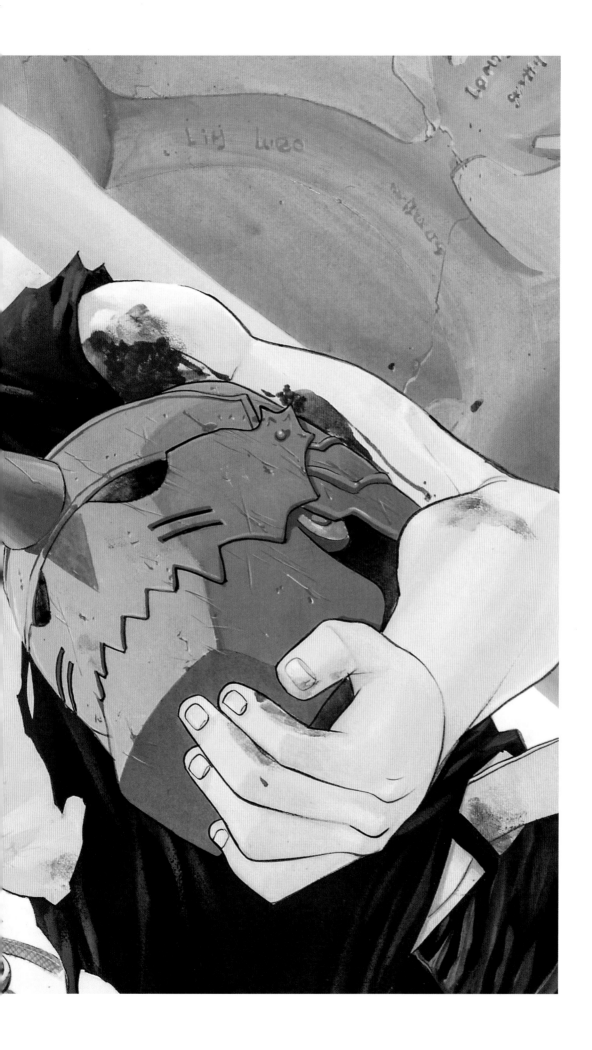

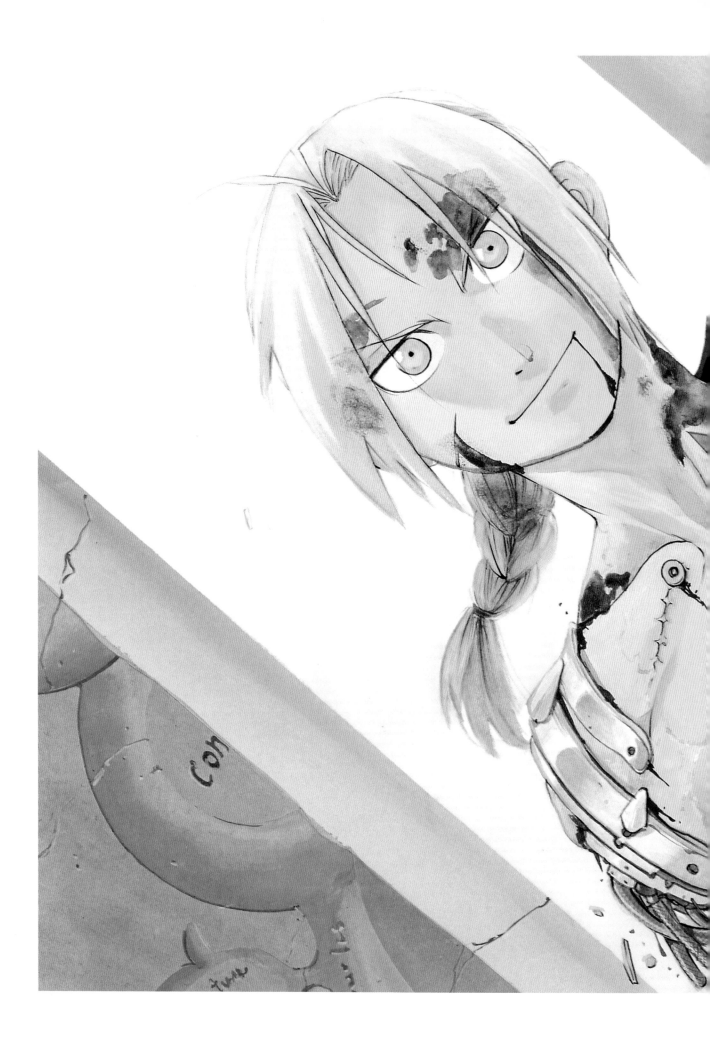

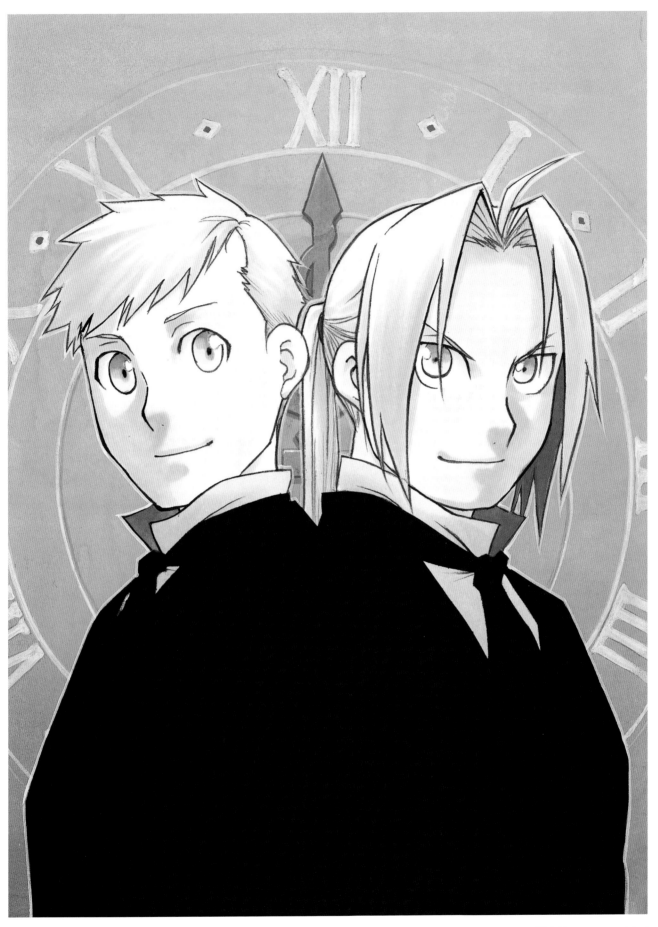

Shonen Gangan, July 2010 / Bonus memorial clock

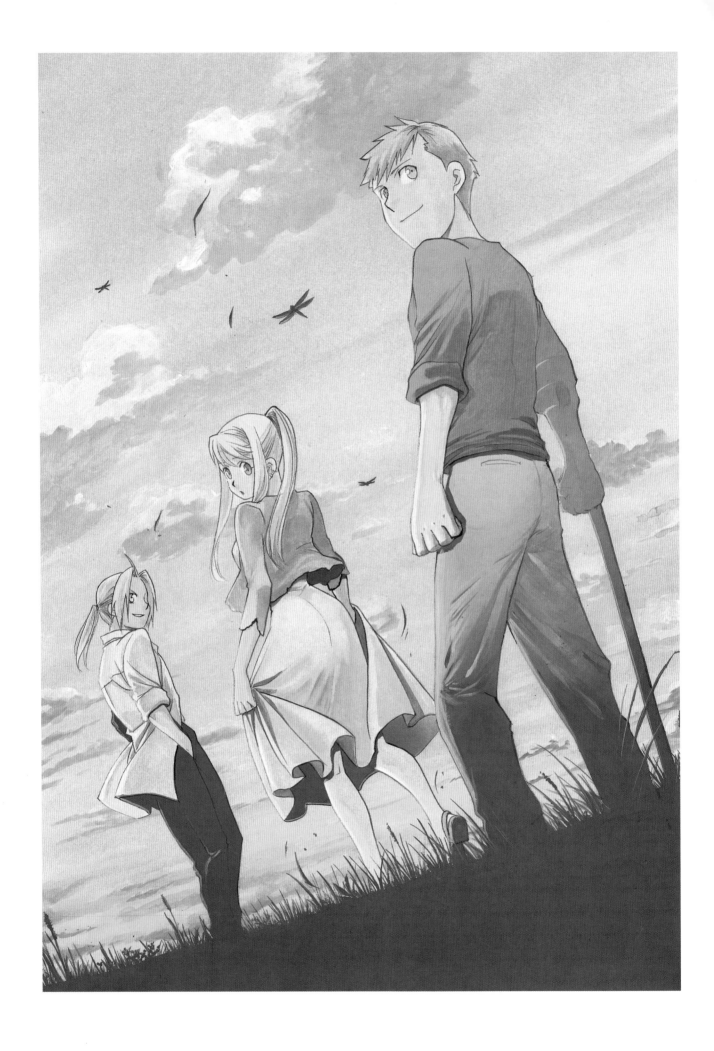

Shonen Gangan, October 2010 / Cover

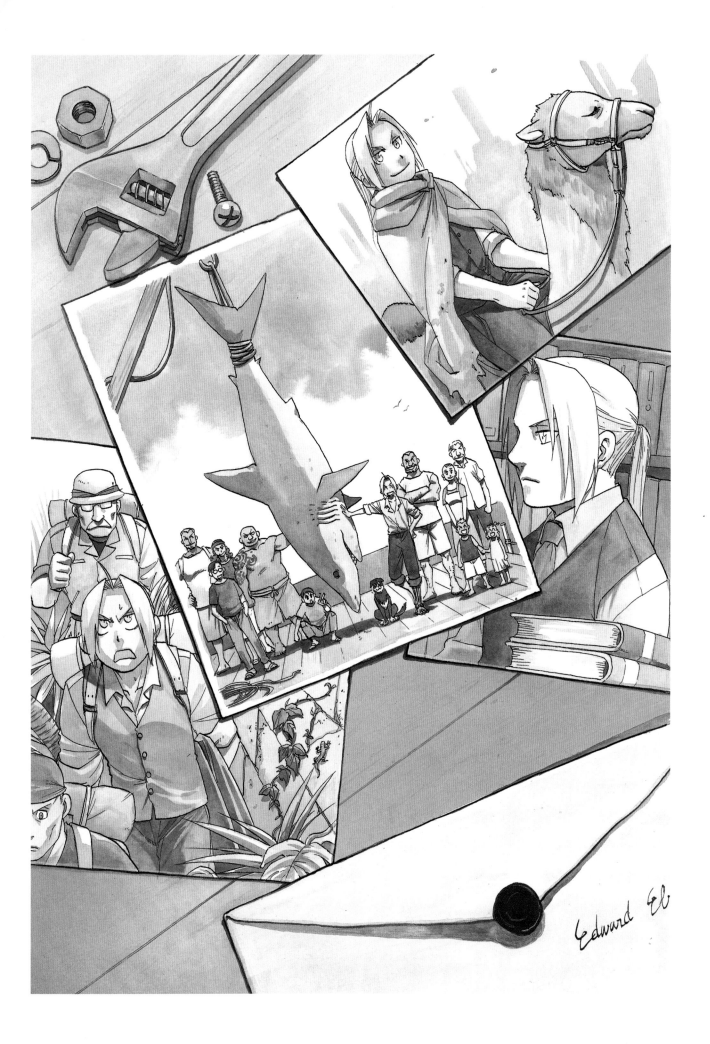

Edward El

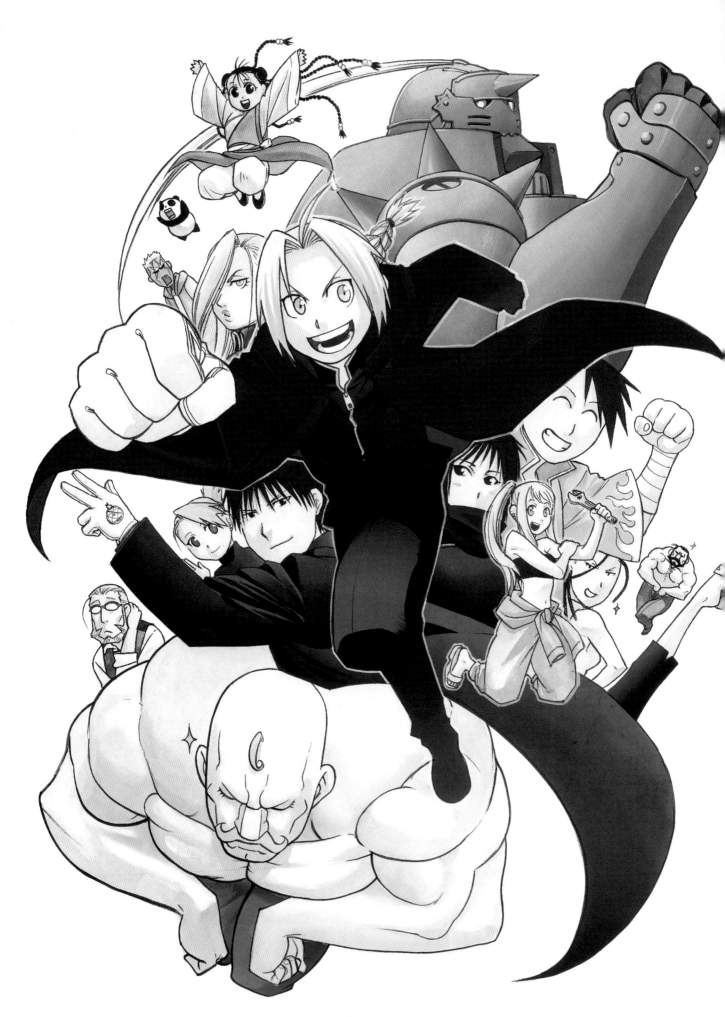

Shonen Gangan, July 2010 / Cover

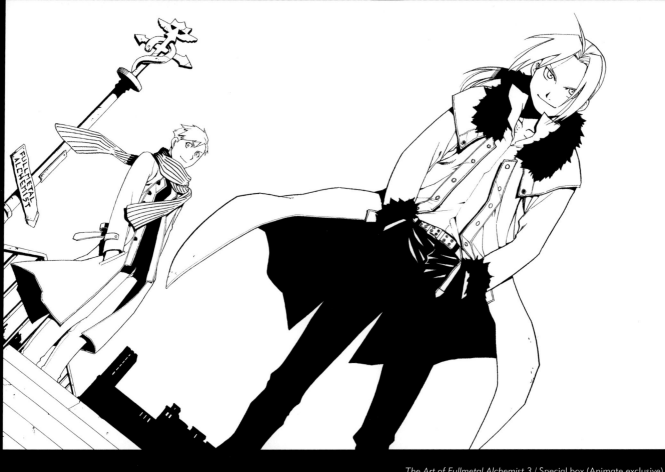

The Art of Fullmetal Alchemist 3 / Special box (Animate exclusive)

Fullmetal Alchemist: Fullmetal Edition / Special box (Animate exclusive)

Fullmetal Alchemist: Fullmetal Edition / Special box (Animate exclusive)

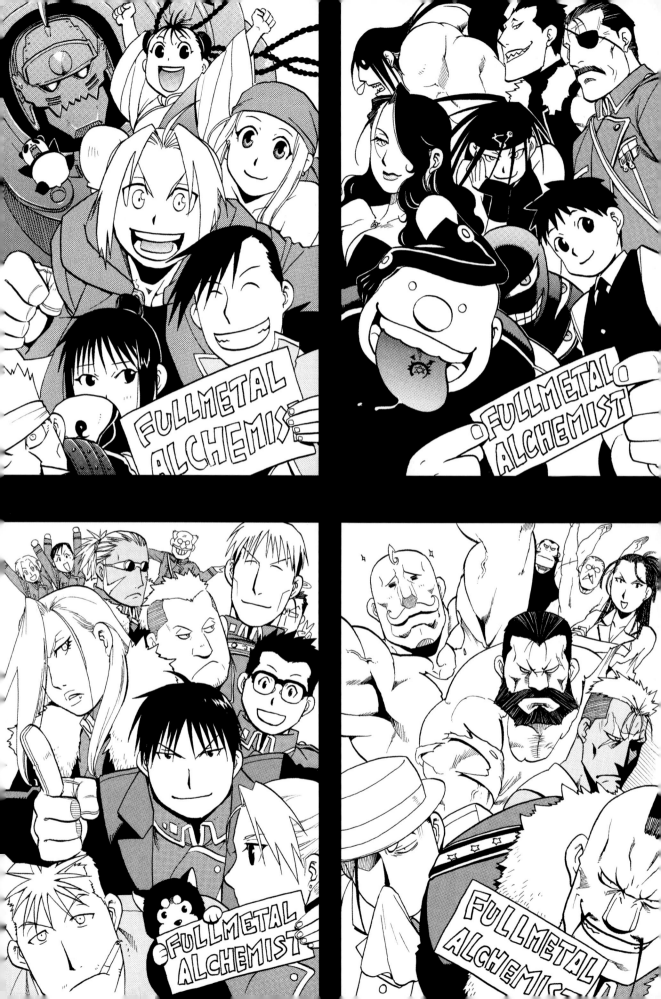

Fullmetal Alchemist
novels, volumes 1–6 / Illustrations

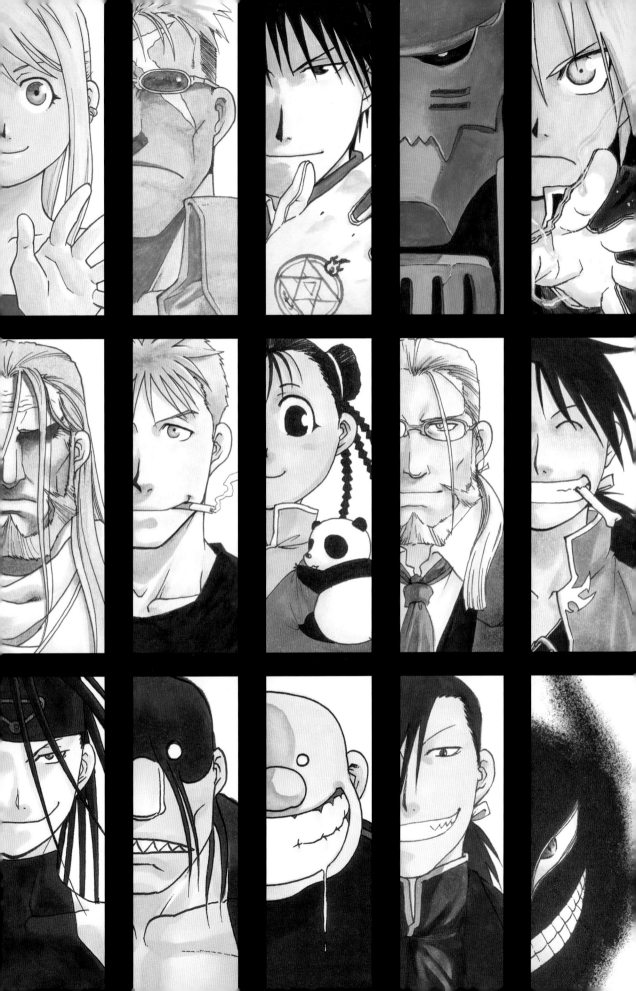

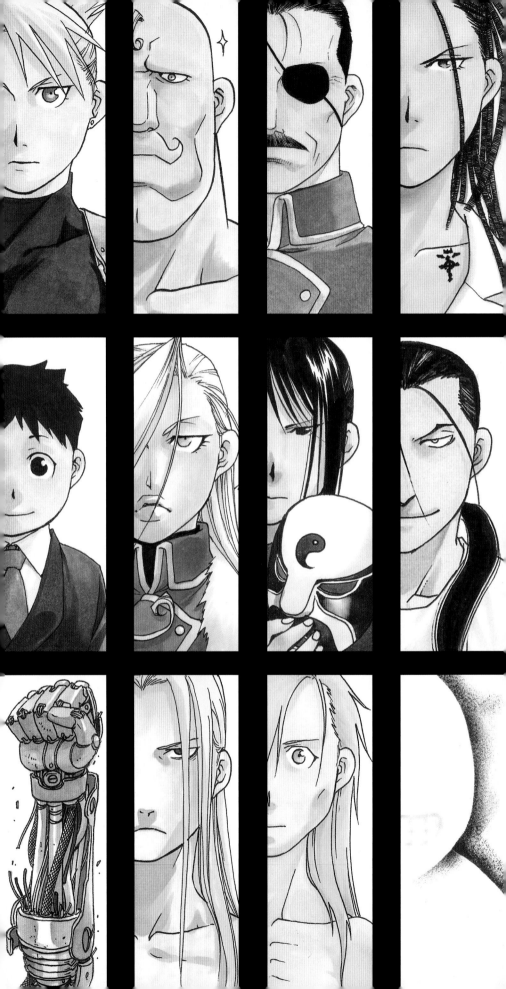

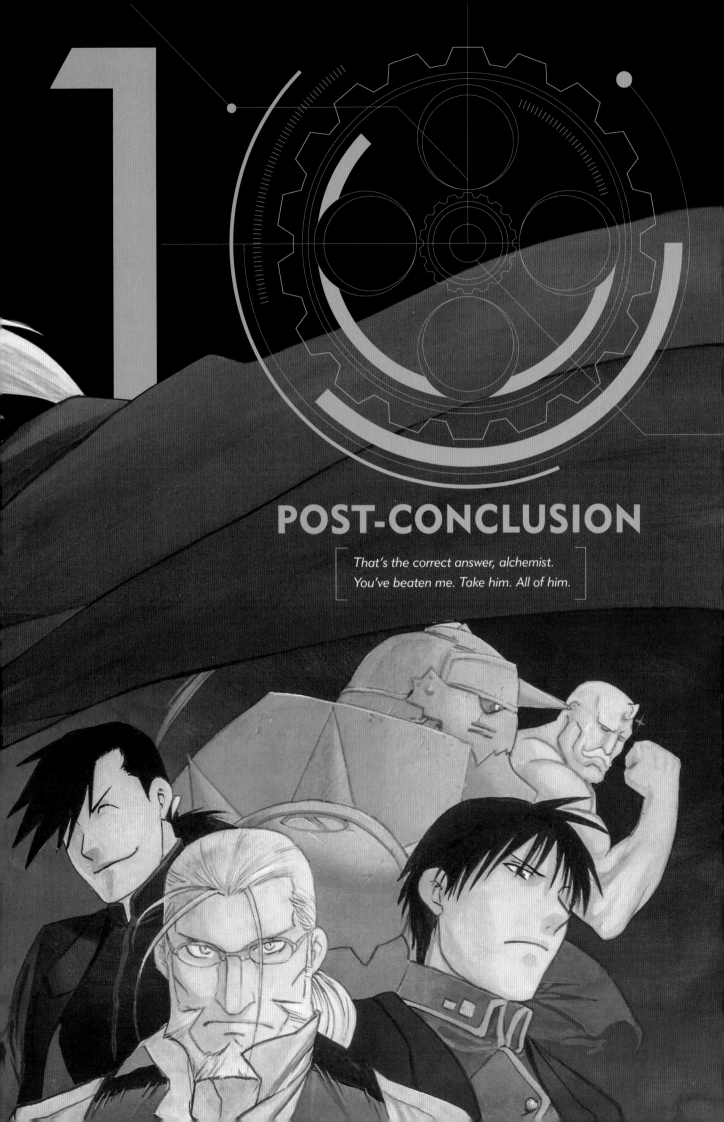

10
POST-CONCLUSION

That's the correct answer, alchemist.
You've beaten me. Take him. All of him.

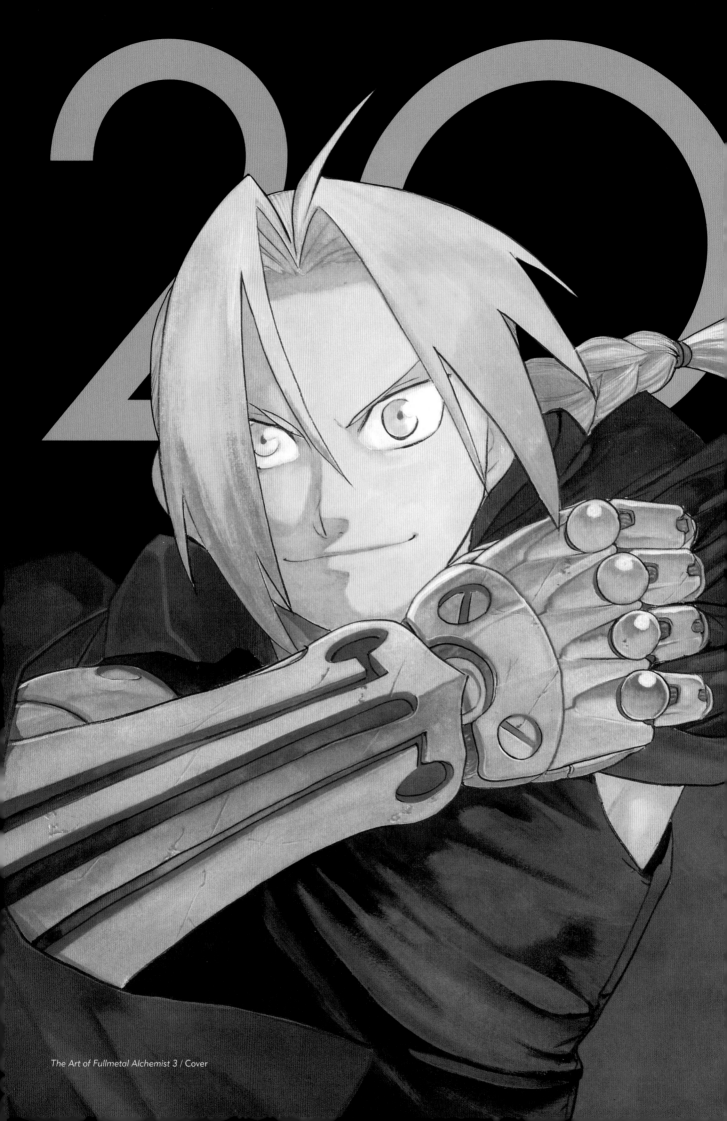

The Art of Fullmetal Alchemist 3 / Cover

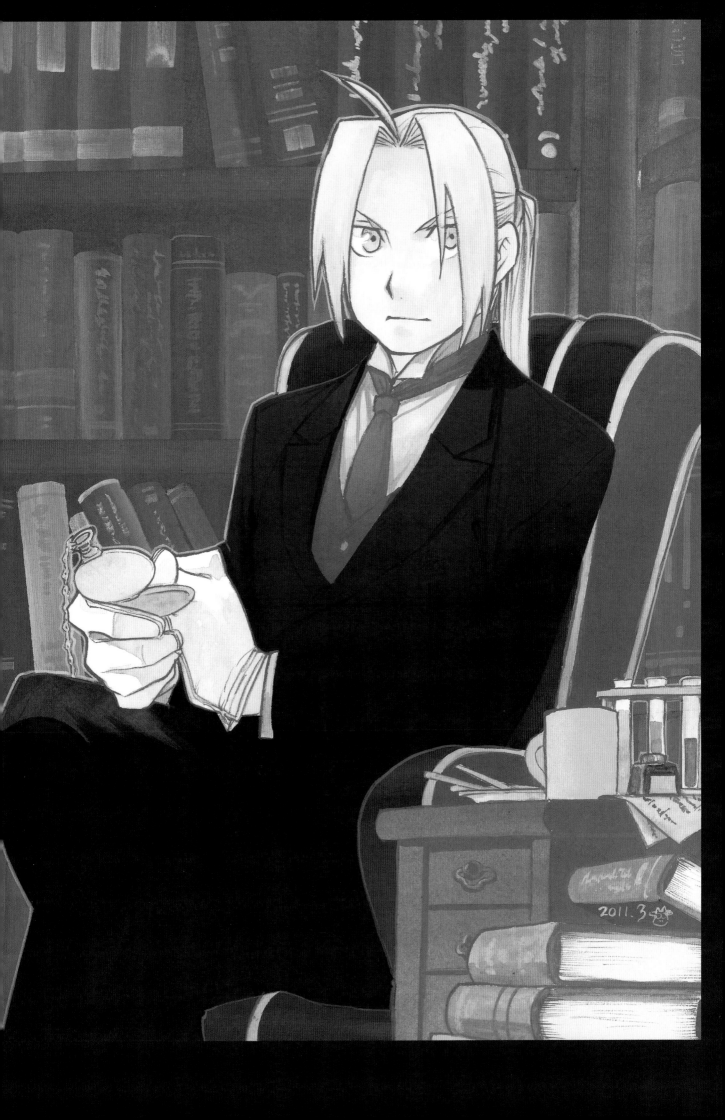

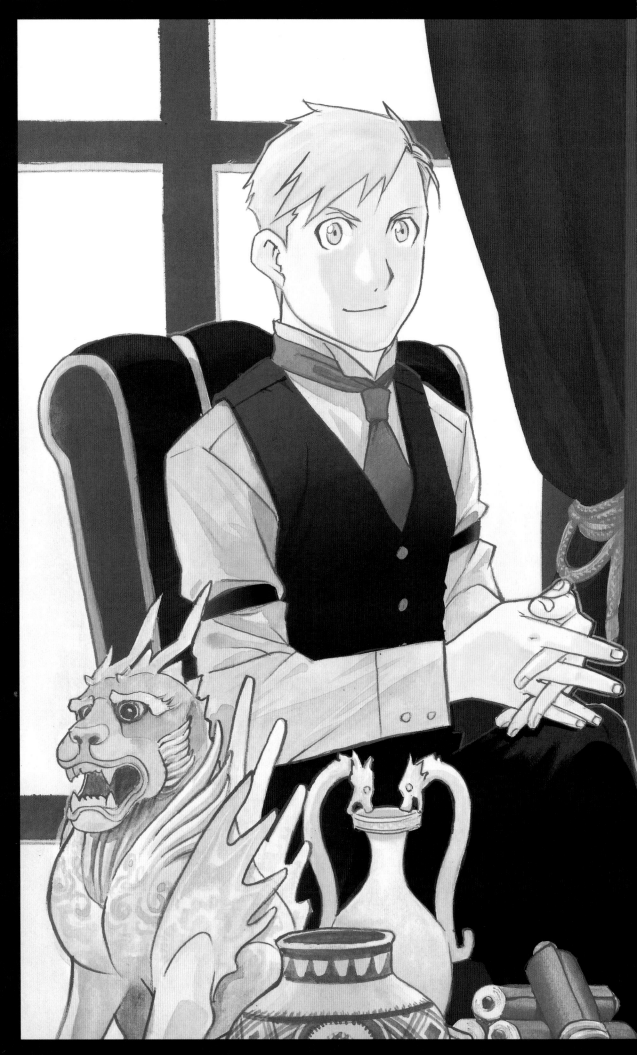

Fullmetal Alchemist: The Sacred Star of Milos theatrical film / Presale bonus school calendar

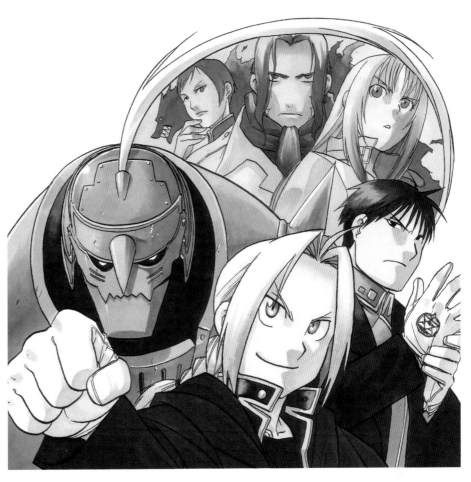

Fullmetal Alchemist: The Sacred Star of Milos theatrical film / Presale bonus

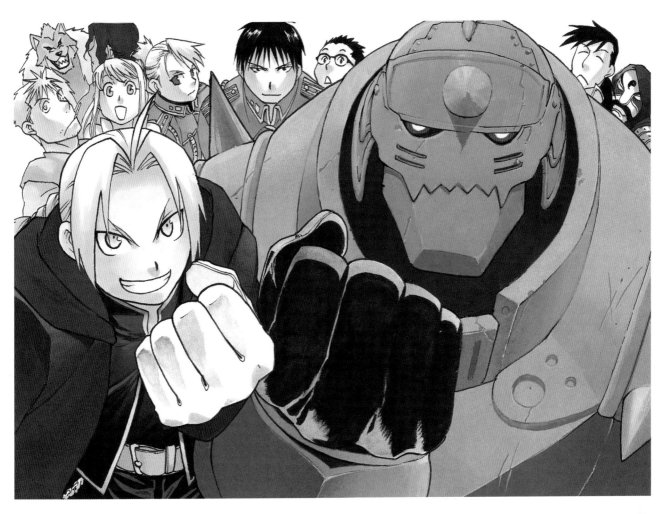

Fullmetal Alchemist: The Sacred Star of Milos theatrical film / "Fullmetal Alchemist 11.5: Before the Journey" pamphlet

256

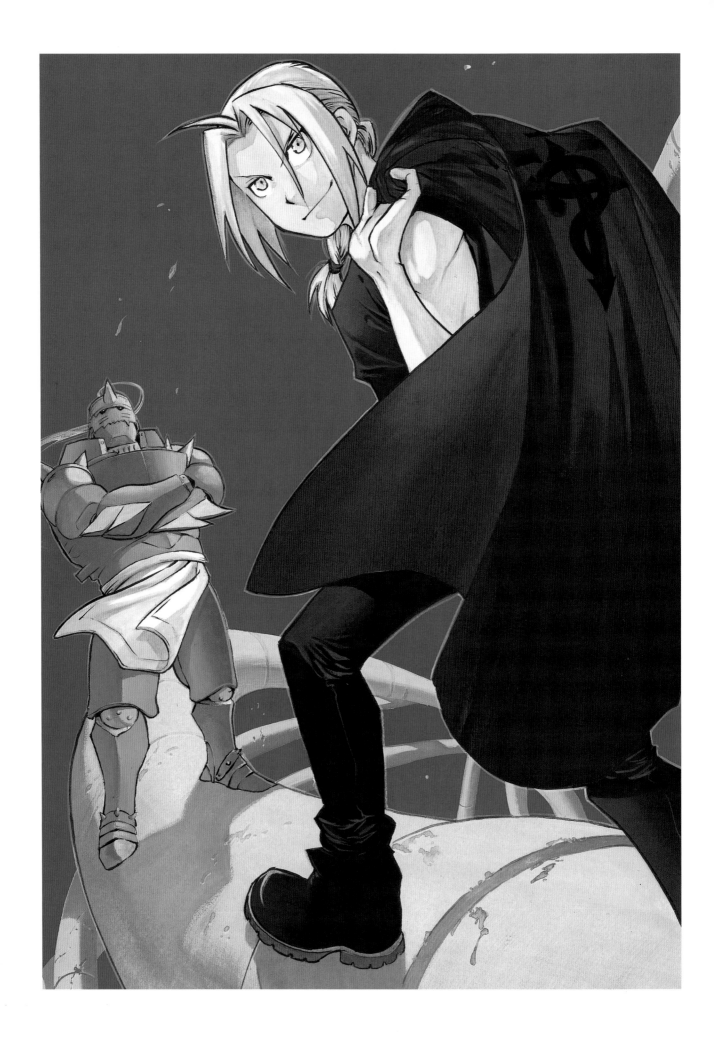

Fullmetal Alchemist: The Sacred Star of Milos theatrical film / DVD & BD box

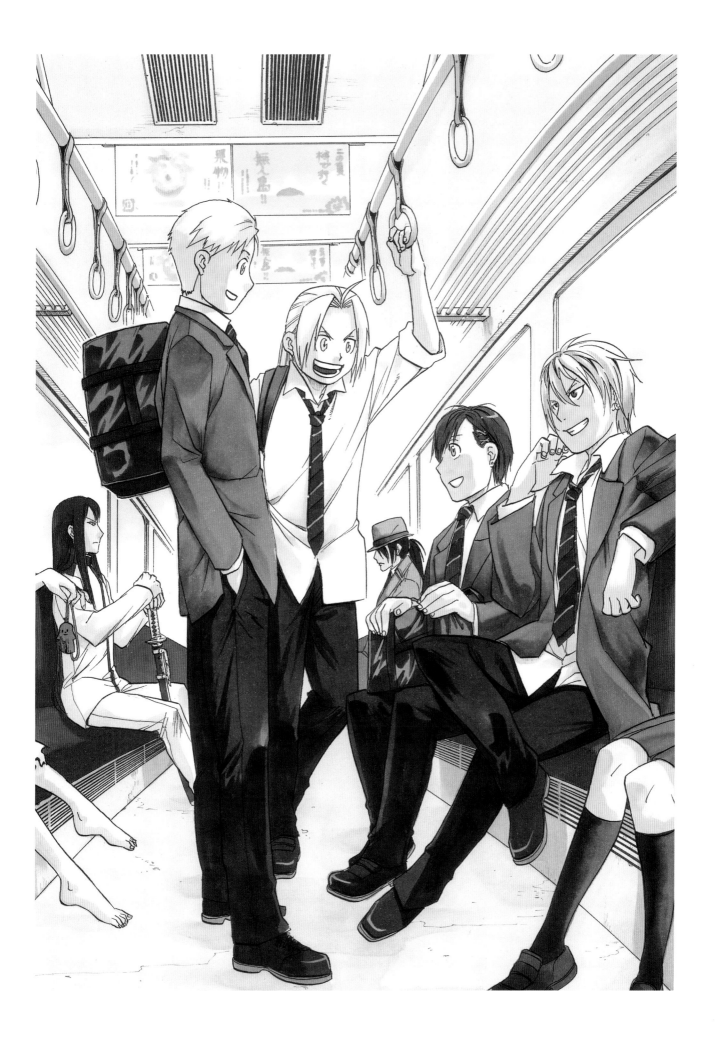

Shonen Gangan, March 2013 / Bonus poster, "Fullmetal Alchemist x Blast of Tempest"

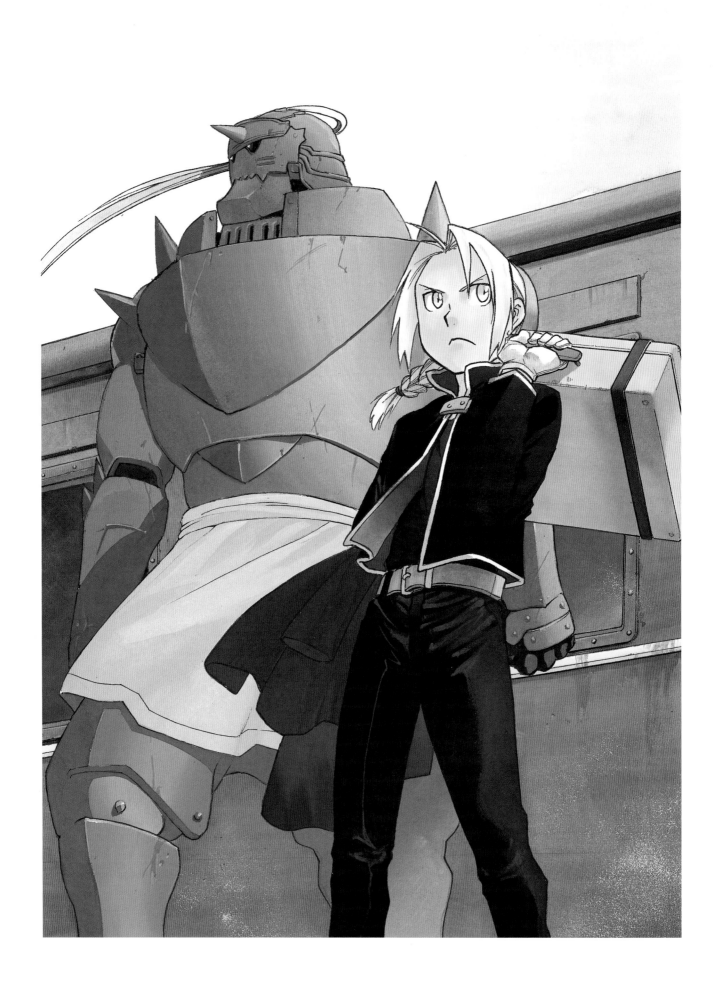

Shonen Gangan, July 2011 / Fullmetal Alchemist prototype

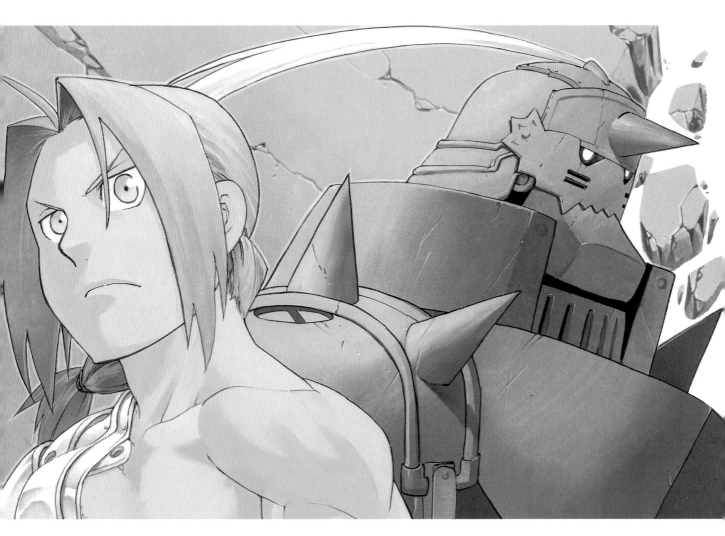

Fullmetal Alchemist: Chronicle / Cover

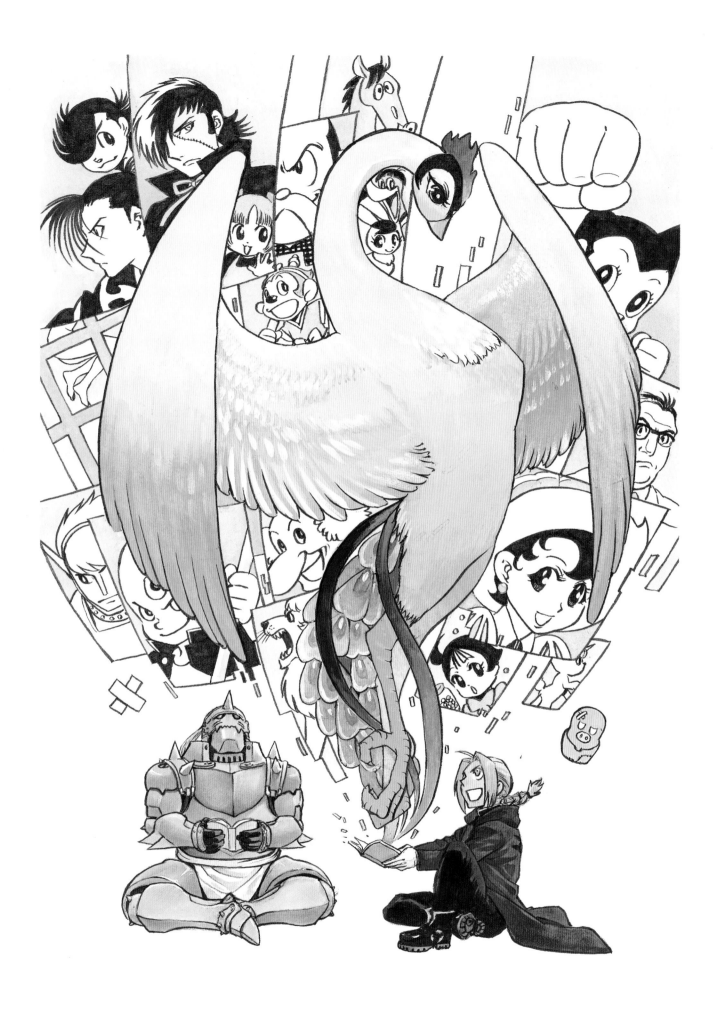

Osamu Tezuka Cultural Award 20th Anniversary Mook: Manga DNA, Those Who
Follow the Will of the God of Manga / Cover (Asahi Shimbun Publications Inc.)

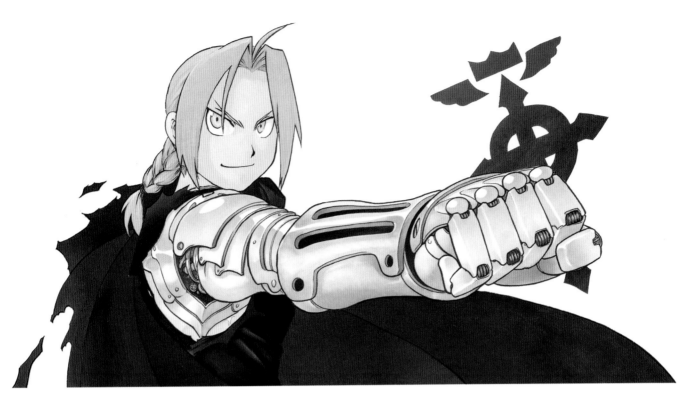

Fullmetal Alchemist: Fullmetal Edition, volume 1 / Cover

Fullmetal Alchemist: Fullmetal Edition, volume 2 / Cover

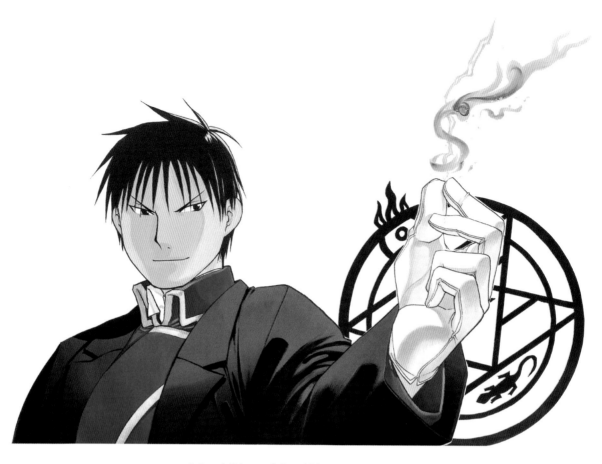

Fullmetal Alchemist: Fullmetal Edition, volume 3 / Cover

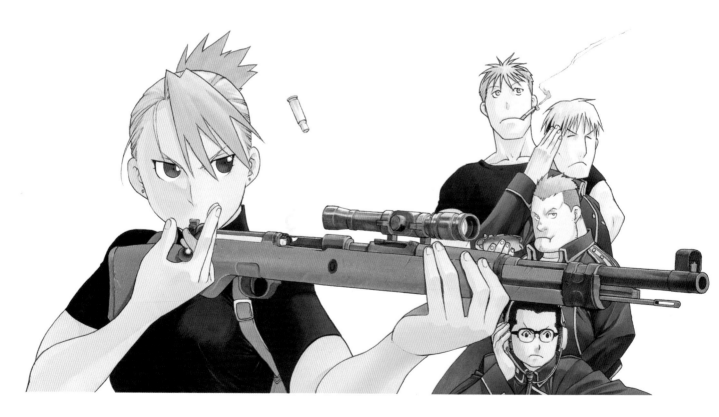

Fullmetal Alchemist: Fullmetal Edition, volume 4 / Cover

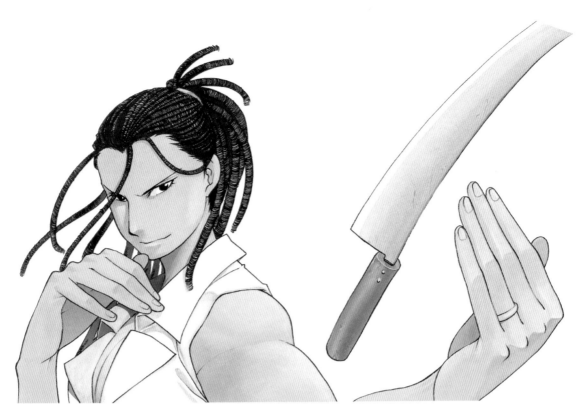

Fullmetal Alchemist: Fullmetal Edition, volume 5 / Cover

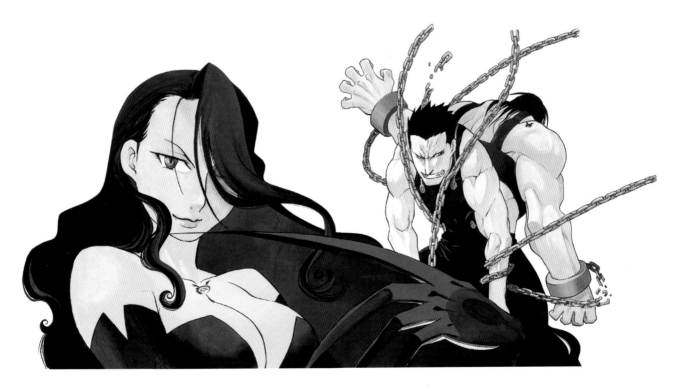

Fullmetal Alchemist: Fullmetal Edition, volume 6 / Cover

Fullmetal Alchemist: Fullmetal Edition, volume 7 / Cover

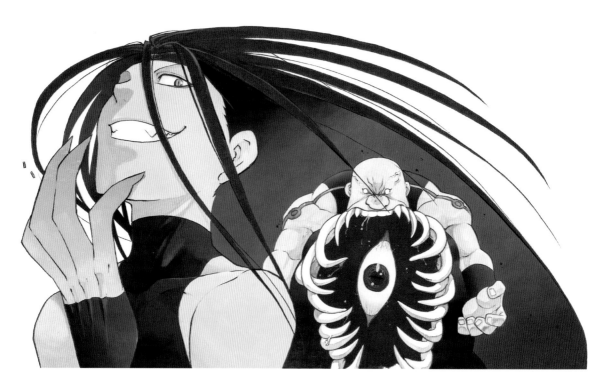

Fullmetal Alchemist: Fullmetal Edition, volume 8 / Cover

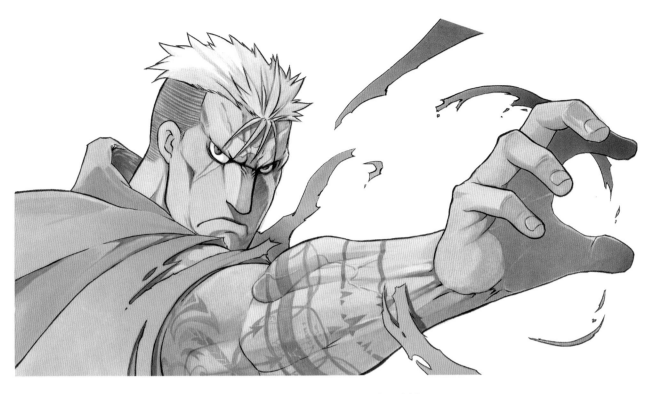

Fullmetal Alchemist: Fullmetal Edition, volume 9 / Cover

Fullmetal Alchemist: Fullmetal Edition, volume 10 / Cover

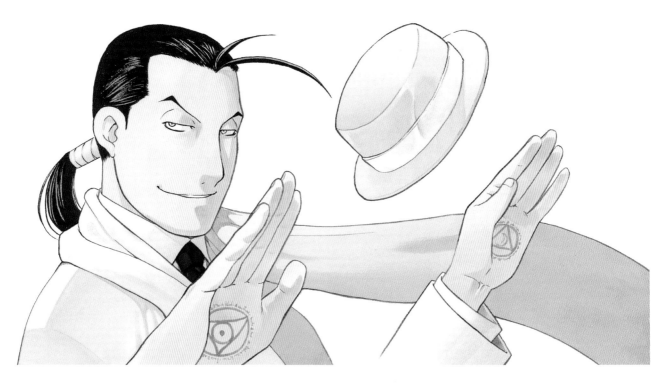

Fullmetal Alchemist: Fullmetal Edition, volume 11 / Cover

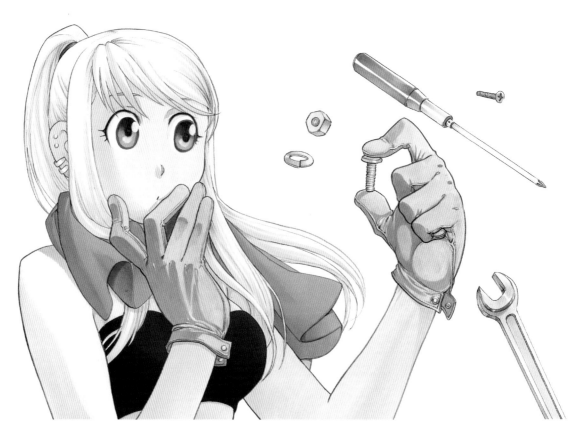

Fullmetal Alchemist: Fullmetal Edition, volume 12 / Cover

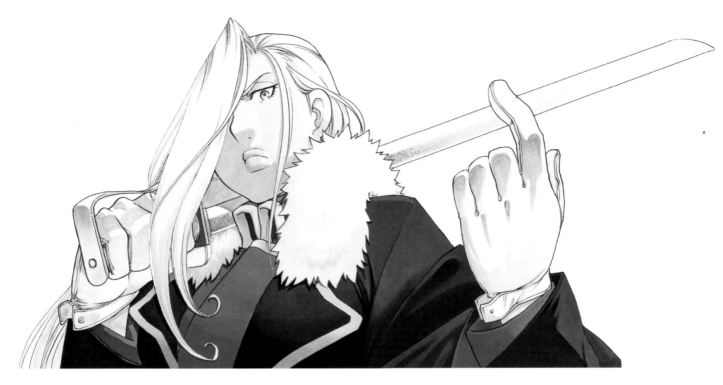

Fullmetal Alchemist: Fullmetal Edition, volume 13 / Cover

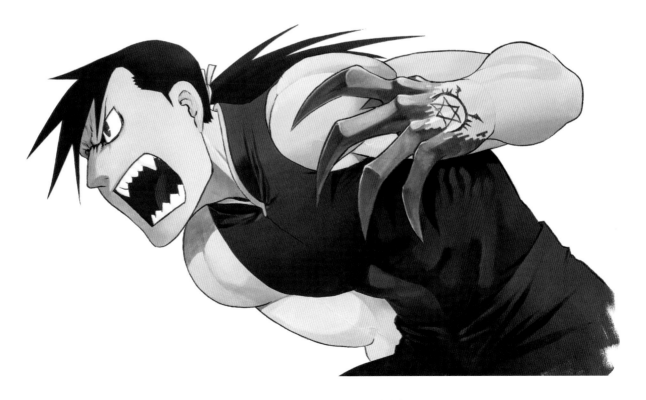

Fullmetal Alchemist: Fullmetal Edition, volume 14 / Cover

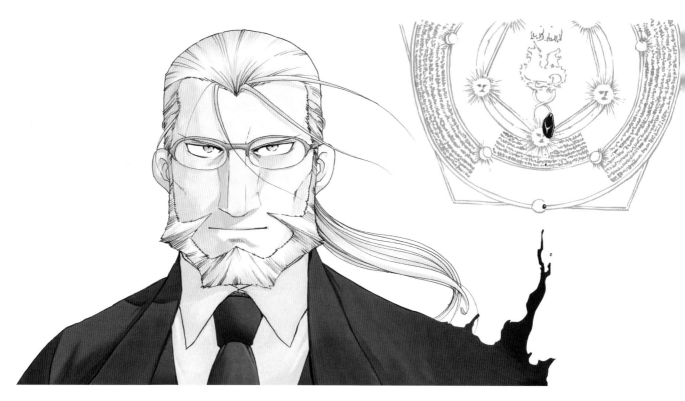

Fullmetal Alchemist: Fullmetal Edition, volume 15 / Cover

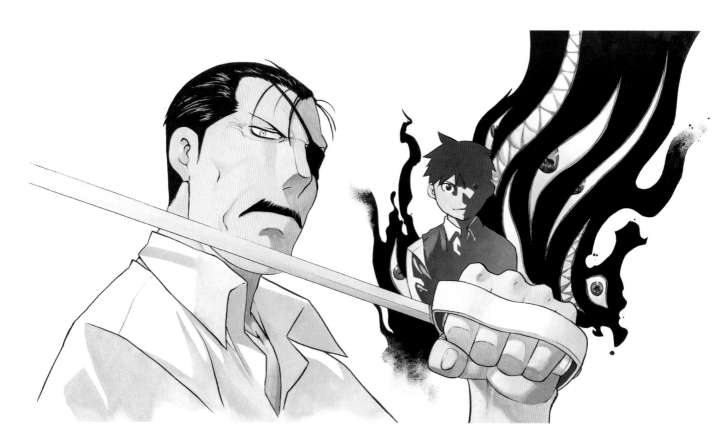

Fullmetal Alchemist: Fullmetal Edition, volume 16 / Cover

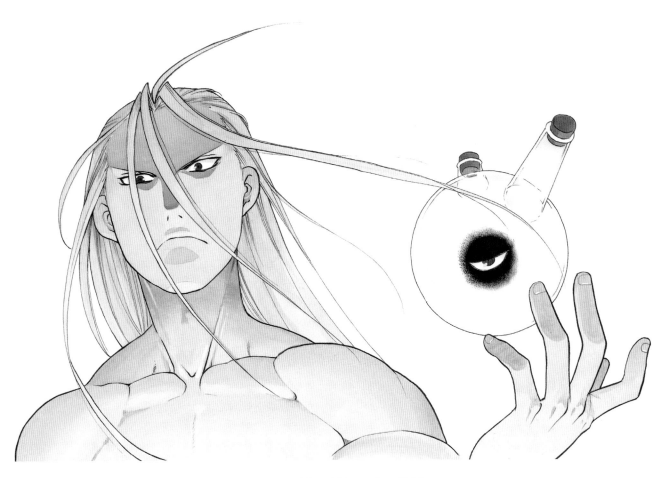

Fullmetal Alchemist: Fullmetal Edition, volume 17 / Cover

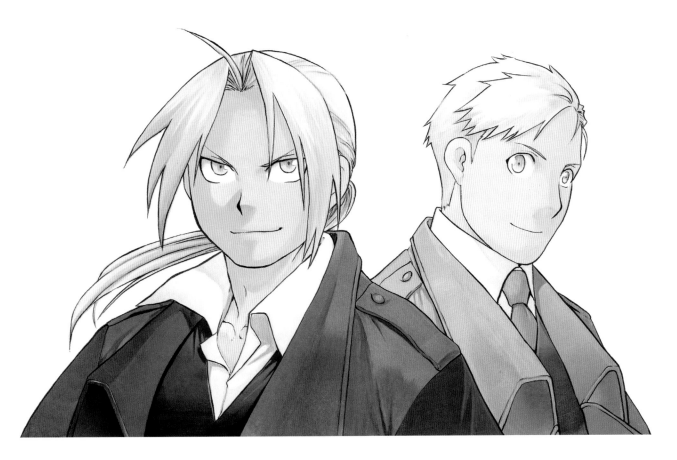

Fullmetal Alchemist: Fullmetal Edition, volume 18 / Cover

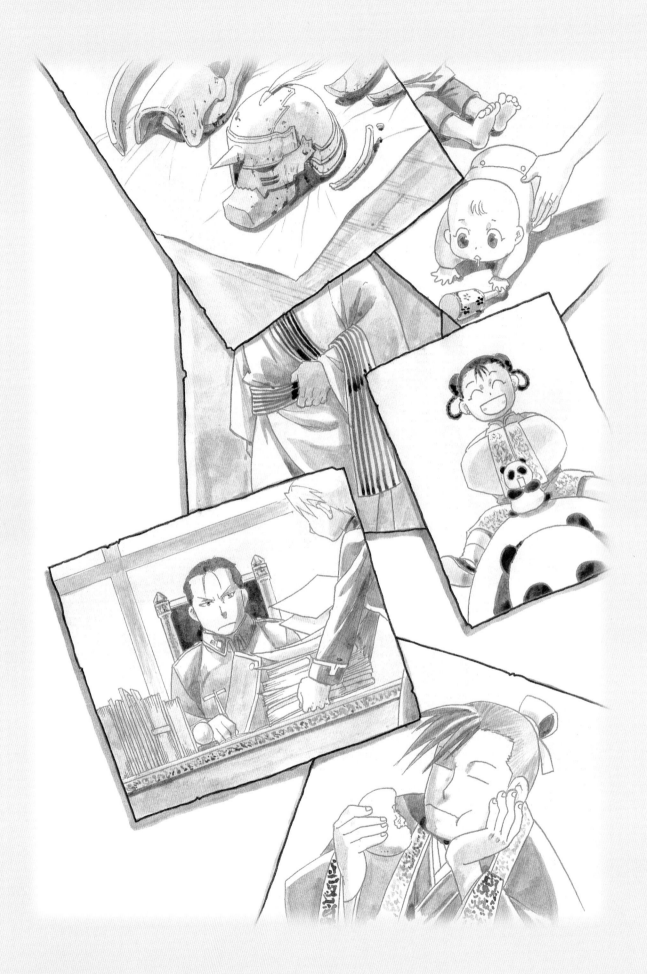

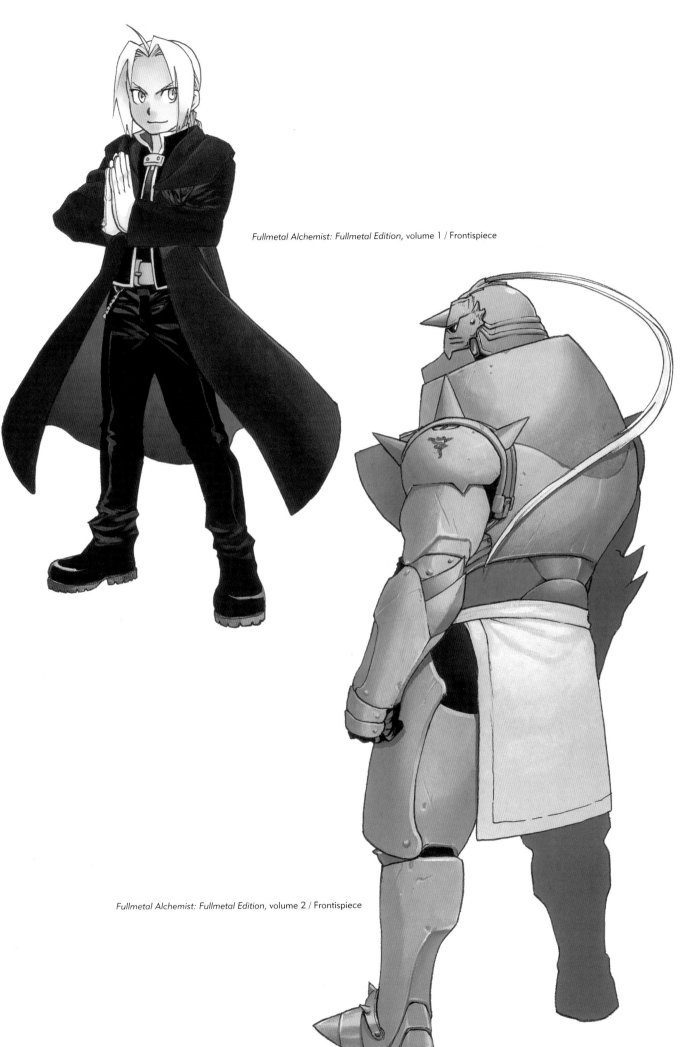

Fullmetal Alchemist: Fullmetal Edition, volume 1 / Frontispiece

Fullmetal Alchemist: Fullmetal Edition, volume 2 / Frontispiece

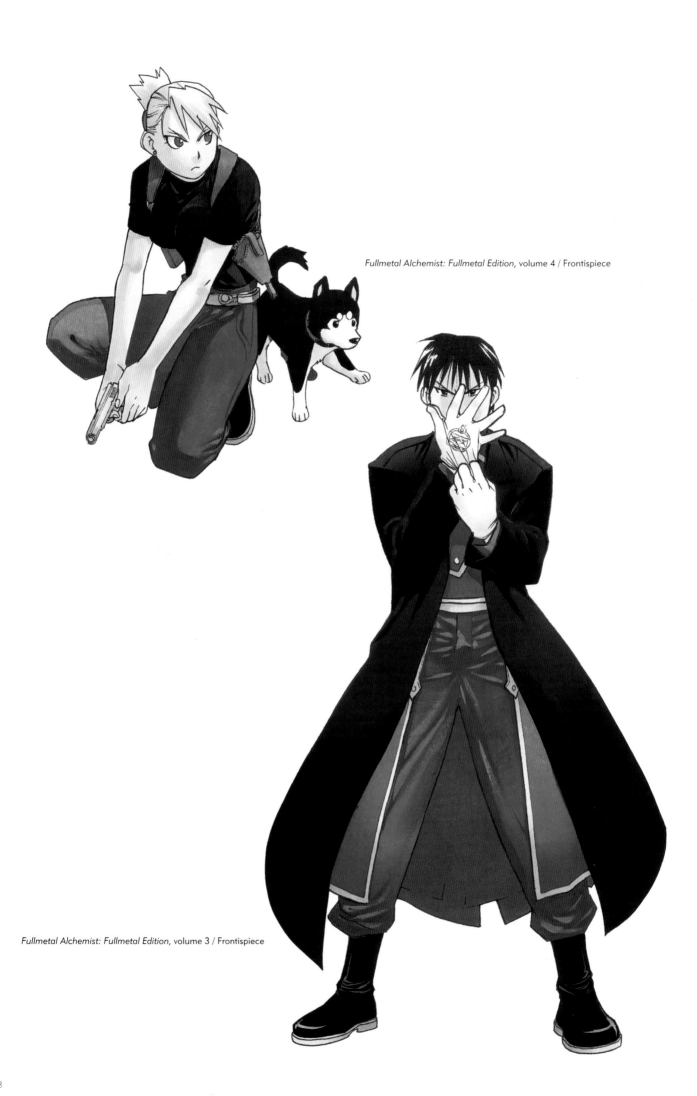

Fullmetal Alchemist: Fullmetal Edition, volume 4 / Frontispiece

Fullmetal Alchemist: Fullmetal Edition, volume 3 / Frontispiece

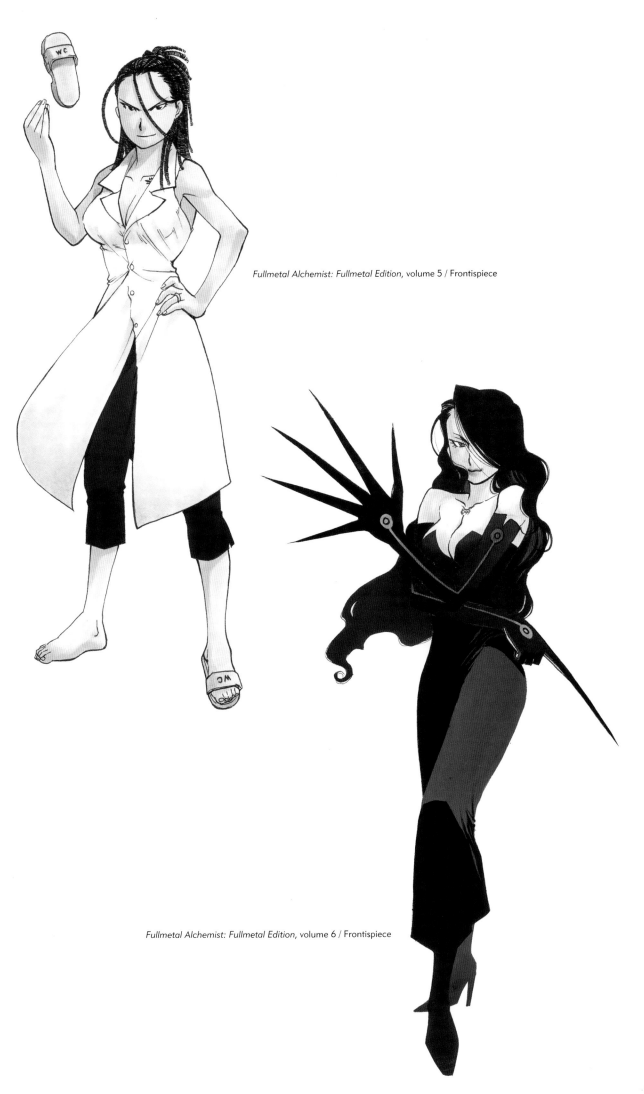

Fullmetal Alchemist: Fullmetal Edition, volume 5 / Frontispiece

Fullmetal Alchemist: Fullmetal Edition, volume 6 / Frontispiece

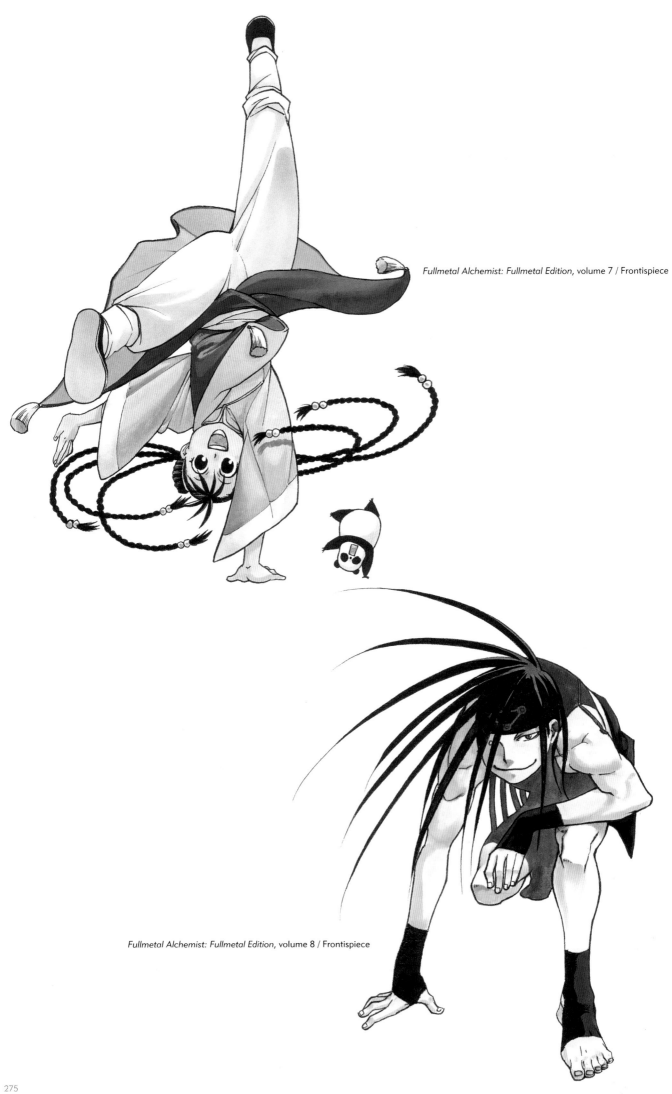

Fullmetal Alchemist: Fullmetal Edition, volume 7 / Frontispiece

Fullmetal Alchemist: Fullmetal Edition, volume 8 / Frontispiece

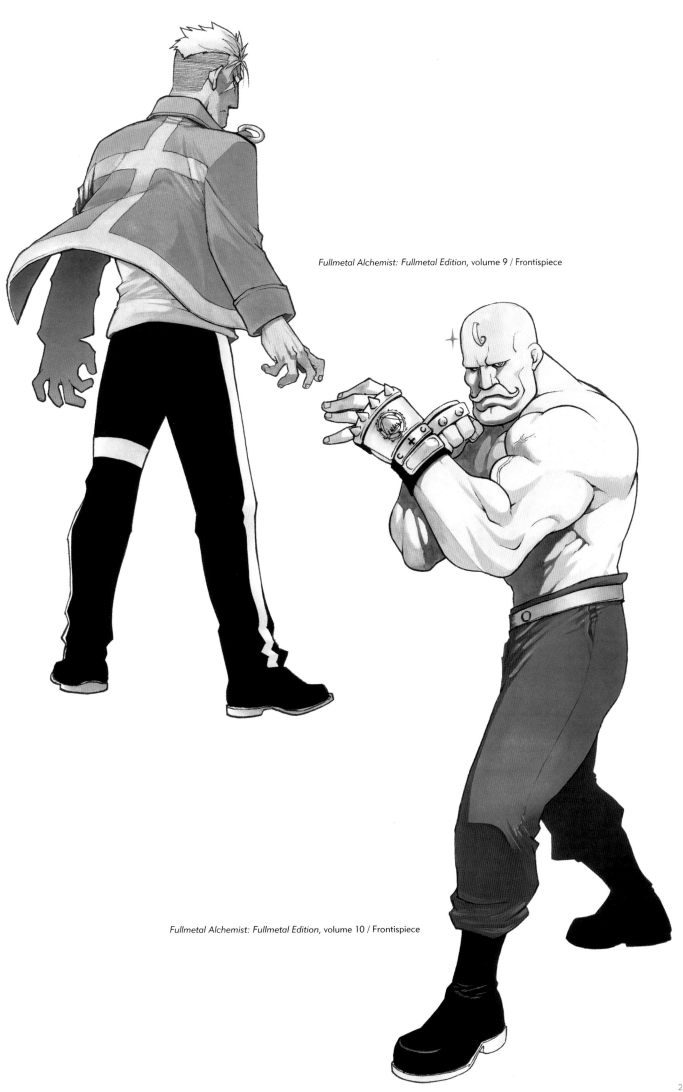

Fullmetal Alchemist: Fullmetal Edition, volume 9 / Frontispiece

Fullmetal Alchemist: Fullmetal Edition, volume 10 / Frontispiece

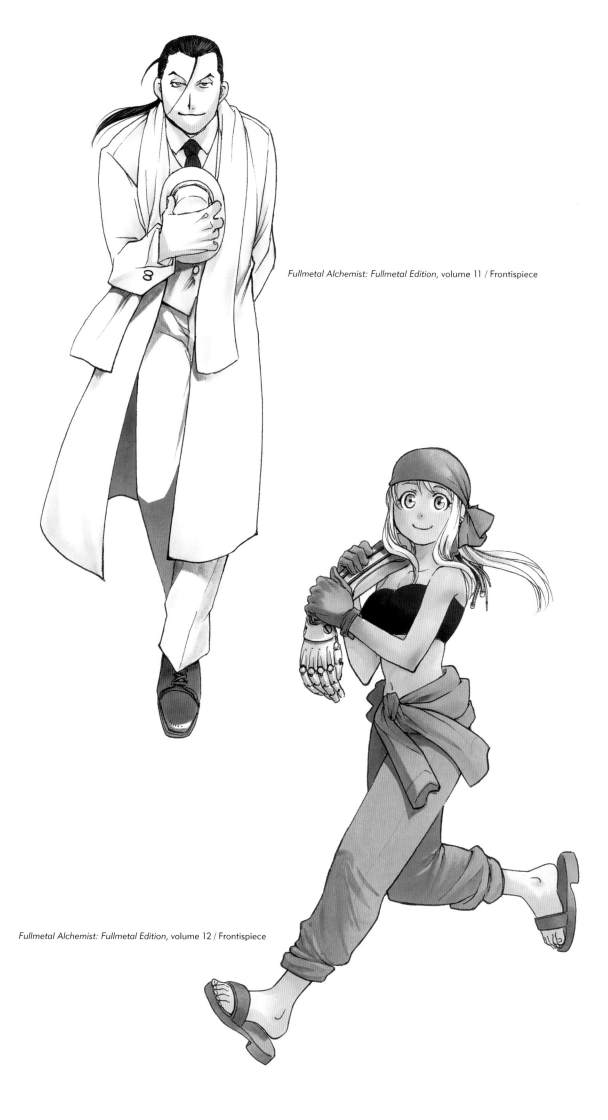

Fullmetal Alchemist: Fullmetal Edition, volume 11 / Frontispiece

Fullmetal Alchemist: Fullmetal Edition, volume 12 / Frontispiece

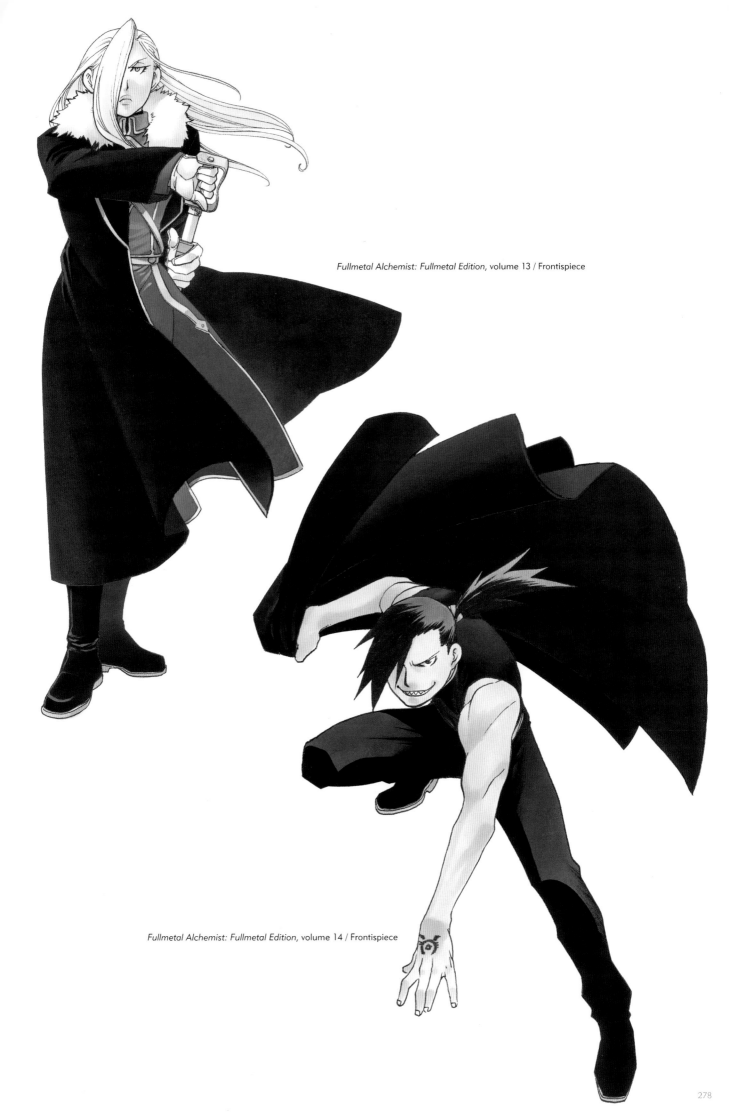

Fullmetal Alchemist: Fullmetal Edition, volume 13 / Frontispiece

Fullmetal Alchemist: Fullmetal Edition, volume 14 / Frontispiece

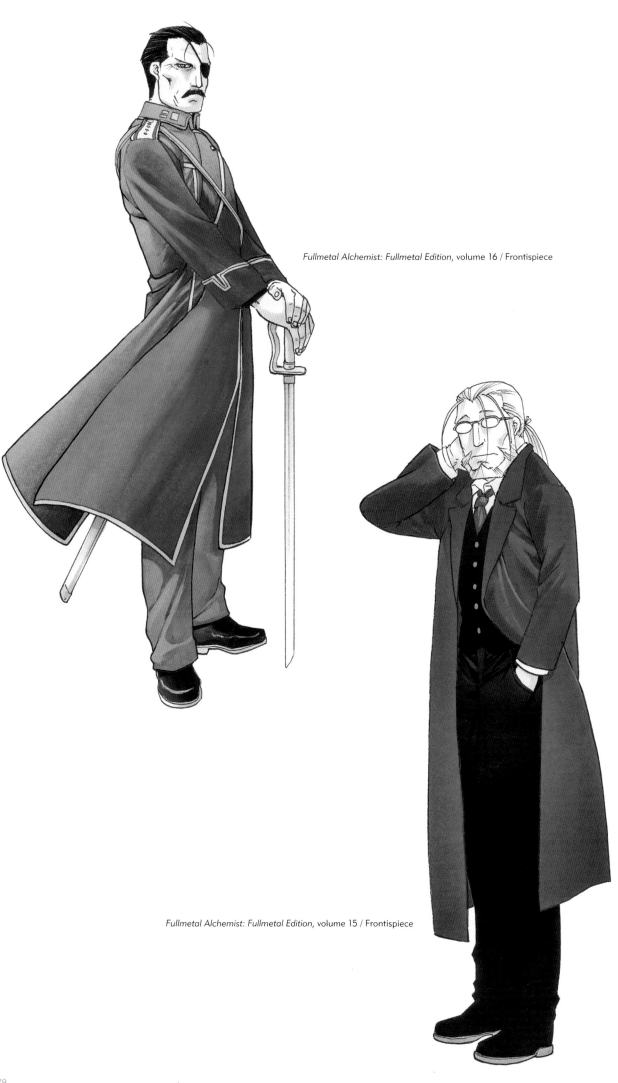

Fullmetal Alchemist: Fullmetal Edition, volume 16 / Frontispiece

Fullmetal Alchemist: Fullmetal Edition, volume 15 / Frontispiece

Fullmetal Alchemist: Fullmetal Edition, volume 17 / Frontispiece

Fullmetal Alchemist: Fullmetal Edition, volume 18 / Frontispiece

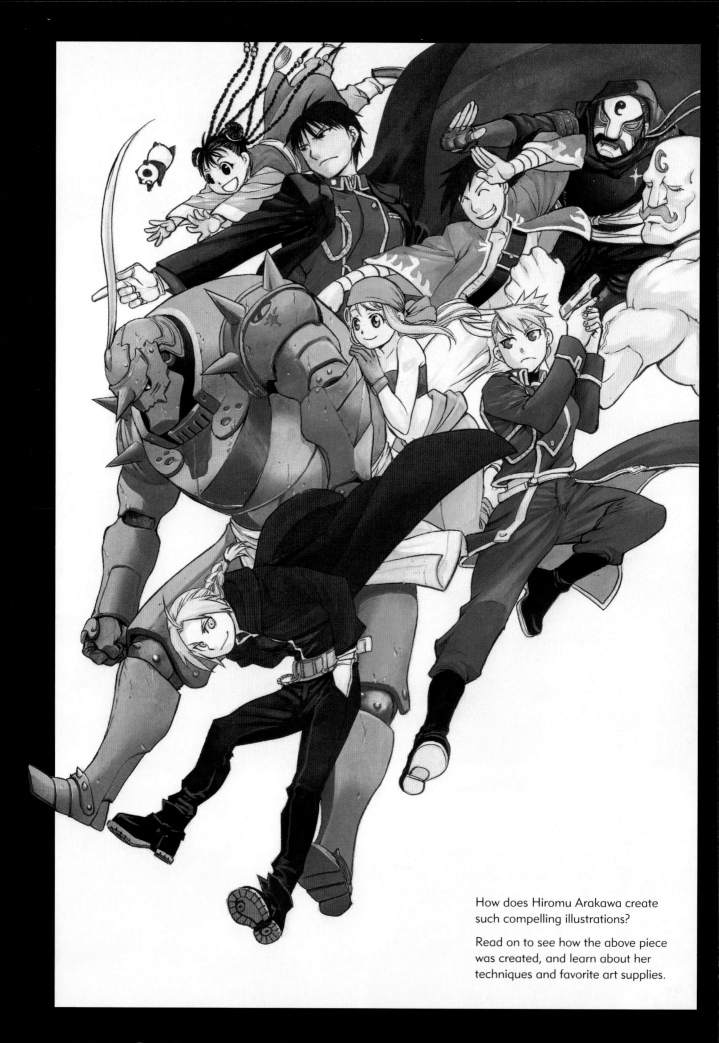

How does Hiromu Arakawa create
such compelling illustrations?

Read on to see how the above piece
was created, and learn about her
techniques and favorite art supplies.

ILLUSTRATING *FULLMETAL ALCHEMIST*

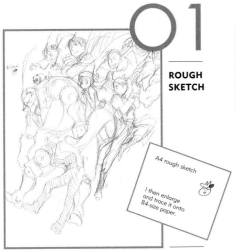

01

ROUGH SKETCH

A4 rough sketch

I then enlarge and trace it onto B4-size paper.

I rough out my concept for the image on A4 copy paper with a mechanical pencil. I get the overall composition and various characters' movements and expressions mostly finalized at this stage. After I consult with my editor, I move on to the underdrawing.

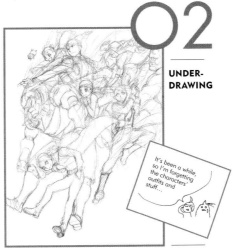

02

UNDER-DRAWING

It's been a while, so I'm forgetting the characters' outfits and stuff...

On a light box, I use the enlarged B4 rough to draw in pencil on watercolor paper. My favorite paper is Muse's Fabriano Extra White (superfine). It's sturdy and absorbent, takes color splendidly, and holds up to masking tape.

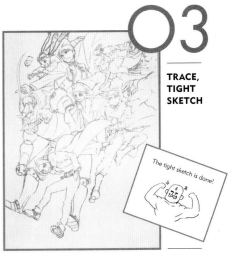

03

TRACE, TIGHT SKETCH

The tight sketch is done!

I do the tight sketch in brown colored pencil. The reason I don't use an ink pen is that if you mess up and have to use Wite-Out over the lines, it starts to become a problem when you go to color. This way, you can use an eraser to remove the colored pencil.

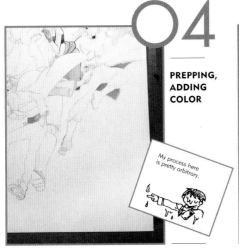

04

PREPPING, ADDING COLOR

My process here is pretty arbitrary.

After attaching the paper to my wooden drawing table, I wet the surface with water. This process, which is called "stretching," helps the paper absorb the color once I start to add it, and protects against wrinkling and buckling. After that, I use Liquitex paint to start blocking in characters' clothing.

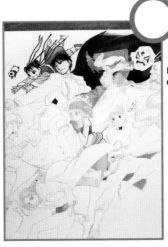

05

BACKGROUND CHARACTERS

I use masking tape to block off detailed areas, like over Mustang's coat or Mei's pigtail braids. I actually went over Mustang's coat again. Even if it's the same person's outfit, the folds of the fabric are different colors, which must be added bit by bit.

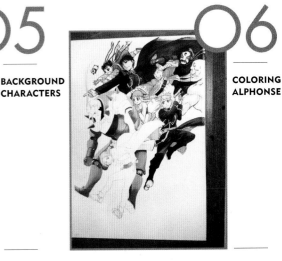

06

COLORING ALPHONSE

I have to be careful when applying and layering colors to Alphonse's body and adding shadows to create a metal look. This is why I say things like, "I love Liquitex, because it dries fast, and once dry, it's water-resistant, so even if you goof up, you can easily paint over it!"

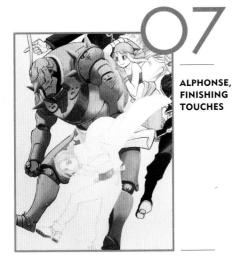

07

ALPHONSE, FINISHING TOUCHES

By giving darker colors to the heavier parts of the armor and adding highlights where light hits, the metallic feel and volume are realized. I don't have set ideas about cracks or dents in the armor, but I do think as I draw, "What kinds of marks would he have picked up in the course of living his life?"

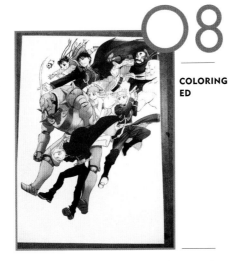

08

COLORING ED

The red of Ed's coat is an ever-evolving shade, and even now it's changing. The red and black clothes show up well on the paper, so doing all the background elements first and then trusting the acrylic paint to do its thing is the best approach. Filling in the details around the face takes particular nerve.

09

FINISHING TOUCHES, COMPLETION

Using a foam brush, I apply a light yellow wash to give everyone that bold, audacious look. This time around, the characters tend to be in red, blue, and green, so I use some nice orange tones as a contrast color. I add the final highlights, and done!

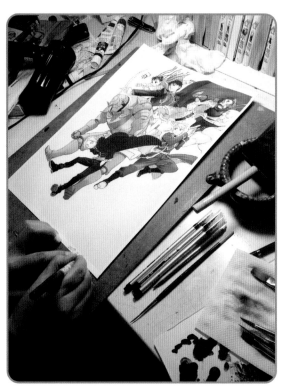

It's been seven years since the serialization of *Fullmetal Alchemist* concluded. But with this special illustration being released and the live-action movie coming out, 2017 seems like a special year for *Fullmetal Alchemist*. You went through your process for creating this illustration on the previous page, but what about the concept behind it?

Arakawa: At first I thought of going for a high-angle shot over a bunch of characters in a group on the ground, but then it evolved into more of a "Hey, it's been a while! We're back!" vibe. So the composition is such that everyone is kind of flying in from above.

What is it like drawing the characters from *Fullmetal Alchemist* after all this time?

Arakawa: Good question… Since it's been a while, I actually wound up referencing my old illustration collections and the graphic novels quite a bit. And I wound up drawing Ed's legs noticeably longer than usual (*laughs*).

Beyond this particular illustration, what tools do you typically use?

Arakawa: As time goes by, my tools change quite a bit. When I go to the art supply store, I pick up new things that look useful, and if they work out, I incorporate them into my process. For inking, I often use a brush pen, but in places I'll switch to a Hi-Tec pen. I generally use Liquitex acrylics for color, but I'll use Copic markers in places, or even pastels.

Are there specific guidelines that you use when coloring that you could tell us about?

Arakawa: The general rule is to start with light areas and move to darker, but Liquitex dries fast and is water-resistant, so I can start at the center and say, "Okay, I'll color here, and then that part over there," "There will be a lighter area, here I'll make it darker." Liquitex gives you the flexibility to do as you please. But I frequently paint the skin tones and then go on to the darker clothing after that.

So when applying color, it seems that particularly with clothing, you use masking tape to divide up areas while you paint.

Arakawa: So fabric, because of the way it folds on itself, has parts that should have gradation into shadow, so it's easier for me at least to use masking tape to separate different areas of that as I paint. Actually, if you look at the maker, this is specifically architectural painter's tape (*laughs*).

For the final touch, you used a large foam brush to do a light yellow wash over the entire image to give it more impact.

Arakawa: After painting various parts individually, I do a light color wash over the whole surface to help blend and unify the image. This time I went with a nice complementary orange for the color wash, but if it were a darker scene, or if it heavily featured Alphonse, I'd go with blue, or if it were a sunset, I'd use orange. And the volume 13 graphic novel has red in three different shades, from foreground to background.

I see. So now that it's complete, what are your thoughts on the illustration?

Arakawa: It really does give the impression of "It's been a while! We've missed you!" I don't know if it's because I was trying to remember how to draw them or was nervous, but I kept thinking, "Maybe I should have drawn the various homunculi in here… But they would have made the image so dark… I guess, balance-wise, this is okay," and stuff like that, in my little one-person artistic postmortem.

Thank you so much for this. Next up, we'll continue by asking more generally about your illustration work.

A homemade color chart that hangs in my studio. It was made shortly after serialization began, but even now it expands bit by bit with new color samples.

ART SUPPLIES

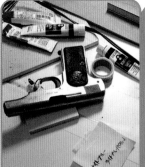

A model of Hawkeye's iconic handgun, a Browning M1910. Her sniper rifle is a Mauser Karabiner 98k.

MASKING TAPE

I use this tape to cover and protect areas of the page from getting splattered with paint and such while I work. I tear it by hand, and it peels off easily.

FOAM BRUSH

This is a painting tool with a thick piece of foam for the brush head. With this one brush, I can spread water to stretch and prep the paper or do a final color wash.

ART TABLE

I've been using this unfinished wooden art board for twenty years. It's like an old battle comrade, and I could never discard it.

WATER DISH

I use a distinctive shallow bowl to hold the water I need to wet my brush tips. It's got a water buffalo motif. I also use a dish meant for sweet sake to rinse my brushes.

COLORED PENCIL AND KNIFE

Now that I'm an adult, out of a sense of nostalgia I've wound up using the knife that my grandfather used to use to sharpen his pencils. I really love using it for my colored pencils.

PENS

This time for inking I used an Akashiya brush pen (superfine line, from Sai), but I also use Nouvel's Pigma Graphic as well.*

PAINTBRUSHES

For painting, I primarily use Talens' Van Gogh Visual brushes and Bonny ColArt's New Bonny Long Brush.

LIQUITEX

With outstanding stability and durability, it's the world's first water-soluble acrylic paint. It can be watered down and layered like watercolors, but it can be used like oil paint as well.

*Recently, the Pigma Graphic has become the Sakura Craypas Pigma.

SPECIAL INTERVIEW
WITH HIROMU ARAKAWA

In this special interview, we asked author Hiromu Arakawa to look back on the many color illustrations she's drawn for *Fullmetal Alchemist* since the series began serialization in 2001! We inquired about both the challenges and the joys of working in color.

Is there any secret meaning to the colors chosen for the characters' designs or costumes?

Because Ed's automail requires oil, he generally wears black. I considered making Colonel Mustang's uniform red at first, but I almost immediately changed my mind. "No, no, no (*laughs*)! That'd make him way over the top!" After more thought, I settled on the current blue.

Is there a particular color you're fond of when painting, or one you find yourself using frequently?

I tend to use light blues and light purples frequently when drawing shadows in particular. When Acryl Gouache first came out with their Ayanami Blue, I bought a whole bunch of it almost immediately. So, yeah.

Is there a particular illustration that you've been hoping to work on that you could tell us about?

It's not so much an illustration, but maybe a bit of pastoral art, I suppose. Obviously, after everyone is done working the fields (*laughs*). Everyone would be sitting around eating rice, slowly digesting. It would metaphorically become the reader's flesh and blood, so it would be the perfect beginning and concluding illustration.

I'd like to ask you about the illustration you drew for the first serialization announcement in *Shonen Gangan*. According to your first illustration collection, you didn't have much time, so you just "did this one in a rush with some acrylic paints." What was that like?

I had a set of twelve acrylic paints at the time, just the basic set from an art supply store. After that, over time I worked hard to create more and more harmonious color work. I started using higher-quality acrylic paints and tools, adding more colors, utilizing masking tape, and so on and so forth. At the moment I've been really enjoying using Muse's Fabriano watercolor paper.

Do you have an example of any color schemes that are completely set?

The military uniforms are Liquitex's Night Blue and Light-Blue Violet. Al's armor is Acryl Gouache's Misty Blue and Ash Blue.

How do you choose an overall color scheme for an illustration? Do you decide in advance, or try out options, or go back and forth about it, or just decide the color as you go?

I didn't really have time to carefully test my options for *Fullmetal Alchemist* (*laughs*). There were so many other things that I dithered about regarding the work that pretty much as soon as I'd settled on the image of what I wanted to draw, I'd just do it in one go. But one time when I had the opportunity to talk to Hirohiko Araki (author of *JoJo's Bizarre Adventure*) he told me that I ought to try to paint more freely, so recently, even when a character has a particular color scheme associated with them, I'll try mixing things up with a different color here and there.

What do you use for reference?

I have models for the guns. (So for example, the standard weapon used by the military in the story is a Colt M1911A1, so I have a reference for that.) And I have a heap of plastic models of military vehicles and steam locomotives that I supposedly keep for reference…

Are there particular motifs that you find interesting to draw, or things that you really enjoy?

I really love drawing animals. And I like drawing piles of rubble. Pipes and utility tunnels are fun too. And I like Envy's true form (the big one!), so when I had the time, I kept wanting to draw it larger and more complicated!

What did you always have to keep in mind while doing color illustrations?

The thing I always had to remind myself of, and that I always forgot was…

Ed's hair tie.

What did you enjoy about the color work in comparison to the manga pages?

I really enjoyed that it was just one page and then I was done! If I really think about it, color illustrations were always grueling but fun. Especially group illustrations, where I'd have to think about where to position everyone and what pose they'd be in. It was like a fun puzzle, and when you're done, there's a great sense of accomplishment. Oh, and drawing characters laughing is usually fun.

When you're doing color work, are there moments that you find easier or refreshing?

When I'm finished, and I can finally throw away the big ball of masking tape (as I work, I make a single big ball of the used masking tape). I find that supremely refreshing.

Looking back on your body of work, I think you've improved in certain areas like color usage and brush technique. I'd love to hear a bit about what you think you've improved on.

Besides advancing my technique, I've improved my processes and my speed. That's true of my black-and-white work too, where the speed of serialization is a great teacher. You can't help but learn how to work faster. You have to scrub second-guessing from your vocabulary and just go for it. So, for example, when I was first working, I tended to paint very heavily, layering thickly as if I were painting with oils. But then I found out that the printer really struggled with my pieces, and I thought to myself, "Maybe try painting a little more lightly." The result was pieces that took less time and reproduced better.

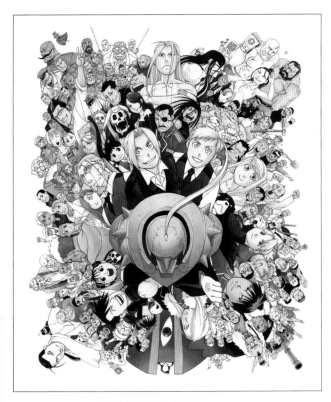

Celebrating the release of the final volume, an autographed illustration board and silver watch set was released.

There are three hundred illustrations in this book. Are there any that have particular meaning to you, and why?

The illustration that we're using as the cover for this collection features the whole cast in a group shot. The paper was huge, and I went all in adding characters, and so when I was finally done drawing, I really felt like I'd accomplished something! Also, that illustration was part of a limited edition release for the final volume, so I went to Square Enix and signed every sheet. But about the same time, the Tohoku earthquake happened, and I remember that vividly as well. Then there's the opening color illustration for the final chapter. I thought to myself, "Wow, all of a sudden we're here!"

Honoring the victims of the Tohoku earthquake and tsunami, Square Enix's authors all put together inspirational and motivational messages and illustrations that were released through *Gangan Online*. This is author Hiromu Arakawa's original illustration.

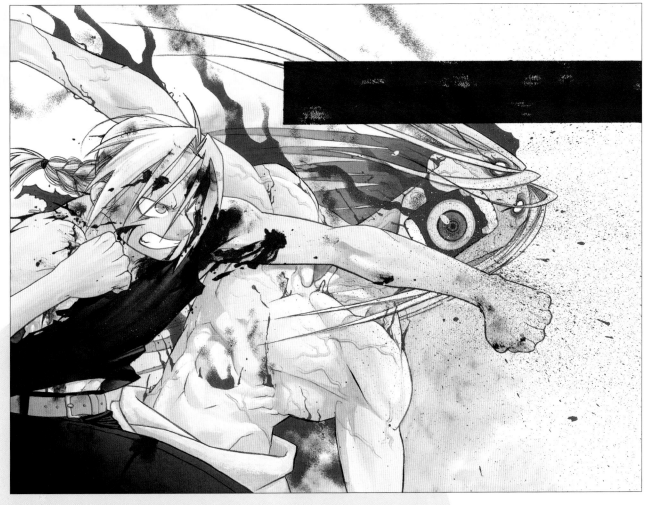

Shonen Gangan, July 2010 / Chapter 108, "Journey's End"

This is my first illustration collection in a while! I never imagined we'd still be putting them out, so thank you, thank you to all of you who pushed for it, and thanks once again!

Gosh, it really has been a while, hasn't it? It's been so long that when I was drawing Al down here ↙ I kept wondering if I was doing it right, but I drew from memory and I guess I've still got it! Aw yeah!

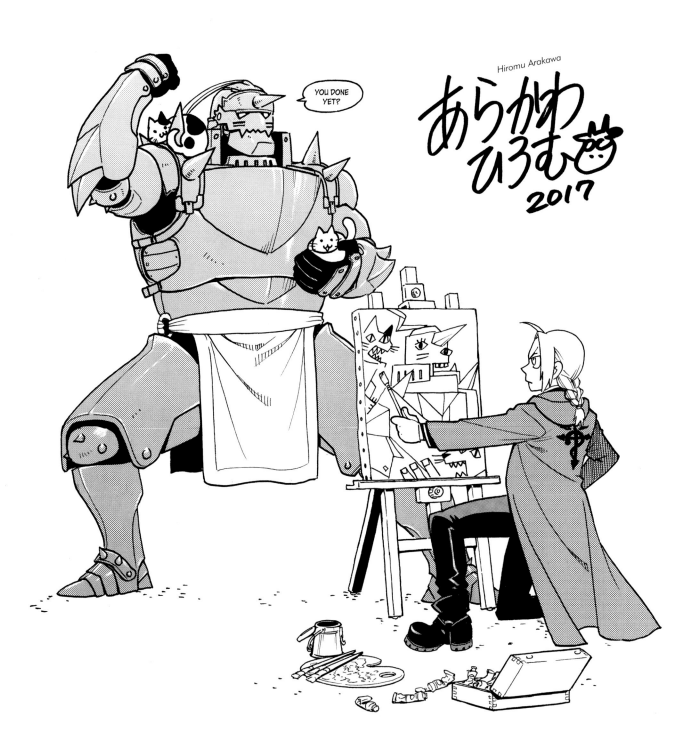

THE COMPLETE ART OF
FULLMETAL ALCHEMIST

HIROMU ARAKAWA

TRANSLATION: Lillian Diaz-Przybyl
DESIGN: Adam Grano
EDITOR: Hope Donovan

HIROMU ARAKAWA ARTWORKS FULLMETAL ALCHEMIST
© 2017 Hiromu Arakawa/SQUARE ENIX CO., LTD.
First published in Japan in 2017 by SQUARE ENIX CO., LTD.
English translation rights arranged with SQUARE ENIX CO., LTD.
and VIZ Media, LLC. English translation © 2018 SQUARE ENIX
CO., LTD.

The stories, characters, and incidents mentioned in this publication
are entirely fictional.

Printed in China

Published by VIZ Media, LLC
P.O. Box 77010
San Francisco, CA 94107

10 9 8 7 6 5 4 3 2
First printing, November 2018
Second printing, June 2021

viz.com

COPYRIGHTS

p.100, *Fullmetal Alchemist and the Broken Angel* game novelization / Cover: © 荒川弘／スクウェア
エニックス・毎日放送・アニプレックス・ボンズ・電通 2003 ©2003 RACJIN/SQUARE ENIX
All Rights Reserved.

p.101, *Fullmetal Alchemist and the Broken Angel* game novelization / Bonus phone card: © 荒川弘／
スクウェアエニックス・毎日放送・アニプレックス・ボンズ・電通 2003 ©2003 RACJIN/SQUARE
ENIX All Rights Reserved.

p.114-115, *Fullmetal Alchemist 2: Curse of the Crimson Elixir* game novelization / Cover: © 荒川弘／
スクウェアエニックス・毎日放送・アニプレックス・ボンズ・電通 2003 ©2004 SQUARE ENIX
All Rights Reserved.

p.118, *Fullmetal Alchemist* DVD, volume 13 / Special illustration: © 荒川弘／スクウェアエニックス・
毎日放送・アニプレックス・ボンズ・電通 2003

p.131 (top), *Fullmetal Alchemist: The Conqueror of Shamballa* theatrical film / Postcard: © 荒川弘・
HAGAREN THE MOVIE

p.131 (bottom), *Fullmetal Alchemist 3: The Girl Who Succeeds God* for PS2 / Preorder bonus:
© 荒川弘／スクウェアエニックス・毎日放送・アニプレックス・ボンズ・電通 2003 ©2005
SQUARE ENIX All Rights Reserved.

p.139, *Fullmetal Alchemist 3: The Girl Who Succeeds God* game novelization / Cover: © 荒川弘／
スクウェアエニックス・毎日放送・アニプレックス・ボンズ・電通 2003 ©2005 SQUARE ENIX
All Rights Reserved.

p.184, *Fullmetal Alchemist* DVD Box Set –Archives– Special Edition: © 荒川弘／鋼の錬金術師製作委員
会・MBS

p.185, *Shonen Gangan*, September 2008 / Cover: "Fullmetal Alchemist x Soul Eater": 「ソウルイーター」
大久保篤 ©Atsushi Ohkubo

p.200, *Fullmetal Alchemist: The Prince of Dawn* for Wii / Announcement: © 荒川弘／鋼の錬金術師製
作委員会・MBS ©2009 SQUARE ENIX CO.,LTD All Rights Reserved.

p.201, *Fullmetal Alchemist: The Prince of Dawn* for Wii / Announcement: © 荒川弘／鋼の錬金術師製
作委員会・MBS ©2009 SQUARE ENIX CO.,LTD All Rights Reserved.

p.202, *Fullmetal Alchemist: The Prince of Dawn* for Wii / Character designs: © 荒川弘／鋼の錬金術師
製作委員会・MBS ©2009 SQUARE ENIX CO.,LTD All Rights Reserved.

p.208, *Fullmetal Alchemist* DVD & BD, volume 1 / Special edition box: © 荒川弘／鋼の錬金術師製作
委員会・MBS

p.225, *Fullmetal Alchemist* DVD & BD, volume 5 / Limited edition box: © 荒川弘／鋼の錬金術師製作
委員会・MBS

p.228, *Fullmetal Alchemist* DVD & BD, volume 9 / Limited edition box: © 荒川弘／鋼の錬金術師製作
委員会・MBS

p.229, *Fullmetal Alchemist: The Prince of Dawn and the Daughter of the Dusk* game novelization /
Cover: © 荒川弘／鋼の錬金術師製作委員会・MBS ©2009 SQUARE ENIX CO.,LTD All Rights
Reserved.

p.232, *Fullmetal Alchemist* DVD & BD, volume 13 / Limited edition box: © 荒川弘／鋼の錬金術師製作
委員会・MBS

p.233, *Fullmetal Alchemist: Final Best* CD: © 荒川弘／鋼の錬金術師製作委員会・MBS

p.254, *Fullmetal Alchemist: The Sacred Star of Milos* theatrical film / Presale bonus school calendar:
© 荒川弘／ HAGAREN THE MOVIE 2011

p.256 (top), *Fullmetal Alchemist: The Sacred Star of Milos* theatrical film / Presale bonus: © 荒川弘／
HAGAREN THE MOVIE 2011

p.256 (bottom), *Fullmetal Alchemist: The Sacred Star of Milos* theatrical film / "Fullmetal Alchemist
11.5: Before the Journey" pamphlet: © 荒川弘／ HAGAREN THE MOVIE 2011

p.257, *Fullmetal Alchemist: The Sacred Star of Milos* theatrical film / DVD & BD box: © 荒川弘／
HAGAREN THE MOVIE 2011

p.258, *Shonen Gangan*, March 2013 / Bonus poster, "Fullmetal Alchemist x Blast of Tempest":
©Kyo Shirodaira・Arihide Sano・Ren Saizaki

p.261, *Osamu Tezuka Cultural Award 20th Anniversary Mook: Manga DNA, Those Who Follow the
Will of the God of Manga* / Cover (Asahi Shimbun Publications Inc.): ©Tezuka Productions

*NOTE: Above titles may not be officially available in English. English titles may be rendered
differently than in other official material.*

COVER ILLUSTRATION: *Shonen Gangan*,
December 2011–January 2012,
Fullmetal Alchemist Final Volume Memorial /
Autographed illustration board and silver watch set

TITLE PAGE: *Shonen Gangan*, July 2011 / Cover

CREDITS PAGE ILLUSTRATIONS: Playing cards included with Japanese
volume 13 limited edition graphic novel